The nature of art

The nature of art

PRENTICE-HALL, INC., ENGLEWOOD CLIFFS, NEW JERSEY

Joseph H. Krause California State College at Long Beach

Design by Walter Behnke

Prentice-Hall International, Inc., London
Prentice-Hall of Australia, Pty., Ltd., Sydney
Prentice-Hall of Canada, Ltd., Toronto
Prentice-Hall of India Pvt. Ltd., New Delhi
Prentice-Hall of Japan, Inc., Tokyo

Current printing (last digit):
10 9 8 7 6 5 4 3 2 1

13–610477–0

To my wife, Jean

Preface

Art is not simple. It is a highly complex phenomenon con-cerned with many aspects of human consideration, including beauty, decoration, and psychological fulfillment; it not only de-fines civic and individual cultural attainment but is valued as a financial investment and used to increase commercial sales. Recog-nized as a legitimate commitment of civilized society, art is cur-rently a means of enriching community life and making it more meaningful. For some people, it prescribes the "real" values of life; for others, it becomes the means by which men would redirect their society. From the contemporary point of view art is a means of personal expression and the mark of the rebellious spirit; it is a way of making life more joyful and is a major means of com-munication, revelation, and therapy. Art is generally conceived of as dealing with man's higher impulses, both intellectual and emo-tional, and is considered vaguely good and something to be ad-mired by most people. Although individual works of art, artists, or even schools of art are sometimes viciously attacked and art as a concept may be ignored or considered of minimal value, it is rarely attacked as being completely worthless or ever completely de-stroyed or eliminated. However, to accept art blindly and without understanding seems as meaningless as ignoring it or attacking its more unfamiliar aspects.

We are currently in the middle of what has been labeled a "culture boom," a condition that has had no precedent in the history of man. Not only do we produce more art than ever before, we consume it at a faster and increasingly frantic rate. In spite of this, however, there is little understanding of the values and limita-tion of art in our modern technological society, and because of this art has often become a superfluous commodity, easily shunted aside as relatively unimportant. The present generation, brought up in the world's most affluent society, exposed to more com-pulsory education than any other, consistently dragged to museums and doggedly exposed to culture, still has little understanding on which to base a meaningful or critical value judgment of the arts. The statement "I don't know anything about art, but I know what I like" is being voiced by far too many who should know better.

I am certainly not the first to recognize this problem. But of the large number of books in the field, some are too complex whereas others are so elementary they fail to bring any new comprehension to the reader. Some tell the reader what to think about art or the art form, rather than indicating the need for considering the arts and helping him learn why they are important. Still others indicate to the reader that everything is art or, at least, can be endowed with artistic qualities, which nullifies the need for critical judgment.

This book does not assume there is only one way to think about art; nor does it presume that its author's personal understanding or involvement with the arts will be meaningfully shared with all its readers. Therefore, it does not merely describe a variety of art forms and declare them good or beautiful by fiat. Rather, the work is based on the assumption that the more one knows about art and the more deeply involved one is with it, the greater significance it will have. Believing this involvement can best be achieved by drawing into focus the relativistic qualities of art, I have used a multifaceted and comparative approach to the subject. By discussing art and the factors involved in developing critical judgment in this way, I have tried to help the reader expand his frame of reference by bringing him to understand that art exists as a meaningful experience beyond subjective values alone. Art is one of the means by which men can objectify most aspects of their world and their feelings about it. Therefore art can have importance, not only for those who produce or collect it, but also for those who take the time and energy to understand it. Art and its appreciation can survive only if men can recognize it as a significant part of the human estate.

A multifaceted approach enables the reader to recognize that art can be examined and judged from many points of view. It can be considered in relation to the nature or appropriateness of its form or formal elements (color, texture, size, scale, shape, and/or volume), its material, the technique by which it was produced, or the skill exhibited in its production. It can be judged in relation to schools of art or esthetic concepts, or in relation to the degree of creativity or self-expression displayed. It can be judged in relation to personal attitudes or on the basis of its worth to society. Each of these approaches can provide a legitimate starting point for one's initial consideration of art.

A comparative approach is essential because art is not a static phenomenon but one that exists in relation to a time, a place, and a set of basic attitudes. It is only when one examines differences as well as similarities that art's fullest range of meanings can be appreciated. Although this book does not approach the study of art via its historical development, neither does it ignore the significance of the historical time and place within which a work of art was created or used. Recognition of the importance of this background is increased when one understands that many objects that are labeled and enjoyed as art in our society come from cultures that neither conceived of, produced, nor used them as art.

Much of the book's examination is based on definition and classification, because I am convinced that these present the easiest and fastest means to comprehension. Although many aspects of art have often been characterized as being of such a subtle or abstract nature that they are best understood as a felt experience, this does not give us an excuse to ignore them or to relegate them to the realm of undefinable experience. With words and pictures we must try to make them comprehensible. To be sure, one description cannot do it; but by carefully building with a multiplicity of definitions, meanings do begin to emerge. The ability to define indicates that awareness exists, and it is only with awareness that meaning and insight is possible. In this sense, definition, when handled carefully, has an almost magical quality.

Although it is impossible for me to recall all those who have been important in helping me form the ideas that served as the basis for this book, I do wish to acknowledge the well-remembered schoolteachers who early in my education taught me to ask why. I also want to thank the scholars and authors whose original research and writings provided meaningful clues to my own understanding through works that were doubly valuable because they were published and available. And I wish to thank the librarians who often helped me find these works. Special thanks go to Ronni Schulbaum, Walter Behnke, Marjorie Graham, and the rest of the Project Planning Department of Prentice-Hall for guiding the book through the complexities of the publishing process in what for me turned out to be a most valuable and interesting experience.　　J. H. K.

Contents

WHAT IS ART? THE ESTHETIC REACTION. *Perception. Response. The Sense of Awe. Taste.* THE DEVELOPMENT OF ESTHETIC JUDGMENT. *The Concept of Good. The Concept of Beauty. The Concept of Interest.*

ONE 3

Art and the esthetic

THE EVOLUTION OF ART. *The Fine Arts. The Minor Arts. Design.* DECORATION —AN ELEMENT OF ART. STYLE. *Methods of Classification. Summary.*

TWO 25

The conceptual development of art

TECHNIQUES AND MATERIALS. *Art Forms. Media.* DEVELOPMENT OF MEDIA AND TECHNIQUES. CHARACTERISTICS OF MEDIA AND TECHNIQUES. *Materials of the Sculptor. Processes of the Sculptor. Painting. Mosaics. Stained Glass. The Print.* CHANGING VALUES AND THEIR EFFECTS ON ART.

THREE 65

Classifications within art

THE CONCEPT OF LINE. *Line and Nonobjective Painting. The Function of Line. Linear Quality.* THE HISTORY OF LINE. *Prehistoric Use of Line. The Ancient World. The Middle Ages.* DRAWING MEDIA. *Chalk. Pastels. Charcoal. Metals. Pencil. Ink.*

FOUR 119

Line and drawing as aspects of art

Contents

THE "LANGUAGE" OF COLOR. *The Primary Properties. Primary, Secondary, and Tertiary Colors. Complementary Colors. Temperature; Recession and Advancement.* COLOR THEORIES. *The Physics of Color—What We See. The Physio-psychology of Color—How We See. The Psychology of Color—Its Effects. The Subjective Nature of Color—Why We See.* COLOR SYSTEMS. *Historical Development. Types of Color Systems.* COLOR RELATIONSHIPS. THE CHANGING NATURE OF COLOR IN PAINTING. SUMMARY.

FIVE 149
Color, its theory and use

TEXTURE IN DESIGN. *Materials. Process. Function. Concept.* TEXTURE IN PAINT-ING. *Naturalism—Adherents and Dissenters. Impressionism. Expressionism. Collage.* TEXTURE IN SCULPTURE. *Primitive Sculpture. Egyptian Sculpture. Greek and Roman Sculpture. Christianity's Effect on Sculpture. Romanesque and Gothic Sculpture. The Renaissance. Baroque Sculpture. The Emergence and Growth of Modern Sculpture.*

SIX 199
The nature of texture

PERCEPTION. MATHEMATICAL ORDER. *Proportion. Symmetry. Proportion and Symmetry in Art. Bilateral Symmetry.* PURPOSES OF COMPOSITION. SPACE IN COMPOSITION. *Conceptual Systems. Optical Perspective. Perspective and Geometry. The Effects of Perspective on the Development of Art.* DEVELOP-MENT OF MODERN COMPOSITION. *Baroque Art. The Nineteenth Century. The Twentieth Century.*

SEVEN 261
Composition, the creation of order

SUGGESTED READINGS 314

INDEX 318

The nature of art

Art and the esthetic

As we in the twentieth century continue to stress the importance of the individual and the values of independent judgment, art moves perilously close to becoming all things to all men and, in the process, begins to lose its identity. It becomes increasingly difficult to consider the study of art as anything other than a study of art history or a completely ego-determined phenomenon, neither of which helps define art as a meaningful part of the human estate. Thus, the first thing to determine when studying art is a frame of reference—the limits defining the scope of art or at least an identification of those objects to be labeled as art.

What is art?

In considering the nature of art, at least two factors seem to be universal to all art objects. First, they are all the result of man's ability to manipulate materials and ideas, that is, they are man-made. Those based on the manipulation of materials are referred to as the plastic arts—painting and drawing, sculpture and the crafts, architecture and design. Those that depend on nonmaterial forms make up the rest of the arts—literature, drama, music, and dance. Another universal characteristic of art is that at some time during the existence of an object men have held it to be of greater significance than other examples of the same form. This is not to imply that only art objects can be of special significance or that objects of special significance are automatically art. We know, for example, that objects can be religiously significant and not be art, socially significant and not be art, economically significant and not be art, technologically significant and not be art. In order for an object to be identified as an art form, it must satisfy more than these universal factors—it must have its primary worth in that area of human involvement we call the *esthetic*.

Art is one of the constructs that man developed to support values that exist apart from what he considers necessary for his physical survival or comfort—that is, those objects or experiences that produce an esthetic response. Because of the scope and varying

nature of art objects, art must be considered as a multifaceted, relativistic phenomenon. Art is not one thing, it is many things. To think of it as a single form implies that it has a monolithic characteristic; this implication cannot be defended in light of our current understandings of the complexities of art or the nature of man.

The esthetic reaction

The term *art* identifies certain objects or experiences as valuable because they are capable of eliciting human responses or judgments about qualities other than those normally associated with morality or the technologically purposeful. These qualities determine the *esthetic characteristics* of an object or experience and, when recognized, cause the *esthetic reaction*.

The esthetic reaction is not restricted to art forms; one can react to beauty wherever or in whatever form it is found. We respond esthetically to a sunset or the sea, to flowers or animals—and even to the weather. The esthetic reaction and art are an integral part of man's humanness and, as such, are two of the factors that set him apart from other animal forms.

Perception

The first stage of esthetic reaction is *esthetic perception*. This perception brings into primary consideration the recognition that a form is beautiful or significant apart from any of its other characteristics. An individual's ability to respond esthetically (that is, to recognize and react to beauty) depends on his ability and willingness to perceive objects and phenomena apart from their everyday qualities and in terms of their formal characteristics. Once the observer is psychologically set to perceive the object as esthetic, it makes little difference what the specific formal characteristics are or how they are arranged. The observer is, in a sense, preconditioned to accept the form as esthetic when the parts take on the conceptual qualities of the total image.

We of the twentieth century judge all man-made objects to be art that we perceive as eliciting an esthetic response. This can be the result of a direct sensory experience, an intellectual engage-

ment, or some combination of these two. The means by which the art object is perceived is important because the form of the art object is affected almost as much by the way the observer views it as by the manner in which the artist had envisioned his work.

If the art object appeals directly to the senses and/or the emotions, the image need not attempt to meet any standards other than its own, because it is essentially a receiver and transmitter of a value or meaning from a source other than itself. For the religious image, the value may be thought to come from a divine source. For the post-Freudian secular image, it may be thought to come from an inner or psychic source. The satisfactions provided by direct sensory perception are achieved because the forms are

Left: "Our Lady of Vladimir," twelfth century, Moscow icon, detail of head. An icon's primary value is religious and increases in proportion to the divine energy it is believed to transmit.

Right: Georges Braque, "Young Girl with Guitar," 1913. A modern painting whose esthetic value is dependent on intellectual understanding. (Courtesy, Musée National d'Art Moderne, Cliché des Musées Nationaux.)

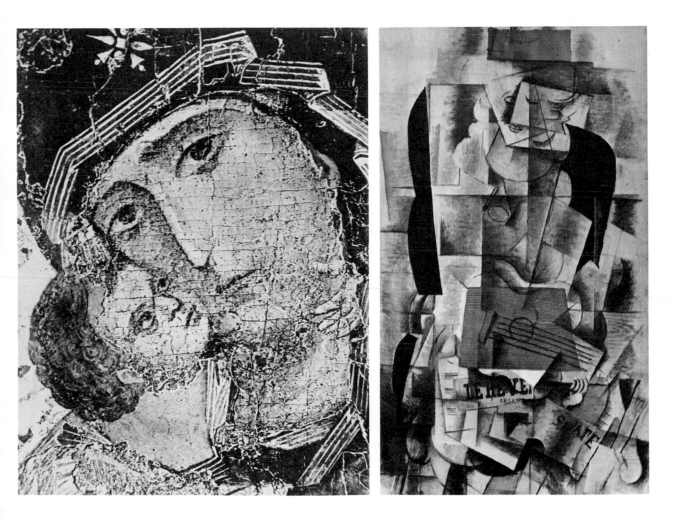

inherently capable of triggering a satisfying emotional or sensuous response pattern.

If, however, perception of the art form depends on the establishment of an intellectual involvement, the image must provide relationships—relationships either among the various parts of the form within the formal context, between the total form and values or ideas external to it, or between the form and a tradition against which it can be judged. The satisfactions that result from this more circuitous involvement occur because the tension produced by the initial stimulation is released as understanding develops.

The intellectual engagement can be based on different levels of response—first, response to narrative or symbolic factors; on a more abstract level, response to rationality or logic; and on an even more abstract plane, to the proportional relationships of the parts that make up the form. But in each case some learning is required so that the observer can recognize the stimuli and become engaged in a manner that can be resolved gradually as understanding is achieved.

Response

The second stage of esthetic reaction is the *esthetic response*, which is based on the observer's ability to perceive those qualities and relationships in which the practical, moral, or social aspects of the object remain unconsidered. The esthetic reaction is a learned response that is one result of man's development beyond an animal or subsistence level. It is the recognition of abstract values that gives evidence of our human and sophisticated state of being.

Although the esthetic response must eventually occur as an isolated phenomenon, it most often occurs as part of the larger response pattern generated by an evaluation of a form's totality. Thus we can respond esthetically to an object whose primary purpose is utilitarian, economic, moral, etc., only by shifting our focus from its primary purpose to its formal characteristics. In the esthetic consideration of designed products or examples of the applied arts, the promise of a high degree of efficiency or the mode and skill of manufacture is also an important factor. Objects become more valuable in our judgment when they can be evaluated positively on more than one value level.

The Sense of Awe

Basic to the esthetic reaction is a sense of awe at an object's very existence—its physical qualities, the skill with which it was produced, its complexity, or the insights one might develop from it. If an object or phenomenon is derived from natural forces (a towering fir tree or a sunset, for example), we see it as the result of a power greater than man's. Often this power is thought of as divine or, if not divine, at least equal to that which is responsible for man himself. If what we are considering is the result of human efforts, we marvel at an individual's ability to produce a form that is above the norm, one that either sensitively reflects nature or reflects the imaginative or nonobjective thinking of mankind.

To primitive man, producing an image was tantamount to having the ability to capture the spirit of that which was pictured. And even for men who were much more sophisticated, the ability to draw or paint was often considered a divine gift, an idea not unrelated to the more primitive concept. Thus, rendering a likeness has powerful connotations far beyond the act of reproduction. There are still many people in the world who feel it is unsafe to have their likeness drawn or their photograph taken.

Many man-made and mechanical forms are also capable of inducing a sense of awe in us, not because we believe them to be the result of a divine power, but because we wonder at man's ability to manipulate materials and build monumental forms. It is this wonder that is basic to our response to such magnificent structures as the Stonehenge, the carefully carved marble temples of ancient Greece, and the monumental pyramids and temples of pre-Columbian Latin America.

Closely allied to our feelings for these great structures is our feeling for mechanical forms. The production of awe-inspiring machines increased significantly during the Industrial Revolution. However, as these became more easily produced and more available, the almost unbelievable skills needed to manufacture them began to be taken for granted and the awe they merited was lost. Thus because we have the ability to reproduce naturalistic forms, either as rendered images via the camera or three-dimensional forms via complex casting techniques, and the means to turn out monumental structures and mechanical forms in unlimited quan-

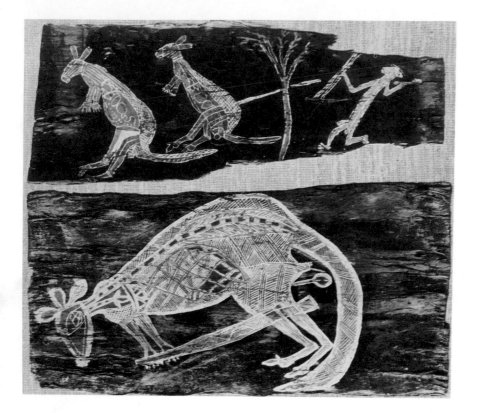

Left: Australian aboriginal spirit drawing. For primitive men, drawings contained all the power and spirit of that which was depicted. (Photo, New York Graphic Society.)

Below left: The Stonehenge, Amesbury, England, built sometime between 1900 and 1600 B.C.E. (before the Christian Era). An example of early man's belief in the mystic significance of the sun and seasons. (Photo, British Information Service, New York.)

Below right: Hoover Dam, completed March 1, 1936. Built to control the waters of the Colorado River, this dam is an example of a modern awe-inspiring man-made structure. (Photo, Union Pacific Railroad.)

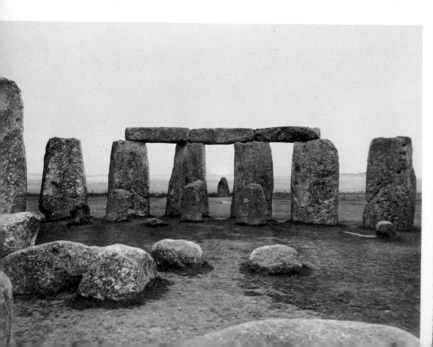

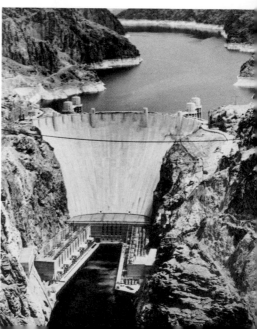

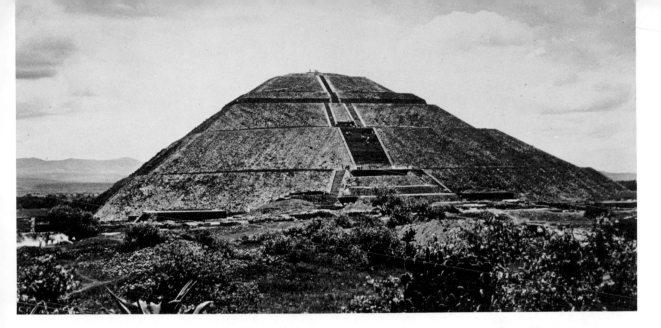

"The Pyramid of the Sun," Teotihuacan, Mexico, sixth to eleventh century, C.E. (Christian Era). A structure of great religious significance, on which ritual sacrifices were carried out. (Photo, courtesy Mexican National Tourist Council.)

tities, we now respond only to forms that are more demanding of the producer and less commonplace to the observer or user.

In the visual arts during the nineteenth century, the forms that filled this need were those invested with moral values or considered picturesque, such as the paintings of Jacques Louis David (1748–1825) or Jean François Millet (1814–1875) and the artificial ruins created for English country gardens. In the twentieth century, the art forms, for the most part, have been representations of psychic revelations, less comprehensible and, because they could not be mass-produced, less available—two factors that are necessary to maintain a sense of awe. Art forms revealing emotional states or conditions that, in earlier times, were not considered nice or proper for public display and forms that expose the feelings of their creator exemplify the modern artist's efforts to maintain the sense of awe for his productions.

Contemporary designers and engineers preserve this vital quality by designing space ships capable of orbiting the earth, freeways that transform the urban environment, and buildings that seem to defy the basic nature of materials and structure. Although synthetic materials, mass production, and miniaturization can help the contemporary designer achieve the necessary sense of awe, only when he approaches his work with a creative spirit that is seemingly in opposition to current production practices are these materials and techniques effective.

Many of the historic objects we of the twentieth century consider art were not created as art forms or for the sake of beauty.

9

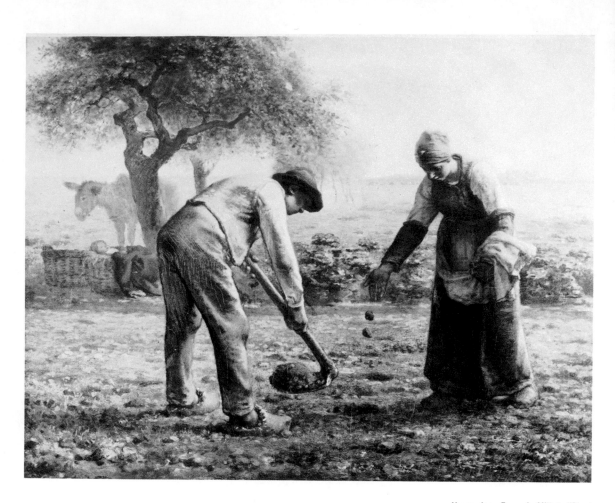

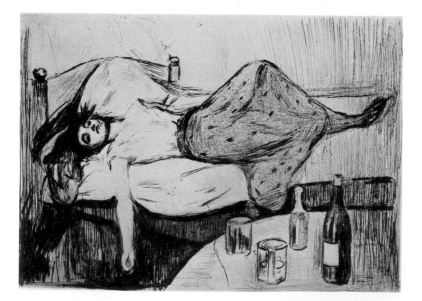

Above: Jean François Millet, "Planting Potatoes," c. 1861–1862. A painting considered both morally significant, because it depicts the virtues of manual labor, and picturesque. (Courtesy, Museum of Fine Arts, Boston. Shaw Collection. Photo, Three Lions, Inc.)

Left: Edvard Munch, "The Day After," 1895. This etching, considered shocking when it was executed, has value for modern man because of its ability to arouse a strong emotional response. (Collection, The Museum of Modern Art, New York. Gift of Samuel A. Berger.)

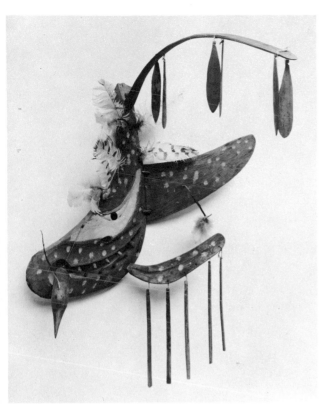

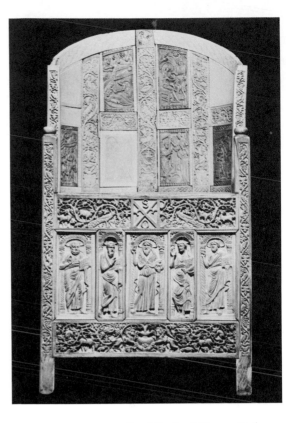

Many were created as magic objects for religious or ritualistic purposes; some were ceremonial objects used to identify or symbolize a position of power or authority; and others were elegantly crafted utilitarian forms produced in periods less technologically sophisticated than our own. That these objects were not produced as art should not invalidate our consideration of them as such, however,

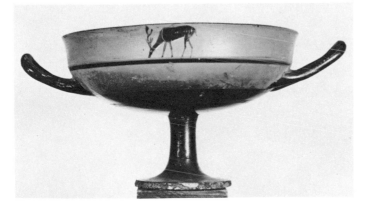

because it must be remembered that we judge them in terms of our own value system.

Ancient man believed in a spiritual relationship between living forms and the environment. The earliest records we have of this belief were found in his paintings, engravings, and sculpture, which date as far back as the Paleolithic period. Primitive man did not depend solely on his own powers for survival or the continuity of his line; his concept of survival was linked to his ability to capture or satisfy spirits external to himself who, in return, would provide for him. Thus, he conceived of an association between himself and the world he inhabited that was different from that of all other living forms.

As man progressed and was able to satisfy his basic needs within the framework of an organized social system and cyclic living pattern, additional controls were attributed to the external forces to which he linked his survival. In extending the relationships that existed between himself and his gods, man began to develop value systems apart from those that were primarily related to his physical well-being. Because he was most comfortable with familiar forms, changes occurred slowly and only when there was overwhelming evidence that a new form offered greater advantages than did the old. The gradually changing forms of ancient Egyptian tombs—from the relatively small and simple mastaba to the monolithic pyramids and the rock-cut tombs of the Middle Kingdom to the temples cut into the cliffs of the Valley of the Kings—illustrate the procedure.

However, because this type of form evolution was based on factors other than choice, it does not reflect what we refer to as *taste*. Only when man is able to choose freely between equally valid forms is taste exercised. For example, a choice between two monumental pieces of figurative sculpture—one by Henry Moore (b. 1898) and the other by Jacques Lipchitz (b. 1891)—might be a matter of taste, if other factors such as size, material, and cost were equal or immaterial. Choice is esthetically significant when taste is the primary variable that determines it.

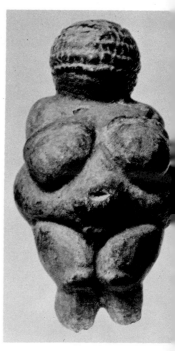

"The Venus of Willendorf." A Paleolithic carving believed to have been used as a fertility figure. The original is in the Natural History Museum, Vienna. (Photo, courtesy of the American Museum of Natural History.)

Top: Henry Moore, "Reclining Nude," 1937. (Courtesy, The Baltimore Museum of Art.) Bottom: Jacques Lipchitz, "Bathers," 1923–1925. (Courtesy, the Norton Simon Inc. Museum of Art, Fullerton, California.) One's preference between these figures would be a matter of personal taste.

The development of esthetic judgment

In the appreciation of art, three terms—good, beautiful, and interesting—are basic for an indication of esthetic worth. These terms are often used interchangeably as a form of general approbation; "I like it because it is good" is heard as often as "I like it because it is beautiful" or "I like it because it is interesting."

The Concept of Good

Much has been written about the nature of "ultimate good" and "ultimate beauty"; the concepts go back to man's early philosophical contemplations, and definitions have varied according to the way man conceived himself and his relation to the universe. For our purpose, *good* will represent a state approaching a preconceived and established condition or quality. In terms of form it presupposes an ideal—either an ideal revealed by God or one that has traditionally worked for the protection or to the advantage of man. Thus, something may be labeled good because, in comparison to the ideal, it approaches an acceptable norm. A form may also be labeled good when it is, in fact, only the best available under existing conditions but is, indeed, better than competing forms. Whether one takes the idealistic or pragmatic position, however, the concept of good is linked to an established quality, and the degree of goodness is measured against it. Thus in the arts, as elsewhere, the observer or critic must be aware of the norm against which a form is judged.

Some philosophers base the concept of good on the consideration that God alone can project the ultimate good. Thus, the best man can do is imitate God's projection as reflected in nature or by revealed doctrine. The artist can act merely as an instrument by which a divine will is projected. Others see good as a relative concept, created by man and therefore capable of being altered to meet man's changing needs. For those who hold this position, forms are good if they reflect or project that which is expressive of man or that which solves his problems.

The Concept of Beauty

Beauty has often been considered in much the same way as good. Some philosophers maintain that beauty is good—but given form and rendered visible; some hold the two to be interchangeable. Saint Thomas Aquinas (1225–1274) in his *Summa Theologica* stated that "Beauty and goodness in a thing are identical fundamentally, for they are based upon the same thing, namely, the form, and consequently goodness is praised as beauty." [1] Other philosophers contend that there is a difference between beauty and good and that both are essential qualities.

George Santayana (1863–1952) held that although the good and the beautiful are closely related, there are important distinctions that must be made between them. One distinction is that esthetic judgments (beauty) are mainly positive whereas moral judgments (good) are made in response to the negative or evil. A second distinction is necessary because beauty is conceived immediately as an intrinsic quality, but goodness is conceived as a projective or extrinsic quality.[2] Beauty also differs from good because it can be based on physiopsychological perception, which is not a necessary attribute of, and is often unavailable to, the establishment of good. In this sense, beauty has been defined as the objectification of pleasure. Thus Santayana said, "Beauty is pleasure regarded as the quality of a thing." [3]

However, it is possible for an art form (or any other form) to elicit a pleasure response that has little to do with the intrinsic beauty of the form. Any form—an icon, for example—that is valued because of what it symbolizes rather than what it is can accomplish this. In this sense then, value is perceived through the art form, not because of it. Thus one of the major considerations about the nature of the art form depends on why it is considered to be of value.

[1] St. Thomas Aquinas, *Summa Theologica* (rev. by Daniel J. Sullivan, trans. by Fathers of the English Dominican Province), Chicago: Encyclopaedia Britannica, Inc., 1952, vol. I, p. 26.

[2] George Santayana, *The Sense of Beauty*, New York: Dover Publications, Inc., 1896, p. 23.

[3] *Ibid.*, p. 49.

FUNCTION AS BEAUTY. In our technologically oriented culture, beauty has often been attached to function, as evidenced by remarks made about the beauty of an engine or mechanical form. But people are usually responding not so much to the qualitative performance as the promise of performance the form suggests. Forms that look as we think they ought to look in order to function efficiently are described as beautiful. The promise of function creates as significant an esthetic response as does highly efficient operation. Throughout history, as far back as the time of the ancient Greeks, men have linked esthetics to function. One

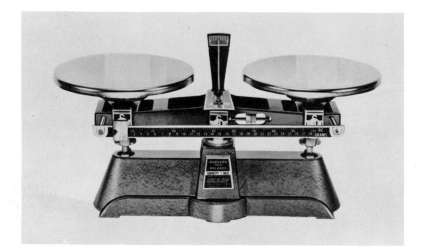

A contemporary beam scale whose form holds promise of efficient function and can thus evoke an esthetic response. (Courtesy, Ohaus Scale Corporation.)

of the more important advocates of this position was the American Horatio Greenough (1805–1852), who has been described by Lewis Mumford (b. 1895) as "the greatest precursor of modern form, or at least [its] greatest philosopher." [4] Greenough believed that economically efficient function was a divine value expressed transcendentally in natural form.

The interdynamic relationship of the elements of any form, including those of the expressive arts such as painting or sculpture, are defined in terms of function. The doctrine of function in

[4] Lewis Mumford (ed.), *Roots of Contemporary Architecture*, New York: Reinhold Publishing Corporation, 1952, p. 8.

the arts contends that each part of a form must operate synergetically (that is, the parts must add up to more than their sum) in order for a work to qualify as art. This is what is usually meant when, upon examining an art object, one says "it works." Each part must relate positively with all the other parts to create a total form that is perceived as something more than that which could be expected if the parts were examined separately or assembled in a different manner.

UNITY AND SIMPLICITY. An object that is composed of a large number of complex parts, all of which maintain a separate interest for the viewer but come together to function or be seen as a single whole, is sometimes referred to as an example of unity in variety. Such diverse forms as Paolo Uccello's (c. 1396–1475) "The Battle of San Romano," Saint Basil's Cathedral built in Moscow between 1554 and 1560, and an Alexander Calder (b. 1898) mobile such as the "Lobster Trap and Fish Tail" illustrate this concept. In each case the diverse parts are unified by the use of scale, the

Paolo Uccello, "The Battle of San Romano," c. 1455. The forms are varied, but, because they all contribute to a credible time, place, and event, they present a unified whole to the viewer. (Reproduced by courtesy of the Trustees, The National Gallery, London.)

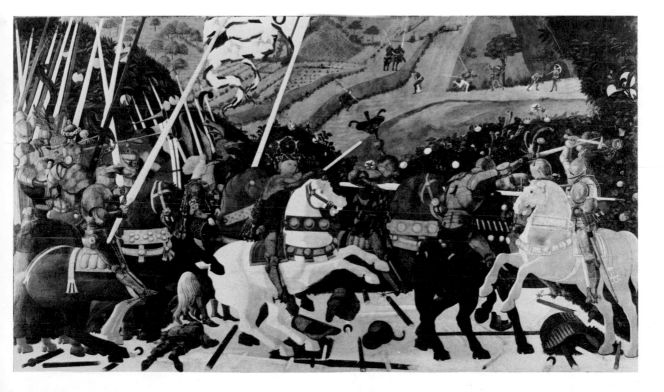

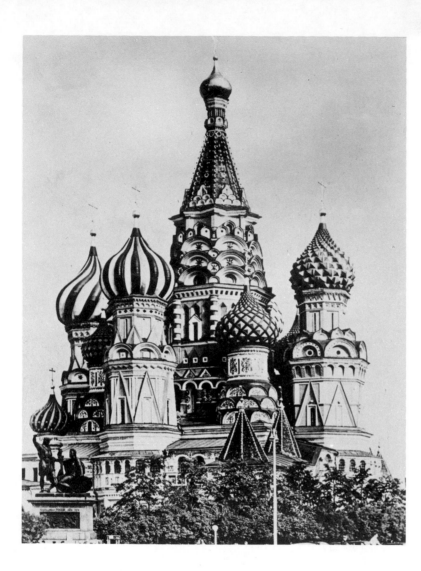

Saint Basil's Cathedral, Moscow. The towers of this cathedral, which was built between 1554 and 1560, have varied and ornate forms that add greatly to the cathedral's general architectural interest. (Photo, Air France.)

proximity of the parts, and the recurrence of similar elements. An extension of this concept is that when the complex is presented simply, it is equal to beauty; and a further extension is that simplicity itself equals beauty. For a number of years this latter concept has been offered as an esthetic platitude and has been a guiding principle for much of today's art education; it reaches ultimate expression in some of the more sterile contemporary architectural facades that refuse to recognize human scale and in minimal paintings that present a single square of color for consideration. When used as a self-contained absolute, as it has been in our own time, the concept can lead only to dismally boring

18

results, a fact amply supported by the multitude of simple and dull images and forms that have emerged, been labeled as art, and been displayed as examples of the artistically significant.

Simplicity for its own sake is, as stated, merely dull, unless it is the result of a sensitive paring down to essential values. Simplicity that results from a lack of education, training, or significance can only be banal. However, it must not be inferred from this that simplicity cannot be an important characteristic of art—it can be and often is. Simplicity is significant to the conception or perception of a form when a more complex form would block understanding or when the simplicity allows the form to be symbolically

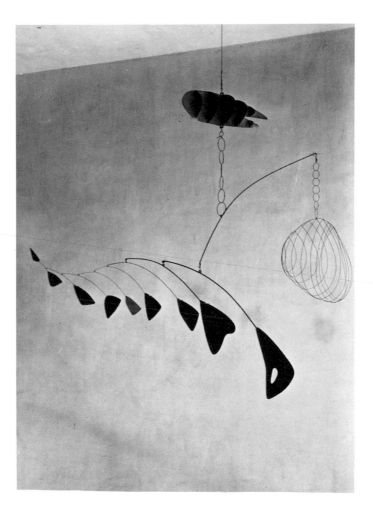

Alexander Calder, "Lobster Trap and Fishtail," 1939. Held together by a common theme and spatial limits, the individual forms take on new esthetic significance as new forms are created by the moving parts. (Collection, The Museum of Modern Art, New York. Gift of the Advisory Committee.)

or functionally meaningful. The greatest danger of simplicity is that after the simple form has been esthetically comprehended, it fails to maintain the interest of the observer and thus loses its esthetic attraction. The simple form can only be esthetically significant—and therefore labeled art—when it successfully invites and holds esthetic attention or a positive response.

The idea that unity and simplicity are basic to significant form is supported by scientists and philosophers. Unity—the quality that allows us to perceive a complex of parts as a total entity—has been a constant element in the arts. At times, it has been labeled the first principle of form. Harold Rugg has written, "The creative task is always the same, whether it be in art, science, or invention: that of reducing a miscellany to order. This is the first principle of form, variously called Heaven's first law, the first principle of the universe and the foundation of all art." [5] Man believes that an elemental aspect of life and the universe is that all things exist in some order by which he and his environment can be explained—either an order discovered by man or one conceived by him. The pattern of the order, regardless of its complexity, has been described most often in our culture by numerical ratios or proportions.[6] Chaos is a form whose order we are unable to perceive or a state of order that fails to meet our preconceived idea of what it ought to be. But much of our response to an art form depends on our ability to perceive the nature of the order established. Some systems of order appear to be beneficial to man and his universe, whereas others seem destructive; however, the system that is perceived is not necessarily an accurate description of the order that actually exists. Relating the belief in an order to our concept of the arts and beauty is our traditional understanding of harmony, originated by the ancient Greeks. This correlation of order and art is evidenced by the many theories of structure or composition that are based on modulation; support for these theories was founded on the belief that they were of ancient or divine origin and therefore revealed perfect order and, by extension, truth and beauty. Support for these theories is no longer based on this belief.

[5] Harold Ordway Rugg, *Imagination*, New York: Harper & Row, Publishers, Incorporated, 1963, p. 124.

[6] For a more complete discussion of ratio and proportion, see Chap. 7.

Simplicity, on the other hand, as related to the concept of economy and when perceived as a total entity (i.e., unity), is considered an absolute good. Support for this idea has been drawn widely from both the sciences and the arts.

Economy would seem to be implicit in the definition of an organization; the ideally perfect order will be guaranteed only by the simplest possible fusion of elements. The instinctive tendency of the animal body is to act that way. The mathematician, building his beautiful definitions, knows it. The expressional artist knows it. The poet seeks the one best word, the briefest possible but most complete phrase to express his feeling. The architect searches for the minimum structural design.[7]

This position, however, is based on assumptions whose validity is supported by a philosophy of economic egalitarianism existing only in a period of need. It has never held true for the artist whose work is based on personal expression or the poet whose aim is to develop insights for his reader, a task that often demands a more complex and elaborate approach than that necessary for direct communication. Even the pragmatic design theories based on a minus economy, which were popular from the 1920s through the early 1950s, have been reconstructed in light of the more affluent, consumer-oriented condition that exists in some Western societies today.

In summary, the characteristics that contribute to our current concepts of beauty are those related to our ideas of morality, pleasure, and function. Moreover, the qualities of beauty are always considered relevant to human perception, whether the beauty is considered to be divinely inspired or conceived by man. Thus beauty is a relative quality that represents, as does good, the best example of a form based on a predetermined standard of the ideal. Or, it is a quality determined by the emergence of a psychophysiological response in the observer. In both cases, however, it has no existence apart from a conceptualized, humanly instrumentalized reality. It is only when beauty becomes related to a mathematically definable standard that it becomes a consideration of proportional relationships.

[7] Rugg, *op. cit.*, p. 125.

The Concept of Interest

Of all the terms used to connote esthetic value, "interesting" is by far the simplest. *Interest* is a quality that expresses an object's ability to attract and hold our attention for a given period of time. The longer the attention span involved, the greater or more intense our interest.

Things become interesting for a number of reasons: they may relate to interests already held; they may be new, different, or unusual; or they may be expressive of ideas or skills we admire. Why an individual becomes interested in an object has as much to do with his total being as it does with the object that has been isolated by his attention. Interests cover a wide range of feelings and include, as William James has pointed out, ". . . not only the pleasant and the painful, but also the morbidly fascinating, the tediously haunting, and even the simply habitual." [8]

Interest at any given moment is that which engages our attention and dominates our thought pattern. Often, things that would normally interest us fail to do so because our attention is on more pressing needs. What proves to be interesting at one moment may not be interesting at another. In the arts, as in other areas, our ability to become interested is correlated to our awareness and to the ease with which we can create meaningful relationships between what we perceive and what we have experienced or what we hope to experience.

One of the keys to an object's ability to hold our attention is its promise of satisfaction. This satisfaction may be the result of a sensual contact or an intellectual engagement successfully resolved and may be expressed by either an emotional reaction or a rational consideration. But forms whose emotional appeal or intellectual aspects are easily recognized and comprehended tend to be less interesting, all other factors being equal, than those whose recognition and comprehension demand a higher degree of intellectual involvement—provided, of course, that this degree is not so high that the promise of a successful engagement is removed.

As extended values, good and beautiful have a positive nature,

[8] William James, *The Principles of Psychology*, New York: Dover Publications, Inc., 1950, p. 559.

whereas interesting remains neutral. Good and its counterpart, bad, beautiful and ugly can all be interesting; that is, each is quite capable of catching our interest and holding our attention for a given time span. The value judgment one might make of the object or experience can be independent of the interest one has in it. But, although interest need not relate directly to a value system, it is one of man's most personal modes of involvement and relates to his sense of the significant. Thus, what may prove to be of great interest to one person may, because of prior experience or the lack of it, prove to be of no interest to someone else.

The conceptual development of art

Art as it is conceived today is an abstract invention of modern man. The meanings we attribute to the word are of relatively recent origin and are restricted in scope. Although all people, as far as we know, respond to the physical form of objects, the basis of their response differs; it is because of these different responses that we find variant meanings attached to the words other peoples use to identify objects we consider art. In English, the word *art*, like most other words, has acquired its present definitions slowly and by accretion. And because these definitions are constantly changing, the word can be defined only by the cluster of ideas and meanings that have accumulated around it. Current dictionaries show the wide range of meanings the word has acquired; to see how these meanings have evolved, one need only consult dictionaries of the last several decades.

In many languages, the words used to connote art are conceptually far removed from the root words that gave them their linguistic form. In Chinese, the modern character for *art* stems from characters whose original meaning was "white mutton fat," a substance considered both good and valuable. Thus the character implies values differing significantly from those of the Latin *ars*, the root of the English *art*. *Ars* carries a commitment to the value of skillful production; literally it means "skillful making" or the product that results from the skillful making. In this respect, *ars* is comparable to the Greek word *techne*, from which we get such English words as *technology* and *technician*. In Sanskrit, the word *çilpa* is used to identify the craft or art form; *çilpa* has been translated to mean *variegated, colorful,* or *decorated*—connotations also carried in our word. The Hebrew word for *art*, which transliterates as *amanut*, stems from the root word *aman*, which carries a sense of knowing. This concept of the art form—that it relates to knowledge and hence truth—is to be seen in the modern belief that the arts are a kind of wisdom gained from an external source. *Aman* also carries the sense of begetting, the most elementary exercise of man's constructive power; this connotation is currently maintained by our association of art with the creative act.

Some African languages—those belonging to cultures in which the concept of art, as we understand it, does not exist—have no words that contain the conceptual abstraction we attach to the word. These same languages, however, often have words that correspond to our concept of the handicrafts or the names of specific craft skills. In still other languages, objects and the men who make them are simply named; the linguistics have not developed to the stage in which there are specific words for general classifications of craftsmen, e.g., potters, weavers.

The evolution of art

Beginning with the artifacts of prehistoric man—from his engraved stones to his venus figures—the majority of forms we currently identify as art consists of objects that were intimately related to the life patterns of the people who created them. The art form as we know it, from man's first manipulation of naturally colored chalks until the beginning of modern industrialization, was created as a part of the religious or political life of the powerful and wealthy.

Man is a maker, and although not all he creates becomes valued or can be identified as art, certainly those forms that project an inherent value because of the nature of their material, the skill of their manufacture, or their ritual or symbolic value are often so identified. The obsidian ear ornaments, the gold ware, the polished clay pots, or the featherwork of pre-Columbian Mexico; the brooches, pins, bronze bowls, or stone carvings of medieval Ireland; the ceramic jugs, bowls, and tiles, ivory caskets, glass lamps, and exquisite carpets of Islam—all these represent forms that we admire today for their esthetic worth. And as such, their classification has been changed from *artifact* to *art*. But lest one think that ancient painting, sculpture, or architecture was created for the esthetic qualities with which we endow them, let it be remembered that painting and sculpture, as we know them, did not begin in the West until the end of the thirteenth century, at which time and for some centuries to follow, their subject matter was dictated by the needs of the Church and a few powerful families. The major architectural forms of antiquity were temples, tombs, and fortress-castles.

The period that allowed for the development of art for art's sake is relatively recent. This concept, which made art a luxury to be indulged in only after man's material and spiritual needs had been met, began with the emergence of esthetic individualism at the end of the seventeenth century and flowered with the effete romanticism of the nineteenth century. Much of the art that has survived has done so because objects were collected and protected as curiosities or antiquities. Other objects were hidden or overlooked and have been discovered recently only because of our modern interest in archaeology and in investigating the past.

Collections of objects we now refer to as art began in ancient times as part of the systems of ritual offering, tribute, and plunder —the methods by which treasures were brought together. The objects, when produced, were not intended for mere collection; they were objects of economic or ritual value and, in some cases, were valued for the cunning workmanship with which they were wrought. However, when they were captured or offered as reparations, the objects' primary value to the conquerors was as a means of augmenting their treasuries. Thus, collections of various types are recorded in the inventories of the powerful Egyptian pharaohs and the Mesopotamian kings, as well as in those of the ancient Greeks and Romans.

In ancient Greece (until the Hellenic period) the collections were, for the most part, stores of treasures belonging to specific temples or cults. It was not until the second century of the Christian era and the time of Alexander the Great that objects of value and interest were collected by individuals to demonstrate power and position. Some of these collections were of valuable and interesting objects that were handed down through generations. Objects of unique natural form and objects from foreign countries, as well as those of highly personal value, were included. During the Roman period, interest in collecting reached heights that were not to be equaled until the modern period.

From the time of the Greeks and Romans until well into the Renaissance, art consisted primarily of those objects that showed extreme skill or cunning in their manufacture. The terms used to identify the arts referred to the skillful performance of almost anything. Thus, there were *ars gymnastica*, the art of gymnastics; *ars civilea*, the art of politics; and, of course, *ars amorata*, the art of love, of which Ovid wrote so convincingly.

The Romans made a distinction between the liberal arts (the arts of free men) and the illiberal or sordid arts (the arts of the slaves and lower classes). The liberal arts were divided into two categories: the *Trivium*, consisting of logic, rhetoric, and grammar, made up the art of persuasion; and the *Quadrium*, consisting of arithmetic, geometry, music, and astronomy, constituted the arts of harmony and numbers. The sordid arts were all those that depended on the physical manipulation of materials; they included not only those forms of production we refer to as the crafts, but also those that today are included in the fine arts, i.e., painting and sculpture.

The Fine Arts

It was not until the Renaissance, when various artisans' guilds were able to achieve some political power and the highly aggressive and articulate painters were able to define their work as intellectual, that painting and, a bit later, sculpture came to be considered a part of the liberal arts. The wedge needed to open the ranks of the *artistas*, the term reserved for those accomplished in one of the liberal arts, was provided by the mathematical aspects of composition and perspective in Renaissance painting. Chief among the protagonists of this fight to achieve a higher status for the painter was Leonardo da Vinci (1452–1519), who claimed that although manual operations did enter into the art of painting, its essential and significant aspects were developed in the intellect of the painter. However, Leonardo thought that the physical effort involved in sculpture precluded the sculptor from this new position, but Michelangelo Buonarroti (1475–1564) was successful in presenting the other side of this argument.

With painting and sculpture well entrenched as part of the liberal arts, it took only the expanding technology of the eighteenth century and the profit-oriented industrialization that followed to shift these one-time sordid arts into a category even farther removed from their plebeian origin. Art came to be identified as objects that were ennobling—in their manufacture as well as in their perception. And this quality was measured by the objects' distance from the machines and profits of a commercial or industrial enterprise. The closer an art object came to expressing an intrinsic truth and the less it was related to a false truth or

mechanical manufacturer, the finer it was considered to be. Sir
Joshua Reynolds (1723–1792), in his inaugural address (delivered
in 1769) as president of the British Royal Academy of Arts, took
an official stand to protect art against the industrial manufacturer,
who was considered to be "her primary seducer." With the
academies of Europe in full support of this position, nothing was
spared in the fight to protect the purity and "fineness" of the arts.
Phrases comparable to the English *fine arts* were established on the

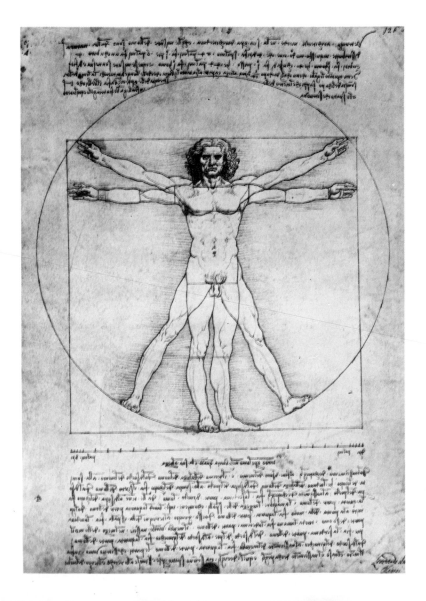

Leonardo da Vinci's study of the
human body, from his Notebooks.
This drawing illustrates Leonardo's
varied talents; he was not only an
artist, but also a mechanical en-
gineer and a student of anatomy.
(Photo, Alinari-Art Reference Bu-
reau.)

Continent to identify this new ideal. In German, it was *Die Schöne Kunst*; in Italian, *le belle arti*; and in French, *les beaux artes*.

Architecture has always held a unique position in the hierarchy of the arts. Because the architect was initially involved with the design of fortifications, temples, and funerary monuments, he and his art always had a high social position. Although there has been and still is some support for casting architecture in the role of "queen of the arts," because it functions in the realm of both two- and three-dimensional forms (painting and sculpture) and is more complex than either, it deserves a place all its own. For, to be successful, architecture must consider not only art and esthetic judgments and technology and practical judgments, but also the economic problems that are a significant part of all construction.

The Minor Arts

Those art forms that failed to achieve the rank of the fine arts were referred to in a slightly deprecatory manner as the minor arts or the decorative arts until quite recently, in spite of the fact that many objects thus identified were extremely valuable and had qualities that made them museum pieces. Because of their utilitarian aspects, objects in the minor arts were considered to be of less expressive or esthetic value, although few critics argued that imagination and skill were required for their production. Included in this classification was the work of the skilled craftsmen whose products were adjuncts of the building arts, interior decoration, and personal or ritual decoration. Workers in precious metals, stone carvers, ivory workers, weavers, potters, glass blowers, and furniture makers were included in the artisan class rather than in that of the artists. The rationale for classifying the products of these craftsmen as minor arts rather than fine arts consisted of several factors: first, the response to these objects was due more to the value of the materials used and the skill of working· with them than to an appreciation of form as a revelation of a noble truth; second, the objects, as a general class, could be considered as supplements to the major arts; and finally, because of their basic utilitarian functions, the objects were not primarily concerned with either esthetic or expressive values.

With the advent of industrialization in the late eighteenth century, the ordinary craftsman became the industrial worker and the

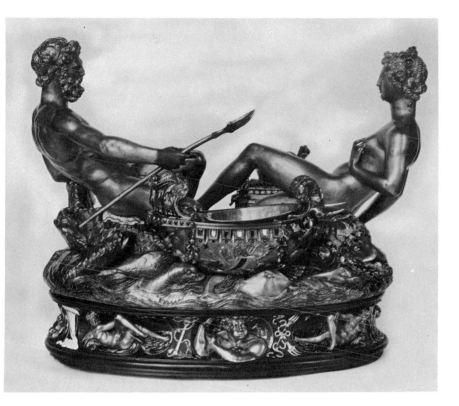

Benvenuto Cellini, "Salt Cellar of Francis I." A superb example of the Renaissance crafts, created between 1530 and 1543. (Courtesy, Kunsthistorisches Museum, Vienna.)

job of designing was transferred from the master craftsman to the entrepreneur, who not only controlled production but was able to manipulate the markets to his advantage. But as industry increased in size and complexity, the entrepreneur was no longer able to control all aspects of production and the necssity to delegate design decisions developed. It was the need for men to fill this role that eventually led to the development of design schools during the nineteenth century, and it was the design schools that led to the development of esthetics as a marketable aspect of product design; this enabled design to be considered as an art form. Thus, the nineteenth century marked the beginning not only of the many schools of art and the many art movements that make up the modern period in painting and sculpture but also of the awareness that brought the commercially designed object onto the level of esthetic consideration it enjoys today.

Because traditionally there has been a separation between the crafts, which have been considered until recently primarily as utilitarian forms, and the fine arts, which have usually been related to matters of the spirit, the opinion that the crafts are

31

inherently inferior is still to be found in the more conservative artists, art historians, and museum curators. However, this position is most vigorously attacked by most of the more important contemporary craftsmen, who maintain that the primary purpose of the crafts, as of all the arts, is to provide vehicles for personal or material expression. Today, many leading craftsmen speak only about those aspects of their work that relate to form, material, and/or expression. Shape, color, texture, characteristics of materials, and personal expression are as important to the modern craftsman as they are to the modern painter or sculptor. Decorative three-dimensional wall hangings, ceramic objects that are not meant to be used as containers, and papier mâché designs that reach sculptural dimensions are examples of forms that no longer depend on the concept of utility to be identified as examples of the crafts.

The extent to which the craft form has changed can be seen in comments by contemporary craftsmen. Kay Denning, in the March/April, 1963, issue of *Crafts Horizons*, the leading magazine devoted to the crafts that is published in America, described her involvement in the crafts as follows:

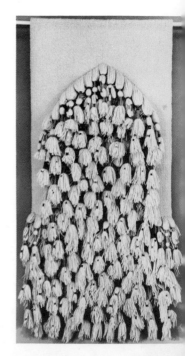

Sheila Hicks, Prayer Rug, 1965. This rug exhibits the interest of contemporary craftsmen in self-expression. (Collection, The Museum of Modern Art, New York. Gift of Dr. Mittelsten Scheid.)

My long-run pursuit is visual truth, knowing and learning all I can about nature—all the while remembering that I am an animal taking in the world through a limited number of senses 'respondable' to stimulation.[1]

Donald McKinley, when reviewing the twenty-fourth Ceramic National (the oldest and most important annual ceramic exhibition in the country) in 1966, noted that the exhibit, which was

. . . designed as a survey of the contemporary ceramics of the U.S. and Canada, . . . is loosely bound by its title and admits all manner of efforts in clay: sculpture, tiles, vessels, the imprint of tool and type, the playful encounter [between the craftsman and his material], the results of a fall [of the material], the calculated assault [on the material by the craftsman], the control of a master (or is he a slave?) [is the artist master of his material, or vice versa?], the flush of the fire, occasionally the dilettante's doodle, but usually the record of SEARCH.[2]

[1] Kay Denning, "Kay Denning: Enamels," *Crafts Horizon*, vol. 23, no. 2, pp. 34–37, March/April, 1963.
[2] Donald McKinley, "24th Ceramic National," *Crafts Horizon*, vol. 26, no. 6, pp. 11–16, November/December, 1966.

Note that the devices used to gain artistic effects—"the playful encounter, the results of a fall, the calculated assault," etc.—had not been conceived of before this time.

For many people art and design are synonomous, but this belief is normally based only on the observation that the two forms have several characteristics in common. Both use the same tools and materials; both arrange and manipulate the same physical elements; and both demand a high order of original thinking and creativity and often result in similar, if not identical, products. The belief is further strengthened by the fact that many objects revered today as art were created or manufactured as production items or craft objects prior to the time when a distinction was made between art and non-art. However, although the close relationship between art and design is clearly apparent, to consider them as identical phenomena is to ignore the intent of the objects' producers and to fail to relate objects to the value systems from which they emerge.

In order to examine the important relationship between art and design, it is necessary to understand the meaning of each. This is not a great problem with design, which is fairly easily defined, but an understanding of art, which is not so easy to define, is more difficult. The problem arises when one recognizes that the definitions that distinguish the art form from the non-art form have been changing ever since the inception of art as a concept and, to a considerable degree, are still in a state of flux. However, by discussing design, we may be able to point out what art is not and thus establish some of the differences that exist.

WHAT IS DESIGN? Design, in reality, has two meanings, both of which must be considered. In the first definition, design is the vehicle used to convey the formal and conceptual aspects of form; in this case, design can exist independently of content. In the second definition, design is the object itself and cannot exist independently of the final form; if the design is changed, so is its content. It is the unique qualities of the form that determine its function, meaning, or value, whereas the importance of designing as an activity is determined by the nature of the finished product.

By its first definition, design is concerned with formal and visual qualities and is limited to those factors of choice, arrangement, and manipulation that produce a form that is more than a sum of its parts. In this sense, design makes use of such familiar visual and physical phenomena as color, value, texture, shape, and line—the elements most commonly used to control composition—and becomes the means by which an artist or designer determines the disposition and rank of the visual elements he has chosen or been compelled to use.

Historically, design has served as the structure of art forms but never as the art form itself. Art is based on ideas that cannot be replaced by the mode of organization or presentation. To claim that *how* one says something is the same as *what* is being said is either to indicate that man has nothing to say or to misunderstand the nature of language or art. Although there may be those who have concluded that modern man has little to say about himself or his universe, to accept the manner in which man expresses himself as the full meaning of what he is expressing is often to miss the meaning of what is being said. When the mode of presentation becomes the dominant quality of a work, the most the work can project is a shallow understanding of basic values that identifies it as less than significant and thus less than art. The artist is always more interested in the *what* of his work than in the *how*, a fact

Paolo Veronese, "Feast in the House of Levi," 1573. The superimposed geometric pattern indicates the painting's structural design. (Courtesy, Galleria dell' Accademia, Venice. Photo, Alinari-Art Reference Bureau.)

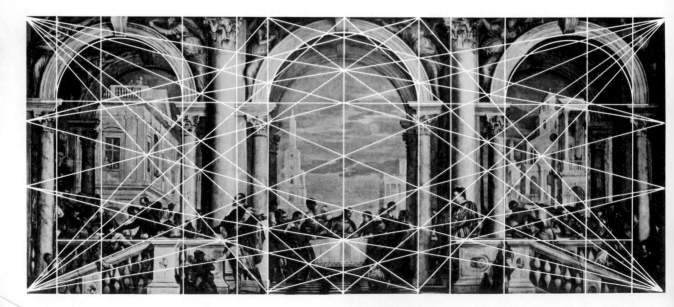

attested to by the historic separation of the artist and craftsman and the efforts of many contemporary artists to abandon technique as a basis for artistic evaluation.

The second definition of design is one that emerged only with the full development of the machine as an industrial tool, the inception of mass production, the emergence of an economy based on a money wage, and the concept of limitless consumption.

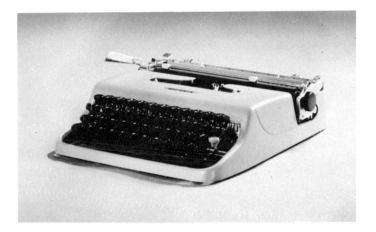

The contemporary typewriter exemplifies design that depends on the relation between function, process of manufacture, and problems of distribution. Manufactured by Olivetti, this typewriter was designed by Marcello Nizzoli. (Collection, The Museum of Modern Art, New York.)

Design in this sense is concerned with the relationship of materials and processes to systems of production and distribution for the purpose of achieving optimum economic efficiency and realizing assumed goals. Thus design and production may be for profit, to increase markets, or to keep a work force employed—all factors that have little to do with the esthetics of the form produced. In our highly sophisticated, technologically oriented world, design becomes the projection of production solutions developed through rational thought processes and problem-solving techniques, not through personal expression. This definition implies that a designed form is most successful when it takes full advantage of relevant technological factors and existent socioeconomic conditions. Ultimately, design success depends on whether the form solves the problem that originally prompted its production. Different solutions to a design problem can be equally successful when they solve the same problems and develop values that project the design form rather than the personal bias of the designer.

The designer is and always has been engaged in the consideration of function and market as defined essentially by the interests of his patron-client. Whether the work is a mural to celebrate the glories of a religious belief or the glories of a chain of hotels or a container to transport small quantities of the rare oils used in the manufacture of perfume or one to transport vast quantities of crude oil for industrial purposes, the eventual form that emerges should be determined by how well the designer understands the product's function and the market for which it is destined and by the technology he has at his disposal. The designer's personal need for expression is not relevant, for often the object is produced under a budget he does not control and for a profit that is not his.

This is not the case for the contemporary artist, however. He sees himself, and is recognized by those who support him, as a producer of forms whose reasons for being are their expressive meaning only—over which meaning the artist exercises total control. The function of the contemporary art object is considered to be the revelation of the personal insights and understanding of the artist based on his intuitive response to the relationships of the elements that determine the form of his work.

Because in this construct design often becomes a partner of modern technology and production (including the profit motive), it has often been assumed that the designer and what he produces is less valuable than the artist and his work (the modern artist is still being identified with those mystic and spiritual forces that first allied him to his religious patron-client). But it should be recognized that life consists of both the material and spiritual and that for the fullest life both these factors must be brought into balance. The nature of the balance must be a personal choice. If and when imbalance occurs, we cannot blame it on either the designer or the artist, for neither of them can be held responsible for the value system under which we and our culture operate. The work of all artists and designers exists only as subsystems of a more inclusive set of values.

To think of the design and art subsystems as being the same or as both being synonymous with the dominant value system under which we function is to lose the values of both design and art. Eventually, man must ask Art for what? and Design for what? Clearly the answers are not the same. Although both forms

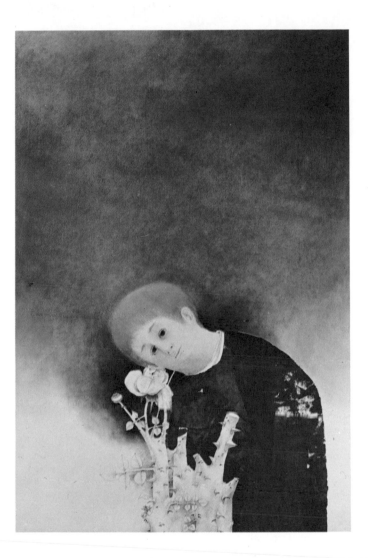

Morris Broderson, "Sound of Flowers," 1967. Morris Broderson's paintings become valuable art objects, because, in revealing his own personal insights and understanding, he creates images to which we respond esthetically and with a heightened sense of awareness. (Collection, Joseph H. Hirshhorn. Courtesy, The Ankrum Gallery, Los Angeles, and The Downtown Gallery, New York.)

are important in our culture pattern, each makes its own contribution. Design is a means of exploiting technology for mankind's optimal material well-being and of allowing man to perceive the most beneficial relationship between his physical resources, either natural or man-made, and the value system that holds material welfare as but one part of a more inclusive system. Art is a means of bringing to man, via the esthetic experience, greater insight and expanded meaning of his philosophical or spiritual realizations and projections. This occurs both within himself and in his relation to the rest of mankind and the universe.

37

DESIGN SYSTEMS. When a design depends on codified methods for the choice, rank, and arrangement of all the elements used, it can be said to be the product of a design system. In the arts, however, design systems usually become evident only after a work or body of work has been produced and thus can be analyzed. In one sense, design systems, when applied to forms that are basically valued for their esthetic worth, are a type of rationalization—one that follows the more creative act that was responsible for the initial form. Nevertheless, the information and insights gained from studying design systems are important not only for the art and design student, who needs to understand the essential structure of objects; they are also important for the general student who wishes to understand value systems as they relate to structure.

It is on the bases of the origin of the design system, the nature of the system, and the intent of the resultant form that art and design separate. Although an art object can be analyzed according to the system responsible for its form, the system can never be the factor that establishes artistic quality. In the production of art objects, the systems that occur are related more to the psyche of the artist than to the nature of the work, whereas the systems that occur in the production of the design object are related more to the object's production-distribution pattern than to the designer. In light of this distinction, it must be noted that many major artists of earlier periods can be recognized primarily as designers rather than artists, because the works they produced were based on the needs of well-defined production-distribution systems. This situation occurs to some degree whenever an artist-designer initiates a work that is finished or produced by someone else, a practice that has existed since the time when the needs of production became too great for the single producer to meet. Our current insistence that the modern artist in the major plastic arts be totally responsible for his work speaks more for the contemporary effort to limit art than for traditional practice.

Historically, the role of the artist in Western culture has been much like that of the modern designer, with the major difference being the identification of the patron-client. Originally, religion was the major power in the community and thus the patron-client of art; later, this changed to the powerful secular interest; and,

beginning with the eighteenth century and the shift in power to the industrial interests, it changed again.

Decoration—an element of art

There is within the Hebraic-Christian ethos the concept that truth and good need not be adorned, and this has led at various times in history to the belief that decoration is essentially dishonest. Therefore, much has been said against decoration's being considered a primary characteristic of the arts. Decoration is, however, a significant human interest and one that has been most important in the production of art. Although much of our art may have stemmed from and been created because of man's interest in the power of the image, that is, its magical qualities for good or evil, certainly an equal amount has been the direct result of man's recognition of the decorative as an aspect of celebration.

When a culture prohibits the use of realistic imagery, the art forms produced tend to rely on involvement with the decorative. This is exemplified by much of Islamic art; one of the basic tenets of the orthodox Islamic faith holds that the creation of living forms is God's prerogative alone and one not granted to man. The attitude that resulted from this belief led, in Islamic art, from the extension of the nonfigurative to a dominance of decorative pattern and a significantly high degree of abstraction of those figurative forms that do occur.

The word *decorate* implies honoring by making more beautiful and, although we no longer take this aspect of the definition very seriously, we still decorate our heroes for acts of special significance just as we decorate our communities, our homes, and ourselves for special occasions. Many of the objects we consider significant as art forms today were originally produced as honorific objects celebrating the glory of a god or a king; in retrospect, however, we often fail to recognize this.

As we search to understand the basic appeal of the arts— although *appeal* is a variable that has as many facets as there are individuals—we begin to recognize the important role the decorative assumes in almost all art forms. In spite of the fact that it is

Located in front of the Marine Midland Building, New York, this contemporary sculpture by Isamu Noguchi functions decoratively. (Courtesy, Skidmore, Owings & Merrill. Photo, Ezra Stoller.)

not considered relevant to modern art, decoration has been an important element in most of the church and court art as well as in folk art. Much of the modern rejection of the decorative is due to the fact that a great deal of our decoration has no real significance. It has become so standardized and overapplied that it is no longer capable of significant expression. By accepting forms for which we feel no emotional attachment, we have reduced decoration to a less meaningful position than it rightly deserves. However, the decorative still assumes a measure of importance when the object decorated is sufficiently significant or when the decoration is an example of a significant artist's personal and creative expression. Although many artists might not wish to accept it, the fact remains that many of our important twentieth-century works of art are used decoratively and much of the painting and sculpture that is commissioned for architecture falls into this category.

40

Style

Form is the sum of the physical attributes that give an object being. *Content* is the intrinsic meaning projected by the object. Both form and content are determined essentially by the attitudes or philosophy accepted by the "producer" as he creates an object with the materials and technology available to him. As already discussed, the primary purpose of many of the objects we identify as art was unrelated to the esthetic response at the time the objects were first created and used. A number of them were part of the magic or ritual life of the group for which they had significance; others were used for identification and, when necessary, to help maintain social organization by focusing attention and energy on specific social activities. During the periods when esthetic reaction was not a primary factor, form and content were inseparable. It was only when objects became valuable primarily for their esthetic qualities that form and content could begin to be considered separately.

Awareness of content is as dependent on the total experience of the observer as on the intent and physical appearance of the art object. But when form—that is, the manner in which the physical aspects of an object are shaped and brought together—is considered apart from content, the qualitative factors of the object can be identified stylistically. Style is thus one of the most important means we have for identifying and classifying art, in spite of the fact that it can be considered on many levels and from many points of view. However, when style is based only on form (excluding content), the resulting object will be superficial and will fail to exhibit significant meaning. An awareness of content is dependent on the observer's past experiences; recognition of style is dependent on his ability to relate the physical form of an object to the manner in which it was produced. Although style cannot be fully separated from content, it is ultimately determined by the physical characteristics of the form; it is the what, where, and how of a form.

The three most inclusive elements of style are *boundaries of occurrence, time,* and *attitude* or *belief*—all interrelated aspects of the singular phenomenon of existence. All forms exist in a space

determined by the boundaries set to contain them, and space exists in terms of time; the attitudes or beliefs of the individuals who create forms, experience them, or respond to them are determined by the space and time in which they are living. Depending on the nature of the art form and the purpose of its being classified, each of the three elements may become a dominant factor of classification.

Boundaries of occurrence, as a stylistic consideration, can range from a highly restricted area to one that defines vast empires. In some cases, stylistic forms have been restricted to a single city or a district in a city. In other cases, they have spanned entire hemispheres or even transcended them. Time is an element of style because everything that man makes can be related to the moment in history in which it is produced, by comparing it either to something that was made earlier or to something made later. Some objects are created as part of a developing or well-established mode; others are based on a new attitude—a reaction against or rejection of what prevails. But a style may change, not only because of a new attitude toward form, but also because new materials or technologies are introduced; however, many stylistic forms are retained in spite of new materials, technologies, and attitudes.

Methods of Classification

An observer can identify or recognize a style; he can even imitate it; but he cannot contribute to it. Style is dependent on recognition and comparison; any object, to be considered stylistically, must have characteristics that enable it to be compared to other objects. It may be compared to the work of an entire culture, a geopolitical or sociopolitical unit, a time span, a movement or school, or, ultimately, other works of a single artist.

The less one knows about a particular art form, the more all-inclusive will be the limits by which he identifies it; conversely, the more he knows about a form, the more restricted will be his criteria of style classification. For example, it is not uncommon to hear someone refer to an Oriental style as opposed to an Occidental style. But these represent such a broad classification that only the grossest kind of identification is being indicated.

Reference to a geopolitical or sociopolitical unit that lasted for centuries is scarcely a finer distinction. Although it is true that

every major culture exhibits characteristic qualities that mark the work it produces, changing conditions create new attitudes that over the years get absorbed into the art. Thus an art form classified stylistically only by its geopolitical or sociopolitical boundaries must allow for the regional and/or temporal differences that occur. For example, Islamic art covers a period that begins officially in 622 c.e.[3] (the year of Hejira, Muhammad's flight from Mecca to Medina, which is considered the first year of the Moslem era) and a land mass that at one time included all the Near East from the Mediterranean Sea to the borders of China, sections of India, all of North Africa, Spain, and Eastern Europe to the gates of Vienna. Although Islamic form occurs in much of the area that Islam once dominated, it is difficult to consider only the sociopolitical boundaries involved, because not only have these boundaries been in a state of flux ever since the inception of Islam, but Islamic thought itself can be fully considered only in terms of the larger flow of ideas of which it is a part. Thus forms that we identify as Islamic appear outside the spatial and sociopolitical boundaries usually considered Islamic.

TIME. Time is in some ways a more accurate method of examining style, because changes that occur can be easily identified by the era during which they appeared. But the time spans chosen must be specific enough to make their use as criteria for classification meaningful. A stylistic period should be determined by the years during which all the objects produced exhibit similar formal characteristics. Whenever there is a shift in the forces that determine the content and form of art, a major innovation in the material available to the artist, a significant change in the location in which the work is created, or a change in the attitude that attends creation or production, the art produced and all other forms displaying similar characteristics become classified as a defined style. On the broadest level these styles form periods that may range from less than one century to several.

Although time is far from a satisfactory means of classifying an object's style, we continue to use it because of convenience. Thus, all art produced during a specific century is often considered a stylistic entity. One of the most easily visible examples of this

[3] The notation c.e. indicates the Christian Era; b.c.e. indicates before the Christian Era.

type of generalized classification is modern or contemporary art; it includes an inordinately large number of various forms held together stylistically, on what is admittedly a vague level, because they were produced within a period that causes them to be differentiated from similar forms produced in earlier times.

The dates used to mark stylistic distinctions either are vague or represent important changes of governments or the deaths of important people rather than immediate or absolute shifts in form. Styles evolve rather than change abruptly, and each major stylistic period contains a number of important and identifiable sub-classifications. Even though the characteristic qualities of a style appear within all the art forms produced under a stylistic classification, there are differences due to the methods of manufacture, size, scale, media, and skill. Also, because there are so many variables that can affect the production of an art object, all the forms may not be represented equally within a given style.

The longest time classification—approximately 30,000 years—is what is generally referred to as prehistoric art. This time span is possible because, although we are dealing with a period of great duration, we are considering a relatively limited number of objects created with a restricted number of astonishingly similar materials and production techniques. On the other hand, the approximately four-thousand-year period that is spanned by what we recognize as Egyptian art must not be divided only into a predynastic period, prior to 3200 B.C.E., and a dynastic period, from 3200 B.C.E. to 525 B.C.E. Because of the obvious formal changes that occurred in the work produced during the 2,800 years of the dynastic period alone, that period must be subdivided before significant stylistic classifications can be made. The art produced in the dynastic period constitutes a broad continuum that reflects the changing conditions, in spite of the fact that all the objects have the characteristic qualities that mark them as unmistakably Egyptian.

Again, if we were to speak of the style of the ancient Greeks (a geopolitical unit of classification), we would have to include all the art produced from about 900 B.C.E. to almost 100 B.C.E. But because we can identify significant style changes within this body of work, revealing the changing conceptual attitudes of the Greeks, we usually divide Greek art into shorter, stylistically cohesive time spans:

Predynastic flint knife from Gebel-el-Arak, c. 4000 B.C.E. Notice the carved ivory handle. (Courtesy, Musée du Louvre, Cliché des Musées Nationaux.)

The Geometric, from about 900 B.C.E. to 700 B.C.E.
The Archaic, from about 700 B.C.E. to 480 B.C.E.
The Transitional, from about 480 B.C.E. to 450 B.C.E.
The Golden Age, from about 450 B.C.E. to 400 B.C.E.
The Fourth Century, from about 400 B.C.E. to 300 B.C.E.
The Hellenistic, from about 323 B.C.E. to 146 B.C.E.

Most of these dates have been rounded off to the century, which indicates the generalization necessary for their establishment; however, 323 B.C.E. marks the death of Alexander the Great, and 146 B.C.E. marks the conquest of Greece by the Romans.

Until comparatively recently, many scholars claimed that the Roman art, which followed the Greek and lasted until the end

"Cattle Fording a River," c. 2400 B.C.E. Detail of a painted limestone relief from the Tomb of Ti, Saqqara, Fifth Dynasty, Old Kingdom. (Photo, Hirmer Fotoarchiv, Munich.)

Top: "Feeding the Oryxes," c. 1920–1900 B.C.E. Detail of a painting from the tomb of Khnumhotep, Twelfth Dynasty, Middle Kingdom. (Courtesy, Oriental Institute, University of Chicago.)

Bottom: "Tut ankh-Amun Hunting Desert Animals," c. 1353 B.C.E. Scene in miniature on lid of painted casket, Eighteenth Dynasty, New Kingdom. (Photograph by Harry Burton, The Metropolitan Museum of Art.)

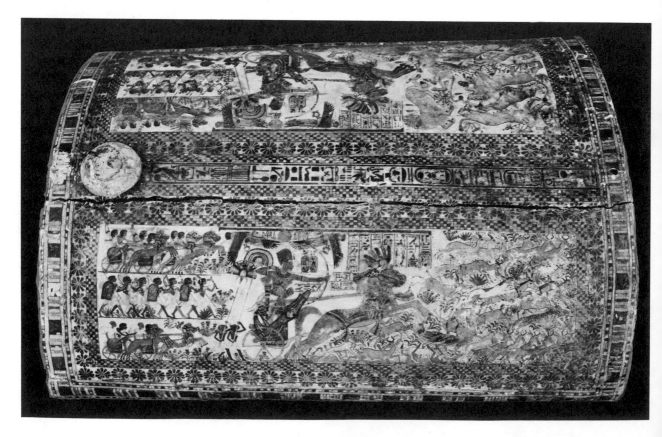

of the second century of the Christian era, was essentially a decadent form of Greek art. As late as 1946, Sheldon Cheney, in his *A World History of Art*, noted that "The desire to impress by bigness led to magnificent works of engineering and building. But the desire to impress by profusion and pomp led, oftener than not, to adornment of those same works with misused scraps and veneers of Greek architecture and weak imitations of Greek ornamental sculpture." [4] But perceptions become more acute and and abilities to detect style differences develop as more information about and insight into history is gained or as attitudes change. Thus, in 1962 Janson pointed out,

> The fact remains that, as a whole, the art produced under Roman auspices does look distinctly different from Greek art; otherwise our problem would not have arisen. If we insist on evaluating this difference by Greek standards, it will appear as a process of decay. If, on the other hand, we interpret it as expressing different, un-Greek intentions, we are likely to see it in a less negative light; and once we admit that art under the Romans had positive un-Greek qualities, we cannot very well regard these innovations as belonging to the final phase of Greek art, no matter how many artists of Greek origin we may find in Roman records. [5]

Undoubtedly one of the reasons we were slow to recognize that the Roman style was distinct from the Greek is the fact that our entire classical concept is based on idealizing the Greek form. Our traditional idealization of the Greek contribution to modern man can be seen in the following statement in *The Classical Tradition in Western Art* by Benjamin Rowland, Jr.

> The Greeks of the Great Period, the age of Pericles, were like no other people before or since, absorbed in the study of themselves, the study of man and his relations to the world of space and matter, as well as to the world of myths, which no philosopher and no scientist had succeeded in explaining away. Perhaps the greatest Greek contribution was the bringing of order and conscious thought into life, the explaining of phenomena by natural events rather than by supernatural intervention; that is, understanding nature in intelligible rather than

[4] Sheldon Cheney, *A World History of Art*, New York: The Viking Press, Inc., 1946, p. 213.

[5] H. W. Janson, *History of Art*, Englewood Cliffs, N.J.: Prentice-Hall, Inc., 1962, pp. 130–131.

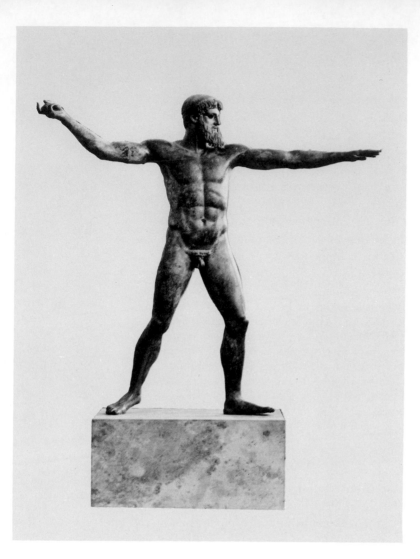

"Zeus" (perhaps "Poseidon") c. 460–450 B.C.E. Greek figure in bronze, 6 feet, 10 inches tall. (Courtesy, National Archaeological Museum, Athens. Photo, Hirmer Fotoarchiv, Munich.)

supernatural terms. According to Anaxagoras it was Mind that brought order out of chaos.[6]

If one believes that the Greeks established the ideal, and there are those who do not, it would follow that anything that replaces it must be of less worth, either in the sense of decay or in the sense of the vulgar or barbaric. It is this logic that results in the belief that the work produced in the period of the Roman conquerors, which followed the Hellenistic in the esthetic continuum, and all

[6] Benjamin Rowland, Jr., *The Classical Tradition in Western Art*, Cambridge, Mass.: Harvard University Press, 1963, p. 8.

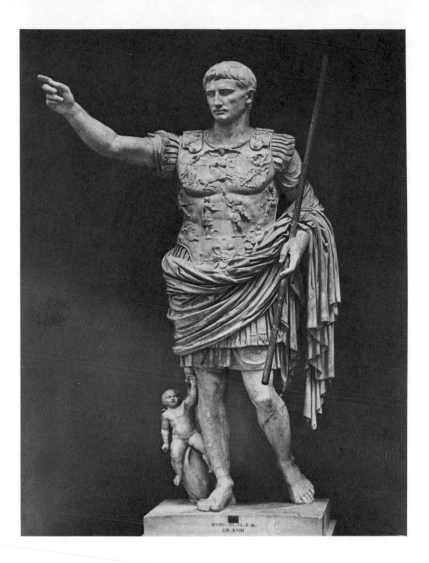

"Augustus of Primaporta," c. 20 B.C.E. Roman figure in marble, 6 feet, 8 inches tall. (Courtesy, Vatican Museums, Rome.)

the rest of man's artistic production that does not match the Greek form is decadent in that it falls away from the ideal.

With the emergence of Christianity, the Western world began a transformation. The time period from the inception of Christianity to the Renaissance can be conveniently, if not accurately, divided into four major styles—the Early Christian, the Byzantine, the Romanesque, and the Gothic. The forms of the Early Christian period, which lasted until the fourth century when the seat of the papacy was moved to Byzantium, were primarily a continuation of the Hellenistic and Roman transformed into symbols of the new religion. Both the styles and techniques of the classical

49

period continued to be used for such purposes as catacomb painting, sculptured sarcophagi, mosaics, and frescoes. Because the Christians were unable and unwilling to use pagan temples for their houses of worship, they turned to the Roman basilica. This was a long rectangular building with a semicircular apse at one end, with the interior divided into aisles by a double row of columns. Originally the Romans used basilicas for municipal buildings and, on occasion, markets.

"The Sariguzel Sarcophagus." Carved in marble during the fourth century, this sarcophagus shows Christian iconography executed in Roman style. (Courtesy, Archaeological Museums, Istanbul.)

Although the Byzantine period began with the establishment of the papacy at Byzantium (renamed Constantinople), it was not to rise to greatness until the fifth century; by this time, Rome had been reduced to little more than a provinical city. Byzantine art was the result of a merger of the classical forms of Greece and Rome, redefined in terms of Christian iconography, with the decorative, sensually patterned forms of the East. The Eastern qualities that appear in the art of Byzantium evolved from the societies that had created Middle Eastern culture—the Mesopotamians, Syrians, Persians, Egyptian Coptics, and tribal Semitics.

From India, through Southern Europe and Northern Africa, to Spain and France, the influence of these cultures has been felt; they were as influential to the Christian forms in the West as they were to the Islamic forms in the East. The time continuum through which their influence can be traced began in the period of ancient Mesopotamia, about 2900 B.C.E., and continued to the Byzantine period, the Middle Ages, and the Renaissance. Currently, the great Middle Eastern style can be seen, in modified and admittedly pale form, in the art of Islam and the iconic art of the Eastern Christian Orthodoxy.

Stylistically, Byzantine art can be subdivided into three major periods. The proto-Byzantine, which began with the move to

"The Annunciation," seventh century. This silk fabric woven in medallion pattern shows Christian iconography executed in the Byzantine style. (Courtesy, Vatican Museums, Rome.)

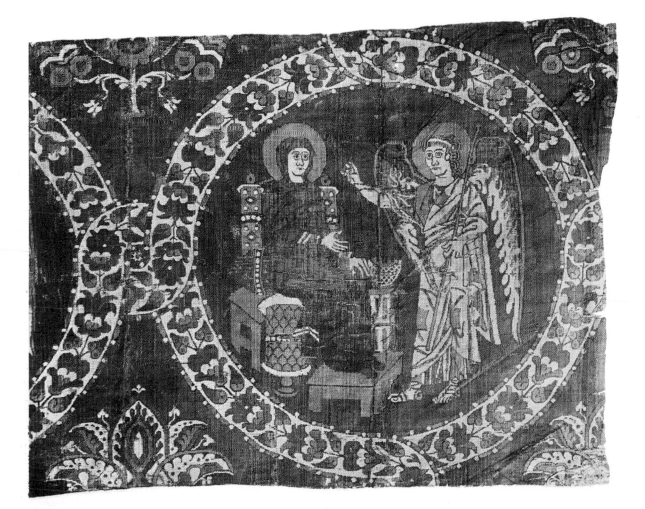

Constantinopole, culminated with the construction of the magnificent Hagia Sophia in the middle of the sixth century. The second period emerged in the eighth century and lasted through the middle of the ninth; it was marked by the controversy over iconoclasm, a controversy that began in 726 and was not resolved until the restoration of orthodoxy and religious decoration some time after 850. The third period, known as the Byzantine Renaissance, began after the use of images was restored and lasted until the Ottoman Turks captured Constantinople in 1453. All three subperiods were dominated by lavish craftsmanship in metalwork, mosaics, enamels, ivory carving, and bas-relief. Byzantine church architecture was characterized by the domed cruciform design, with the dome supported by squinches or pendentives, features that increase the sense of interior space.

MOVEMENTS OR SCHOOLS. In the West, the period between the sixth and eighth centuries was marked by a struggle for political power that involved a number of "barbarian" tribes—the Ostrogoths, Visigoths, Franks, Celts, Germans, Lombards, Slavs, Angles, and Saxons. It was not until the ninth century that political

Hagia Sophia, 532–537. Originally a church, this museum in Constantinople remains one of man's greatest architectural monuments. (Photo, Turkish Tourist and Information Office.)

Top: San Vitale, Ravenna, 526-547. Exhibits the Byzantine style carried to the West. (Photo, Alinari-Art Reference Bureau.)

Bottom: Fibula, sixth century, C.E. This clasp used for clothing is an example of "barbaric" style and craftsmanship. (Courtesy, Universitetets Oldsaksamling, Oslo.)

domination was won by Charlemagne and not until a century later that Christian theology and iconography were defined enough and the Church strong enough to project a comprehensive artistic style. The Romanesque style, although a misnomer, was definitive enough to be found throughout Western Europe; it was an amalgamation of classical, Byzantine, and regional barbarian forms, overshadowed by a fully developed feudal Christianity. However, in spite of the structural and visual qualities that marked the art of the eleventh and twelfth centuries as Romanesque, regional differences were strong enough to distinguish French, Italian, Spanish, English, German, and Northern European subgroups, or schools.

The Gothic period followed the Romanesque in Western Europe. Emerging first in the thirteenth century, Gothic style eventually developed into regional schools as had the Romanesque

Left: "Christ in Glory," c. 1050. Romanesque sculpture from the Church of St. Sernin, Toulouse. (Photo, Jean Roubier, Paris.)

Right: "Abraham and Melchizedek," c. 1251. Gothic sculpture from the Cathedral at Reims. (Photo, Marburg-Art Reference Bureau.)

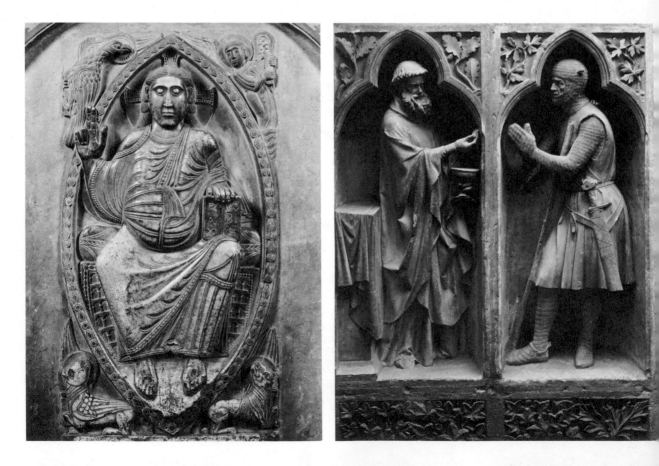

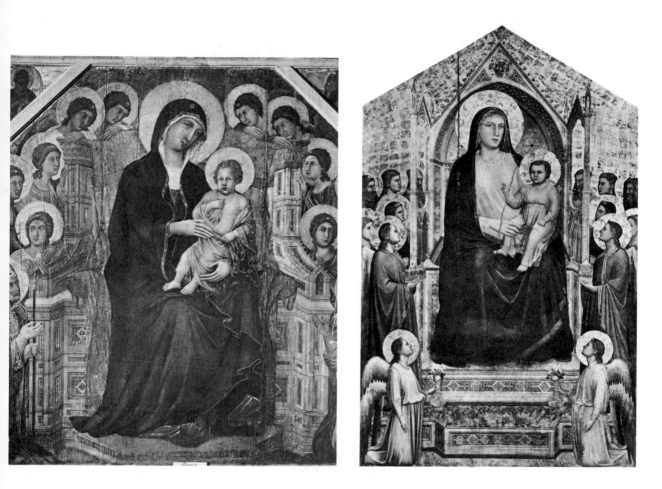

Left: Duccio di Buoninsegna, "Madonna Enthroned," 1308–1311. The center panel of the Maestà Altar; an example of the Sienese school of painting. (Photo, Alinari-Art Reference Bureau.)

Right: Giotto di Bondone, "Madonna Enthroned," c. 1310. An example of the Florentine school. (Courtesy, Uffizi Gallery. Photo, Alinari-Art Reference Bureau.)

before it. Originally, the term *gothic* was used to depreciate a style that was considered barbaric when compared to the classical forms. However, in our time, when the Gothic style is considered significant, the term indicates the Northern European traditions that used skeletal stone construction, pointed arches, and skyscraping spires. But not only were new heights of engineering skill developed; in sculpture, there was a new plasticity that matched a growing sense of idealistically conceived naturalism and monumentality.

Because of the difficulties of travel and communication, even at the end of the Gothic period, the city-states were able to develop quite independent styles. For example, in the Grand Duchy of Tuscany, now part of modern Italy, the painting of the Florentine school, represented by Giotto di Bondone (c. 1276–1337), differed markedly from that of the Sienese school, repre-

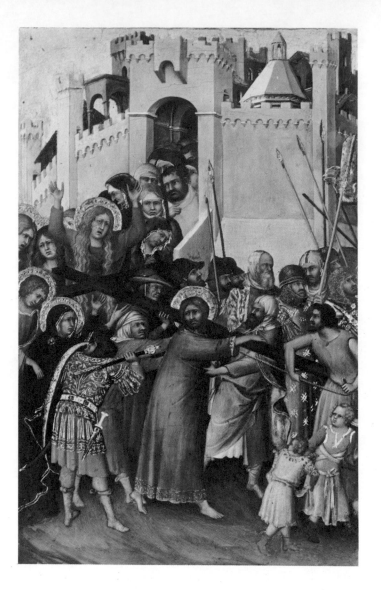

Simone Martini, "The Road to Calvary," c. 1340. A small panel painting that reveals its link to the Byzantine style. (Courtesy, Musée du Louvre, Cliché des Musées Nationaux.)

sented by Duccio di Buoninsegna (c. 1255–1319) and Simone Martini (c. 1284–1344), in spite of the fact that the two styles developed in cities less than 50 miles apart. It is clear that both Martini and Giotto produced work in the Medieval mode. However, there was enough difference between them for us to recognize that the work of Martini and of the school of Siena, although modified by the forms of the northern Gothic, remained within the Byzantine tradition that had earlier come to Italy. On the other hand, the work of Giotto and of the Florentine school, because of the consideration the painters gave to the illusion of

space, marks the point in history at which painting moved into the modern period, which began with the Renaissance.

Although some of the innovations that indicated the shift from the Medieval to the Renaissance period occurred as early as the fourteenth century, it is commonly recognized that the fifteenth (the quattrocento) was the beginning of the Renaissance and the sixteenth (the cinquecento) the High Renaissance. During these two centuries, the spirit of rebirth, which gave the period its name, spread from Italy, the birthplace of the Renaissance, throughout all Europe. In the arts, the period was characterized by a revived interest in the classical style of the Roman Empire. Politically and socially, it was characterized by a decline in the power of the

Giotto di Bondone, "The Lamentation," 1305–1306. A fresco that shows a new awareness of spatial illusion. (Photo, Alinari-Art Reference Bureau.)

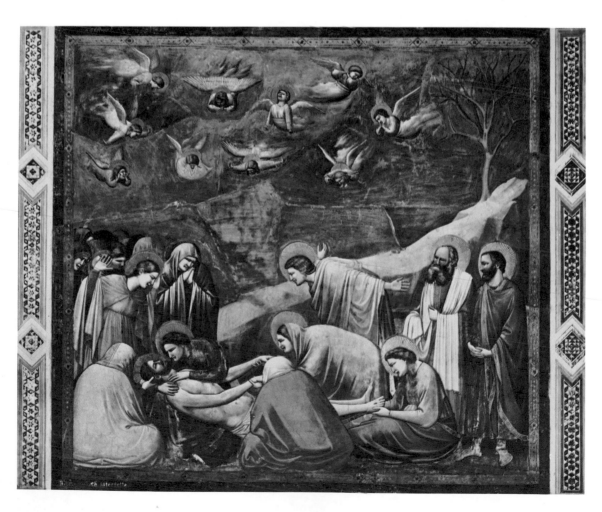

Church and a rise in the power of the city-state, and an understanding of this shift is essential to an understanding of the arts produced during the time. The Renaissance marks the decline of the rural, feudal economy and the growth of an economy based on urban mercantilism. It signals the beginning of modern exploration, technology, science, and education.

The elegant Mannerist style that developed at the end of the sixteenth century proved to be the transition from the Renaissance to the Baroque and Rococo, both of which lasted as stylistic forces until the middle of the eighteenth century. The Baroque and Rococo can most easily be characterized by their concepts of architectural space. Defying the classical principles of the Renaissance, the new styles produced lavish and intricate spatial harmonies that possessed a sense of exuberance that destroyed the classical constraint and symmetry on which they were based.

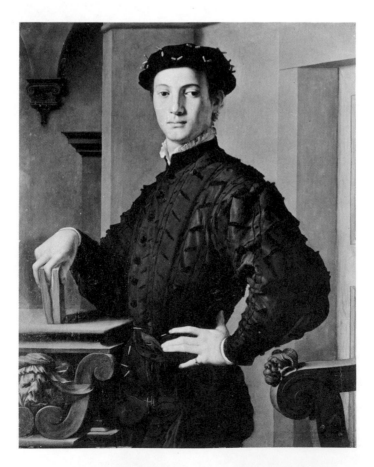

Agnolo Bronzino, "Portrait of a Young Man," 1535–1540. An example of the elegant Mannerist style. (Courtesy, The Metropolitan Museum of Art, New York. Bequest of Mrs. H. O. Havemeyer, 1929. The H. O. Havemeyer Collection.)

With the beginning of the social and technological revolutions that marked the eighteenth century, the tendency for styles to exist over long periods of time with only minor variations came to an end. The styles that emerged in this period projected the ferment of the times. And by the nineteenth century, when means of communication and travel were much improved, the number and frequency of stylistic changes greatly increased. Stylistic eclecticism was inevitable; the exotic form and the picturesque or curious subject became standard intellectual fare. *Eclectism*, a gathering from many sources, sanctioned a new diversity of form. Of primary interest were those styles—Egyptian, Chinese, Hindoo, Turkish, and Japanese—whose origins lay in exotic lands. Also of interest were such styles as the floral and rustic, which satisfied those who sought to return to nature or had visions of a simpler life. Forms were cast in metal, carved in wood, or reproduced as graphic and decorative motifs. All were used with little regard to their source, their function, or their original materials or scale.

Allied to the eclectic, but of greater significance, were the Classic and Gothic revivals (which still appear with some persistence and regularity). The Classic forms were direct descendants of those of ancient Greece and Rome; and although they were maintained, to some extent, from their inception, it was not until the Renaissance that they burgeoned as a dominant theme in Western art. Although they became submerged during the Baroque period, the classic forms were maintained as a basic element of the opulent and expansive images, which were essential to the new sense of order and space characteristic of this era.

By the end of the eighteenth century, with European and American interest in ancient Greece and things Greek reaching a new peak, the Neoclassic style gained momentum. As the Classic was reintroduced, it was redefined in terms of new materials and technology to meet the contemporary needs of its borrowers. By contrast, the Gothic, which also reappeared for the first time during the eighteenth century, was the result of a romantic view of the Medieval and an interest in the picturesque. Although it started much later than the Classic, it played a successful counterpart to it as a revival style. These two movements represented the polar ends of esthetic consideration in the nineteenth century. The Neogothic moved into prominence under the sponsorship of nineteenth-century reformers who saw in the Medieval guild

Francesco Borromini, facade of the church of S. Carlo alle Quattro Fontane, built in Rome between 1665 and 1667. An example of the Baroque architectural form. (Photo, Alinari-Art Reference Bureau.)

Top: An eighteenth-century chair of pierced fretwork mahogany in the Chinese style. (Courtesy, The Metropolitan Museum of Art, New York. Kennedy Fund, 1918.)

Bottom left: A nineteenth-century chair of carved, painted, and gilded wood in the Egyptian style. (Courtesy, The Victoria and Albert Museum, London.)

Bottom right: A nineteenth-century chair in the rustic manner, exhibited at the Great Fair of All Nations held in London in 1851.

Benjamin Henry Latrobe, the Bank of Pennsylvania in Philadelphia, 1798. The design has the facade of a Greek temple. (Courtesy, Maryland Historical Society.)

system a social form they felt meaningful to the problems of growing industrialism.

By the end of the nineteenth century, the mercantile and industrial interests, whose energies had introduced the modern period, dominated the spirit of the Western world politically and socially. The ascendancy of these new interests plus the twentieth-century discoveries of new materials and methods of production

A bookcase carved in oak in the Neogothic style. It was a gift from the Emperor of Austria to Queen Victoria of England and was exhibited at the Great Fair of all Nations, London, 1851.

brought inevitable changes in what was considered significant and beautiful. And the establishment of a consumer economy was accompanied in the arts, as elsewhere, by an increasing awareness of and demand for individualism and intellectual freedom for the artist.

Thus, beginning in the late nineteenth century and proceeding through the twentieth, a number of conceptual positions about the nature and function of art resulted in easily defined stylistic schools or movements. Among these were such philosophically and conceptually definitive groups as the Impressionists, the Pointalists, L'art Nouveau, Les Fauves (the wild beasts), the Cubists (in several clearly delineated stages), the Constructivists, de Stijl, the Expressionists, the Abstract Expressionists, the Surrealists, the Futurists, the Dadaists, the Social Realists, the Magic Realists, the American Regionalists, and, more recently, the Action Painters, the Pop Artists, the Op Artists, the Obscene Artists, the new Figurative Painters, the Hard-edged Abstractionists, and, of course, the Antiart Artists. Some of these, and the list could be extended, represent only two or three men who gathered together quite informally but whose work, because of discussion and a pregnant exchange of ideas, took on similar characteristics; others represent large groups of people working at approximately the same time but with no direct personal contact—contact being established through exposure and reading; still others depended on a more formally established goal-oriented group.

Perhaps the most significant reason for the occurrence of this multiplicity of schools, and thus styles, is modern man's search for truth and identity. The contemporary artist in Western culture has for some time felt called upon to support what he considers the artist's obligation and right to remain individual in a world that seems to be determined to develop along lines of mass conformity. He believes that only by remaining free can he play a meaningful role in society. Thus each school, style, or direction an artist discovers or projects represents one more avenue and guide to freedom—and he often considers freedom to be the greatest offering society can make to its members.

In spite of the artists' desire to maintain their individuality, however, the same images and forms are being produced in all the major art centers of the world. On almost any given day in New York, London, and Tokyo, paintings, sculpture, pottery, and

examples of graphic design or industrially designed products are exhibited that look as if they came from the same studio. This unwanted conformity developed because, as artists and designers became more oriented toward self-expression and the pressure to be unique, they became involved with identical problems approached from similar frames of reference. Our increasingly effective means of communication and travel plus the fact that the major training centers for the arts have become international in their appeal are the causes of this unusual phenomenon. Trained to solve similar problems in similar ways, artists produce like solutions regardless of where they are working. Similarity of form is inevitable when painters and sculptors depend on the same rationale and set of formal elements for the content and form of their creations. The result has been a firmly established international style in all the arts, even though most modern artists and designers who work with abstract or nonobjective forms prefer not to think of their work as a part of it.

Summary

Style in its best sense reflects all the factors that make up a form. It exists because of the qualitative differences that occur when an object is subjected to the pressures of being produced and is eventually identified as the wholeness of a man's belief as he translates that belief into form, shaping it by the materials and technology at his disposal. Style in its worst sense is a surface quality that engages the observer and prevents him from finding anything more significant in the form. This use of style is one cause of its transitory nature and partially explains why many styles have appeared that we no longer value. Artists and designers who would have their work be more universal in appeal often try to ignore style. They equate it with stylishness (relating it to changing taste and fashion) and fail to recognize the inevitability of stylistic recognition. Even when a designer works only to solve a problem in the most rational manner possible or the artist, refuting the existing modes, works only to express himself, the final object will be part of the continuum of man-made forms and thus as stylistic as all other forms. Although objects can be and often are evaluated on considerations other than style, style will remain a most important element of all objects.

Classifications within art

As one examines form and content, it becomes apparent that in order to make meaningful judgments about art, objects must be classified. Having established that art is relative, it follows that classification can exist on many levels. When these levels are clearly separated, they direct judgment into a single frame of reference; but when the levels overlap, the observer is simultaneously presented with several frames of reference, all of which he must use to form his judgment. Thus, classification can either call attention to those qualities that make an object unique or set the broad, generic limits within which the object exists. Because it is dependent on perception, classification is as relative as the art forms it helps us understand; therefore, its most important contribution is in aiding us to avoid errors of judgment.

All art objects are related insofar as they all have form and content. In the plastic arts, this means that art objects are made of materials that, in most instances, have been worked and that the objects project an identifiable meaning, or Gestalt. Thus, all art objects can be analyzed by either those physical characteristics common to material forms—size, scale, shape, volume, color, texture—or by their projected and comprehended meanings. The manner in which the physical qualities appear, the relationships developed among them, the relationship between the physical qualities and the whole form of which they are a part, and the relationship between the physical qualities and the meaning of the form—these characteristics provide the most significant criteria for contemporary evaluations of the arts.

Techniques and materials

An art object can be classified as either a generic form or a unique object. But because all objects are made of worked materials, the first classifications to establish should pertain to the techniques of the general art forms and the materials used to produce them. Although it is true that an examination of techniques and materials, because of their universal occurrence in

general production, can lead to many considerations that are in no way related to either art or the esthetic experience, such an examination can provide a frame of reference within which interest in the art form can begin and an understanding of art develop. It is only when one becomes engaged with forms on this level that many of the contemporary attitudes of the arts can be understood.

Art Forms

The term *art form* refers to an object's general structure and intent, e.g., sculpture, painting, crafts. For example, when we say that a certain work of art is sculptural in form, we are indicating, not only that it fits our preconceived concept of sculpture, but that it meets the general structural considerations and purposes of sculpture. And, although we can establish standards in art, as in other things, one type of art cannot be judged by the standards for another. We can no more consider the quality of a piece of sculpture by the standards we use to judge a painting than we can judge the quality of a lemon by applying the criteria for apples. In addition, the accuracy of one's judgments about an art object depends on an understanding of the value system under which it was created. Although a preconceived concept may exist for a generic art form, each form usually consists of a range of subforms rather than a single one. For example, sculpture, which is based on the manifestation of three dimensions, ranges from the static and massive forms of earlier centuries to the mobile, ethereal, and ephemeral forms of our own time. Therefore, even within a single form category, different standards must be used. The criteria for analyzing the work of the Spanish painter Francisco José de Goya y Lucientes (1746–1828) could not be the same as those used to analyze the work of Jackson Pollock (1912–1956), who is primarily known as the American innovator of Action Painting.

As the values we esteem in art have shifted away from those related to skill and imitation toward those related to creativity and expression, the physical attributes of objects have become less important and the experience of and response to the total form more important. An examination of the physical attributes of form is still fruitful, because even the most contemporary investigators agree that the nature of an object has an effect on how it is perceived.

Left: Francisco José de Goya y Lucientes, "The Third of May, 1808," 1814–1815. This painting commemorates the execution of Spanish citizens by soldiers of Napoleon's army. Its force is strengthened by its narrative quality. (Courtesy, Museo del Prado, Madrid.)

Below: Jackson Pollock, "Number 32," 1950. A positive response to this painting depends on one's ability to perceive value in the record of a creative act or in the formal relationships that have been created. (Courtesy, Kunstsammlung Nordrhein Westfalen, Duesseldorf.)

If an image is significant for purposes other than those related to art, its form many make little or no difference, as illustrated by the many forms of the crucifix that are used by various segments of the Christian church—all the forms maintain their sacred role despite their formal differences. If, however, we are to perceive an image or an object as art, its form does make a difference. A drawing is perceived as being different from a painting or a piece of sculpture. Because perception depends on our ability to categorize, it should be clear that examples of the various art forms will be considered within different frames of reference; thus, qualitative judgments can be made only when they are appropriate to a specific frame of reference. This should not, it must be noted, affect the intensity of the response to the form or the significance of the esthetic experience.

The religious connotation of the crucifix or its power as a significant symbol is not determined by the details or exactness of its form. Left: Cimabue, "Crucifix," S. Croce, Florence, c. 1290. (Photo, Alinari-Art Reference Bureau.) Right: "Cross of Garnerius," France, c. twelfth century. (Courtesy, Musée du Louvre, Cliché des Musées Nationaux.) Far right: Traveler's crucifix, originally enameled. Old Russian type made between eleventh and sixteenth century. (Collection of author.)

Techniques and materials

Until recently, art objects were evaluated primarily by generic type, but today such distinctions are considerably less important: drawings, once considered only as preliminary studies for more important works, can be as significant as paintings; easel paintings have become as significant as murals; water colors, as significant as oil paintings.

Media

Difficulties of classification arise when an object exhibits formal characteristics that satisfy more than one set of standards. Al-

though we can identify an object by the technique used to produce it, such as drawing, painting, printmaking, graphic design, decorative design, architecture, sculpture, or product design, the general nature of these categories makes them less than definitive. To arrive at a more meaningful identification, one must turn to more specific characteristics, the most useful of which is the materials of production. *Media*, the plural of *medium*, refers to the materials that act as an intermediary through which a form comes into being. Thus, graphite is a medium by which drawings can be produced. Other media, such as chalk, wax crayon, charcoal, pastel, ink, or metal points, also lend themselves to the techniques of drawing. Although the value of a work of art need not be affected by the medium used to execute it, the choice of medium affects the qualitative characteristics of the resultant image.

Man has traditionally produced objects to meet his needs with the materials and techniques available to him. This is as true today as it ever was. What has changed as man extended his understanding of the environment and thus his control over it is, first, the relation his work bears to the social and utilitarian needs of his community, second, the range of materials from which he is able to choose, and, third, the sophistication of the technology of which he is able to make use. Whereas in earlier times man was restricted to local materials or the relatively few he could get by trade, today he can choose the materials that best suit his needs.

Because our current definition of the arts includes so much that man has made, from his paleolithic beginnings to the present, the range of materials and techniques that relate to art is overwhelming. Images (pictures or decorative patterns) have been created from all the natural and artificial materials that could make a mark or color and on all surfaces that could be found or manufactured. In Japan, for example, human skin provided the background for some of the world's most complex and creative tattooing. Sculpture has been formed from most woods, stones, bone, ivory, and primary metals, plus clay, mud, plaster, and such impermanent materials as ice, bread, and butter. The weavers contributed their talents to the art of sculpture by introducing woven sculpture in the early 1960s.

The crafts have always included a wide range of materials as well as techniques; any available material that can be worked has an

Although tattooing is an esoteric art form, in Japan it is admired for its esthetic qualities. (Photograph courtesy, Lennox P. Tierney, Pasadena, California.)

excellent chance of becoming a craft form, with even such unlikely materials as human hair and fish scales having been used. In architecture, the range of materials used is limited only by man's imagination; in addition to wood, stone, clay, and metal, which are the principal building materials, there are architectural structures made of ice, mud, reeds, animal skins, canvas, felt, plaster, and paper. The list of materials with which man has either chosen or been forced to work is seemingly endless.

In earlier times, reverence for the past had effectively canonized the media and techniques used to create what we consider the more significant art forms. Neither the media and techniques nor the forms were to be tampered with or used in an unprescribed manner. The contemporary artist no longer adheres to these limitations. The newer attitudes maintain that the essential value of a work of art is determined by factors other than subject, media, or form. They also hold that no value distinction should be made between the two- and three-dimensional art forms or between forms that combine two or more media and those that make use of a

Contemporary ice sculpture created in New York City. (Courtesy, Knickerbocker Ice Company.)

Contemporary butter sculpture created in Tibet; traditionally used in the First Moon Festival. (Photo, Harrison Forman, New York.)

Contemporary bread sculptural ornament, created in Ecuador by Margarita Reza. (Courtesy, Vivian Burns Imports, San Francisco.)

single medium in the more traditional manner. Included under the classification of mixed media are paintings whose surfaces are added to or structured to be three dimensional (see Plate 1) and sculpture that depends on a worked surface or even a flat, colored quality for its esthetic effect (see Plate 2). What is projected in a mixed-media form is left entirely to the personal initiative of the artist or designer.

Because the nature of mixed media is so personal, studying it does not normally help us understand the work created before our own time. However, study of the more traditional media and techniques, which have contributed to such a wide range of the arts, is imperative if one is to gain broad artistic understanding. Each medium and each technique contributes to the creation of a unique form, which must be judged by those factors that pertain to it. The physical qualities that make a drawing significant may never appear in a painting, and much that makes the mosaic form artistically meaningful is certainly not possible in a water color.

73

Robert Rauschenberg, "Canyon," 1959. The mixed-media approach to the creation of the plastic art forms has helped erase the differences between painting and sculpture. (Collection, Ileana Sonnabend, Paris.)

Development of media and techniques

If we study the work of the paleolithic image makers, we find that they painted on open sites as well as on the walls of deep caves. Because their paintings were of special significance, those in the caves were usually placed in chambers and on surfaces that were accessible only with difficulty. It is believed that these images and the clay or earth sculptures that have been found in the same areas were part of a religious ritual related to the continuity of their food supply. The images were painted with varying techniques that were sometimes combined with engraving or scratching (see Plate 3). Charcoal was used for blacks and grays; iron oxides for yellows, red-brown, purplish-red, and browns; manganese

74

for brown-black and blue-black; and occasionally slaked lime or clay for white. After being reduced to a powder, the pigments were probably mixed with animal grease or resins for binding.

Paleolithic carvers and engravers worked on ivory, bone, horn, and stone; it is likely that they also made forms of wood, although no examples of this type remain. A piece of raw material had to be reduced to workable size before it could be shaped, and the available techniques, which depended on the use of flint, stone, and bone tools, consisted only of pounding, scraping, engraving, cutting, and rubbing. These early sculptors carved figures of animals and human beings (both male and female) in full round and bas-relief and as flat cutouts. Aside from these images, which were executed in both naturalistic and stylized form, nonobjective patterns, the meanings of which we can only surmise, were also produced. It is remarkable that the Paleolithic carvers, with only limited techniques at their disposal, were able to produce such skillfully worked forms.

As man emerged from the prehistory of the Paleolithic period into the better recorded Neolithic, the crafts emerged with him as industries that were no longer only a part of household production. Craftsmen, recognized as men with special skills who could produce objects that were in demand, were supported by the social unit because of their production. As Gordon Childe, one of the foremost scholars of prehistory and the ancient world, has pointed out,

"Vénus Magdalénienne," from Grotte de Bruniquel, c. 15,000–10,000 B.C.E. This type of venus figure is believed to have been created as a fertility fetish. (Photo, Yan Reportage Photographique, Toulouse.)

craftsmen may have been the first group after the ritual-religious leaders not directly involved with food production. Because their skills were portable, the early craftsmen were granted a certain degree of territorial freedom that allowed them to move from group to group plying their trade—a nomadic condition that has been repeated periodically throughout history, e.g., the Medieval masons, the Renaissance printers.

Of the Neolithic craftsmen, the first group to gain these privileges were the metal workers; their work was considered god-given and in many cases they were treated as demigods. Neolithic metallurgy was encased in ritual magic that set the ancient miner and smith apart from ordinary men and gave them, it was believed, special powers. Their secrets were most often protected and passed on by an apprenticeship system that depended on guilds to maintain the mysteries and standards of the craft. In many cases, the guilds were the bases for the formation of clans or castes, a phenomenon still observable in many of the emerging African cultures.

As the crafts became specialized and the products that could no longer be manufactured within the clan became necessities rather than luxuries, the self-sufficiency of the village was attacked. The result was the development of trade and its concomitants—socialization, urbanization, and the sophistication of society—and in the center of these cultural changes were the craftsmen. However, as the urbanization process grew and increased production was demanded, craftsmen found themselves in a less advantageous position. By the time of the great dynasties of Mesopotamia and Egypt, craftsmen had become part of the royal work force maintained within the existent power structure. Metalsmiths, masons, jewelers, carpenters, potters, and weavers—as well as agricultural and household workers—were fed, housed, and supplied with the raw materials of their work. As the craftsmen lost control of their raw materials, they lost control of the nature of their production; the inevitable result was a lessening of their power and status. The quality of their work came to depend on a new hierarchy of values, which was based on the rarity of the materials used, the complexity of the skill involved, and the magnitude and significance of the final product. Thus, the crafts, which began as a part of the ritual aspect of the Paleolithic social order and emerged

during the metal-based Neolithic period still retaining their ritual-religious qualities, became, in the evolving social patterns, only a part of the production of the skilled work force that attended to the needs of the powerful. In general, the crafts were maintained in this position in Western civilization until the Renaissance, when, as explained in Chapter Two, artists such as Leonardo and Michelangelo were instrumental in raising painting and sculpture to the level of the liberal arts. The other crafts, however, were kept in their lesser status position until the third quarter of the twentieth century.

The crafts emerged into the mainstream of the contemporary arts only as the dominant *raison d'être* of art shifted from intellectualism to creativity and expression. With these new values, form, media, and techniques became less important. The new status of the crafts was strengthened by their role in art education, especially at the collegiate level, and by the fact that a number of the more important artists of the modern period such as Henri Matisse (1869–1954) and Pablo Picasso (b. 1881) produced major works within the framework of the craft form. Historically, this was within the tradition of the Western artist: Raphael (1483–1520) designed tapestries for Pope Leo X; Peter Paul Rubens (1577–1640) designed tapestries for the factories of Brussels; and John Flaxman (1755–1826) produced many of the medallion insets commissioned by Josiah Wedgwood for his pottery.

Characteristics of media and techniques

The elevation of the art and craft forms into the status of fine art does not lessen the need to study media and technique; if anything, it strengthens it. For if we can understand the traditional limitations of media and techniques as well as the new contexts in which they occur, our chances of understanding art as a factor of man's universal involvement with production are greatly increased. Today, although the traditional classification by art forms (drawing, painting, sculpture, architecture, industrial design, and the crafts) still exists, the generic forms are becoming less and less mutually exclusive. We hear architects speaking at length of sculptural form, whereas sculptors discuss modulation and the use

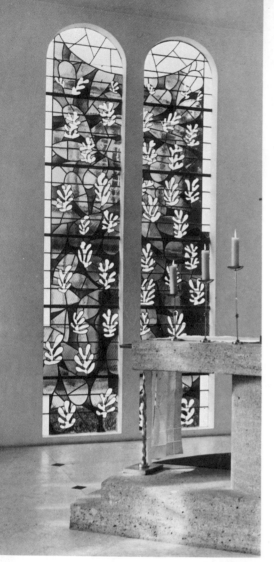

Top left: Stained-glass window designed in 1947 by Henri Matisse for the Chapel at Vence, France. (Photo, Hélène Adant, Paris.)

Top right: Ceramic platter designed by Pablo Picasso in 1949. (Courtesy, Galerie Louise Leiris, Paris.)

Bottom: "Sacrifice to Hymen," medallion designed for Josiah Wedgewood by John Flaxman in 1778. (Courtesy, Josiah Wedgewood & Sons.)

Right: Detail of the tapestry "The Miraculous Draught of Fishes," designed by Raphael between 1517 and 1519. (Courtesy, Vatican Museums.)

of space; what exists as painting in one context becomes more sculptural in another; and what might pass as sculpture is admired for its relation to basic craft techniques and the fine craftsmanship it displays.

The sculptor, like other craftsmen, first worked with indigenous materials. It is because of the availability of stone and clay in Central America that these materials dominated the early sculpture of that area. And for the same reason, wood was the chief material first used in sections of North America and Africa. Sculpture fashioned from reeds and grasses—or even mud—has been produced where these were the only materials at hand. However, in spite of the fact that the modern sculptor's choice is not restricted by local availability, most of his materials were also used by ancient man. The only new materials available for sculpting are the newer metal alloys and the plastics.

Because sculptural ideas and forms are often worked out in preliminary models, the sculptural materials are frequently classified as either temporary or permanent. Of course, many materials can be used for both preliminary models and final works, but some, such as clay and plaster, may have to be treated differently depending on their use. With other materials—wood and metal, for example—the technique is the same for both a preliminary model and a finished form.

PLASTER. Plaster, a material well known to the ancient sculptors, is finely ground dehydrated gypsum (burned limestone). When mixed with water, it reconstitutes to form a solid material, basically the same as the original gypsum but with new qualities of workability. If necessary, more plaster can be added to a work before it sets—and the setting process itself can be retarded or accelerated as desired. Moreover, even after the material has hardened, it can be easily carved. Normally, plaster is worked on an armature of metal wires or rods, but, if need be, the material can be strengthened by the addition of various materials and fibers. If sculpture is to remain outdoors, the plaster must be used in as dense a form as possible and coated with waxes or oils; these

Francesco Primaticcio, stucco decoration, c. 1541–1545. An example of plaster (stucco) sculpture used as interior decoration at Fontainebleau. It is not considered significant, because, in addition to not meeting current standards of taste, it is made of plaster and was designed to function decoratively. (Photo, Editions "Tel," Paris.)

techniques help prevent the absorption of moisture, which causes deterioration. Plaster can be colored by adding mineral oxides to the material as it is mixed or by painting the finished form.

The medium has proved to be a popular one, because it is cheap, universally available, and easy to handle. It is used extensively for models, molds, and some indoor sculpture and architectural decoration.

Luca della Robbia, "St. Michael, the Archangel," c. 1475. Because clay, as a sculptural material, has traditionally been considered less desirable, less technically demanding of the artist, and less permanent than stone or metal, terra cotta sculpture is considered less significant. (Courtesy, The Metropolitan Museum of Art, New York. Purchase, 1960.)

CLAY. The two general types of clay available to the sculptor are the earth clays and Plasticine; the earth clays are subclassified as *earthenware*, which is coarse, soft, and porous; *stoneware*, a denser, harder clay; and *porcelain*, which is vitreous (glasslike). Firing, or baking, the clay causes its form to become permanent: earthenware must be fired at a relatively low temperature, about 1800°F; stoneware at between 2100 and 2700°F; and porcelain above 2800°F. Earthenware and stoneware are often referred to as *terra cotta*, which means baked or cooked earth. The clays are almost universally available and have been used for sculpture since Paleolithic times; they are water soluble and can be either modeled or cast.

Although earthenware and stoneware can range in color from light buff to dark red-brown, porcelain is normally white and, when cast thinly enough, translucent. To change the color of a clay form, mineral oxides may be added to the medium before it is worked or the sculptured form may be covered with an *engobe*— a coating of liquid clay to which colorants have been added—before it is fired. The surface qualities of clay forms may also be changed by waxing, painting, or glazing. Glazes are vitreous coatings with an affinity for clay, which causes them to adhere to the form when it is fired. They can be transparent or opaque, shiny or dull, and a wide range of colors can be achieved by the addition of mineral oxides.

Plasticine is a synthetic nonhardening compound of earth clays, sulphur, and oil or grease. It is extremely plastic, has a waxlike

consistency, and is used by sculptors almost exclusively for sculptural-sketching or model-making. Similar to plaster and the earth clays, Plasticine, when used for models, must be worked on an armature.

STONE. Stone, the traditional material of the sculptor, is subclassified on the basis of its origin. *Igneous stones* were molten masses of volcanic materials that cooled and solidified as they rose to the earth's surface. These stones, the hardest and most brittle of those used by the sculptor, include the granites, diorite, basalt, and the glasslike obsidian. *Sedimentary stones* were formed by deposits of stones combining with organic matter, which formed both the filler and binder. The denser the sedimentation, the harder the stone. The primary sedimentary stones used by the sculptor are the limestones and sandstones; they are relatively soft and

"Head of Buddha," c. 100 C.E. This sculpture from Mathura, India, exhibits a typical sandstone texture. (Courtesy, Museum of Fine Arts, Boston. Gift of Dr. Ananda Coomaraswamy.)

porous and fairly easy to carve but do not weather as well as the harder stones.

To the sculptor, the term *stone* includes all those he uses except the *metamorphic*—the marbles—which are igneous and sedimentary stones whose structure has been changed by great pressure, heat, or chemical reaction. The term *marble* is generally reserved for compact, crystalline varieties of carbonate of lime but excludes alabaster, even though the two are closely related chemically and structurally. The marbles are easier to carve than igneous stones because they are softer; and they can be given a smoother and more lustrous polish than sedimentary stones, because they are generally denser than the latter and are crystalline in structure. Although marble varies greatly in color and texture, it is found almost universally. Its prevalence in the sculpture and architecture of Western culture began with the Greeks; they seemingly had an unlimited supply and used it extensively—as did the ancient Romans and the Italians of the Renaissance. The best Greek marbles were the Pentelic and Parian; the best Italian, those of Carrara and Siena.

Jade; the various types of quartz, including rock crystal; and alabaster, which is very easy to carve when freshly quarried, are other varieties of stones that have been used extensively by sculptors.

WOOD. Although wood is not as durable as stone, it is also one of the traditional materials of the sculptor. But the same trees do not grow everywhere, so, until modern times, sculptors had to depend on those in their own region to satisfy their wood needs. Today, however, even rare woods can be obtained from dealers, who stock varieties from around the world. Wood is generally purchased in log form and must be thoroughly dried, or seasoned, before it can be carved; if worked before it is properly seasoned, wood will split and warp.

Wood used for sculpture is categorized according to its degree of hardness. The soft woods most commonly used are the pines, cedars, and firs; the most commonly used domestic hardwoods include birch, maple, oak, elm, and walnut; and the most commonly used exotic hardwoods are mahogany, ebony, rosewood, and teak. The harder the wood, the denser it is and the finer finish

Characteristics of media and techniques

and polish it will take. Modern sculptors have evidenced great prejudice against painted or polychromed wooden sculpture, although this finish bothered neither sculptors of former eras nor today's less sophisticated folk carvers.

METALS. Working with metals, the last of the traditional materials of sculptors, demands a fairly sophisticated technology,

"Kongorikishi," guardian figure from the Great South Gate outside the Temple of Todai-jin, Nara, Japan, Kamakura period (1185–1333). A superb example of wood carving, this guardian demon stands 26½ feet high and displays a vigor and presence seldom seen in wood carvings. (Photo, Japan National Tourist Office.)

but we have evidence not only that metals were available to ancient man but that he knew how to use them. Metal sculpture was prominent in the cultures of ancient Egypt and other areas of the pre-Christian Middle East, in ancient Greece, in pre-Columbian America, and in the ancient Orient. As usual, the choice of metals was originally dependent on availability. Copper, brass, bronze, gold, silver, iron, and lead were all used; aluminum is the only modern addition to the list.

Bronze, used by Chinese sculptors as early as the third millennium before the Christian era, was and continues to be one of the most universally popular metals for sculpting. Its popularity is due to the fact that its properties make it particularly suitable. Being an alloy, essentially of copper and tin, bronze is very strong, highly durable, and resistant to atmospheric corrosion. It can be used for finely detailed castings, is easily forged, takes an excellent polish, and develops a fine patina. Moreover, its color can be varied without affecting its other properties.

Brass, an alloy of copper and zinc, has been used only to a limited extent for sculpture. Yellower than bronze, brass has traditionally been used for small well-polished forms.

Copper, characteristically reddish in color, was used in its pure form in ancient times as a casting medium. More recently, however, its use has been as a *repoussé* medium, shaped by hammering over sandbags or stakes. Because copper becomes brittle during the hammering process, it must be continually annealed by heating it to a dull red color and then allowing it to cool slowly.

Gold and silver have been used as casting materials for small pieces or for *repoussé*. However, because they are rare and thus very expensive, their use has been restricted. Most of the pieces we see in museums are either historic or, if contemporary, are small and produced primarily for either religious purposes or personal adornment.

Lead has been used for both casting and *repoussé* work, and iron has been used primarily for forging and some casting. With the advent of modern welding techniques, iron has become a popular material for constructed sculpture. Aluminum has been used as a casting material and for the production of fabricated sculpture. The fact that it is a very light metal has been an advantage in the production of architectural pieces, and with current methods

Right: Bronze standard, Pre-Hittite, about 2100 B.C.E. Demonstrates the high standards achieved by ancient metalworkers. (Courtesy, The Metropolitan Museum of Art, New York, Joseph Pulitzer Bequest.)

Far right: Marino Marini, "Horse and Rider," 1947–1948. A contemporary bronze casting whose surface quality is indicative of current interest in texture. (Collection, The Museum of Modern Art, New York. Acquired through the Lillie P. Bliss Bequest.)

of anodizing, sculptors have been able to achieve a range of colors with aluminum that are not possible with other metals.

Processes of the Sculptor

Historically in the Western world, sculpture has been thought of as three-dimensional form carved from stone or wood or cast in metal. Modeling was considered only a means to an end; even during the nineteenth century modeling was not seriously thought of as a sculptural technique in its own right. This attitude has all

but vanished under the impact of twentieth-century sculptural concepts, which hold as potentially significant any form that is three dimensional, regardless of the method of its production.

CARVING. Carving—removing unwanted material to reveal the form the artist has visualized—is the most common method of working stone and wood. When working with stone, the sculptor selects tools according to the type of stone he is planning to carve. The most useful tools are a point (or punch), used for roughing out the form; a bouchard (a clawed hammer), used to bruise stone away; chisels and claws (chisels into which teeth have been cut), used extensively on marble; the drill, used to make the holes necessary for splitting stone; a wooden mallet made from beech or lignum vitae; and assorted rifflers, rasps, and abrasives for finishing. With many of the harder stones, abrasion is the only means by which forms can be fully developed. The tools of the wood-carver —chisels, gouges, rifflers, and rasps—are like those of the stone-carver except that they are finer and provide the carver with more of a cutting edge. To clear waste material, the wood-carver uses the axe, adze, and saw.

The are two basic methods of carving stone, of which the direct method (the more difficult of the two) is currently favored by artists. A sculptor following this method may use a small model to help him develop his final form, but his finished work is never in any sense a reproduction of the model. This method demands a complete understanding of the stone that is being carved; great skill in using the tools; and, of course, a full understanding of the nature of the subject matter. The indirect method, used extensively in the past and by eminent artists, consists of creating a detailed scale model and then reproducing it, almost mechanically, with the aid of pointing devices—tools that allow the carver to locate as many points as necessary on the surface of the model and transfer them to the stone. There are several arguments against the indirect method: its supposedly mechanical qualities; the fact that the original, which may have been created in clay or plaster, was not conceived of as carved stone; and the lack of involvement of the artist with his work. The last criticism results from the practice of employing professional stone-carvers to execute the final figure in stone; thus the artist who conceived the work actually creates only

Characteristics of media and techniques

the model. Those who support the indirect method, however, point out that not only does it enable the artist to save time and energy, but less stone is wasted and the artist's lack of mechanical skill need not hamper his creativity.

MODELING. In order for a material to be useful for modeling, it must be highly plastic, for the success of a model depends on the sculptor's being able to work the material as long as necessary. Plasticine, which is nonhardening, meets this requirement, but the earth clays must be kept fairly wet in order for them to retain their plasticity. Modeling is a popular technique with contemporary sculptors, because it makes possible direct contact between the artist and his material and results in a type of creative spontaneity.

Student sculpting by direct carving on stone. (Photo, Cooper Union for the Advancement of Science and Art, New York.)

A B C

CASTING. Casting allows the spontaneity achieved in the modeling process to be faithfully reproduced in bronze or other metals. The choice of molding material—plaster, gelatine, agar plastics, rubber compounds, or waxes—depends on the intricacy and type of mold needed. *Waste molds* are those from which only a single cast can be made, for the mold is destroyed as the cast is removed. But *piece molds* are made in a number of easily removable pieces held rigidly in place during the casting process and can be used for a number of casts.

The technique begins with the production of a negative mold (referred to as a *female mold*). The artist covers the original model with the molding material in such a way that a faithful negative reproduction is created. However, unless a soft wax or clay was used to construct the model, some type of separating material must first be applied to it so that the cast can be removed. Moreover, because molds can be made from almost any form, including live human beings, each material requires a different type of separator.

After the negative mold is made, the casting material is introduced into it to make a positive cast (referred to as a *male mold*).

90

D E

Robert Harris, untitled, 1966.
(A) Wax model. (B) Preparing for
casting. (C) Waste mold. (D) Pour-
ing. (E) Finished bronze piece.
(Photographs courtesy, Robert Har-
ris, Long Beach, California.)

Making casts of plaster, plastics, or clay can be fairly simple. The
processes used for metal casts are somewhat more complicated,
however, because the metal must be in a molten state when it is
poured into the mold and it is not feasible to pour the molten
metal out of the mold. Most metal castings are hollow because
hollow castings require less metal, an economic factor; are lighter,
thus easier to handle; and are stronger, because solid castings shrink
more when cooling and thus may crack or become distorted.

Sand-molding and the lost-wax, or *cire perdue*, process are the
two principal techniques used in metal casting. For sand-molding,
the artist places his model in a series of close-fitting frames that
are filled with a very fine sand (French sand), which must be moist
enough and tamped enough so that the negative mold will be
maintained when the model is removed. To make a hollow cast,
a core is inserted within the casting cavity and held in position
with metal pins to ensure that the walls of the cast will have a
uniform thickness. Grooves are then cut into the sand to provide
channels, through which the molten metal can be poured in; gates,
through which excess metal can be discharged; and vents, through

91

which the air and gases given off by the metal can escape. To ensure a clean pour, the molten metal is worked with at temperatures well above its melting point.

In the lost-wax process, a carefully shaped core is prepared of brick dust, plaster, and water and then coated to the desired thickness—which varies with the size of the cast—with special waxes. The wax coat is worked to form a positive model of the piece to be cast. The final wax form, after being given vent openings and gates (also made of wax), is carefully pinned to the core and encased in a prepared investment or a mixture of plaster and refractory materials. Again, in this process, as in sand-molding, the pinning is essential to hold the core in a fixed position so that the walls of the final casting will be of an even thickness. At this stage the entire form is baked at a high temperature to burn out the wax completely, leaving the core suspended within the negative casting cavity. Then the molten metal is introduced and the cast made. The vents and gates, known as *sprues*, appear as a series of metal rods attached to the finished cast when it is removed from the mold. These, in addition to the pins that held the core in place and the core itself, which is friable, are then removed. The final steps consist of any necessary surface work, cleaning, and polishing.

Casting has become increasingly expensive in recent years, and many sculptors have been restricted to producing small pieces, which they can cast themselves, or have resorted to using the services of foreign foundries. Some attempts have been made to use industrial foundries, where sculpture can be cast directly and without elaborate corings. One method by which this can be accomplished—a technique that was also used by the ancient Greeks—is by designing the work as a number of small pieces that can later be assembled to produce the final form.

FABRICATION. One of the significant results of the rising costs of material and casting, as well as of the difficulties involved in producing large stone carvings, has been the increased use of fabrication as a sculptural technique. The sculptor, when using this process, can use any materials but must discard the rules that bound the classical and romantic sculptor. He must rely on the creative imagery he is capable of evoking through the use of

David Hare, "Juggler," 1950–1951. An example of contemporary welded-steel (fabricated) sculpture. (Collection of Whitney Museum of American Art, New York.)

a combination of materials and the production of ordered arrangements.

The concept of fabrication as a sculptural technique has been responsible to some extent for the interest in found objects (*objets trouvés*) as a source of sculptural form. Initially, many of the found objects were incorporated into the fabricated forms, but soon, fostered by the new sense of imagery that is a significant part of contemporary art, they came to be admired for their own formal qualities and as a type of sculpture in their own right with their own intrinsic values.

Painting

Of all the picture-making techniques, it is painting that dominates the general consideration of art. For many people, art and painting are synonymous, even though painting is but one form among many.

DISTEMPER PAINTINGS. Aside from the Neolithic cave paintings, which are generally considered apart from the developing continuum of Western art, the earliest significant painting we have came from Egypt. There, the excessively dry environment has, to a great extent, acted as a preservative. Although the ancient Egyptians painted on a number of surfaces, including leather, woven linen, papyrus, wood, stone, pottery, and plaster, it is usually their paintings on plaster walls that are considered most important to the development of the art of painting. They prepared most of the surfaces to be painted by applying one or more coats of plaster and glue; however, the paintings in the tombs were normally applied directly to the plastered walls. In spite of the use of plaster surfaces, these paintings cannot be considered frescoes; they were distemper paintings in which the finely ground mineral pigments were mixed with water and then applied to the dry wall. Later, beeswax was mixed with the pigment or applied to the painted surface; the wax not only increased the luster of the pigment but acted as a protective coat. The Egyptian wall paintings, when fully developed, were rich in color and pattern, and they have maintained those unique qualities—which so enchant modern man.

The greatest problem with distemper painting on plaster is that the pigment scales off. This did not occur to the Egyptian wall paintings so long as they were in sealed chambers in what was a very dry, stable environment. However, many of the paintings have begun to scale because the tombs have been opened. The problem of scaling was solved only with the development of fresco techniques—techniques that had been employed as early as 1500 years before the birth of Christ in the palace paintings at Knossos on Crete.

Distemper wall painting from the tomb of Tut ankh-Amun, a minor pharaoh of the Eighteenth Dynasty, c. 1350 B.C.E. (Photo, Trans World Airlines.)

BUON FRESCO. In true fresco painting, *buon fresco*, the pigment is applied to the final plaster coat while the plaster is still damp. The active lime in the plaster combines with the pigment in a chemical reaction that makes the color an integral part of the plaster; the image is thus permanently fixed and will last as long as the wall on which it is painted. The techinque is involved and begins when the rough plaster wall is covered by the *arricciato*, the intermediary coat of plaster onto which the cartoon is transferred. A final layer of plaster, called the *intonaco*, is applied, but only to an area small enough to be painted during one day. Traditionally, the cartoon is applied onto the *intonaco* and the area painted while the plaster is still damp. Any of the *intonaco* not covered is removed and reapplied the following day. Thus, true fresco can always be identified by the joints between each day's painting.

The technique, which had been used by the Romans, continued to be a major form of wall painting in Italy until the end of the Renaissance; it reached its zenith during the sixteenth century. The most famous examples of fresco are those by Michelangelo in the Sistine Chapel and Leonardo da Vinci's "The Last Supper"; unfortunately, because of improper preparation of the wall, Leonardo's painting has not resisted the ravages of time.

FRESCO SECCO. Because true fresco is a very demanding technique, the simpler method known as *fresco secco* has at times been substituted. In this variation, the *intonaco* is applied over the entire surface at one time and washed down with lime water just prior to the painting. The pigments are usually ground in lime water, which is the vehicle by which the paint is applied. This technique does not produce as durable a surface as *buon fresco*. Because larger surfaces have to be covered in a shorter period of time, that is, while the surface is still damp, there is a tendency for paintings produced by this technique to have less detail and a generally freer style. The term *secco*, when applied to wall painting, can refer to any paint media used on a dry plaster wall. The technique usually relied on the textural quality of the plaster for its visual character.

ENCAUSTIC PAINTING. The techniques of encaustic painting, like those of *buon fresco*, are ancient and demanding. Known to the Egyptians, Greeks, and Romans, the method was described

Domenico Ghirlandaio, "St. Christopher and the Infant Christ," c. 1475. A buon fresco in which the intonaco joints are clearly visible. (Courtesy, The Metropolitan Museum of Art, New York. Gift of Cornelius Vanderbilt, 1880.)

(albeit, in not as much detail as we should like) by the famous Roman chronicler Pliny (c. 23–79 C.E.). It consists of applying a mixture of hot beeswax, resin, and ground pigments to any porous surface and then applying heat, a process known as *inustion* (burning in), to set the colors and bind them to the ground. Working with hot tools and a warm surface, the wax is easy to manipulate—it is not unlike handling thick oil paint. The ancient

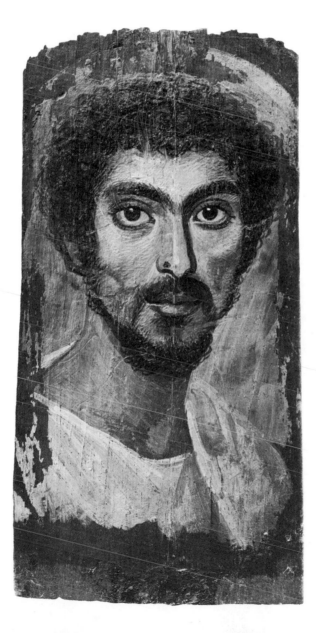

Portrait of a man, encaustic on wood. Taken from a second-century mummy case found in Fayum, upper Egypt. (Courtesy, The Metropolitan Museum of Art, New York, Rogers Fund, 1909.)

Greeks and Romans accomplished the process by passing a special container filled with hot charcoal over the surface of the painting; contemporary artists more often rely on electric heaters. After the burned-in surface cools, it is polished with a cloth; this gives the wax a soft luster that heightens its translucent quality. One of the most remarkable characteristics of encaustic painting is that the wax can retain its original surface quality.

The technique, although used in Byzantium in the manufacture of icons, apparently was not successfully practiced in the West after the fall of the Roman Empire until the middle of the eighteenth century. At that time, there was some exploration of the techniques described by Pliny. The greatest interest in modern times has been shown by the Germans who, with the thoroughness with which they have been stereotyped, analyzed all the materials and processes of encaustic painting. However, their research and subsequent experimentation with this method was carried out strictly on the level of technique without their recognizing or allowing for the differences between technique and art. The result was work that more often than not lacked esthetic quality.

TEMPERA PAINTS. Until the development of oil paints during the fifteenth century, most paints were made by mixing finely ground natural pigments with a binder and water. In all water-soluble paints, it is the binder that holds the pigment particles in suspension, thus creating the paint-like quality that enables the color film to adhere to the support surface. A ground pigment that has been mixed with a binder is known as a tempered pigment. The word *tempera*, although it can refer to pigments that have been tempered with any binder, traditionally refers to pigments tempered with pure egg yolk; these pigments are known most commonly as *egg tempera*. The white of the egg, albumin, was also used as a tempering medium, most often for painting on vellum in the production of books.

Although egg tempera is no longer popular, it was the paint most generally used for panel painting in Western Europe during the fifteenth and sixteenth centuries. Painting with egg tempera was a demanding art calculated to show off the jewel-like qualities of the pigments, which were often made of crushed gem stones. Malachite was used for yellowish greens, azurite for sky blue, and lapis lazuli for ultramarine. The significance of the technique was

due not only to its physical properties, however, but also to the attitudes that attended its use (attitudes not held to any great extent by contemporary artists). A belief in the nobility of materials and a consideration of their rarity, value, and symbolic associations were important factors in the choice and use of pigments during this period. It was this same consideration that led to the use of gold leaf in tempera painting (see Plate 4).

The paintings were executed on wooden panels—single boards for small paintings but laminated boards for larger ones, in order to counteract the inevitable warping. The panels were carefully surfaced with *gesso*, a combination of gypsum (plaster of Paris) or chalk with gelatin size or glue. The surfaces were prepared by first making them fairly smooth and then covering them with the gesso, applied in two basic forms and in many layers. The first coats, of *gesso grosso*, were relatively coarse and absorbent; the final coats, *gesso sottile*, were finer and less absorbent and, when finished, created a surface that was not unlike that of an ivory panel. The pigments were stored dry and, when they were to be used, were ground with water and mixed with egg yolk as needed. The resultant paint dried as an almost indissoluble tough film of color "characterized by a brilliant, luminous crispness which is never exactly duplicated by the use of oil or other mediums." [1] Egg tempera on gesso has proved to be most durable and to retain its freshness better than much of the oil painting that supplanted it in the sixteenth century.

Water color is a tempered paint made of pure ground pigment bound with an aqueous gum, such as gum arabic; it retains a transparent quality (see Plate 5). *Gouache* is paint in which the pigment has been ground with some inert material such as chalk. The chalk, nominally known as a filler, is used not as an adulterant but as an additive to make the paint opaque. It should not change the basic color quality or the paint texture.

One other type of water-soluble paint, which has had an extended, if somewhat irregular, use, is made by mixing pigments with *casein*, a binder that depends on the fatty lactic acid found in milk and cheese. Referred to by the name of its binder, this paint has been used successfully for both wall and panel painting.

[1] Ralph Mayer, *The Artist's Handbook of Materials and Techniques*, rev. ed., New York: The Viking Press, Inc., 1966, p. 231.

Although it can be made most simply by binding a dry pigment with milk, the more traditional recipe calls for casein to be made by grinding washed cheese with slaked lime until a thick paste results. This forms an exceptionally strong adhesive that must be thinned before it can be combined with the pigments. If not diluted, the adhesive quality of the casein can pull part of the ground away when the paint dries. The paint, which resembles the opaque gouache, often lacks the transparency and brilliance obtainable with water colors and oils.

Raoul Dufy, "The Butterfly Ballet," 1951. A painting executed in gouache, appreciated for its spontaneity. (Collection, Henri Gaffié.)

OIL PAINTS. The exacting techniques of egg tempera were eventually replaced by the less demanding techniques required by oil paints. The "invention" of oil paint is often erroneously attributed to Jan van Eyck (c. 1370–1441)—erroneously because there is evidence that pigments bound with drying oils were used during the Middle Ages. Oil paint was introduced dur-

ing the fifteenth century, but because it was originally used in conjunction with tempera, it can be considered only as complementary to the tempera techniques until as late as the seventeenth century. At the end of that century, oil paint as we know it—pigment ground only in oil applied to primed canvas—appeared. However, work in oils, since the beginnings of its general use in the seventeenth century, has been so universal and rich that for much of the general public oil painting has been synonymous with "real" painting.

During the eighteenth century, the changes in the needs that painting was required to satisfy and the several advantages of oil-mixed pigments combined to make this painting medium the most popular. The ground (primed canvas on stretchers) not only allowed for much larger paintings but was easier to prepare than the gessoed wooden panels it replaced. However, the most important quality of oil paint—the quality that has maintained this medium as the one most universally used—is the wide variety of ways in which it can be applied. Methods of application range from the impeccably controlled blending of Jean Auguste Dominique Ingres (1780–1867) through the spontaneous impasto brush work of Frans Hals (1580–1666) to the stroke-dominated textures of Vincent van Gogh (1853–1890). An additional factor supporting the popularity of oils is that the direct application of the paint provides an immediately intimate contact between the painter and his medium, regardless of the qualitative effect he chooses to develop. Using only normal materials, the artist can apply the paint thinly or thickly, as a transparent film or an opaque surface, and with little, if any, change occurring when the paint dries. Only with the recent introduction of plastic-based paints have oils been challenged as the most flexible painting medium available.

The ability of oil paints to function as they do is based on the drying property of the oils, which makes them form a tough but flexible adhesive film, thus creating a dry, solid material that cannot be brought back to its original state by any means. Linseed oil, obtained from the seed of the flax plant, is the basic grinding oil used in making oil paints and is also used in the production of glaze media, clear varnishes, and various painting emulsions. Traditionally, artists either ground and prepared their own colors or had it done by their apprentices. Most present-day painters,

however, make use of prepared tube colors, which became commercially available at the end of the eighteenth century. The oil paints, which are relatively thick when they come from the tubes, are usually thinned with oils, varnishes, turpentine, or other solvents that have no reactive effect on the pigment.

Unfortunately, there are some disadvantages to oil paints—two of the most common are cracking and color changing. Cracking occurs when a bottom layer of paint contracts more than the top

Jean Auguste Dominique Ingres, "Portrait of the Comtesse d'Haussonville," 1814. Oil on canvas. (Copyright, The Frick Collection, New York.)

Top: Frans Hals, "Malle Babbe," c. 1650. Oil on canvas. (Courtesy, Staatliche Museen Berlin, Gemäldegalerie Dahlem.)

Bottom: Vincent van Gogh, "L'Arlesienne," 1887. Oil on canvas. (Courtesy, The Metropolitan Museum of Art, bequest of Samuel A. Lewisohn, 1951.)

layer; it can happen if the amount of oil in the paint of the top layer is considerably less than that in the bottom layer or if the bottom layer is not completely dry before the top layer is applied. Cracking also develops if a painting is subjected to extreme temperature changes or if the support surface is not kept rigid. Color changes will occasionally result from chemical reactions between certain pigments, chiefly occasioned by the combinations of sulphur-bearing pigments with the two leading lead pigments, flake white and naples yellow. The paints made with organic dyes and some of the more brilliant aniline dyes tend to fade on exposure to light. In some cases, the aniline dyes can also bleed into other pigment layers. However, if the painter is aware of his materials and how they can be used, cracking and color changes can be avoided.

SYNTHETIC RESINS AND PLASTIC PAINTS. The newest media and ones that have gained wide acceptance by contemporary artists are the synthetic resins and the plastic paints. Based on materials originally produced for industry, the advantages of these new media include their being soluble in water, drying rapidly, and being completely insoluble when dry. In addition, they can be treated as transparent water colors or traditional impasto oils and they can be blended with various fillers such as chalk or sand to produce a variety of textural effects. The plastic paints can be mixed with either ground dry pigment or any water-soluble tube pigment and can be used equally well on heavy paper, cardboard, or untempered Masonite. Unlike oil paint, they do not tend to crack, turn yellow, or darken. However, although the plastic media have introduced a new freedom to painting techniques, they have have not seemed to develop any startling new visual qualities.

Mosaics

The techniques used in the production of mosaics relate to painting only in terms of their ability to create pictures or images on the surfaces of forms. However, instead of using a medium, such as chalk, ink, or paint, that lies on the surface and allows for the manipulation of a continuous surface, the mosaic depends on the manipulation of discontinuous units called *tesserae*, small cubes of stone or glass that collectively form the surface. The mosaic

Characteristics of media and techniques

technique was used as far back as the third millenium before Christ, when mosaics of semiprecious stones held in place with bitumen were produced in the city of Ur. The first general use of mosaics for floor and wall decoration occurred during the period of the Roman Empire. They appeared over a wide area, with perhaps the most famous examples being in Pompeii and Herculaneum. However, it was in the murals of the Byzantine and early Christian churches that the technique reached its apogee.

The traditional technique consisted of imbedding individual tesserae into a matrix of damp mortar, following a well-planned cartoon. The tesserae, usually imbedded at irregular heights in order to reflect as much light as possible and so increase their brilliance, were arranged in patterns that helped create the illusion of three-dimensional forms, thus adding additional levels of interest for the observer. The tesserae, themselves irregular, were made of polished colored marbles and semiprecious gems as well as glass. However, it was only the glass that was used to produce gold tesserae—the usual method being to sandwich gold leaf between two sheets of transparent Venetian glass. Because of the wide range of colors available and the great scale difference between individual tesserae and the total mosaic, the possibilities for color transitions and blending were almost limitless. Brilliance

"Donkey Nursing Two Lion Cubs," a Roman mosaic, c. fourth or fifth century. The illusion of naturalistic form is heightened by the manner in which the tesserae have been set. (Courtesy, Museum of Fine Arts, Boston, Otis Norcross, J. H. and E. A. Payne Funds.)

and richness of color plus size, scale, and intricate patterns enabled the mosaics of early and medieval Christendom to evince some of the most remarkable and magnificent pictorial images man has ever created.

Although interest in mosaic techniques as a decorative form has been recently revived, the modern mosaics cannot compare to those produced under the influence of Byzantium. To some degree this is because of changes in scale and technique. With the advent of modern production methods, the number of available colors has increased—but so has the regularity and evenness of the tesserae. The mortar matrix has been replaced by modern adhesives and waterproof plywood supports. Instead of the tesserae being imbedded directly into the mortar to create a variety of levels and directions, they are glued with water-soluble adhesives to sheets of paper on which segments of the total cartoon appear. These sheets are then glued, tesserae side down, to the permanent surface and the temporary paper support is washed off. The result is a mosaic that lacks the variation and brilliance of earlier examples. The new techniques have been responsible, at least in part, for reducing the mosaic form from an expression of a statement about the nature of man and his universe to the coffee-table platitudes produced from kits available at the local hobby shop.

Modern artists too often consider mosaics as a shallow form of decoration and in terms of a scale and approach more normally allocated to small, nonobjective easel painting. This attitude is in part the result of present-day economics but is also often due to the modern artist's refusal to allow other workers to contribute directly to his work of art. In the past, the designers of monumental mosaics depended on crews of trained craftsmen to execute their designs; these craftsmen, who did not consider themselves artists, did not feel that self-expression was either a necessity or their inalienable right. The skilled artisans who produce the visual conceptions of others is a group that is dying out of the American labor scene as far as the arts are concerned. (Perhaps the only exceptions are those few foundry workers who still cater to the needs of sculptors.) In the past, our craftsmen were primarily European immigrants, who found their skills welcomed in the expanding American economy. However, with advances in industrial technology and the general mobility of our society, the function of the craftsmen has changed, as have the craftsmen themselves.

Today, the majority of those engaged in the crafts we currently relate to the arts are for the most part university- or college-trained men and women who earn their living as teachers of the crafts; they use their creative skill for the production of luxury goods or for personal expression rather than for the production of necessities.

Stained Glass

One of the picture-making techniques that evolved as a Byzantine craft along with mosaics is that of stained glass. There is some evidence that the technique was used as early as the ninth century, although no examples from this period exist. The earliest examples date from the beginning of the eleventh century; they are in Augsburg, a city in the Duchy of Swabia, in what was the Kingdom of Germany, which at that time was part of the Holy Roman Empire. But stained glass did not reach its fruition as a major form until later when it appeared as an important part of the Gothic church. By the twelfth century, the technique was being used in France, where the form reached heights that made the French its leading creators and manufacturers (see Plate 6). It reached England late in the twelfth century; the most famous English examples produced were for the cathedral at Canterbury. Two of the important characteristics of stained glass, as it was used in Gothic cathedrals, were its light-admitting quality and the blazing richness it gave the interior space. Thus, the use of stained glass in medieval cathedrals was in part due to the theological interest in light, which developed at the time. At the peak of the form's use, the stone structure of cathedrals acted primarily as skeletal supports for a mass of light-admitting glass.

The glass used in medieval windows was of two types: pot metal, a solidly colored sheet made by adding metallic oxides to melted glass, and flashed glass, consisting of a thin layer of color fused to a sheet of plain glass. Although glassmaking techniques have been refined steadily over the years, the refinements have not always been beneficial to art, and the techniques used today to produce stained-glass windows hardly differ from those used in the fourteenth century. Glass, still colored by metallic oxides, is still cut to shapes predetermined by full-scale cartoons and details are still applied to its surface with a low-firing enamel. It

Detail of "History of Charlemagne," showing method of leading and surface-detail painting. (See Plate 6 for an illustration of the complete window.) (Photo, Giraudon, Paris.)

is then assembled into the desired image by the use of malleable H-shaped lead channneling that holds it in position. To these traditional techniques the modern stained-glass producer has added a further dimension by deeply embedding thick hunks of colored glass into reinforced-concrete forms. This demands a different type of imagery, one that depends on a deepened color or on the refracting surface of the glass, which imparts a faceted

jewel-like quality. Although the new methods often result in dramatic effects, the forms are not as complex or significant as are the older ones.

As with mosaics, the new stained-glass techniques are partially the result of a changed economic pattern. In modern times, stained glass can be fully exploited only where society's affluence can be directed to the production of a monumental decorative form. Thus the fully expanded techniques appear today only in those structures with a large budget for their decorative elements or those for which the interest and financial support of wealthy donors can be arranged.

The Print

The media and techniques discussed thus far are those associated with the production of a single work of art. There are, however, other media and techniques that are used to produce multiple copies of a single art form. In the graphic art of printmaking, the artist's original intention is the production of a limited number of identical prints, known as an *edition*—the number varying with the intention of the artist and the process involved.

It is important to make a distinction between prints and reproductions. In contemporary terminology, a *print* is the graphic image that results from the printing of a plate or plates produced or worked on by the artist, with each print being considered an original work of art. The modern practice is for the printmaker not only to sign the prints but to number them in such a manner so as to indicate the relative position of each impression in the total number printed. The notation 10/25 would mean the tenth impression of an edition of twenty-five. A *reproduction,* on the other hand, although often a facsimile of an original work of art, is most usually a photomechanically reproduced image in the production of which the artist responsible for the original has had no hand; reproductions are more often than not the result of a commercial interest rather than a creative or artistic one. Nevertheless, they have been a major means of familiarizing Americans with important paintings and have been used successfully for esthetic purposes in the American home and school, in spite of the fact that contemporary printmakers and print en-

Antonio Frasconi, "Self-Portrait," 1951. This woodcut illustrates the usual notations on modern prints used to indicate the print number and the size of the edition. (Collection, The Museum of Modern Art, New York. Inter-American Fund.)

Typical early prints used as an inexpensive means of producing popular religious pictures. Left: "St. Dorothy," c. 1420. Early Northern European woodcut. (Courtesy, Staatliche Museen Berlin, Gemäldegalerie Dahlem.) Right: "Kannon" (goddess of mercy). Japanese woodcut; votive figure of type produced as early as twelfth century. (From the collection of Mr. and Mrs. William Enking, Pasadena, California.)

thusiasts repeatedly point out the greater esthetic and monetary value of prints.

In Europe and the Orient, prints were originally a relatively inexpensive means of distributing pictures to meet growing demands. They were used as early as the ninth century in China and Japan to produce religious tracts and images to be sold to pilgrims visiting temple shrines. When they were introduced in Europe five centuries later, their first use was also based on the creation of objects of religious veneration. The usual image portrayed was a popular saint and some appropriate text. Because the printing process made possible the inexpensive reproduction of many similar images, these early prints were important for religious rather than esthetic purposes. Prints did not begin to be ap-

preciated for esthetic qualities until they became the picture form
available to the emerging middle classes in Europe and the Orient.
In England during the eighteenth century, subscriptions to print
editions were maintained by patrons who collected and enjoyed
the prints for their literary and moral aspects. "The Harlot's
Progess" and "The Rake's Progress," by William Hogarth (1697–
1764), became extremely popular in their print form, and they were
so flagrantly pirated that a copyright act was established in 1735
to protect the original work of artists, designers, and engravers.
Hogarth was instrumental in having the act passed. Historically,

William Hogarth, "In Bedlam," c.
1734. An engraving after one of
the paintings in the artist's "The
Rake's Progress" series. (Courtesy, The Metropolitan Museum of
Art, New York, Harris Brisbane
Dick Fund, 1932.)

prints resulted from the combined efforts of several workers: the artist, who produced the original drawing; the engraver, who made the plates; and the printer, who pulled the impression. Only in modern times has the artist prepared his own plates and pulled his own prints.

Prints are generally classified according to four basic printing techniques—*relief, intaglio, planographic,* and *stencil printing.* A relief print is produced by pressing paper onto a raised, inked surface. The technique is used for wood or linoleum cuts, in which the areas the artist does not wish to print are cut away from the plate.

Toshusai Sharaku, "Otani Oniji III as Edohei," 1794. A woodcut portrait of the Japanese Kabuki actor. (Courtesy of The Art Institute of Chicago.)

Characteristics of media and techniques

To produce an intaglio print, lines are cut, scratched, or bitten into a plate, after which the plate is inked and wiped clean so that the only ink left is in the lines. Damp paper is then placed on the plate and great pressure is applied. Because of the absorbent quality of the paper, the ink in the lines of the plate is drawn onto it. The intaglio method is used for engravings, which are cut; dry points, which are scratched; and etchings, which are produced by scratching or drawing on a resist-covered plate in such a way that when the plate is subjected to an acid bath, the lines are eaten into it.

Lithographs are produced by planographic printing, which is based on the principle that oil and water do not mix. Developed late in the eighteenth century, the technique involves chemically preparing the area of the plate that is to be printed to hold and transfer ink and the areas that are not supposed to print to reject

Pablo Picasso, "Minotauromachy," 1935. An etching. (Collection, The Museum of Modern Art, New York. Purchase.)

George Bellows, "Stag at Sharkey's," a lithograph. (Courtesy, The Cleveland Museum of Art, gift of Charles T. Brooks.)

ink. This is accomplished by the artist's drawing on a specially prepared limestone with a wax crayon or greasy ink. The drawing is chemically fixed on the stone so that it will hold ink, and the rest of the stone surface is thoroughly wetted to reject ink. The process is the same as that used in commercial offset printing. It is the least demanding of the four print techniques, because it most directly reproduces whatever the artist wishes to transfer from stone to paper.

Early in the history of printmaking, simple stencils were used in conjunction with woodcuts to create crudely colored images. Silk-screen printing, or serigraphy, is a more sophisticated form of this process; it makes use of a fine silk mesh stretched in a printing frame. The areas that are not to print are coated with any water-soluble medium, such as varnish or glue, that will successfully block the ink. The screen is then placed in contact with paper and a

114

specially prepared ink is passed over it with a squeegee, forcing the ink through the unblocked part of the mesh onto the paper. The blocking media are water-soluble so that they can be washed out of the screen, which thus can be reused. Currently, silk screening is very popular, not only because it allows the artist to work with directness, but also because it is relatively simple, not requiring a large, heavy press or extensive plate preparation with acids or chemicals.

Prints have became one of the most popularly collected art forms of modern times, and all the major museums in America have extensive print collections and employ special curators and staffs to care for them. Most practicing artists are able to use one or more of the available processes and often do. Although a rare print by a famous artist would command a higher price than a

Robert Click, "Still Life #1," 1968. A contemporary serigraph. (Courtesy Robert Click, Manhattan Beach, California.)

painting by a less well-known artist, in general prints are less expensive than paintings. The combined attractions of reasonable prices and abundant selection have made prints especially prized by the less affluent beginning collectors.

Changing values and their effects on art

By the end of the nineteenth century "art for art's sake" had developed into an established esthetic position. And along with this development there was a major change in the nature of the art form. The shift in values that produced this change was of such a high magnitude that many people were, and still are, unwilling to accept it. The shift occurred when the primary value of the art form became the perfection of technique or the projection of formalism. The art object was then free to exist as a form in which the *how* was more important than the *what*. Easel painting reached new heights of respectability, for when a painting, or any art form, could exist on its own cognizance, it no longer had to transmit any narrative or symbolic meaning. But because art and the artist no longer produced a form essential for the secularized majority of the urban population, the problems that accompanied the new esthetic values went mainly unheeded except among the artists, scholars, and intellectuals who raised them. Currently there is a further shift in the basic criteria for judging art. This time it is away from skill, technique, and problems of arrangement and toward creativity and the phenomenon known as total involvement. These value shifts must be counted among the pressures that led to the modern artist's interest in the abstract and nonobjective form.

Today the artist can draw on the art of the past as well as on a wider variety of techniques and media than have ever been available to him before. However, availability alone cannot guarantee the creation of art. The form the artist chooses to work in is relatively unimportant, because what he must eventually came to grips with is neither the art of the past nor techniques and media but rather content and value. Without these as the core of an object, even the most skillfully produced form, made of the most valuable or the newest materials, will lack the qualitative factors that alone identify it as art. The element essential to

all the arts, however, regardless of their form or content, is human creativity; that is, art must be created by a sensitive, involved imagination that will be projected by it to excite the imagination of others. It is human imagination and skill that create or re-create the forms we recognize as art; the artist must manipulate his raw materials to produce a meaningful whole that assumes special significance in the hierarchy of man's values. How these values are defined by the artist depends on the framework of cultural values within which he is working, whereas how the object is received depends on the viewers' prior experiences and their ability to use their imaginations and expand their view of reality to give significant meaning to the image perceived.

Line and drawing as aspects of art

Because the formal elements exist for all objects, they become important to the arts only when certain of their qualities, in synergetic intra-action, assume special value in response to the nature and depth of the reaction they elicit. This reaction, which is usually referred to as the esthetic response, is discussed in Chapter One (see pages 4 to 14). In order to discover the factors that grant positive values to certain relationships but not to others, we must examine specific qualities of the formal elements and their relationships. None of the factors that have come to light has proved to be absolute; rather, they all exist as a value set subordinate to the total value system. It is only by considering the formal elements, however, that the factors that tie them to the arts can be understood.

Everything has shape, volume, size, and scale; shows color and texture; and is to some degree perceived by the occurrence of its edge, which we conventionally call *line*. Of these elements, color, texture, line, and shape are more directly related to the two dimensional surface than the three-dimensional form. And of these, color, texture, and shape are essential aspects of all surfaces, whereas line appears either as a construct defining the surface plane or as an element added to it. As a construct including the establishment of contour, structure, and even surface quality, line is a major means of describing form.

The concept of line

Man, throughout his history, has used line as an important element in all systems of graphic communication and art. It is difficult, indeed, to find a time or place in which a concept of line was not evident. Most of our construction is dependent on it, and most of our marking instruments—styluses, brushes, reed pens, quill pens, chalk, and such modern devices as pencils, wax crayons, steel pens, and ballpoint pens—lend themselves to the execution of lines. It is primarily because of line that we can communicate, to other men as well as to ourselves, on all graphic levels.

Certain aspects of line are a major means of communication; we use them to define and describe space and direction, a function that is as vital to our concepts of representational and nonobjective art as it is important to communication. Another aspect of line that makes it a major tool of the artist is its versatility. It can range from fineness and thinness to great breadth and power; it can be precisely definitive or used merely to hint at the form it presents. The only limits of its qualitative aspects are the imagination and creative power of the artist or designer.

Line does not have, as do the other visual elements, an independent existence in nature. At best, what appears as line is the meeting, in an inferred direction or a multidimensional form, of two edges that have linear qualities. According to its geometric definition, line has but one dimension—distance. It is the movement of a point through space, the tracing of a point on a surface. (And a point is a dimensionless position in space indicated by the smallest mark possible.) Also, according to geometric definition, a line can be infinitely extended beyond itself in either direction. Because line is such a well-integrated concept, we tend to use the term to describe all things with linear qualities. We speak of the lines created by the streets, the lines painted on them, and the line of traffic. Although the only quality these "lines" have in common with the concept is direction, this single quality is strong enough to carry the name *line*. We are more correct when we speak of the tide line or the timber line, which has only one dimension—length—extendable in either direction.

In spite of the fact that line, by definition, becomes an almost impossible concept to visualize, it is extremely important in the arts. In this sense, we are not really interested in a geometrically defined line but in what is more properly referred to as a *line segment*, that is, a portion of a line that has a definable length and performs in a given or prescribed manner. A line segment, as it is conceived in relation to the plastic arts, goes beyond its geometric definition and takes on several well-defined jobs. The most important of these and one that does relate to the geometric definition of line is its use as a determinant of direction. Although the meaning of the term includes physical direction, it more generally refers to eye movement from one point to another. And this characteristic is closely related to the determination of *distance*, also a major aspect of line. In this usage, distance can be defined

as being either visual, in which case it is dependent on some known or sensed concept of scale, or measurable. When the direction between two points is reversible and the observer is continually drawn from one to the other and back again, the line is called a *line of visual tension*; it is the quality that can be established between two or more points that maintain an equal ability to attract and hold the observer's attention.

In addition to being able to define both distance and direction, line, in its capacity as a boundary, is capable of defining the edge at which a plane changes direction or the plane or surface on which the line occurs. Although defining the total extent of a plane usually demands more than one line, only one is necessary if the line forms a closed or nearly closed figure. In this case, the figure is an area or shape that is a plane by definition. As a

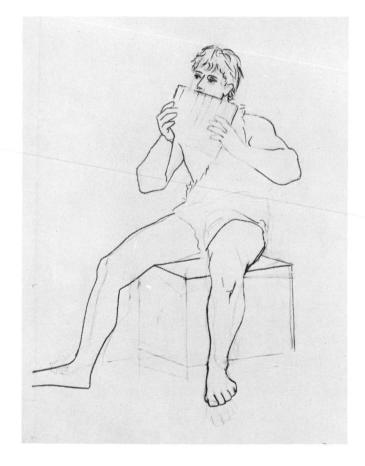

Pablo Picasso, study for "The Pipes of Pan," 1923. A charcoal drawing that demonstrates the use of line to define form. (Courtesy of The Art Institute of Chicago.)

closed boundary or contour, its most frequent form, line has often been used to define a world and all the elements in it.

One final aspect of line, which is only slightly less important than its ability to define form by outline, is its ability to define structure. Line defines structure primarily because it visually indicates the major and minor axes of a form, thus describing the basic growth or evolution of the form. Although establishing these axes is the same as establishing the major and minor directions of a form, the axes are also capable of establishing a form's structure because all extensions of a form are dependent on structure.

Primarily, the meaning of line is directly related to the form it engenders, but another important meaning is its symbolic use, which is often calligraphic in both the East and the West and includes its application for ritual markings and decoration. In this sense, however, the meaning can never extend beyond the meaning of the symbol itself, for if it does, the symbolism is lost; linear quality can be used only to enhance or intensify an existing meaning (see illustration on facing page).

Line and Nonobjective Painting

With the development of nonobjective painting, new meanings for line were sought—meanings that would be divorced from subject matter and thus universally understood. Nature and what were considered to be the laws of the universe provided the grounds for the search, observation and contemplation the means. The result was the establishment of a grammar or syntax of line, according to which specific types of lines were assigned specific meanings and response patterns. Horizontal lines became lines of rest, calm, peace, inertia, and even death; vertical lines were to evoke feelings of dignity, aspiration, stability, action, and growth. Diagonal lines were to suggest unrest, danger, excitement, and imbalance; jagged lines, anger and rapid movement; and undulating lines, slow movement. In this way, each type of line was arbitrarily assigned a meaning in terms of the response it elicited, with varying line types often being assigned similar or overlapping meanings.

The most significant examination of the universal, nonobjective qualities of line was carried out by Wassily Kandinsky (1866–

湘厓雨上晚來空

煙艇泛泛一枝橫

篷撑棹舞荷衣輕

共汝經魚三弄名

Wu Chen, "Fishermen." Detail of calligraphy from a Chinese ink and wash scroll of a river landscape, after a design by Ching Hao. (Courtesy, Smithsonian Institute, Freer Gallery of Art, Washington, D.C.)

1944), one of the originators of nonobjective painting and an early developer of its theoretical base. Kandinsky maintained that line was endowed with qualities of temperature and, in boldface type in his book *Point and Line to Plane,* he wrote, "The Horizontal can be designated as the most concise form of the potentiality for endless cold movement. . . . The vertical line is the most concise form of the potentiality for endless warm movement. . . . The diagonal line is the most concise form of

the potentiality for endless cold-warm movement."[1] Kandinsky also invested line with the qualities of sound, the determination of which depended on the length of the line, its approximation to a well-defined acute or obtuse angle, and its relation to "the conquest of the plane." However, although Kandinsky outwardly insisted on the need for an exact scientific examination of the "pictorial means and purposes of painting," his descriptions clearly define the mystic implication that attended his theory.

Because the non-objective painter reacts intuitively to a superior influence and realization of the universal law, thus enabling him to give his message, this sensitive and prophetic artist of our day has refined his senses to receivership of those invisible, spiritual forces which he intuitively expresses. He then derives with subtle sensibility his visionary inspiration from the spiritual domain which is indestructible and his very own, in the same degree in which he has developed his faculty to receive. Thereafter, his creations develop with a wealth of variation those visions of beauty which controlled by laws of counterpoint, make his artistic message as endlessly alive and original as nature itself.[2]

The Function of Line

Thus the meaning of line is related to either its intrinsic quality, recognized because of the response pattern it evokes or its relation to a "universal law," or its function. To examine the function of line, we have to consider its different uses and, eventually, its quality. Line can have either of two functions: it can present a symbolic, literary, or decorative meaning; or it can be used as a means of expression. In the first of these uses, the various qualitative differences of the lines become less important because the meaning of the work is not dependent on them. This is the type of line most often used to make plans or graphs or writing, where legibility and precision are the mark of success.

This type of line is also the tool employed when success depends primarily on the degree of intellectual imagination or thought contained in the forms described by the lines or on their

[1] Wassily Kandinsky, *Point and Line to Plane*, New York: Solomon R. Guggenheim Foundation for the Museum of Non-Objective Painting, 1947, pp. 58–59.
[2] *Ibid.*, pp. 9–10.

relation to convention. And it is this use that best relates line to decoration. In decoration, with the exception of banding and striping, line is not used primarily for its linear qualities. These are given up in favor of qualities more closely related to the design motif, a defined form that is capable of being repeated or varied in such a manner as to produce a rhythmically cyclic or ordered textural pattern. Line used in this way has appeared in all types of decoration from the earliest times up to and including our own and has been especially prevalent in the area of the crafts, where the utilitarian aspects of an object are often made less obvious by decorative patterns or where the decoration is used to indicate that the object is of special significance. Many of the craft techniques lend themselves easily to the repetition of a linear pattern. For example, weaving is based on parallel lines and groups of threads, embroidery often depends on the stitch as a line, and even carving and imprinting can be quickly and easily accomplished if the decorative form is a relatively simple linear one. It is easy to make lines and the fact that they can be combined in an almost infinite variety of patterns has not been lost on the craftsmen of the world. However, the more sophisticated the craftsman, the more curvilinear and complex his use of line usually becomes.

Ceramic forms by Harrison Mc-Intosh, a contemporary American potter. These forms demonstrate the use of line as a decorative element. (Courtesy, Long Beach Museum of Art, California. Photo, American Craftsmen's Council, New York.)

Mildred Fischer, "Improvisation," 1963. A woven wall hanging by a contemporary American weaver. Made of linen with strips of celanese, it depends on parallel lines and groups of threads for its structural pattern. (Courtesy, American Craftsmen's Council, New York.)

In the second function of line, that is, as a means of expression, the quality of the lines is most important, because any change in their nature will alter the response evoked. This function pertains mainly to line as it appears in drawing or as it is used as a means of expression by the artist. The more sophisticated of our craftsmen, those who see the crafts as a means of personal expression rather than as the creation of utilitarian or decorative forms, also frequently use line in this way. Drawing has only recently been employed as a definitive and total art form and thus has not received the attention as an esthetic form, even from the artists who produced it, that painting has. However, we have come to recognize that drawing can be as significant and expressive as the more traditionally acceptable art forms.

Linear Quality

Line quality has several determinants, the most important of which is the intention or feelings of the artist. Only slightly less important is the tool and medium used and the surface on which the lines appear. (An additional factor, one that is of most interest to graphic designers and illustrators, however, is the manner in which the line is to be reproduced.)

One of the significant determinants of linear quality in ink drawings is the wide choice of drawing instruments now available to the artist and designer. The traditional instruments were pens, originally made of reeds or quills, and brushes. Steel penpoints were not introduced until the end of the eighteenth century; they completely replaced the reed and quill pens by the nineteenth. Steel nibs were manufactured in a number of point styles, each capable of producing a different type of line, ranging from the very fine and delicate to the heavy and forceful. The steel pen-point gave the artist more control and enabled him to extend his drawing over a larger surface. And with the invention of the fountain pen, the artist could have an ink reserve that was part of the pen itself. The newest pens have either felt or nylon tips. Both these forms produce a softer line than the steel point and offer the artist some of the qualities of brushes, not including, however, the possibility for a full line flexibility or the ability to handle washes. The felt-tipped and nylon-tipped pens, originally available only in shades of black, are now produced in a variety of colors. There are also special pens for lettering and calligraphy, which add to the wide choice available to the artist or designer. The brush, perhaps the most flexible of all drawing tools, can produce the widest range of line quality—from a thin hairline to a broad, powerful stroke.

The quality of a pencil line depends on the hardness of the graphite as well as the hardness and texture of the paper. The texture of the paper is also important in ink drawings, as is the quality of the ink, which can range from a thin, transparent ink to one that is dense and opaque. Chalk, charcoal, metal points, wax, and clay have all been used for drawing in line, each creating its unique set of qualitative differences.

Top: Paul Klee, "The Great Dome," 1927. A pen and ink drawing exhibiting an expressive line that is dependent on the artist's feeling. (Courtesy, Kunstmuseum, Bern.)

Bottom: H. B. Lehman, pen and ink drawing (flourishing). The drawings of Lehman, a nineteenth-century American penman, were based on a precise means of stylization. (From C. P. Zaner, Gems of Flourishing, 1888.)

By H. B. Lehman.

Edgar Degas, a black-chalk study for a portrait of Édouard Manet. (Courtesy, The Metropolitan Museum of Art, New York, Rogers Fund, 1918).

Kano Tanyu, "Ducks and Reeds." A brush and ink drawing from the seventeenth century which takes full advantage of the wash qualities of Chinese ink. (Courtesy, The Metropolitan Museum of Art, New York. Gift in memory of Charles Stewart Smith, 1914.)

The history of line

Prehistoric Use of Line

Line is one of the most important devices developed in man's effort to communicate on functional and expressive levels. The so-called macaroni lines—marks scratched in what was a relatively soft surface—are one of the earliest records of man's use of this device. These lines are important because they represent an early attempt at organization, which is an essential factor in the arts. Other early records appear as incised marks or imprints on rocks or cave walls.

The so-called macaroni lines, the earliest known example of drawn lines. (Courtesy, Bollingen Foundation. Photo, Achilles Weider, Zurich.)

It has been fairly well established that man's first use of line was either ritualistic or symbolic, rather than naturalistic, because the use of line to represent natural form is a construct of a relatively high order of sophistication. The fact that three-dimensional form can record the appearance of an object whereas linear form can record only the appearance of the image of an object is the important distinction. It means that the man who wants to draw a chair, if his drawing is to look natural, cannot draw what he knows about the chair; instead, he must draw what the chair *appears* to look like, even though this may defy his sense of reality or logic. Also implied in this distinction is the fact that the visual representation of form, by line or any other means, cannot exist without being related to a spatial concept, which represents a high order of intellectual abstraction.

This does not mean that primeval man did not make use of representational outline, for we know that he did; it does mean that the use of outline in this manner indicates a high stage in his development. The early outlines represent man's efforts to establish the formal and psychic content of the animal and human forms with which he was forced to contend. The way in which the use of outline developed is not clear, nor is there any indication of the time sequence that attended its development. It is believed, however, that the use of outline evolved as the result of man's regarding the world as an inseparable whole—one that made no distinction between man and animal or animal and rock, e.g., an animal's form and spirit could reside in a rock formation as well as in a living creature. Accepting this as an essential core of man's belief, it is easy to see how he could have recognized animal and human spirit forms within the scope of the natural elements. Giedion indicates how early man saw a bison in a rock formation at La Mouthe (Dordogne). ". . . where the whole outline of the back, and to a certain extent even the head had been formed by the natural rock; and in the bison of the cavern of El Castillo (Santander), where major parts of the body had been seen in a stalactite and only a few lines were necessary to bring out the image." [3]

[3] Sigfried Giedion, *The Eternal Present*, vol. 1, *The Beginnings of Art*, Princeton, N.J.: Princeton University Press, 1962, p. 370.

Bison from the cavern of El Castillo, c. 15,000–10,000 B.C.E. The artist's sketch (left) demonstrates Paleolithic man's ability to see forms of animals in natural rock formations (above). (Photo, Achilles Weider, Zurich.)

To some extent man still exhibits this same type of imagination. If we can see animal and human forms in rock formations or cloud formations, it should not be considered strange that primeval man was also able to do this. The only difference is that he took it more seriously than we do. He ascribed its occurrence to the nature of his world and saw no difference between the physical and spiritual; we ascribe it to our imaginations.

Plate 1. Claes Oldenburg, "Hamburger with Pickle and Tomato Attached," 1963. An example of a three-dimensional image that portrays imagery at one time reserved for the painter. (Collection, Carroll Janis, New York.)

Plate 2. Vasa, "Blue in the Middle," 1966. Contemporary sculpture whose esthetic quality is based on color relationships extended three dimensionally. (Collection of the artist. Courtesy, Los Angeles County Museum of Art.)

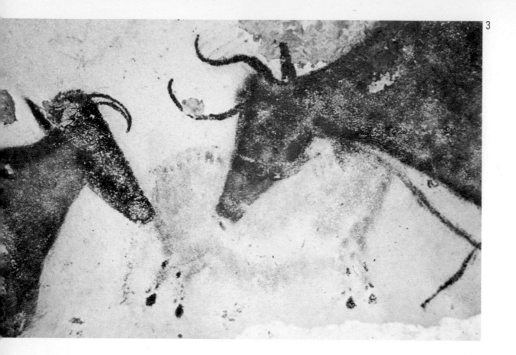

Plate 3. "Cows on the Ceiling." Images painted by Paleolithic artists are believed to have been part of their ritual magic. (Photo, Three Lions, Inc., New York.)

Plate 4. Gentile da Fabriano, "The Adoration of the Magi," 1423. This exceptionally large tempera panel has been enriched by the full use of gold leaf. (Photo, Scala, Florence.)

4

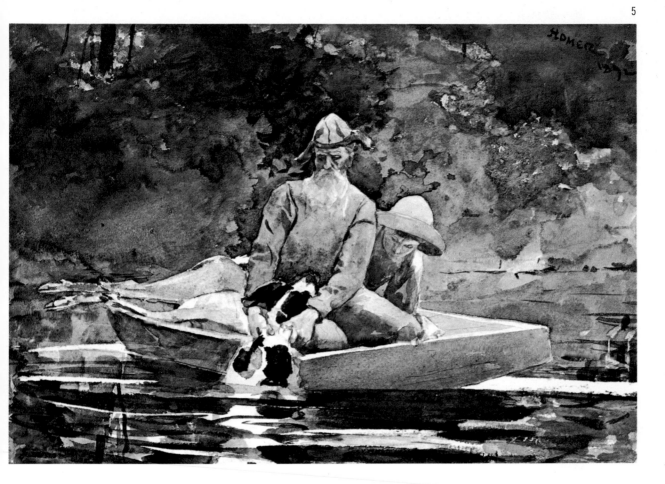

Plate 5. Winslow Homer, "After the Hunt," 1892. A fine example of rich, wet, transparent watercolor. (Courtesy, Los Angeles County Museum of Art. The Paul Rodman Mabury Collection.)

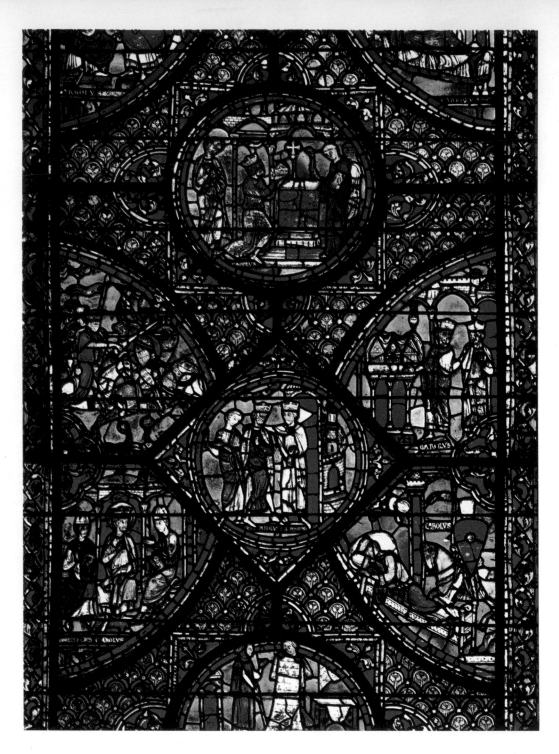

Plate 6. "History of Charlemagne." Central window, Chartres Cathedral.
(Photo, Giraudon, Paris.)

7

Plate 7. "Shoemaker's Shop." Greek amphora (vase) decorated in the black-figure style. (Courtesy, Museum of Fine Arts, Boston. H. L. Pierce Fund.)

Plate 8. "Herakles, Nessos, and Deianeira." A painting in the red-figure style on an Attic kylix (drinking cup). (Courtesy, Museum of Fine Arts, Boston. H. L. Pierce Fund.)

Plate 9. "Woman Playing Lyre." Greek lecythus (vase) decorated in the white-ground style. (Courtesy, Musée du Louvre. Photo, Giraudon, Paris.)

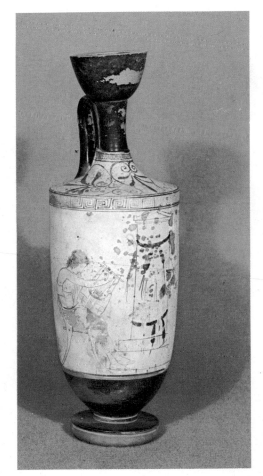

8

9

Plate 10. Raphael, "The Three Graces," c. 1516-1517. A study for a group in the "Wedding Feast of Cupid and Psyche." Drawn in red chalk. (Reproduced by gracious permission of Her Majesty Queen Elizabeth II.)

10

Plate 11. Edgar Degas, "The Tub," 1886. Executed in pastels. (Courtesy Musée du Louvre, Cliché des Musées Nationaux.)

Plate 12. Giovanni Battista Tiepolo, "Two Magicians and a Youth." Brown-ink drawing on white paper. (Courtesy, The Metropolitan Museum of Art, New York. Rogers Fund, 1937.)

The Ancient World

Drawing is the most basic of all skills demanded by the arts, not only in its capacity as an independent form capable of precipitating the esthetic response, but also as the major means of producing preliminary visualizations of large and complex projects. In addition, drawings are an essential element of all designed objects that are produced by someone other than the artist or designer. This category includes architecture, all industrially produced forms, and, to some extent, many of the hand-crafted forms produced in our modern technology.

In the ancient world, where no distinction was made between drawing and painting, line was an equal part of both forms in a manner that was not to reappear until the development of modern esthetics. The Greeks and Romans conceived of drawing and painting as a single form, attested to by the fact that in Greek and Latin, a single word is used to designate both forms. The Chinese and Japanese pictorial arts also considered drawing and painting to be one. The distinction we make between these forms seems based on the surface conformation of the pictorial image—painting depending more on the manipulation of surface, and drawing, more on the delineation of form. Because of this distinction, line is more closely associated with drawing than painting, despite the fact that there are many significant drawings that depend completely on tonality and many paintings that rely on line.

In Egypt, where drawing and painting also existed to perform but a single function, the two forms were produced with the same tools (brushes and, later, pens), the same materials (a limited palette of water-soluble colors), and the same support (generally the stuccoed wall or a papyrus sheet, occasionally leather or linen cloth). Both forms were used as only a part of a larger purpose, which was concerned more with the transmission of information than with what we consider factors of esthetic viability. Regardless of the form, the main purpose of most of the Egyptian graphic arts, as we know them, was directly related to helping the soul of the deceased into the next world. It is interesting to note that in the more elaborate tombs of the affluent, polychromed bas reliefs were used to perform the same function as the paintings in the lesser tombs. Egyptian painting depended primarily on outlining

"Triumphant Hunter," Eighteenth Dynasty, c. 1580–1350 B.C.E. An example of Egyptian tomb painting that shows careful observation and a lyric, naturalistic drawing style.

and filling in, a technique that led to some fine delineation and careful drawing.

The Greeks, whose drawing and painting techniques and forms can be related to those of the Egyptians, produced what is generally considered the most significant and sophisticated drawing of the ancient world. Their drawings appeared as narrative elements on most of their pottery and provide us with a comprehensive catalog of Greek activities. Drawn with sensitive line, either

134

incised or by masterful brush work, the drawings usually related to the limiting pottery shapes on which they appeared; however, they often attained the monumentality more generally associated with Greek architecture or sculpture. The qualities of Greek drawing were projected consistently regardless of the style used: in the black-figure style, delineation was attained by incising light lines within the dark silhouetted figures; in the red-figure style, the figure occurs against a dark ground, with texture and form delineated by dark brush lines drawn within the light silhouette; in the white-ground style, which enabled releasing the figures from the grip of the background, a greater freedom and delicacy than had been attainable with the earlier forms was possible (see Plates 7 to 9).

The Middle Ages

During the Middle Ages, drawing was restricted, as far as we know, to the copy books, manuscript illuminations, and marginal drawings that appeared in paged manuscripts and scrolls. Drawing was not considered to be an independent art form; it was, rather, the means of maintaining traditional forms and passing them on.

"Figures and Decorative Elements." Medieval pen and ink drawings on vellum. (Courtesy, Janos Scholz, New York.)

European drawings of the Middle Ages can best be considered as a craft form within the monastic tradition of the period. Later, it was expanded to the form of the diminutive and often brilliant and elaborate miniature paintings and decorations that appear in luxurious religious manuscripts (see illustration on facing page).

The drawings that have survived were executed with water-soluble pigments on vellum; although, according to Chinese records, paper had been invented in China by Tsai Lun in 105 C.E., the techniques of its manufacture were not known in the Middle East until the eighth century and not introduced into Europe until the twelfth century, when the Moors established paper mills in Spain.

However, although drawing in Western Europe prior to the Renaissance was mainly used for preliminary sketches or artists' notes and although the advent of paper and chalk did not cause these uses to disappear, drawing began to emerge at this time as an independent art form capable of sustaining its own esthetic response. A significant part of this new independence was the result of the recognition of the art as the graphic form closest to the conceptual moment in the creative act. Lorenzo Ghiberti (1378–1455), writing in his *I Commentari*, stated that drawing was the source of the generative reasoning behind painting. Thus, he helped establish the distinction between working drawings and those created to evoke an esthetic response. This dichotomy continues to our own day, with overtones of the nineteenth-century concept that held esthetic drawing to be the type that had as its primary purpose the development of "a pleasure in which there are the most various degrees of dignity and nobleness, a pleasure which may elevate and strengthen our nature, or corrupt it like a vicious indulgence." [4]

Working drawings are seldom prized for their sensitivity or other esthetic qualities. However, those of our more famous designers and architects, from Leonardo da Vinci to Louis Sullivan and Frank Lloyd Wright, are regarded as images of esthetic worth and as examples of creativity in their own right. The high regard for these drawings is, of course, supported by their degree of rarity, the fame of their creators, and their historic significance.

[4] Philip Gilbert Hamerton, *The Graphic Arts*, Boston: Little, Brown and Company, 1902, p. 23.

Right: The Limbourg brothers, "Octobre," from the book Les Très Riches Heures du Duc de Berri, c. 1413–1416. Illustration of the month of October in a book of hours contains a group of prayers, a calendar, psalms, and devotional lessons. (Photo, Bulloz-Art Reference Bureau.)

Far right: Louis Sullivan, a drawing for an architectural ornament taken from the architect's book A System of Architectural Drawing, 1922. (Courtesy, American Institute of Architects.)

Drawing media

Chalk

By the fifteenth century, paper mills had been established in Europe to meet the demands created by the increase in printing that resulted from the development of movable type. It was the availability of paper and the use in Italy, at about the same time,

of the black chalk often referred to as Italian or black stone that brought about the birth of drawings as we know it today. The chalk, a soft natural carboniferous slate that could be cut into strips, gave to drawing a freedom and tempo that was not easily attained with the more traditional pen and ink or metal points. In addition to black chalk, red chalk (originally, *hematite*), rang-

Luca Signorelli, "Satyrs and Nymphs," c. 1415–1420. Drawn in black chalk. (Photo, Alinari-Art Reference Bureau.)

ing in color from a violet red to an orange red and often referred to by its French name, *sanguine*, became popular in the sixteenth century. White chalk (*steatite* or *gypsum*) was used either to highlight black- or red-chalk drawings or to prepare the tinted grounds on which the drawings often appeared.

The chalk drawings, which continued to be created as preliminary studies as well as definitive art objects, played a significant role in the developing awareness of the human form that characterized the Renaissance. Drawing from models, Andrea Mantegna (1431–1506), Raphael, and Michelangelo Buonarroti reached a new and imposing naturalness in their work (see Plate 10). The tradition of the full chalk drawing, which was developed at this time, was carried into the seventeenth century in Flanders by Peter Paul Rubens and into the eighteenth century in France by Jean Antoine Watteau (1684–1721) and François Boucher (1703–1770). During the Renaissance and even later, many of the drawings were reinforced and strengthened by water colors or inks used in conjunction with the chalk.

Pastels

The final development of chalk drawings were pastel drawings—or paintings, as they are more correctly called (see Plate 11). Pastels, which became, in the eighteenth century, a major medium for portraiture, are available in soft, medium, and hard grades; they are made of dry pigment and filler, usually precipitated chalk, held together with a gum binder. Because dry pastels cannot be mixed as can wet media, the artist must resort to blending. To compensate for this limitation, pastels are available in a wide range of shades, which, like chalk, are best applied to a toothed surface than can grip and hold the color. When a drawing is finished, only the lightest and clearest fixative can be applied without changing either the color or the soft texture that is so characteristic of the medium. Many artists prefer to use no fixative, choosing, rather, to place their pastel drawings behind glass, leaving enough space between the pastel surface and the glass so the pigment will be neither brushed off nor rubbed away. Although quite fragile, pastel drawings will maintain their full brilliance and freshness if they are handled carefully and protected.

Charcoal

Prior to the beginning of the sixteenth century, when the first serviceable fixatives were developed, charcoal, one of the most ancient of the drawing media, was suitable only for preliminary drawings and sketches. This restriction resulted from the fact that charcoal, although capable of adhering to all but the smoothest surfaces, is easily smudged or rubbed off. Originally, the highest quality artists' charcoals were made by burning grapevine roots; thus, they are often still referred to as "vine charcoals," even though currently they are more usually prepared from sticks of willow or other easily obtained close-grained wood. Charcoal sticks are available in a range of hardness from the very soft, which produces the darkest, most velvety surface, to the hard, which produces the lightest, grayest quality. Compressed charcoal, which is made from ground charcoal plus a binder, produces a much blacker mark than natural charcoal. It does not erase as easily as charcoal, handles like black chalk, and produces drawings similar in texture to those made with black chalk. Much of the current esthetic response to charcoal drawings is determined by the directness or boldness with which the charcoal is used, skill in manipulating the medium being the primary consideration.

Metals

Along with the chalk and ink drawings of the Renaissance and before the development of graphite as a drawing medium, artists used thin rods of metal, primarily lead and silver, sharpened into points and held in a stylus. When drawn over a prepared surface, small quantities of the metal would be deposited, which, after exposure, would oxidize and produce a visible mark or line. The color quality varied according to the metal used. During the Renaissance, silver was the most popular metal for drawing; lead, also used for drawing, was used more extensively for writing and bookkeeping. The ground, a fine abrasive surface, was obtained by covering either paper or parchment with a flat coat of finely powdered bone size. Often the ground was tinted and the drawing highlighted with white tempera. The metallic point produces a thin, even line that cannot be erased; it demands a deliberate

Pierre Paul Prud'hon, "Head of a Woman" (Marguerite). Drawn in charcoal. (Courtesy of The Art Institute of Chicago.)

technique that offers the artist none of the freedom or spontaneity of the softer modern lead (graphite) pencils. Fine line, careful detailing, and subtle values built up by the use of parallel or crosshatched lines are characteristic of the many silver-point drawings that have survived from the late Middle Ages and Renaissance.

141

Rogier van der Weyden, "St. Mary Magdalene." Silver-point drawing on prepared paper. (Courtesy, The British Museum, London.)

Although many of the artists who produced these drawings in the Middle Ages are unknown, we do know that during the Renaissance, the technique was used by such masters as Pisanello (1395–1455), Jacopo Bellini (c. 1400–1470), Raphael, and the great German draftsman, Albrecht Dürer (1471–1528). Few modern

artists, however, make use of the medium, preferring the less demanding, more direct, and easier handled graphite pencil.

Originally, the term *pencil* referred to a small, finely pointed brush used by painters to draw fine lines. And, although Cennino Cennini (c. 1370–1420) described, in the late fourteenth century, the practice of using lead held in a stylus and the technique continued to be used during the fifteenth and sixteenth centuries for making preliminary drawings, the graphite pencil apparently was not produced much before the beginning of the seventeenth century. The first pencils were of natural graphite (plumbago), either encased in wood or held in a *porte-crayon*. Attempts at making pencils of ground graphite combined with various binders and adhesives took place throughout the middle of the eighteenth century, but the production and general distribution of the pencil as we know it did not occur until 1795. The process was developed by N. J. Conte (1755–1805), whose methods are still the basis of modern pencil manufacture.

Conte's manufacturing techniques included the combining and baking of finely ground graphite with equally fine viscous clay. It is this process that makes possible the wide range of pencil hardness; graphite pencils range from the very soft, smudgy 6B to the extremely hard, needlelike 9H. Because graphite is also available in the form of graphite sticks, drawings can vary considerably from the exclusively linear to those that depend entirely on tone. The range of line quality possible is almost unlimited—from the fine, delicate controlled line of Amedeo Modigliani (1884–1920) to the freely drawn, loose line of George Grosz (b. 1893); from the delicately delineated tonality of Jean Auguste Dominique Ingres to the bold tones of Jean Baptiste Camille Corot (1796–1875). (Compare the illustrations on pages 144–145.)

Although not as old as either chalk or charcoal, ink, the artist's primary fluid drawing medium, is one of the more ancient materials still in use. Carbon inks were used in Egypt and China well

Left: Amedeo Modigliani, "Portrait of Madame Zborowska." Drawn in pencil. (Courtesy, Museum of Art, Rhode Island School of Design.)

Upper right: George Grosz, "Portrait of Anna Peter," 1926–1927. Drawn in pencil. (Collection, The Museum of Modern Art, New York. Gift of Paul J. Sachs.)

Lower right: Jean Baptiste Camille Corot, "Henry Leroy as a Child." Drawn in pencil. (Courtesy of the Fogg Art Museum, Harvard University. Bequest of Meta and Paul J. Sachs.)

Far right: Jean Auguste Dominique Ingres, "Portrait of Madame Armande Destouches." Drawn in pencil. (Courtesy, Musée du Louvre, Cliché des Musée Nationaux.)

before the Christian era. A wide range of qualities can be achieved with inks, but the results depend more on the tools and techniques with which the inks are applied and the surfaces to which they are applied than on the inks themselves. We in the West acknowl-

edge our debt to the Far East for our black inks; most of them
are known as either Chinese or India inks. Chinese ink is usually
in the form of a solid cake that has to be dissolved before it is
ready for use; India ink is usually in liquid form. Both are soluble

145

Above: Wu Chen, "Fishermen," c. 1300. A section of a handscroll drawn with ink, which makes full use of the ink's transparent qualities. (Courtesy, Smithsonian Institution, Freer Gallery of Art, Washington, D.C.)

Left: Leonard Baskin, "Head of a Poet," drawn with India ink. The effect of this drawing depends on the full contrast of ink and ground. (Courtesy, The Brooklyn Museum.)

in water and produce a rich, intense black tone that can be diluted to produce a wide range of gray washes. The quality of these inks depends on the purity and particle size of the carbonaceous material (lamp black) used in their manufacture. The best cakes of Chinese ink are highly prized, and there are records in China indicating that especially fine ink sticks have been handed down from father to son and from master to pupil. Most of the

India inks in use today contain adulterants, each guaranteed to enhance one or more of the inks' qualities—but usually at the expense of qualities not mentioned. Thus a dark, opaque black may not flow well or be permanent, whereas one that flows freely and does not clog the pen may not be opaque or permanent. In the Orient, ink drawing was executed on silk and paper in both panel and scroll form. Often these drawings achieved forms that could be judged only as paintings; even though they were monochromatic, the full range of tonal and textural changes they exhibited and their lack of linear qualities related them more closely to painting than to drawing.

Two other inks that have been used extensively by artists in the West are bistre and sepia. Bistre, the gray-brown ink popular during the Renaissance, was made from the soot obtained by burning certain resinous woods. Because of the high tar content of the soot, it was possible to manufacture the ink without adding a binder; in many cases, however, binders were used to stabilize the ink. Used for both pen and brush work, bistre ranged in color from a yellow to a red-gray brown. Sepia reached its peak of popularity during the eighteenth century. It was made from the dried ink sacs of the cuttlefish or squid and was a strong, semitransparent, dark, rich brown. Although artists used sepia for both line and wash drawings, it was especially useful for wash drawings because of the extremely fine size of its particles and its great solubility. It is extremely difficult to determine whether a drawing was made with bistre or sepia. Therefore, current museum practice is to identify both types as brown-ink drawings unless there is recorded information about the ink used (see Plate 12).

In the nineteenth century, the popular use of sepia gave way to the use of India ink; today, neither natural sepia nor bistre are readily available, having been replaced by the aniline dyes. These modern chemical dyes, available in the full range of colors, along with India ink, now constitute the most popular forms of drawing inks.

Color, its theory and use

Of all the visual elements of art, the most extensively studied is color. There have been more theories about the nature of color, and it has been the basis for more design classes than has any other element. In addition, a wider range of professional investigators—physicists, physiologists, anthropologists, ophthalmologists, etc.—has been interested in color than in any other element. And still, the artist's use of this element remains one of the most subjective aspects of his work. Although studying color in relation to technology and the sciences offers little understanding of its nature in relation to the arts, this type of examination does offer the student a chance to think about color and its many ramifications and is practically the only way to gain any understanding of it or insight into its use.

Color exists in almost all places and at almost all times; it is a constant factor in our natural as well as our man-made environment. Even on the darkest nights and in the darkest places, if we allow our eyes to adjust to the dark and look carefully, we are often able to distinguish some color. When light was introduced into the deepest reaches of the ocean, where no natural light has ever penetrated, it was discovered that sea life was brilliantly colored. The most transparent materials, such as glass or crystal, are judged to be more or less blue-white or more or less yellow-white. A surface that is highly reflective—such as a mirror, polished chrome, or a clear pool of water—takes on, in addition to its own color, usually seen as a blue-silver, all the color that is reflected by it.

The fact that color is always around us does not mean that everything is always brilliantly colored. It should be noted that even the subtle gray that pervades a dull, foggy day is a color—one that has not only a unique set of characteristics but also the ability to affect all other colors with which it comes in contact. Very often we are not perceptive enough or trained well enough to see color. The stretches of sand that make up much of our deserts and coastlands at first appear dull and monochromatic; but when sand is carefully examined, it is seen to be composed of brilliantly multicolored particles. Thus, color is one of the basic

conditions under which we live, being a part of all visual phenomena and all materials, and, as such, is one of the primary elements of the visual arts.

Because of the nature of materials, a designer or craftsman cannot avoid either contact with color or a consideration of it. To be sure, his choice of material may limit or even renounce a color choice, but this decision must be made with full knowledge of the restriction and how to circumvent it if the artist wishes to. Painting is the one art form that is completely bound to the use of color for its visual and surface qualities. Even a painter who chooses to work with only black and white, as several have, or with just black or white, as a few have, should be making a conscious choice in relation to color. Unless a surface is changed by some use of pigment or in some way so that a color quality can be identified with it, the work will not be a painting according to our usual definition of the form.

An esthetic response may be evoked by any degree of involvement with color—from the point where color is the center of the esthetic involvement to that where it is of no importance. A craftsman may choose a piece of wood, a stone, or a ceramic body because he feels that only by using the color quality of the specific material can he achieve his desired effect; or, he may have no concern for the intrinsic color because it is his intention to dye or paint the finished form. Indeed, a craftsman may apply color in such a way as to produce a visual surface that is the complete opposite of the one with which he began. This is possible with any material—even changing a white surface to polychrome or black is within the range of the artist's capability.

The study of color involves three distinct aspects: the physical, which includes the physics of light and the chemistry of pigments; the physiopsychological, which includes the nature of vision as it relates to the structure of the eye and the psychological aspects of perception; and the psychocultural, which concerns the physical and emotional responses to color as well as the cultural and learned responses. Although designers, artists, and craftsmen need not understand the physics, chemistry, or physiology of color vision as do specialists in these fields, it is important that they have some basic understanding of color and color phenomena. Too often the attention and energy of creative people who lack this understanding have been directed to the production of large-scale color

images that are merely examples of optical color illusions that have previously been described and are well known and understood. It is true that these may act as a form of exercise for the artist and observer, but the mature artist who simply reproduces large, colorful optical illusions is far from engaging in the most fruitful artistic activity. The production of these images more properly belongs in the realm of the student's classroom, the psychologist's laboratory, or the designer's studio, where they should be discovered early enough so they can become tools for later creative activity. Although the chromatic optical illusion, projected and rendered on a large canvas, has a certain decorative effect, any significant esthetic response to it generally must be based on a personal or esoterically mystic symbolism.

Because art is concerned with the creation of form, of which color is an integral part, it is necessary that the artist know how to manipulate color to achieve the qualities that are the core of his original intention. Failure to understand the mechanics or symbolic value of color can be responsible for the artist's failure to achieve his desired results.

The "language" of color

Before one can begin to understand any aspect of color, its terminology, in which most of the words relate to qualitative aspects, must be learned. In some cases, more than one term is used to describe a single quality or color property, but it is important to know them all, because in the literature and, quite frequently, in the classroom, the different terms will all be used.

The Primary Properties

In order to specify or accurately describe a color, three of its characteristics—called the *primary properties*—must be known. Without this knowledge, one could only vaguely place the color in a primary- or secondary-color classification. The primary properties are *hue, lightness,* and *saturation*; aside from a relatively few basic hues, colors are described as having a more or less specific color quality (hue), being lighter or darker (lightness), and duller or brighter (saturation). For the most part, these properties are

relative qualities that can be judged only as points on a known value scale. Lightness can be judged as an absolute value only when it is photomechanically measured according to an absolute scale ranging from the complete absence of light to a condition of total light; and the degree of saturation present in any given color sample is *always* relative.[1] At this point it is important to note that although, in terms of light, black is considered to be the complete absence of color, and white, the presence of all color, in terms of visual description or pigment, black and white become single colors. The term *achromatic color* is used to refer to white, black, and gray, and all other colors are referred to as *chromatic* (see Plate 13A).

HUE. Hue is a generic term that indicates a general color classification such as red, blue, or brown. It is a color's "family" name, signifying that certain color qualities are shared by all colors that fall within the range of the given hue. Generally, though not always, the major characteristic involved is a specific location within the full spectrum.

Using blue as an example of a typical hue, one can see that there are literally hundreds of color variations that belong to the blue family. Primarily, they are classified as blues because they share a certain hue quality and fall within defined spectral limits (see Plate 14). But the colors can vary in their degree of lightness, brightness, and temperature and in their proximity to violet or green. They can also vary in their chemical composition and physical properties; that is, a single color—one having a single location on the spectrum—can often, as a pigment, be made from a variety of materials. However, the term *hue*, although referring primarily to a generic color classification, has also come to refer to a single color marked by a point on the spectrograph; a color name accepted because of common association and use but not appearing on the spectrum; a color limited or qualified by commonly used adjectives; or a color with a fancy, one-season fashion name.

The mineral or chemical composition of a color does not always indicate its specific color quality, regardless of whether

[1] Ralph Evans, *An Introduction to Color*, New York: John Wiley & Sons, Inc., 1948, p. 101.

the pigment is mined or chemically compounded. For example, chemically compounded ultramarines will range from those that exhibit a greenish quality to those that show a reddish cast. The range of hue difference in colors made from impure minerals shows an even wider range—iron ores produce yellows, oranges, reds, browns, blacks, and greens, plus hundreds of variants of each.

Since the discovery of aniline dyes, most colors that were originally manufactured from either mineral ores or natural dyes are produced synthetically. Cobalt, originally made by heating and grinding cobalt oxide, was one of the last of the mineral colors to be synthetically compounded; it now appears on the market as Cobalt Tint or Cobalt Color. Cerulean blue, originally made of cobalt and tin oxide, is also now primarily a synthetic color. Indigo, originally an organic dye, is usually associated with eighteenth-century trade articles and colonial America; it is now produced artificially. Turquoise and other aquamarine blues, once obtainable only by grinding various forms of copper oxide (including turquoise gem stones), can now be made much more cheaply and easily as synthetically compounded dyes.

Classifying a color by the material of which it is, or was, composed is only one form of color identification. The most frequent form of identification is a common or popular name. However, this method is often the least adequate, because in the English language, there are fewer than thirty words whose major function is to designate a specific color. These include auburn, azure, brown, black, blue, cerise, crimson, cyan, dun, ecru, gray, green, indigo, khaki, maroon, mauve, puce, purple, red, russet, scarlet, sepia, taupe, ultramarine, white, and yellow—they are all defined in the dictionary as either a specific location on the spectrum or with the phrase "as having the color of" or "being the color of" followed by the names of objects bearing the color. A typical color definition of this type in *Webster's Third New International Dictionary* is that for green: "a. of the color green ~ jade b. having the color of growing fresh grass or of the emerald." [2] For a less common color, the definition includes more modifiers: "puce . . . a dark red that is yellower and less strong than cranberry, paler and slightly yellower than average garnet, bluer, less strong, and

[2] *Webster's Third New International Dictionary of the English Language*, Springfield, Mass.: G. & C. Merriam Company, 1961, p. 996.

slightly lighter than pomegranate, and bluer and paler than average wine—called also *eureka red, flea, Victoria lake.*" [3]

There are also colors that are named after specific objects—animals, vegetables, or minerals; their names, having been in use for a long time, have come to be regarded, when used in the proper context, primarily as colors. Within this group are such names as beige, buff, lavender, lilac, orange, pink, sienna, umber, rust, turquoise, silver, gold, emerald, sapphire, and fawn. And some of these names have lost their original meaning and now stand for the color alone. However, even with this list, the number of color names remains fairly small. Therefore, we use a variety of linguistic devices to extend it.

1. Combining names for a single color that has two hue qualities, e.g., yellow-green, blue-violet, yellow-orange
2. Limiting names by the use of a modifier denoting lightness, e.g., dark blue, dark red, light red, light blue, light green
3. Limiting names by the use of a modifier referring to the degree of color saturation, e.g., dull red, bright red, dull green, bright green
4. Adding the suffix *ish*, e.g., yellowish, greenish, reddish
5. Using such descriptive adjectives as mellow, harsh, garish, or subtle

Because there are as yet no "standard" colors, a color not only may vary, as has been noted, but may be known by several different names. This ambiguity is most frequently seen in home-decorating and the fashion industries. In fairness, however, it should be pointed out that fanciful color names are much more suggestive and romantic than a standardized nomenclature would be. Burnt orange, mist blue, apricot ice, sea-froth green, heavenly lilac, and and aphrodisia red are alluring, evocative, and more appealing than spectral numbers or more plebeian names.

LIGHTNESS. Lightness is the primary property of color that denotes the amount of light a color reflects to the observer. It is usually measured against an achromatic scale in which a number of swatches ranging from black to white are arranged in a progressive order. *Value* is the term commonly used to describe a specific point on this scale. Dr. Albert Munsell (1858–1918) introduced the term early in the twentieth century, and when one uses it to

[3] *Ibid.*, p. 1837.

describe the lightness of a color, he is usually referring to the Munsell value progression. (See Plate 13B.)

A few colors, such as yellow or beige, are characteristically light; some colors, such as orange, range from a middle value to light; but most colors, unless they have been deliberately lightened, seem to range from a middle value to dark. Red, blue, green, and violet fall into this category, although they can all be made light by the addition of white. When this is done, the resultant mixture is traditionally referred to as a *tint*. When black is added to a color, there is a greater tendency for the color to dull than to darken; the resultant mixture is referred to as a *shade*. The advantage of using *tint* and *shade* to refer to the addition of white and black, respectively, is that these terms help define colors more accurately than would be possible if this distinction were ignored.

SATURATION. Saturation concerns the proportion of pure hue present in a color; it refers to the purity or contamination of a color or the degree of dullness the color exhibits. Saturation is the degree to which a chromatic color sensation differs from an achromatic color sensation of the same brightness.

Each tube or jar of paint that is produced has a definable saturation. Some paints contain more filler or are prepared with a less pure pigment. The intensity of a pigment cannot be increased beyond its basic saturation, for to do this, one would have to add a purer color or use a different basic pigment. In working with saturation, the general direction is down—decreasing the saturation of the original color. The amount of saturation in a color is often referred to as its *intensity*, or *chroma* (the term popularized by Munsell). Sometimes a color can be made more brilliant if white is added, but the result is most often more a change of value than of saturation. (See Plate 13B.)

Hue, lightness, and intensity exist in all colors and provide the clues by which colors may be matched. Also, they are so interrelated that a change in one means the others will also change. To darken or lighten a color usually indicates a chroma change, and to change hue usually indicates a value and/or chroma change.

A color is usually made less intense (duller) by mixing it with either its complement or black. Complementary colors are those that lie opposite each other on a standard, equidistant red-yellow-and-blue color wheel or those pairs in which each member is most

unlike the other. Some people maintain that only a color's complement should be used as its dulling agent, because they feel black has a tendency to deaden colors. This argument seems to have reference to the fact that when a complement is used, the resultant color has a subtle suggestion, missing when black is used, of the original color's opposite. Thus the color has a wider affinity for other colors, a quality that increases its value to the painter and consequently makes the color more pleasing. However, before *complementary* can be adequately defined, other basic terms must be explained.

<div align="center">

Primary, Secondary, and Tertiary Colors

</div>

When speaking of *primary colors*, it is necessary to distinguish between those that are primary in terms of light and those that are primary in terms of pigment. Red, green, and blue are the primary colors in terms of light. In this sense, *primary* indicates that these three hues are those from which the greatest number of other colors of light can be mixed and that the result of combining these three is white light, i.e., the presence of all colors. Psychologically, however, the primaries are red, green, blue, and yellow, which, when added together as light, also produce white. In terms of pigments or paints, the primary colors are red, yellow, and blue, the pigments from which the greatest number of other colors can be mixed. In printing, which uses pigments in the form of printing inks, the primary colors are four—magenta, cyanamid blue, lemon yellow, and black. These are mixed optically by the observer rather than on the printed page.

In order to get the broadest possible color range of paints, the primary colors have to be broken down into double units—two reds, two blues, and two yellows—because the pigments that are available to us do not match the purity of the spectral colors. For example, a brilliant orange can be obtained by mixing a yellow that has a positive red factor with a red that has a positive yellow factor. However, if either the red or the yellow contains a positive blue factor, the resultant mixture will be a dull orange. Dullness can also result when yellows and blues are mixed to produce greens and when reds and blues are mixed to produce purples and violets. The brilliance or lack of brilliance of the mixtures depends on the presence or absence of factors of the third primary;

because the third primary is complementary to any mixture of the other two, it acts as a dulling agent. (For a fuller explanation see the discussion on complementary colors, page 158.) Thus, in order to have the colors necessary for mixing a full set of secondary colors of maximum brilliance, two sets of "primary" colors are required. It therefore seems better to refer to the double set of colors as basic rather than primary.

The secondary colors theoretically are produced by mixing pairs of basic colors in equivalent proportions. *Equivalent* is used here to indicate that unequal proportions have to be used to obtain a secondary color of maximum intensity and one that is visually equidistant from the original pair. The secondary colors are (1) orange, mixed from red and yellow, (2) green, mixed from yellow and blue, and (3) violet, mixed from blue and red. Normally, the minimal full palette of the modern artist and designer contains red, orange, yellow, green, blue, and violet—the traditional basic and secondary colors—plus a black and white, each as intense as possible. These colors, which are usually compounded rather than single pigments, when combined, produce mixed colors in the widest range available and with the maximum intensity.

The traditional secondary colors, when mixed in equivalent proportions, produce the six so-called tertiary colors: (1) citrine, a grayed yellow, (2) buff, a grayed orange, (3) russet, a grayed red, (4) plum, a grayed violet, (5) slate, a grayed blue, and (6) olive, a grayed green. The names of these colors, although fairly standard, do change; they are all dulled (grayed) versions of the six basic colors—yellow, orange, red, violet, blue, and green. The formulas for mixing these colors are interesting and illustrate all there is to know about color mixing. With practice, anyone can learn to mix colors.

Citrine, a grayed yellow, can be produced by mixing two parts yellow with one part red and one part blue, which is two parts yellow plus one part violet. The formulas for the other tertiary colors are

$$
\begin{aligned}
\text{Buff} &= 2Y + 2R + 1B = (Y+R) + (R+B) + Y = Or + V + Y = \text{Buff} \\
\text{Russet} &= 1Y + 2R + 1B = (Y+R) + (R+B) \qquad\quad = Or + V \qquad\; = \text{Russet} \\
\text{Plum} &= 1Y + 2R + 2B = (Y+R) + (R+B) + B = Or + V + B = \text{Plum} \\
\text{Slate} &= 1Y + 1R + 2B = (Y+B) + (R+B) \qquad\quad = \quad\; G + V = \text{Slate} \\
\text{Olive} &= 2Y + 1R + 2B = (Y+R) + (Y+B) + B = Or + G + B = \text{Olive}
\end{aligned}
$$

These formulas contain so many potential variables that, at best, they can serve only as guide posts or starting points for color mixing; however, they contain enough general information to lay the groundwork for all color mixing or matching. Theoretically, the number of color variations that could be developed from a set of three pigment primaries is huge—and the figure could be almost doubled if six basic colors were used.

All tertiary colors have low intensity and are usually referred to as dulled or grayed. In writing about these colors, Arthur Henry Church (1834–1915) observed,

> Numerous other tertiary hues beside the six just named are constantly observed in natural objects, and may be reproduced with great advantage in decorative art. It is, however, very difficult to describe the composition and character of such colors. These tertiary hues are, however, frequently used in modern art-manufactures with the happiest effects.[4]

Church's statement, although written in the nineteenth century, points to the vague and nonscientific approach, which is still the primary one, of the artist or designer toward color.

Complementary Colors

If we accept the commonly used six-color wheel made up of the so-called primary and secondary colors arranged as they appear in a spectrum—red, orange, yellow, green, blue, violet—we can say that complementary colors are those opposite each other on the color wheel; these prove to be the colors that are the most different in hue (see Plate 15). However, there are other ways to determine color complements. They may be defined physiopsychologically as those optical afterimages that appear when we stare at a basic color and then focus our attention on a white ground. Or they can be determined by adding and subtracting the primary and secondary colors. Thus, to find the complement of any primary color, the other two primary colors are added.

The complement of red equals yellow plus blue, or green.
The complement of yellow equals red plus blue, or violet.
The complement of blue equals red plus yellow, or orange.

[4] A. H. Church, *Colour*, London: Cassell & Co., Ltd., p. 49.

To find the complements of the secondary colors you subtract instead of add.

The complement of orange (red + yellow) equals the remaining primary, blue.
The complement of green (yellow + blue) equals the remaining primary, red.
The complement of violet (blue + red) equals the remaining primary, yellow.

And, of course, because there are relatively few complements in which the artist or designer is interested, they can simply be memorized.

The complement of yellow is violet.
The complement of orange is blue.
The complement of red is green.
The complement of violet is yellow.
The complement of blue is orange.
The complement of green is red.

Analogous colors are those that appear next to each other in the spectrum or on the standard twelve-color wheel (see Plate 15). Blue, blue-green, and green are analogous, as are yellow, yellow-green, and green. Three colors that belong to the same hue family, e.g., dark blue, dull blue, and light blue, form a monochromatic color scheme; *monochromatic* indicates that all the colors are of the same hue, differing only in their range within the hue, intensity, and/or value.

Temperature; Recession and Advancement

Temperature is another universal property of colors. There are hot, warm, cool, and cold colors, and although the temperature of a specific color can be reported only relatively, some generalizations are possible. Yellow and orange are warm, whereas red may be warm or cool, depending on whether blue or orange is dominant in the red. Blue and violet are cool; and green, like red, may be either cool (if blue dominates) or warm (if yellow dominates). Within any hue, color temperatures range from warm to cool; thus, one may find oneself speaking of a cool yellow even though this color would be warmer than other hues.

The color property of receding and advancing is the most relative quality of color; it depends not on the specific color involved but on the background and surrounding colors. For example, a white patch on a black ground placed against a white background will appeal as a hole, thus exhibiting a recessive quality; if the same patch on black ground appears against a dark gray background, it will look as though it had been applied to the surface, thus exhibiting an advancing quality. This phenomenon occurs more frequently in nonobjective than in naturalistic painting, where, because a color is seen in context, it can be more easily related to its appropriate level. Being able to manipulate the recession or advancement of color is valuable to designers, especially interior designers and architects, who, using this principle, can change the spatial or proportional qualities of a building.

Color theories

The practice of coloring existed long before man developed either a science or a theory of color. Our earliest examples of painting, as seen in the caves of Lescaux and Altamira, were dependent on it. Although painting cannot exist without color, color is not, of course, restricted to painting. All the early cultures of the Middle East used color as an integral part of buildings, artifacts, and decorations (see Plate 16). Each culture made use of the colors that were available to it and invested them with meaning. In Egypt from the earliest predynastic times, color was used conspicuously in the man-made world; it was interjected consciously as part of the people's lives. The man-made objects of the early Egyptians were dominated by the easily accessible earth colors; the later Egyptians made extensive use of brilliant mineral dyes and semiprecious stones for their coloring materials. The Assyrians, Babylonians, Chaldeans, and ancient Israelites each had specific systems of color usage. And, although most of our knowledge of the Greek and Roman uses of color comes from their literature rather than from remains of their work, it is clear that these cultures also used color extensively. In spite of the myth, which is still with us, of pure white Greek temples and sculpture, most Greek architecture and sculpture was highly polychromed (see Plate 17).

Thus, all early civilized people made use of color. It was not until the Greeks, however, that theories dealing with the nature of color and color perception were developed. And apparently it was also the Greeks who first acquired the knowledge necessary for the controlled mixing of paints. There are Greek manuscripts dealing with painting and decoration from as early as the fifth century before Christ; they discuss color harmony and the preparation, mixture, and use of pigments. Thus, in Western civilization, it was the Greeks who made the first attempts to understand color; and some of the questions they posed have still to be answered satisfactorily.

There is no one color theory that is applicable to all aspects of color: some deal with color as a factor of light physics; others concentrate on how we see color in relation to the physiology of sight; a third group deals with the psychological aspects of how we perceive color; and a fourth considers the mystical qualities of color. Each area of investigation has its own concepts—concepts that relate mainly to its specific concern. A theory about the physical nature of light includes no data on how light is perceived, whereas one that deals with the mechanics of sight does not consider the perception of color as affected by the observer's attitude. Thus, because no one theory can totally explain the phenomenon of color, all the theories must be examined in order to achieve understanding.

As yet there is no definite explanation of how we perceive color, except that we do know there are at least three major factors involved—the physical, the physiopsychological, and the psychological. We also know that the perception of color is not a simple thing. Color perception not only takes place in widely differing environments and under widely differing conditions but, in all probability, is strongly conditioned by learning, which gives color its meaning and relates it to our feelings and emotions.

The Physics of Color—What We See

ARISTOTLE. As far as we know, the first scientific contemplation of color began with the work of Aristotle (384–322 B.C.E.), who recorded that light was a necessary component of ordinary color perception. It was his contention that all objects impose a quality of "blackness" on the white light that falls on them and

that it is the qualitative aspect of this blackness, in relation to the white light, that makes for color differences. He considered the blackness to be a form of contamination that blocks out the colors not seen. Aristotle's theory stood until the seventeenth century and the beginning of scientific inquiry; it was not unlike our modern theory of color—that of selective absorption and reflection —by which an object is seen to have a specific color because the object's surface has the quality of absorbing all colors except the one reflected. However, several other theories intervened between Aristotle's and the one that now provides the basis for our understanding of the physical nature of color.

NEWTON. The theory most generally supported for almost three hundred years was postulated by Sir Isaac Newton (1642–1727), who was the first man able to separate the components of white light into a series of colors, which he called the *spectrum*. Newton identified the spectrum as being composed of a group of refrangible rays that appeared as a series of seven colors—"violet, indigo, blue, green, yellow, orange, red, together with all their intermediate Degrees in a continual Succession perpetually varying. So that there appeared as many Degrees of Colours, as there were sorts of Rays differing in Refrangibility." [5]

He arranged his seven colors into a wheel proportionally patterned on the seven intervals of the eight sounds in the musical scale and, in order to avoid hard edges, blended the colors where they met. The wheel was set up so that the colors ranged from full intensity at the circumference to white in the center. Newton used his color wheel to demonstrate that "in all whites produced by Nature, there . . . [is] a mixture of all sorts of Rays, and by consequence a composition of all Colours." [6] Realizing that white light was a mixture of all colors, Newton tried to obtain white by mixing opposite primaries—all the colors located at the edge of his color wheel (his original spectrum). Although he failed, he did contend that white might be compounded of a mixture of three at equal distances in the circumference.

Newton's color wheel differed from most of those considered

[5] Sir Isaac Newton, *Opticks*, or *A Treatise of the Reflections, Refractions, Infractions and Colours of Light*, New York: Dover Publications, Inc., 1952, p. 122.
[6] Church, *op. cit.*, p. 150.

standard today. He used seven colors in his wheel; most contemporary wheels use six, or a multiple of six, colors, with indigo being the one most frequently left out. In addition, today the colors occupy an equal amount of space, whereas in Newton's concept they occupied proportional spaces. When opposite colors were mixed in equivalent amounts in Newton's system, the result was a near white light; in most modern color wheels, this mixture results in a dark, neutral gray. The explanation is relatively simple but is often glossed over—*Newton's discoveries were primarily based on light, whereas modern color wheels and systems are conceived in terms of pigment.* Light and pigment being different, they demand different treatment and produce different results. (For a further explanation, see page 156.)

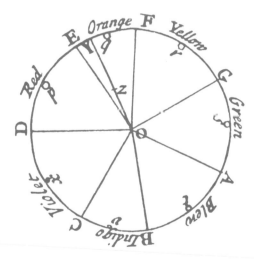

The Newton color circle.

All the colors Newton refracted when he passed white light through a prism turned out to be measurable in terms of wavelength, a wave being a continually pulsating charge of energy moving in a vibrating or an undulating forward motion from its point of inception. The length of a wave is determined by the vertical distance covered in its forward movement; all waves travel at about the same speed, 186,000 miles per second, so the length is measured from crest to crest. Wavelengths, which can measure the energy responsible for such phenomena as light, sound, color, radio trans-

mission, and heat, vary from those that can be measured in parts of a mile to those that are so short they are measured in millionths of a millimeter. Color is measured in terms of millimicrons ($m\mu$), a unit of length equal to one-thousandth of a micron or one-millionth of a millimeter. Energy becomes visible as color between approximately 380 to 760 $m\mu$, each color having its own range.

Violet	380 to 450	$m\mu$
Blue	450 to 490	$m\mu$
Green	490 to 560	$m\mu$
Yellow	560 to 590	$m\mu$
Orange	590 to 630	$m\mu$
Red	630 to 760	$m\mu$

It was Newton's theory that we see color because only certain wavelengths of color are being reflected from an object's surface while all others are being absorbed. Thus, green objects are those that are absorbing all the wavelengths of visible radiant energy except those between 490 and 560 $m\mu$, which are the ones reflected to the observer. And to see orange, one must perceive reflected light whose range is somewhere between 590 and 630 $m\mu$. White light—the light that comes from the sun—is a combination of all wavelengths. It is only when this light strikes an object or surface that is capable of selectively absorbing and reflecting wavelengths that we are able to perceive color. The agent of absorption and reflection he generally believed to be pigment, although an absolute black could be described as either the visual aspect of a totally light-absorbent surface or the absence of all light.

The wavelength theory, as conceived by Newton and Maxwell, (see p. 167) is being replaced by the quantum theory, which holds that energy is transmitted in bursts of separate groups, or quanta. However, in the field of color, the wavelength theory still dominates the reported research.

The Physiopsychology of Color—How We See

The description of color that we have been discussing so far has involved *what* we can see and measure but not *how* we see it.

In order to determine how we see color, we have to shift our consideration from its physical to its physiopsychological aspects.

GOETHE. The first move in this direction was made by Johann Wolfgang von Goethe (1749–1832), who bitterly attacked the ideas of Newton. However, his color theory was generally discredited because people saw it as less than scientifically oriented; it was subjective and based as much on the mystical as on the physiopsychological. All the colors were arranged in a neatly organized triangle: yellow, red, and blue were the primaries; and orange, violet, and green, the secondaries. Dull blue-red; pale, dull yellow-green; and dull slate-blue were the tertiaries. Although Goethe's color theory was not generally accepted, a fairly consistent apology was made for it because of his stature as a poet and philosopher; there have been some favorable references to his work by several modern authors, including Bauhaus staff members, Johannes Itten (b. 1888) and Josef Albers (b. 1888). Albers, in his book *Interaction of Color*, begins his section on color theories and systems by discussing Goethe's triangle and presenting it, with a page of its subdivisions, in a full-color, silk-screened reproduction, pointing out those colors that project qualities of the lucid, serious, mighty, serene, and melancholic.[7]

YOUNG AND HELMHOLTZ. Newton's theory was not related to one of color vision until the turn of the eighteenth century and the work of Thomas Young (1773–1829). Newton believed that color was seen by means of a sympathetic vibration caused by the incidence of light on the retina, with the vibration transmitted from the retina to the brain via optic nerve fibers. Young could not accept this concept because he reasoned that "it is almost impossible to conceive each sensitive point of the retina to contain an infinite number of particles, each capable of vibrating in perfect unison with every possible undulation."[8] In 1801, Young postulated that the receptors were limited to "the three principal colours, red, yellow, and blue" and that all other colors were the

[7] Josef Albers, *Interaction of Color*, New Haven, Conn.: Yale University Press, 1963.
[8] Thomas Young, "On the Theory of Light and Colours," in Richard C. Teevan and Robert C. Birney (eds.), *Color Vision*, Princeton, N.J.: D. Van Nostrand Company, Inc., 1961, p. 5.

result of proportional reception. Later, he changed his primary colors to red, green, and violet and stated:

From three simple sensations, with their combinations we obtain seven primitive distinctions of colours; but the different proportions in which they may be combined, afford a variety of tints beyond all calculation. The three simple sensations being red, green, and violet, the three binary combinations are yellow, consisting of red and green; crimson, of red and violet; and blue, of green and violet; and the seventh in order is white light, composed by all the three united.[9]

Young's ideas about the mechanics of color vision were not regarded very seriously until they were adopted and popularized by the German scientist Hermann von Helmholtz (1821–1894). The result of Helmholtz's involvement was to bring Young's ideas to the foreground of scientific consideration and to rename them the Young-Helmholtz theory of color vision. In explaining Young's position, Helmholtz said:

1. The eye is provided with three distinct sets of nervous fibers. Stimulation of the first excites the sensation of red, stimulation of the second the sensation of green, and stimulation of the third the sensation of violet.
2. Objective homogeneous light excite these kinds of fibers in various degrees, depending on its wave length.[10]

Variations of color were created by the optical fibers' reacting selectively to the amount of light wave reflected. Perceptible color changes would be compensated for by the lessened or increased number of optical fibers stimulated at a corresponding point of perception, each color appearing as it does because of variations in reception.

Helmholtz, in his *Handbuch der Physiologischen Optik* (published in 1866), established what has come to be known as the classic color theory. Ever since its inception, this theory has been the most widely accepted, used, and heralded of all those advanced, although there has been no direct evidence to support it until recently. Scientific verification came only with experiments, reported early in 1964, conducted at Johns Hopkins and Harvard

[9] Thomas Young, "On Physical Optics," in *ibid.*, p. 8.
[10] James P. C. Southall, ed., *Helmholtz's Treatise on Physiological Optics* (trans. from 3d German ed.), New York: Dover Publications, Inc., vol. II, p. 143.

Universities. The reports of the university experiments—although not agreeing on which colors are absorbed by the receptors—agreed with Young and Helmholtz's hypothesis that the key to color vision exists in a series of selectively sensitive retinal receptors.

HERING. When the Young-Helmholtz theory was expounded, it was subject to critical examination, with the result that theories aimed at overcoming its deficiencies were launched. Chief among these was the theory postulated by Ewald Hering (1834–1918), a German physiologist who proposed four primary colors rather than the three of Young-Helmholtz. Hering grouped his four colors into opposing pairs—blue and yellow, red and green—to which he added another pair—black and white. Each pair was governed by a chemically different substance "able to dissimilate and assimilate independently of the other two," so any combination of the four primaries—red, green, yellow, and blue—plus black and white would be visible on the basis of light acting on three sets of paired receptors—green-red, blue-yellow, and black-white.

MAXWELL. Another leading contributor to the study of color was the English physicist James Clerk Maxwell (1831–1879). Carrying the theories of Young and Helmholtz further, Maxwell conducted a historic color demonstration in 1855 to prove the existence of red, green, and blue as the basic primary light colors. He "produced the world's first color photograph by exposing individual black-and-white plates through red, green, and blue filters. Converted to positive plates, the three photographs were projected individually through the original filters, producing a composite image in life-like color." [11] According to Maxwell, the most effective three primaries "for the purpose of compounding the largest number of other colours [are] pure scarlet, pure green, and pure blue," originally noted as "wave-lengths in millionths of an inch, and following positions in the spectrum of the sun."

Any individual's perceptual deviation or inability to perceive color in the manner presented by the physiopsychological theories was laid to visual fatigue or color blindness, a condition in which some of the retinal receptors were thought to be damaged.

[11] Francis Bello, "An Astonishing New Theory of Color," *Fortune*, vol. 59, pp. 144–148, May, 1959.

LAND. Classical color theory as initiated by Newton, verified and projected by Young, Helmholtz, and Maxwell, and fostered by most of the color systems has been the basis for most of our knowledge of color. Newton's concept of spectral color formed the foundation of most modern color theory and was, until 1955, relatively unassaulted. In 1955, however, Edwin Land (b. 1909), repeating some of Maxwell's experiments in color photography, began the work that was seriously to question the long-held assumption that color is a function of wavelength.

When Land repeated Maxwell's experiment, he discovered that he could get a full-color image even if he left out the blue record. That is, he could get a full-color image by projecting through their original filters the black and white transparencies that had been exposed through the red and green filters only. He also discovered that when he projected the green record without its corresponding filter but in conjunction with the red record, he was still able to achieve a "highly satisfactory color picture." Land realized that he was actually combining a series of short wavelengths (those produced by the green record emitting wavelengths shorter than approximately 585 mμ) and a series of long wavelengths (those produced by the red record emitting wavelengths longer than approximately 585 mμ) in order to get a full-color image. It should be noted that a greater separation of the long and short wavelengths is needed to get a satisfactory color image. When the long and short wavelengths are separated by only 2 mμ—584 mμ for the short and 586 mμ for the long—the resultant color image is less than satisfactory.

The results of Land's experiments led him to challenge the classic color theory. In place of the spectral system dependent on wavelengths and the energy content of wavelengths, he proposed a new coordinate system of color dependent on the relationship of available long wavelength stimuli and available short wavelength stimuli.

In later experiments, Land found that the width of the long and short wavelengths made no difference so long as the long wavelength transparency—more properly referred to as the *long record*—is illuminated by the longer wavelength and the short record by the shorter wavelength. He also discovered that the best and most convenient width for the short record was the

entire width of the spectrum, or white light. According to classical color theory, when white light is combined with red light the result should be pink light, as would happen if you simply projected a red filter in front of a white light or if you projected a beam of red light and a beam of white light onto a screen. However, when Land did substantially the same thing with a long-record red transparency and a short-record white transparency, the image was not pink but full natural color.

Thus, according to Land's theory, which has been validated experimentally, color is not dependent on a specific wavelength at all but is produced by a combination of relatively arbitrary long and short wavelengths. Land was also able to show that color was "largely independent of the relative energies of the two stimuli" and that when colors "finally did change because of extreme changes in relative energy, they [did] not alter in the way that the classical laws of color-mixing predicted." Thus, instead of being described by wavelength, color can be described as a point on a physically dimensionless coordinate system in which the percentage of available short wavelength stimulus relative to the potentially available short wavelength stimulus is plotted against the percentage of available long wavelength stimulus relative to the potentially available long wavelength stimulus, each specific point of color being the result of a specific ratio of ratios or proportion of long to long and short to short wavelengths.

The Psychology of Color—Its Effects

The psychology of color is most commonly related to personality or the effects of color on our feelings or emotions. We can all picture the drab personality surrounded by dull, middle-value colors or the bouncy extrovert who uses colors that shriek of mad gaiety. And we all recognize that we use color in statements about our emotions: "I've got the blues"; "He's in a blue funk"; "She's green with envy"; and the old standby, "purple passion." These uses of color, however, are too narrow for a full consideration of the psychology of color. A thorough study must be concerned with "the bearing of color on any or all of the conscious functions and behavior of the organism, including sensation,

perception, attention, learning, recall, recognition, imagination, motivation, feeling, emotion, reasoning and action." [12]

NONOPTICAL COLOR. Normally, radiant energy in the form of light is necessary for the perception of color. But the sensation of color can be produced without any light and even without the process of normal sight. Simply closing one's eyes should produce some color sensation—sensation that can be intensified and changed by applying pressure to the closed lids. Also, chemical or physical irritation of the sensory fibers or electric currents applied to the body will produce sharply defined color sensations. Certain drugs and diseases produce or change color images, and it has been shown that "direct stimulation of the primary visual areas of the brain will produce color sensations." Another type of nonoptical color response—correct color identification through fingertips—has been reported (and seriously questioned) in the popular and science press. [13] To assure that the response was to color rather than to texture, in some experiments the printed color was covered with a sheet of clear plastic. But perhaps the greatest occurrence of nonoptical color is found in our response to the internal stimuli that cause dreams, for many dreams are experienced in color.

There was some early support for a theory of color vision not dependent on a specific type of optic stimulation. Johannes Müller (1801–1858), the most important physiologist of his time, developed the principle of specific nerve energy. He maintained that the type of sensation experienced does not depend on the form of the stimulation but on the nature of the sense organ stimulated. The eye thus becomes only one of the means by which energy can induce a color-sensed pattern within the perceptual framework of the individual.

Color is always perceived as a shape in time, having size and dimension. It can be seen as a surface, a film, an illumination, or an illuminant. Although it is possible to conceive or speak of a

[12] Optical Society of America, *The Science of Color*, New York: Thomas Y. Crowell Company, 1953, p. 100.

[13] The initial report of digital perception was made by two Russian investigators in October, 1962. Abstracts of their reports appeared in *Psychological Abstracts*, vol. 38, p. 761, October, 1964, and *Biological Abstracts*, vol. 46, no. 19, p. 7136, October 1, 1965. American testing for digital perception was reported in *Perceptual and Motor Skills*, vol. 20, no. 11, pp. 191–194, 1965.

color as an abstract quality, it is impossible to see one in this manner, that is, detached from reality. Even fog can be plotted for shape and size.

COLOR CONSISTENCY. Colors of everyday objects are seen more or less as consistent; color perception tends to cluster about the color norm for known forms. Ripe bananas are yellow and good grass is always green and fire engines are always red (except in Denver, Colorado, and a few other cities, where they are white). And although we may see the red fire engine or the green grass or the yellow bananas under various light conditions and at different times of the day, we know they do not change color even though the most casual observation tells us that they do in fact look different. The fire engine seen close up in the cool, dark recesses of the firehouse is one red; seen in the cold light of early morning, another; and in the warm, orange light of the late afternoon sun, still another. We know that under varying light conditions colors change. In spite of the changes, however, people tend not to see or perceive color inconsistencies in expected color norms. Some people may lack a developed color sensitivity so they literally may be unable to see the differences in lightness or saturation between two colors. But part of the inability to see such differences must certainly be ascribed to attitude. People do not expect certain objects to change color and therefore do not see the color changes.

COLOR PREFERENCES. There has been some work on color preferences; we know, for instance, that generally children and the relatively unsophisticated tend to like bright, gay colors, whereas adults and the more sophisticated tend to like more conservative colors. But more important than this distinction is the fact that most people, children and adults alike, once they have developed color standards, prefer colors that are "right." Whereas the color preferences of man-made forms are determined by what is fashionably acceptable or considered to be functional, those of natural forms are determined by what is considered normal. Bananas are yellow; we even pick them by color. The meat of a watermelon should be a deep, rich red; if it is not, we say the melon is not good. Blue milk, red peas, purple mashed potatoes, black eggs, orange grass, or pink lions might be all right for a joke or a psychological test—but they are never preferred.

The food industry is especially aware of the necessity for colors to be right. Because a very orange orange and a very lemon-yellow lemon are better received than those that show a normal degree of natural color variation, even if the latter are tree-ripened and full of juice, fruit growers pick early and process for color. Colorants are added to winter butter, which is whiter than summer butter, to make it yellow, although the true color of butter can vary from almost white to deep yellow. And, of course, colorants are added to margarine all year round to make it look like butter.

Emotional or psychic reactions to color range from responses to color temperatures and values through psychosomatic responses to responses that can only be labeled spiritual or psychical. The classic example of responding to color temperature concerns workmen who complained they were cold, even though the temperature in their factory was maintained at 68°F, the temperature that was considered proper. The room in which the men worked was a typical workroom; it had an adequate amount of fluorescent light, was constructed of steel, and was kept freshly painted—but with a blue-gray paint. The room was considered in every way a good working environment, except that it was cold. The problem was finally solved, with the aid of a color consultant, when the lower half of the room was painted a warm orange. The workers then reported that the room was comfortable to work in, neither too cold nor too warm. The cause of the improvement was that the orange color was able to elicit a response to its warmth in spite of the fact that the temperature of the room was maintained at the original 68°F.

The Subjective Nature of Color—Why We See

The subjective nature of color is a part of that broader area of study that considers man's reactions to color to be a totally psychic phenomenon or a conditioned response. The subjective response is a product of the mind; it is the *why* of color rather than the *what* or *how* and is the quality that relates most closely to esthetics. However, before we can discuss this quality intelligently, we must understand the conditioned response to color. In this context, conditioned response primarily concerns color symbolism.

Color symbolism played a part in the cultures of all ancient civilizations and followed a general pattern that is still recognizable today. One of the earliest effects of color symbolism related men to their racial groups; people recognized and gave special significance to those whose colors matched their own. Each racial group has within its folklore pattern the idea of its own color superiority, plus remnants of color superstitions lifted to symbolic positions.

Only a few colors, among which are yellow (or gold), red, and blue, have transcended such partisanism. Yellow has been widely used to signify the sun, light, and power and, in Christian iconography, is always used as the color of the nimbus. In the language of symbolism, however, colors are seldom restricted to a single meaning. Thus, yellow is also the color of triumph, insanity, revealed truth, and cowardice. Red is often used to represent power, strength, and daring; and blue is used to represent aspects of good or heaven. (Mary's robes, in traditional Christian painting, are always blue.) In addition, color has often been related to rank or position. Purple, known as the color of intelligence, knowledge, pride, and passion, is also the color of royalty.

Literature throughout the ages has been filled with allusions to color, because color is one of the chief means by which man's range of verbally induced imagery can be expanded. However, as with other symbols, color can become significant only when its relation to its meaning is established. Thus, the red dress worn by Bette Davis in the 1938 film *Jezebel* was significant because everyone knew what it meant.

Sometimes the color symbols of one culture are quite different from those of another. In the Western world, black is the color of death and mourning; but in the East, white symbolizes death. In India, yellow is a sacred color; it is the color of the marriage ceremony, the Buddhist priest's robe, and Buddha himself (see Plate 18). In America, yellow has no religious or pious association; it is the color of cowardice. And in Germany, yellow is the color of jealousy. Red has long been associated with sin and evil in the United States; many women refuse to wear a red dress or blouse because it makes them uncomfortable to be seen in red. But in China, red is the color of longevity. In many cultures (including our own to some extent), color is also symbolic of

age and is therefore age-graded. Bright colors are for children and young people; more subdued colors are used by the maturing individual; and the dull, dark colors are reserved for the elderly. Even though we do not have strong mores about this (as do the Japanese, for example), we are usually somewhat startled to see an elderly lady in bright pinks and oranges.

Another aspect of color symbolism within the American culture concerns the fashion or taste cycle, which is attached to our concepts of status or social position. Wearing or using certain colors makes one a member of the "in group." Some women would not wear what they consider to be last year's colors; and in many parts of the country, people can have their cars painted at a discount if they are willing to accept the colors that were popular during the previous year. At one time, all modern furniture was made of blond wood; the color indicated the furniture's style. Today, dark woods are used for modern furniture. And the muted colors associated with certain eastern colleges became *de rigueur* for the clothes of people on many levels of our society not even remotely related to the academic world. In the case of the gray flannel suit, which became the accepted uniform for a considerable segment of our business population, the symbolism became so strong that the phrase could be used as a significant book title.

Because of the nature of our fashion industry and economic structure, many colors and color combinations once associated only with peasants or ethnic groups of lower-class status are now considered to be high fashion. Until relatively recently, it was considered bad taste to combine such colors as red and pink, orange and magenta, or blue and green. To do so indicated one was undoubtedly poor, was probably of foreign extraction, and obviously had no taste. But, picked up by some of the fashion editors, these combinations became daring and exciting; after exposure in "Harper's Bazaar" and "Vogue," then in "McCall's," and finally in the "Ladies Home Journal," they became accepted in the world of middle-class fashion. It should be clear to everyone by now, at least in our own culture, that colors have no status connotations other than those we ascribe to them. No colors are intrinsically better than others. Today, artists and designers set and support the color trends and cycles. Although these professional people should be aware of the color superstitions of the past

as well as those of their clients, they must not fail to recognize the inherent good of all colors.

Of course, this argument must not be interpreted as license to apply any color to any object. One of the important factors in color choice—and now we begin to approach the problems of esthetics—concerns color function or appropriateness. Through experience and experimentation, some colors have been found to perform more efficiently for some objects than other colors. For example, it is known that for a printed page the best (i.e., most readable) colors are black for the type and a soft, creamy yellow for the paper. We also know that colors of maximum contrast are easiest to see at a distance and that colors most unlike their immediate environment are the first to be seen; this is the reason that chrome yellow is used for rescue gear. Conversely, colors most like their immediate surroundings are the most difficult to see. As recently as World War I, some troops went into battle in bright red tunics, making them excellent targets for their enemies. It was difficult for some governments to accept the fact that brightly colored uniforms were not appropriate battle dress, but by World War II, soldiers were wearing uniforms designed to camouflage them. Linoleum manufacturers also have adopted the concept of functional coloration. Many of their floor coverings are so multicolored that spilled food cannot be seen on them (a function of doubtful value by some standards). Functional color is important, however, wherever and whenever efficiency becomes the dominant factor in determining the success of the form involved.

One's response to color used in this manner should be determined initially by how well the color performs its function and how well it is integrated with the total form. The response should have little to do with personal preference. Another instance when one must disregard personal taste is when responding to colors as they relate to an overall color scheme of which they are a part. One's preferences in this case should be based on the formal relationships projected and the tradition to which the colors relate, because only certain color combinations can be used to convey specific decorative traditions.

Architecturally, color operates in conjunction with light and surface quality. Dark, warm colors plus low polish and low light create a more inviting environment than do bright, cold colors

coupled with hard surfaces and high gloss. Color and light are traditionally used to set the stage, not only in the theater, but wherever mood or the manipulation of space is important, because the size of an architectural area can be perceptually increased or decreased by varying color and light.

Although color symbolism and function provide for a response that is closely allied to the esthetic, it is primarily in the study of decoration and painting that the esthetics of color becomes an independent problem. Color is always a part of something else; it cannot be conceived apart from form. The problem arises only because the modern theory of esthetics holds that color has a being and existence of its own and should be judged independently of the shape and texture it is given or the form on which it occurs.

Color may be seen in relation to a single natural or man-made product or as a segment of some form that extends beyond the observer's range of vision; it may be perceived as a fleeting phenomenon or one that may be studied and considered. The response to any color phenomenon is so complex that one must remember that, although there may be a few color changes to which most human beings respond and some culturally developed color responses that hold throughout a culture, color response is basically an individual reaction. It is determined by the observer's experience, which includes not only his individual reactions but also the reactions of his environment and culture. This is evidenced by the fact that most people respond to what they consider the "correctness" of a color and to color symbolism. Although each color response can be a unique experience, depending on the observer and what he observes, responding to color alone as an isolated phenomenon or as a unique experience demands that the observer be able to isolate the color aspects of what he is perceiving, and this is a learned response.

Color systems

Historical Development

Although men had undoubtedly been working with color long before they became civilized, it was not until the beginning of

the eighteenth century, which was the start of an unprecedented surge of technological development, that they tried to standardize or systematize color. As the potential for the distribution of products grew, the need for production simplification and control became inevitable. In the realm of color, it was Sir Isaac Newton who defined the rationale that was to make this possible.

Newton began working on his theories of optics and color in 1666, but it was not until 1704 that his ideas were published in his famous book *Opticks*, in which he alluded to the problem of color mixing on the basis of a minimum number of colors. It was Newton's idea that all colors could be divided into two basic sets. One set, the heterogeneous, comprised those colors that appeared in the spectrum but that could be reduced to their component parts; the other set, the homogeneous, comprised those colors that could not be reduced. Furthermore, Newton held, first, that the more component parts it took to produce a given color, the less full and intense the color would be and, second, that colors unlike any of the colors of homogeneal light could be produced by mixing.

In later experiments, Newton investigated mixing pigments, which he referred to as Coloured Powders, rather than mixing light. However, from all evidence, it was Jacques Christoph Le Blon (1670–1741), a printmaker, who saw within Newton's ideas the rationale necessary for developing a full-color printing process based on three colors—red, yellow, and blue. Thus, although Newton was working primarily with light, his experiments led Le Blon and others to a consideration of the problems and theories of mixing pigments.

Le Blon, who had been born in Frankfurt and had settled in Amsterdam, was a painter of miniatures. However, by 1711, he was writing essays about his three-color printing process; by 1720, he had improved it by adding a fourth color, black, and had gone to London where he was granted a Royal Patent for his discovery. In 1730, he published a book, in both French and English, explaining the process. (The addition of a black plate in effect made Le Blon's process parallel to our own modern four-color printing process.)

Although Le Blon's ideas, which were taken to France by the Gautier D'Agoty family (who claimed them as their own), were being expounded on both sides of the English Channel, they

were not adopted very widely as a printmaking technique. His process did, however, advance the idea that red, yellow, and blue are the three primary colors, an idea that fits very neatly with the demands of a color system based on pigment mixing but not at all with a theory of color based on the physics of light. When the light primaries—red, green, and blue—are mixed, the result is white light; when the pigment primaries are mixed, a near-black results. The light primaries are known as the *additive* primaries, because any single light primary color can be changed only by adding other light primaries, resulting in white when they have all been added. Pigment primaries are referred to as *subtractive*, because a primary color can be changed only when the light quality interfering with the reflection of the desired color is taken away (subtracted) by a pigment that will absorb it. Theoretically, when all the subtractive primaries are combined, all the light would have been subtracted through absorption and no color (black) would be reflected to the observer.

The theory that red, yellow, and blue were the primary colors had many champions, and the three-color process of Le Blon and the D'Agotys was soon adopted by various industries. Wilhelm Ostwald (1853–1932), an important contributor to modern color systemification, noted that "about 1737 Dufay described how, by means of these same three colours, *Yellow, Red and Blue*, mixed colours of all hues could be prepared in the dyeing of yarns and fabrics." [14]

Johann Tobias Mayer (1723–1762), a German astronomer, formulated a color triangle with red, yellow, and blue at the corner angles and the secondary and tertiary colors as the sides and interiors. Other triangles he constructed compounded black and white with his primaries. In 1772, the color triangle was formed into a color pyramid by Johann Heinrich Lambert (1728–1777), a German scientist who had collaborated with Mayer; he produced the first color system based on a three-dimensional solid form. Lambert based his system on gamboge, carmine, and Prussian blue, which he felt were the only pigments from which he could get pure color mixtures. In the color triangles he brought together to form his pyramid, Lambert did not use either black or white. Blackness was achieved by the mixture of equivalent pro-

[14] Optical Society of America, *op. cit.*, p. 8.

portions of his primary colors; whiteness was achieved by thinning the paint to allow the white paper to reflect through. The first known example of a color *circle*, which also made use of red, yellow, and blue primaries, was produced by Moses Harris of England in about 1766.

In 1810, Phillip O. Runge (1777–1810) published his *Color Sphere*, which purported to show the parts of each compounded color as well as the relationship of each compounded color to every other compounded color. This work was a major advance and was to be important to the development of present-day color solids, because, like many of them it made use of hue and black and white to define each color sample. The hues formed a band at the hemispherical circumference and the black and white formed the polar ends of a graduated gray axis placed perpendicularly to the hue band. Thus for the first time, achromatic and chromatic colors were brought into a positive relationship to form all the compounded hues.

It was also in 1810 that Goethe, who, as previously noted, violently opposed the color theories of Newton, published his own ideas about color. The ideas of Goethe were expanded by Arthur Schopenhauer (1788–1860) in a book published in 1816. Although Schopenhauer's theories made use of the red-yellow-and-blue primary system, they were at such odds with those of Goethe that Goethe repudiated them. Schopenhauer had stressed the psychological aspects of color vision but did not pursue this aspect to any great extent; his ideas were later picked up and expanded by Hering. Ostwald, in commenting on Goethe's color theory, blamed him for popularizing the concept of red, yellow, and blue as primaries.

The false doctrine that *Yellow*, *Red* and *Blue* are the three *Primary Colours*, which by mixture, give use, in the first place, to secondaries Orange, Green and Violet, and then to the remaining compounded colours was made so extremely popular by Goethe that it has become almost ineradicably rooted alike in expert and layman.[15]

By the time of Schopenhauer, this concept had become the foundation of industrial interest in color. Michel Eugène Chevreul

[15] Wilhelm Ostwald, *Colour Science* (trans. by J. Scott Taylor), London: Winsor & Newton, Limited, vol. I, p. 16.

(1786–1889), a brilliant French chemist who became one of its strong supporters, had undertaken the job of superintendent of the dyeing department of the French royal tapestry manufactory (Gobelin) because of serious complaints about the quality of the dyes produced. Upon investigation he discovered that

. . . the want of vigour complained of in the blacks was owing to the colours next to them, and was due to the phenomena of contrast of colours. I then saw that to fulfill the duties of director of the dyeing department, I had two quite distinct subjects to treat—the one being the contrast of colours generally considered, either under the scientific relation, or under that of its application; the other concerned the chemical part of dyeing.[16]

Eventually Chevreul's discoveries were published as his book *The Principles of Harmony and Contrasts of Colours and their Application to the Arts: including painting, interior decoration, tapestries, carpets, mosaics, coloured glazing, paper staining, calico printing, letterpress printing, map colouring, dress, landscape and flower gardening, etc.*, which had three editions and several print-ings in French and English. His basic idea was presented as the "law of simultaneous contrast of colours" and stated that "two coloured surfaces in juxtaposition will exhibit two modifications to the eye viewing them simultaneously, the one relative to the height of tone of their respective colours, and the other relative to the physical composition of these same colours." [17]

Chevreul went on to explain the results obtained when specific colors are juxtaposed and how specific relationships affect colors. In addition, he described the industrial applications of a lengthy series of color combinations. The work was monumental and gives us a good understanding of nineteenth-century color taste. It also established many of the terms and principles that have become a standard part of modern art education, including most of the concepts of harmony based on the red-yellow-and-blue-primary color wheel.

At about the same time in England, Sir David Brewster (1781–1868) was presenting a color system based on a red-yellow-and-

[16] Michel Eugène Chevreul, *The Principles of Harmony and Contrasts of Colour and Their Application to the Arts*, 3d ed., London: G. Bell & Sons, Ltd., 1890, p. x.
[17] *Ibid.*, p. 10

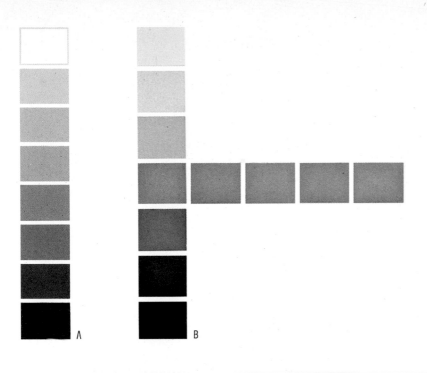

Plate 13. A. Achromatic gray scale. Shows a series of eight grays in their order of value from white to black. B. Chroma and value scales. The five horizontal blues illustrate chroma and the eight vertical blues illustrate value. (Both courtesy of Munsell Color Company, Baltimore.)

Plate 14. A continuous spectrum from a white-light source. (Photo, Henry B. Spitz, New York.)

14

Plate 15. A. Six-color circle. B. Twelve-color circle.

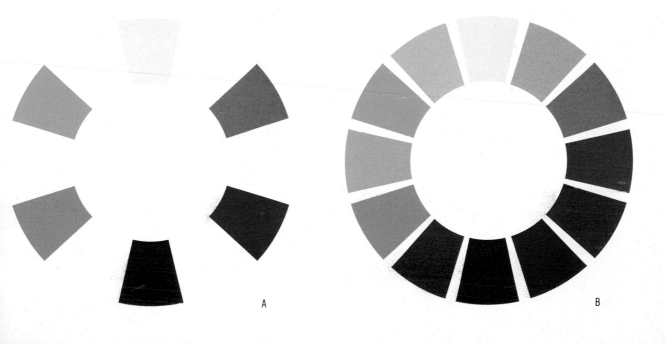

A

B

Plate 16. The Ishtar Gates (restored), Babylon, c. 575 B.C.E. An example of the early use of vivid color, which depended on highly developed technological skills. (Courtesy, Staatliche Museen, Berlin.)

Plate 17. "Kore." Polychromed Greek sculpture of a maiden. Few of the Greek marbles still available show the colors with which they were polychromed. (Photo, Hirmer Fotoarchiv, Munich.)

18

19

20

Plate 18. Cambodian Buddhist priests in their traditional saffron-yellow robes. (Photo, Lennox P. Tierney, Pasadena.)

Plate 19. An Ostwald color triangle showing some of the colors classified in the Color Harmony Manual. (Copyright 1948, 1958, Container Corporation of America, Chicago, Ill. Made and printed in U.S.A. All rights reserved under universal international, and Pan American copyright conventions. Published simultaneously in Canada.)

Plate 20. Diagram of the Munsell color solid. Selected combinations of hue, value, and chroma are located at specific points within Munsell's system. (Courtesy, Munsell Color Company, Baltimore.)

Plate 21. Claude Monet, "Two Haystacks," 1891. One of the many paintings comprising Monet's haystack series. It was in this series that the artist began to isolate specific lighting effects as important factors in his paintings. (Courtesy of The Art Institute of Chicago. Mr. and Mrs. Lewis L. Coburn memorial collection.)

Plate 22. Claude Monet, "Haystacks, Setting Sun," 1891. (Courtesy of The Art Institute of Chicago. Potter Palmer Collection.)

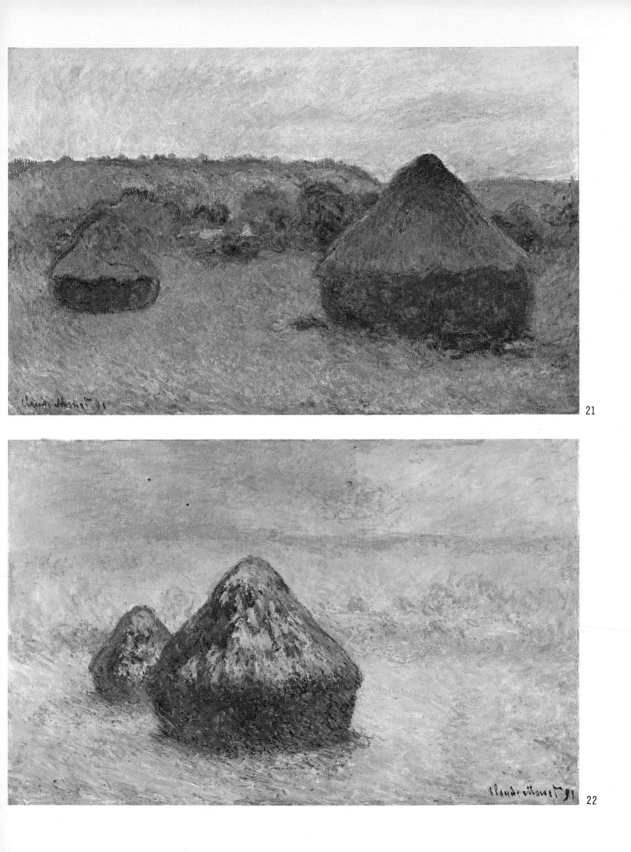

21

22

23

Plate 23. "Krishna with the Gopis," c. 1650. Krishna always appears as a blue figure; it is one of the means by which he may be identified. (Courtesy, Museum of Fine Arts, Boston. Gift of John Goelet.)

Plate 24. Leonardo da Vinci, "The Virgin of the Rocks," c. 1485. In this painting the illusion of three-dimensional form has been built up by the strong dark and light pattern known as chiaroscuro. (Courtesy Musée du Louvre, Cliché des Musées Nationaux.)

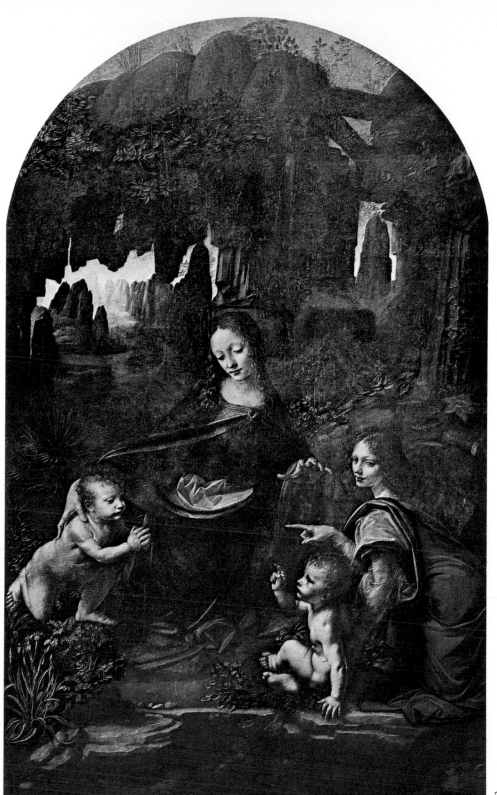

24

25

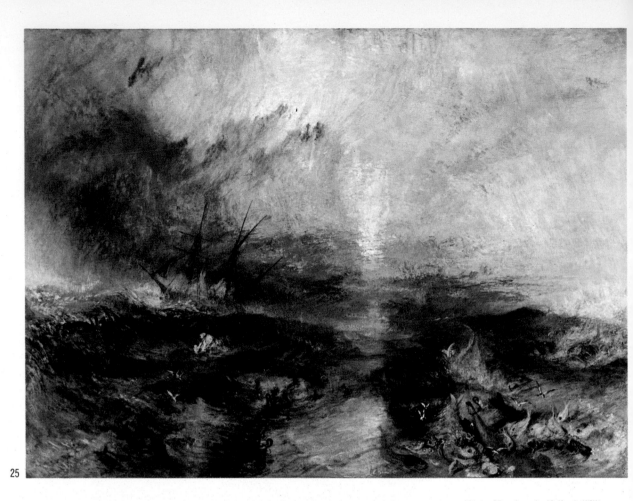

26

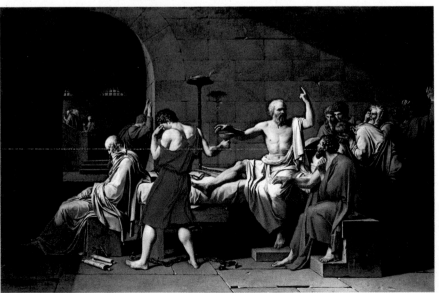

Plate 25. Joseph Mallord William Turner, "The Slave Ship," 1839. Color becomes an integral and expressive factor in the painting's visual quality and supports its narrative aspect. (Courtesy, Museum of Fine Arts, Boston. H. L. Pierce Residuary Fund.)

Plate 26. Jacques Louis David, "The Death of Socrates," 1787. In the neoclassic style used by David, color, although an essential component of composition, is not the means by which a painting's structure is created or its narration sustained. (Courtesy, The Metropolitan Museum of Art, New York. Wolfe Fund, 1931.)

blue-primary color wheel. Brewster, who was a major physicist of his period and repsonsible for, in addition to the invention of a number of major optical instruments including the spectroscope, the development of the kaleidoscope, advanced the theory that although white light (sunlight) was composed of the seven colors described by Newton, only three of these could be defined as primary. He referred to these three primaries as the "spectral colours" and concluded that although they were different, they were of the same wavelength. He also believed that if one of these rays were to disappear, its corresponding color would no longer be seen. The Brewster wheel was formed with red, yellow, and blue as primaries; orange, green, and violet as secondaries; and six intermediate hues arranged so that diametrically opposed colors were complementary. Support for Brewster's theory was based on the observation that it was from the three primaries that the greatest range of compounded colors could be mixed, whereas the primaries themselves could not be mixed from other pigments. Brewster's color wheel was broadly adopted, especially by people in art education.

Quite a different approach to the problems of color systemification was advanced by Maxwell, who had shown that red, green, and blue were the light primaries. He designed a series of disks that, based on the proposition that "all quantitative color [mixture] equations are *linear*," could be used to establish any color produced by proportional combinations of chromatic and achromatic color. Maxwell's disks become increasingly important when it is recognized that the components of any printed halftone color can be found by his system.

Types of Color Systems

Color systems, which are used primarily by designers, printers, manufacturers, and others interested in either matching colors or producing colors to be matched, fall basically into three categories: (1) the colorant-mixture systems, in which a limited number of colors are developed into a series of proportionally compounded variants; (2) the color-mixture systems, in which the tristimulus values of colors are varied systematically and measured instrumentally (the most common use of this type of system is in the halftone printing process); and (3) the color-appearance sys-

tems in which colors are collected and organized according to their relationship as perceived by an observer with "normal color vision."

COLORANT-MIXTURE SYSTEMS. The *colorant-mixture systems* are used primarily by painters, interior decorators, paint salesmen, and designers—all of whom need a large selection of colors and easy formulas for mixing them. Included in this systems category are the New Hue Custom Color System of the Martin Senour Company, the Plochere System, and a large number of systems established by paint companies, whose primary aim is to sell a wide range of compounded colors based on a limited number of stock colors. The Plochere System, one of the best, consists of 1,248 mat-finished, spray-painted, 3 \times 5-inch cards, each identified by a serial number denoting its formula and a rather arbitrarily and romantically selected name. There are 26 cards of basic hues, each hue having 6 cards showing shades approaching black and each of these in 8 tints approaching white, a total of 48 variations of each hue; all the cards are packaged in a neat little black box.

COLOR-MIXTURE SYSTEMS. The *color-mixture systems* are the graphic presentation of three-dimensional color solids, such as Lambert's early color sphere. Ostwald, one of the most important contributors to this type of system, acknowledged Lambert's contributions but would not accept the idea that the study of color perception was the responsibility of either the physicist or the physiologist. Ostwald placed the examination of color perception into the scope of modern psychology and accepted Hering's psychological primaries—red, yellow, green, and blue—and use of black and white as the polar pair that, combined with the primaries, created the base from which all other colors could be formulated. All colors thus became a compound of measurable amounts of basic hue plus black and white. Beginning with two complementary pairs—yellow-orange–blue-purple and red-green— Ostwald built a color wheel of twenty-four colors equidistantly spaced, four colors between each pair of primaries. To this he added an eight-step, black-to-white scale of visually equidistant grays, which ranged from an 85 percent white to a 96.5 percent black. (This scale thus was arranged according to the Weber- Fechner Law, which defines the relation of a sensation to the

intensity of its stimulus.) With the gray scale as one side of an equilateral triangle and a full hue the apex of the opposite angle, Ostwald built color triangles (see Plate 19). All the triangles, with the gray scale as the common vertical axis, formed his color solid. Each triangle contained thirty-six color swatches—twenty-eight chromatic colors plus the eight achromatic colors of the common gray scale. Each line of color parallel to a specific hue and white contained an equal amount of black; each line of color parallel to a specific hue and black contained an equal amount of white.

Ostwald's system was exceptionally well received by industrial designers and formed the basis for the Container Corporation of America's *Color Harmony Manual*, which has had four editions. The second edition, published in 1946, used 680 color chips, and the third, published in 1948, contained 943, the additional chips having been necessitated by the addition of six other dominant wavelengths. Each chip has one mat side and one glossy side and is individually replaceable.

Another system, based on Ostwald's concepts, was designed by Faber Birren (b. 1900). But instead of using Ostwald's twenty-four "full colors" or "semi-chromes," Birren used only the eight principal hues and added five intermediary ones—red-violet, red-orange, yellow-orange, yellow-leaf, and green-leaf. These thirteen colors formed what Birren referred to as his Rational Color Circle. In his system, all hue variants were computed to equal 100, compounded of x percent white, x percent black, and x percent hue. Full black equaled 100, full white equaled 100, and each full color equaled 100. This system included, in addition to thirteen full-color disks and a black-and-white disk, a calculatory disk by which specific colors could be determined.

Also to be included among the color-mixture systems based on hue, black, and white are the *Dictionary of Color*, by A. Maerz and M. Rea Paul, first published in 1930 and with a second edition in 1950, and the *Villalobes Color Atlas*, published in 1947. The *Dictionary of Color* has become a basis for color standards in many industrial fields and contains 7,056 colors plus 4,000 color names. The *Villalobes Color Atlas* contains 7,279 color swatches; it is considered one of the better color atlases because of its uniform color spacing and the precision of its color samples, which are 1 centimeter square and have a 4-millimeter hole cut in each to help in comparing colors.

COLOR-APPEARANCE SYSTEMS. One of the most important color systems in use today is Albert Munsell's; it is based on *color appearance*. Munsell accepted the concept, proposed by Helmholtz, that all colors can be determined by hue, lightness, and saturation, but he built his system into a color solid substituting the term *value* for *lightness* and *chroma* for *saturation*. Arranged spatially, these qualitative aspects formed a color sphere, which was described by Munsell in geographical terms.

The north pole is white. The south pole is black. The equator is a circuit of middle reds, yellows, greens, blues, and purples. Parallels above the equator described this circuit in lighter values, and parallels below trace it in darker values. The vertical axis joining black and white is a neutral scale of gray values, while perpendiculars to it are scales of Chroma. Thus, our color notions may be brought into orderly relation by the color sphere. Any color describes its color quality, light and strength, by its place in the combined scales of Hue, Value, and Chroma.[18]

The hue scale was built from Munsell's five principal hues expanded to ten and designated by their initial letters—red (R), yellow-red (YR), yellow (Y), green-yellow (GY), green (G), blue-green (BG), blue (B), purple-blue (PB), purple (P), and red-purple (RP). These ten were again expanded—to one hundred hues designated by initial letters plus the numbers from 1 to 10. The value scale had nine steps spaced according to the Weber-Fechner Law; the chroma scale was extended to ten steps from the central axis, which was a chroma of 0, or neutral gray. Color at the limit of the chroma scale would be full saturation, or a chroma of 10. Munsell's notation system was based on a combination of these scale designations. The hue was given its letter and number designation (10 PB, 6 GY, 4 RP), with the value indicated as the numerator of a fraction (5/ , 6/ , 8/) and the chroma as the denominator (/4, /6, /8). Thus, typical Munsell color notations would be 4 YG 6/8, 8 YO 2/8, or 2 R 4/6 (see Plate 20). One of the main advantages of this system for understanding color is that it shows clearly that not all colors have the full range of values and that not all full-chroma colors are of equal intensity.

[18] Albert H. Munsell, *A Color Notation*, 11th ed., Baltimore, Md.: Munsell Color Company, Inc., 1961, p. 18.

The Munsell system is used throughout the world, and its master standards have been spectrophotometrically measured and recorded with the United States National Bureau of Standards.

Another system of international importance that makes use of color appearance is the DIN Color System, the official German color chart developed in 1953 by Manfred Richter (b. 1905). DIN stands for *Deutsches Institut für Normen*, which is the organization that helps set and maintain standards for all German industry.

All the color systems noted thus far are primarily of interest to the graphic, decorative, or industrial designer. Some systems attempt to consider color harmony or the esthetics of color, but these are areas in which color systems are not very useful. Because they are forced to standardize, the systems have a tendency to become self-limiting. But this is their major value; that is, they help establish and maintain standards. Although most systems were originally designed to facilitate the matching of colors, they have other uses as well. They are valuable for recording or transmitting color information when a color swatch is not available. The colors can be recorded by formula—either pigment or tristimulus value—and their codes designated. The codes can then be checked against the master standards. In addition, color systems offer the designer a wider range of colors than he could possibly remember; they can, and often do, act as a stimulus to an artist or designer who is looking for a color or color combination. They present the raw material from which artistic choices can be made. What they do *not* do is establish color responses or deal with the subjective nature of color.

Color relationships

"How well do the colors work together?" is a question that is posed often. The verb *to work* is one of the overused terms in modern art education and is a counterpart of *interesting*, which is often used to cover the lack of real critical judgment or evaluation. But both words have meanings that can contribute to increased understanding of the arts. *Work* is used here to mean that one element, in this case, color, has a positive relation to the other elements—a relation that is supportive of the unity of

the total visual impression. In the decorative arts, the answer to the question can be on at least two levels. One can be based on the relation of the colors to an established mode or the canons of current taste, and the second can be based on the rational relationship of the colors' chromatic qualities.

Much of the response on either level is subject, as are all formal relationships, to what Stephen Pepper of the University of California at Berkeley has so aptly called *habituation*—"The process whereby sensations originally disliked come to be much liked as a result only of experience with them." [19] However, this concept of habituation can lead, through overexposure, to a state of boredom, at which point the sensation is once again disliked (though for entirely different reasons). Thus people have come to lose interest in some of the more traditional and symbolic color schemes, such as red and green or orange and black.

In attempting to judge color apart from other considerations, we look for that which we know or can rationalize but which at the same time moves us to consider the creativity with which the colors were combined. Inherent in this is the danger that we may become so absorbed by the freshness of the color combinations that we forget all other considerations. Judgment on this level demands that all the inherent color qualities be considered, not only separately, but in relation to all other pertinent factors. And although these relationships can be those of contrast or analogy, hue, lightness, saturation, temperature, recession or advancement, or apparent weight, they must at some point include intention and/or function.

Until relatively modern times, strict rules were laid down for color harmony. One of the most complete sets of rules in the nineteenth century was developed by Michel Chevreul; he not only gave general instructions for the development of color schemes but outlined the effectiveness of each scheme for the various industries that used his system. Following is a typical entry in his section titled "Assortment of Colours with White."

1. Red and orange are very bad together.
2. The assortment white, red, orange, white is not at all preferable.
3. The assortment white, red, white, orange, white, etc. is not so bad as the preceding because white being favorable to all colours, its

[19] Stephen C. Pepper, *Principles of Art Appreciation*, New York: Harcourt, Brace & World, Inc., 1949, p. 28.

interposition between colours which injure each other can only produce an advantageous effect.[20]

Although we no longer accept such strong dicta concerning which colors will go well together and which will not, as recently as 1928 a noted German colorist, Martha Bernstein, reiterated a quotation from the *Principles of Aesthetic Colour* by Emil Utitz: "Colours which lie more than a sixth and less than two-sixths of the circumference of the colour disc apart go badly together. Up to a sixth they work with agreement and therefore with harmony; and at more than two-sixths distance from one another, they afford a grateful contrast." [21] Bernstein restricted this rule as follows: "This applies only to yellow, red, and blue, however, green, violet, and orange remaining harmonious. What he says is fairly consistent with the existence of offensive contrasts—those between orange and carmine, between yellow and yellowish green, between green and cyanine-blue. . . ." [22]

This type of rigidity about color relationships has been criticized by all who take a more relativistic attitude toward the nature of color. Among the first to support the concept of a broader base on which to judge color relationships were Ostwald and Munsell, both of whom believed that color harmony was the result of a rational relationship between all the color attributes. Writing before the turn of the century, Ostwald took Goethe to task for his intuitive conclusions about color relationships.

Thus Goethe in his final chapter discusses the Aesthetic effect of colours, i.e., the effect of the *opposite, distant* and *adjacent Pairs* in his Six-Hued, and therefore wrongly arranged Colour Circle; whereby he arrived at conclusions which were not at all in agreement with experience. Thus he absolutely rejected the pair *Blue-Green*, which he stigmatised as mutually disagreeable and foolish colours, while nowadays we concede great Aesthetic Value to certain of their combinations.[23]

Ostwald went on to point out that

From our present-day standpoint the following principle is firmly established. If Colours of different Hue combine harmoniously, then

[20] Chevreul, *op. cit.*, p. 73.
[21] Martha Bernstein, *Color in Art and Life* (trans. by R. Granger Watkins), New York: Robert M. McBride Co., Inc., 1928, p. 19.
[22] *Ibid.*, p. 19 20
[23] Ostwald, *op. cit.*, vol. II, p. 18.

their other elements, viz. their Content of White and Black, must also combine harmoniously—otherwise no law-conforming connection can exist between them.[24]

Much the same position was taken by Munsell.

A colorist is keenly alive to these feelings of satisfaction or annoyance, and consciously or unconsciously he rejects certain combinations of colors and accepts others. Successful pictures and decorative schemes are due to some sort of balance uniting "light and shade" (value), "warmth and coolness" (hue), with "brilliance and grayness" (chroma), for, when they fail to please, the mind at once begins to search for the unbalanced quality, and complains that the color is too hot, too dark, or too crude. This effort to establish pleasing proportions may be unconscious in one temperament, while it becomes a matter of definite analysis in another.[25]

The current concept of color does not include harmony as the sole or even a dominant factor in the development of a color scheme. Today's color schemes are more likely to be determined by a combination of factors such as function, uniqueness, and the existence of rational relationships. In some cases of modern advertising or display graphics, especially when shock is a desired effect, a conscious discord is sought.

Some of the more important factors to be considered when working with color schemes are the relations between the quantities of the colors used, the colors' rhythmic distance from each other, and the relative location of the colors in the total pattern. These factors, although they cannot be considered in the abstract, must be considered as they relate to the individual color scheme. It should also be noted that color schemes recur in a cyclic manner; thus, they are often so related to time and place that they are useful as means for identifying specific geographic locations, art periods, cultural subgroups, and even individual artists.

In working with color schemes, it becomes apparent that there are great differences between those used by designers or decorators and those used by painters. The primary difference lies in the nature of the observer's response. Although the color in a designed form is a part of the total form, it is an element that can be changed. This is not so for the color in painting. Although it is undoubtedly true that to change the color scheme on a building

[24] *Ibid.*, p. 149.
[25] Munsell, *op. cit.*, p. 35.

or on an industrial design does change its appearance and therefore its visual characteristics, the relationship between color and form is not nearly so critical as it is in painting. A building is not re-formed if its color scheme is changed. And red cars, white cars, and blue cars operate equally well; neither the performance nor style of an automobile depends on its color. But if the color, or even a portion of the color, of a painting is altered, the painting becomes an entirely new form, because color is an integral aspect of its principal condition. And changing a form's principal condition results in changing its total form. If the perceived image is altered, its nature and the esthetic response it elicits is also altered. This should not be interpreted to mean that there is only one color arrangement by which an idea can be expressed in painted form, but rather that once the colors of a painting have been established, to change them means to produce a new paint-ing. Claude Monet (1840–1926) clearly demonstrated this with his series of haystack paintings (see Plates 21 and 22).

When I began I was like the others; I believed that two canvases would suffice, one for gray weather and one for sun. At that time I was painting some haystacks that had excited me and that made a magnificent group, just two steps from here. One day, I saw that my lighting had changed. I said to my stepdaughter: "Go to the house, if you don't mind, and bring me another canvas!" She brought it to me, but a short time afterward it was different again. "Another! Still another!" And I worked on each one only when I had my effect, that's all. It's not very difficult to understand.[26]

It must be recognized that there is no one way to respond to the color in painting. On the first level of perception (the naturalistic level), one recognizes and responds to the "correct-ness" of the color; that is, the color is within the range of the expected, natural appearance of the object painted. This is the response of the untrained observer; although it does not comprise the esthetic response, it is the base from which the esthetic re-sponse must arise. If the colors appear in their "proper" relation-ship, the specific relationships that make up the esthetic nature of the form can be perceived and a new level of appreciation can develop. The second level of perception is based on the symbolic use of color. In Indian painting, Krishna—the human form as-sumed on Earth by the god Vishnu—always appears blue; it is

[26] William C. Seitz (ed.), *Monet*, New York: Harry N. Abrams, Inc., 1960, p. 22.

by this convention that he is recognized (see Plate 23). In the Medieval painting of Western Europe, color symbolism was much more important than was natural color. But although the perception of color symbolism demands a learned response, one must remember that once the symbolism has been accepted and internalized, it in no way interferes with the development of the broader esthetic response.

The changing nature of color in painting

The personality of the modern artist is characteristically that of a searcher; as meanings become clear to him, he undertakes new problems. These new problems may be of a philosophical, sociological, or technological nature—but they are always before him. When we realize that each painter, because of his personal interests, also brings a unique contribution to the problems he faces, we are ready to consider the changing nature of color in painting, recognizing that it cannot be the result of any single force or even a single complex of forces. The nature of color changed in painting as the painter, the nature of painting, and the world changed; and as the nature of color changed, so did the basis of the esthetic response it evoked.

Form and color are the two primary considerations of the artist; they are the factors that bring his image into being. Painters have probably always been aware of this, even during those moments when drawing and line preempted the role of color. Most painters have also been aware of the relational aspects of color; they have understood that the colors we call complementary produce a quality unlike that of the colors called analogous and that the lightness and saturation of color could be used to build imagery.

When color had been accepted as being either naturalistic or symbolic, the next problem was to consider color in relation to form. The artists approached this problem through form rather than color; they made an effort to give the illusion of three-dimensional reality to their painted figures by manipulating light in a system known as *chiaroscuro* (see Plate 24). The theory was that figures could be modeled by light and shade so they would seem to be independent of their backgrounds and have the three dimensions of living forms. Although the chiaroscuro effect was at-

tempted early in the Renaissance, it was not until the work of Leonardo da Vinci and Michelangelo Buonarroti that it was brought to fruition. The system demanded modeling the painting in tones and values of brown to white first and then using color washes over the original painting in order to indicate local color. This technique became a compositional device for such artists as Jacopo Robusti Tintoretto (1518–1594), Peter Paul Rubens (1577–1640), and Rembrandt van Rijn (1606–1669); the application of color as a tinting medium on fully sculptured form was to dominate painting for the next hundred years.

A break did not occur until the English painters Joseph Mallord William Turner (1775–1851) and John Constable (1776–1837) and the French painters Théodore Géricault (1791–1824) and Eugène Delacroix (1799-1863) introduced the concept of color, conceived by light, as an integral and expressive element correlated to a painting's subject matter (see Plate 25). This concept was in direct opposition to chiaroscuro, which still governed the color system of the day and was espoused by Jacques Louis David (1748–1825) and the French Academy (see Plate 26). Once the way had been opened, however, color began to be perceived as an element whose form-producing potential was as great as that of line or chiaroscuro. And although officially the Salon, the marketplace of the Academy, still maintained a tight grip on what was accepted as art, the new artists turned to light and color as an increasingly important element in painting.

In 1863, the forces of opposition to the official position on the nature of painting could no longer be ignored, and Napoleon III authorized the opening of the Salon des Refuses. Although this salon exhibited no great number of important works, it did show three paintings by Édouard Manet (1832–1883), who perceived color as a broad surface quality that could be used for image formation alone. Manet's color, brilliant in its contrasts and range, took on a life of its own that had seldom been found in earlier painting (see Plate 27).

IMPRESSIONISM. Working at the same time as Manet were the painters whose work was later grouped under the title of Impressionism. These artists also were interested in light and color but, at this point, not for color's own sake; they used color as the means to perceive a form. Introducing color via the brush

stroke rather than as a solid surface, they produced paintings that were a montage of juxtaposed color. The paintings were meant to give the observer the impression that a specific moment in time had been captured—a moment when the existing light and color caused the image to be perceived in a special way. Later, as the group's adherence to form began to recede, some of their canvasses were little else than textural images of perceived light and color. Chief among the Impressionists were Camille Pissarro (1830–1903), Claude Monet, and Alfred Sisley (1830–1899) (see Plate 28). There were other important painters in the group, but their work expanded beyond the color usages discussed here.

NEOIMPRESSIONISM. The Impressionists were quickly followed by the Neoimpressionists, primarily Georges Seurat (1859–1891) and Paul Signac (1863–1935), who tried to combine Impressionism with the important scientific work being done at that time in the realm of color. Seurat, aware of the optical discoveries of both Maxwell and Helmholtz, drew heavily on Chevreul's "law of simultaneous contrasts" to form a base for his painting theories. He also made use of the writings of Ogden N. Rood (1831–1902), which showed that the luminosity of optical mixtures is always superior to that of pigment mixtures, and a series of six articles "Les Phénomènes de la Vision" by David Sutter, from which he gleaned not only information on the nature of color vision but also support for his completely scientific approach to painting. Seurat tried to create images whose luminosity was increased because of his use of what he considered optically true colors (see Plate 29).

He proceeded by first placing on his canvas pigments to represent the local color, that is, the color the represented object would assume in a completely white light (or if seen from very close by). This color was then "achromatized" by additional strokes corresponding to (a) the portion of colored light which reflected itself, with alteration, on the surface (usually a solar orange); (b) the feeble portion of colored light which penetrated beyond the surface and which was reflected after having been modified by partial absorption; (c) reflection from surrounding objects; and (d) ambient complementary colors.[27]

[27] John Rewald, *Post-Impressionism from van Gogh to Gauguin*, Garden City, N.Y.: Doubleday & Company, Inc., 1958, p. 83.

Seurat's work was carried on by Signac, who by this time had eliminated all earth colors from his palette, preferring to work with what he considered spectrally "pure" color. But the attempt to combine science with art was doomed to failure, for although Seurat and Signac practiced their concepts with a searching personal involvement, their theories, when filtered down to those who were looking for a safe way to produce art, were used in such a manner as to achieve only mediocre painting bereft of any personal involvement.

Although Paul Cézanne (1839–1906) worked during the same period, his contribution to art was made independently. He turned the techniques the Impressionists developed into a form that was to mark the beginning of contemporary painting. The Impressionists used color as a means of examining and re-creating light and atmosphere; Cézanne used color to create form by modeling objects as a series of planes, each plane determined by a color change. Regardless whether their subject was a landscape, a still life, or a portrait, Cézanne's paintings exhibited his new vision, which depended on color and plane to determine form (see Plate 30). Cézanne believed that all forms should be reduced to their geometric essentials—cylinder, cube, sphere, and cone—and that distortion into these basic elements was structurally and expressively essential to composition. Whereas Giotto by the beginning of the fourteenth century had shifted the focus of painting from formula to nature, Cézanne by the end of the nineteenth had formally introduced it to abstraction and a new expressive regard for color and form.

POSTIMPRESSIONISM. But Impressionism led to other styles of painting that were to have more important implications for color esthetics. Important Postimpressionist contributions to contemporary color usage were developed by Vincent van Gogh, Paul Gauguin (1848–1903), and the Fauves and Expressionists.

Van Gogh, who painted for only the last ten years of his life, brought a new freedom to the use of color; through him, color became a means of personal expression. Writing to his sister, he explained: "A palette nowadays is absolutely colorful: sky-blue, pink, orange, vermillion, strong yellow, clear green, pure wine red, purple. But by strengthening *all* colors one again obtains calm

and harmony; there happens something similar to Wagner's music which, even though performed by a great orchestra, is nonetheless intimate." [28] Each of van Gogh's paintings expresses or reveals a personal meaning—a compassion or fervor, a tenderness, or a response to humanity—that exists beyond its surface illusion (see Plate 31).

Fortunately for us, van Gogh not only was a prolific painter but also wrote at length. In a final letter to his brother, Theo, he made his own position on painting clear and pointed the way for the new esthetic: "Really, we can speak only through our paintings." For van Gogh, the only important aspect of painting was "the artist's reaction to his subject matter." Colors did not have to correspond to reality; they were, in fact, to be used symbolically— "Red and green, for example, symbolize the terrible passions of men [and could] . . . replace tonal values, perspective, chiaroscuro, even, to a large extent, relief." [29]

Gauguin, a friend of van Gogh's, used painting in much the same way. He, too, gave new meaning to color, which by this time had come to be a dominant element of form (see Plate 32). Following is an anecdote of a conversation he is supposed to have had with Paul Sérusier (1864–1927), a younger painter: " 'How do you see these trees?' Gauguin asked him. 'They are yellow.' 'Well, then, put down yellow. And that shadow is rather blue. So render it with pure ultramarine. Those leaves? Use vermilion.' " [30] Gauguin, who advocated purer color, put down directly, and his ideas became extremely important to a younger group of painters known as the Nabi. One of the Nabi explained Gauguin's importance as follows:

He freed us from all the restraints that the idea of copying imposed on our painters' instincts. The theory of equivalents gave us the means to do this. We derived it from his expressive imagery: it gave us the right to be lyrical, and we learnt from his example that if it were permissible to paint a tree vermillion because it appeared very red to us at a particular moment, then we might also interpret our impressions by means of certain formal exaggerations, stress the colour of a shoulder, push the pearly white of a carnation to extremes. [31]

[28] *Ibid.*, p. 216.

[29] Jean-Paul Crespelle, *The Fauves*, Greenwich, Conn.: New York Graphic Society, 1962, p. 44.

[30] Rewald, *op. cit.*, p. 206.

[31] Crespelle, *op. cit.*, p. 37.

The Fauves were a group of young painters who had come together in 1905. In addition to learning from the dynamic quality of van Gogh's color, they independently discovered the concept, which Gauguin helped them assimilate, that with strong colors worked in flat unmodulated areas, a picture became its own reason for being. When they began, the Fauves made use of broad, flat areas of pure color—used for its own sake—but later, their paintings were objected to as being, as John Canaday has noted, "at the opposite pole of hyperrefinement and artificiality." [32] One of the most important painters to emerge from this group was Henri Matisse (see Plate 33), who wrote, "I respond to the expressive qualities of my colors in a purely instinctive way. . . . My choice of them is made without the benefit of any scientific theory; it is based on observation, on feeling, on experience, and on my own sensitivity." [33] Thus, color had gradually shifted—from its original place as a secondary consideration to, first, a position of equal status with form in relation to subject matter, then, a position unique in the conception of form, and finally, a position divorced from any relation to subject matter. From this point, color became the expressive tool of the artist, existing only in relation to its ability to project an image and the artist's creativity.

NONOBJECTIVE PAINTING. The most recent phase of color usage arose with the elimination of subject matter, which resulted in the emergence of nonobjective painting and the full bloom of Expressionism. In the middle of the nineteenth century, the developing sciences and industrial technology provided the environment in which art grew. One of the men caught up in the ferment that resulted was the Russian-born painter Wassily Kandinsky, who arrived in Munich in 1896 and sought the spiritual soul of art through nonobjective painting. Always having a strong receptivity to color, he believed—although he took pains to point out that his theory was not scientifically developed—that color could directly influence the human soul (see Plate 34).

Yellow is the typical earthly color. It never acquires much depth. When cooled by blue, it assumes, as I have said before, a sickly tone.

[32] John Canaday, *Mainstreams of Modern Art*, New York: Holt, Rinehart and Winston, Inc., 1959, p. 399.
[33] Crespelle, *op. cit.*, p. 61.

If we were to compare it with human states of mind, it might be said to represent not the depressive, but the manic aspect of madness. The madman attacks people and disperses his forces in all directions, aimlessly, until it is completely gone. To use another metaphor, we are reminded of the last prodigal expansion of summer in the glaring autumn foliage, whose calming blue component rises to the sky.

Depth is found in blue, first in its physical movements (1) of retreat from the spectator; (2) of turning upon its own center. It affects us likewise mentally in any geometrical form. The deeper its tone, the more intense and characteristic the effect. We feel a call to the infinite, a desire for purity and transcendence.[34]

Kandinsky was extremely important as a teacher and spokesman for nonobjective art. He felt it was only when the last traces of natural form were withdrawn that the painter could discover the laws of pure pictorial construction—and then only through the formal elements, with shape and color relationships playing the dominant roles. When this was achieved, painting, he believed, could take its place next to pure music and pure poetry. When colors were used symbolically and combined "according to their spiritual significance," pure composition of great significance could result. "Color itself offers contrapuntal possibilities and, when combined with design, may lead to the great pictorial counterpoint, where also painting achieves composition and where pure art is in the service of the divine." [35]

Thus Kandinsky brought color back to its symbolic usage. He proposed that it be employed for pure abstraction in which its formal qualities would create a compositional interplay that would, in turn, create significant meaning from the abstract color and the formal composition alone. Color had now become a totally independent force that could be used as the artist saw fit; it no longer had to belong to anything but the space and time it occupied and the form it created. The inevitable result of this new color dimension was paintings in which the total esthetic reaction involved a purely psychomystic response induced by the color form and space of the perceived image. There is a wide range of paintings included in this definition—from those that depend on a multicolored, faceted image to those that depend on the projection

[34] Wassily Kandinsky, *Concerning the Spiritual in Art*, New York: Wittenborn and Schultz, 1947, p. 58.

[35] Peter Selz, *German Expressionist Painting*, Berkeley, Calif.: University of California Press, 1957, p. 230.

of a few or even a single color; from those to which the response evoked is one of calm and quiet contemplation to those that evoke an experience of vivid excitement (see Plate 35).

Summary

Although color need not assume a position of primacy in all that we perceive visually, it does exist as an integral part of all visual phenomena. It occurs as a factor in all painting—either as local color and not essential, all form having been fully developed by other means, or as the completely essential element by which all forms are developed. Today's world of art encompasses such a wide range of acceptable form that it is impossible to assign any single role or function to color. The importance of color and the artist's or observer's response to it is such a complex phenomenon and dependent on so many variables that it can only be successfully considered in terms of specifics. Those color qualities that lend themselves to generalization are of relatively little importance to the modern painter.

The nature of texture

The term *texture* comes from the Latin *textura* (a web), which in turn was taken from *texo* (to weave). Originally, *texture* referred to a woven fabric, a relationship that can still be seen in our word *textile*; now, the word more properly refers to the surface quality of all materials. The *Oxford English Dictionary* relates *texture* to its original meaning when it states that texture is "the character of a textile as to its being fine, coarse, close, loose, plain, twilled, ribbed, diapered, etc., resulting from the way in which it is woven." In an extended definition, the word is shown to relate to all materials: "The constitution, structure, or substance of anything with regards to its constituents or formative elements." [1] The words *constitution, structure,* and *substance* as used here indicate the arrangement of those particles that make up a material. From the definition, it should be clear that everything has texture and that texture must be considered wherever a surface exists.

Texture, like color, is an integral part of man's environment but, also like color, is easy for people to ignore. Because it is always around us, we tend not to see texture unless our attention is focused on it or it is of such an unusual nature or so out of context that we cannot help noticing it. For the most part we take it for granted. Despite this general lack of interest, however, texture has proved to be one of the major qualitative concerns of modern artists and designers. In order to examine it in terms of esthetics, texture must be separated from its context and considered as a distinct quality, one that is capable not only of contributing to our sense of reality but also of arousing our emotional response.

Texture is a highly complex physical and visual phenomenon. In many respects, its perception and appreciation are directly related to those of color; however, it has been less thoroughly examined and codified than has color and, for this reason, seems to appear as less important. When one examines or tries to define textures, it becomes clear that they must be judged in relation to

[1] *The Oxford English Dictionary,* Fair Lawn, N.J.: Oxford University Press, 1933, vol. I, p. 467.

a continuum, the extremes of which represent opposite ends of a single quality characteristic. For example, hard and soft could be the extremes: then textures on this continuum would be graded by the degree of hardness, decreasing from the extreme until they reached the middle point, at which the texture would be neither hard nor soft; after this middle point the textures would be described by increasing degrees of softness until they reached the extreme soft. The continuums usually used to describe textures are hard to soft, smooth to rough, fine to coarse, wet to dry, and tight to loose.

Textures exists in both the natural and man-made worlds on two levels. The first is the tactile level—that which is perceived by touch alone and does not depend on the sense of sight. However, to fit into this category, the number of surface irregularities —regardless of their regularity of occurrence—must be fairly small. If there are too many or they occur too far apart, they cannot be perceived by touch. Thus, the range of surfaces that can be perceived on the tactile level is limited.

The second level on which textures can be examined—indeed, the level that gives us most of our textural responses—includes all the nontactile perceptions of surface quality, that is, the mental images of textures that one has without actually touching the surfaces. The textural qualities of paintings, photographs, and sometimes even sculptures are perceived in this way. The range of perceivable differences on the nontactile level is much greater than on the tactile level. For one thing, the observer is no longer restricted by scale; he can "feel" textures that he could not sense by touch. The textural qualities of vast areas such as a desert or a pebble-washed shoreline can be sensed; one does not have to touch the sand or walk on the pebbles. If one were to touch the surface of either, he could report only on the surface qualities of the specific items felt, while the larger textural sensation would be lost. (Architectural textures also fall into the classification of those that are perceived on the nontactile level.)

Texture in design

Texture has four major components—materials, process, function, and concept—each of which contribute to the textural quality

of a product and how it is perceived. The material of which a form is made and the process by which it is worked are the primary determinants; function and concept are also important, but secondarily. Because clay differs materially from wood, wood from metal, metal from plastics, and so on, and because each of these materials lends itself to a different form of processing—clay to moulding or modeling, wood to carving and fabrication, metal to casting and forging, and plastics to extrusion or casting—the form and surface qualities of objects made of the various materials will differ. But the function of an object and its producer's concept of it also affect its texture. For example, ceramic dinnerware should be nonporous and smooth enough to function within the framework of our eating habits and concepts of efficiency, whereas a sidewalk should be designed with a surface rough enough to prevent our slipping on it when it is wet. Further, if a painter or sculptor intends a specific work to be perceived sensually, the object will probably exhibit a smooth, soft, opulent surface; a form meant to portray alienation might be rough, hard, and jagged.

Before we can move to an examination of the textural qualities of historic periods, it must be understood that generalizations refer only to the broadest stylistic distinctions and in no way negate the individual qualities of each object. A piece of art is primarily the conceptual work of a single man; although contained within the stylistic framework of time and place, it reflects the unique imagery of its creator.

Materials

Perception of and response to texture are determined by the psychological set of the observer and by his life experiences. Thus the physical qualities of a texture and an individual's response to it, although linked, depend on different factors and must be examined separately. All materials have innate textural qualities that are determined by the process of their creation. For example, the growth pattern of a tree determines not only the tree's shape but also the textural quality of its wood, and the structure of a mineral's crystal pattern determines the textural quality of the mineral. Moreover, similar materials (two types of wood or two different minerals), although showing some textural differences, in general exhibit similar textures. And the quality of any material or form

can be altered only by taking away from or adding to the existing surface; in either case, change can be effected either by man, through the use of tools, or by the forces of nature.

SURFACE ORNAMENTATION. From the seventeenth century to the first decades of the twentieth, many materials used by craftsmen formed the base for textured surfaces that disregarded any natural qualities inherent in the materials themselves. One of the more successful methods of disguising a core material—covering it with a veneer—was employed as early as the seventeenth century but did not come into general practice until the eighteenth. The increased use of thin wood coverings brought necessary changes in form—flat surfaces instead of panels, restricted carving, and joints that would not reveal the inner core. Veneers were applied to show off both the decorative grains of exotic woods and the intricate patterns that could be obtained by symmetrical or repeated use of whorled or burl wood. In the highest quality work, the surfaces were made more brilliant by several covering coats of lac varnish (see the illustration, page 204).

Veneers were used for two reasons, the first of which was economic—less expensive wood could form the base of a piece and the piece could still exhibit the textures and fine grains of the more expensive and desirable woods. The second reason was that veneers enabled the achievement of highly decorative effects, the ultimate quality of which was displayed in the skilled marquetry developed in the seventeenth century. Intricate scroll patterns made use not only of contrasting woods but also of such materials as tortoiseshell, silver, brass, and mother-of-pearl.

During much of the nineteenth century and the first decades of the twentieth, it was considered important for craftsmen to be able to imitate various surface qualities, and the most important techniques used to accomplish this were graining, marbling, and gilding. By *graining,* several different species of ornamental woods —satinwood, rosewood, mahogany, oak, etc.—could be simulated. In the nineteenth century, the technique was in such demand that a graining machine was even patented. It consisted of a patterned roller that applied the desired grain to any surface. *Marbling,* a much simpler technique, was accomplished by splashing and rubbing the appropriate pigments on a wet undercoating of paint; when dry, the surface received one or more coats

of clear varnish. *Gilding* was the tedious process of applying gold leaf. The best work was achieved by using a water-soluble size to hold the burnished gold leaf in position. Less expensive furniture was covered with silver and then colored gold. The desired shade of gold changed from period to period and was usually determined by the color of the final coat of size.

These effects, although part of the craftsman's stock in trade during the seventeenth and eighteenth centuries, became so popular in the nineteenth century that the techniques were included in do-it-yourself columns of nineteenth-century periodicals written for middle-class families. The techniques even warranted separate attention at the Great Fair of All Nations held in London in 1851, the fair to which England invited the nations of the world to exhibit the acme of their industrial and handicraft production.

SURFACE INTEGRITY. At this time, materials were used, not because of any intrinsic surface qualities, but because their surfaces could be worked to achieve the contemporary concepts of beauty, which held that the ornamented surface was more beautiful than the unornamented. All materials were used in an ornamental and decorative manner, and some new materials, including papier mâché, gutta percha, and papier carton, were introduced primarily for this purpose. But during the early part of the twentieth century, when nineteenth-century ideas were generally being refuted, the validity of ornamentation came into question; some designers realized that ornament could be applied to cover poor craftsmanship and to hide inferior materials. This questioning resulted in the designers' call for a return to more honest workmanship and more careful selection of materials, because they came to believe that only exposed craftsmanship and surface qualities that could be considered innate were honest or good. If wood were used, it must look like wood; if plywood were used, the core must show; if the material were marble, a marble quality had to be retained. As a reaction to the overworked surfaces of the nineteenth century, this provided a certain amount of welcome relief; however, as an absolute principle it was just as wanting as those that had preceded it.

The concept of surface integrity reached its peak in the machine art of the 1930s and 40s; all visual characteristics resulted

from the nature of the material, the process used to work it, and the functions of the final form.

Beauty of surface is an important aesthetic quality of machine art at its best. Perfection of surface is, of course, made possible by the refinement of modern materials and the precision of machine manufacture. A watch spring is beautiful not only for its spiral shape but also for its bright steel surface and its delicately exact execution. . . .

Machine art, devoid as it should be of surface ornament, must depend upon the sensuous beauty of porcelain, enamel, glass of all colors, copper, aluminum, brass and steel.[2]

[2] Philip Johnson, *Machine Art*, New York: The Museum of Modern Art, 1934, foreword.

Left: Secretary, mahogany veneer and marquetry, French, c. 1780. The use of veneers allowed the decorative qualities of exotic woods to be shown to their fullest advantage. (Courtesy, M. H. DeYoung Memorial Museum, San Francisco, Roscoe and Margaret Oakes Collection.)

Right: Papier mâché teapoy. The use of papier mâché for furniture during the nineteenth century is a prime example of the manufacturing inventiveness that was characteristic of the period. (Courtesy, Victoria and Albert Museum, London.)

Coors porcelainware. Plain, unadorned forms that expressed the nature of the materials and the processes used in manufacturing were valued examples of "good" design from the late 1920s to the early 1950s. (Photo, Prothmann Associates, New York.)

Thus a material was held to be honestly used only when, first, it was most appropriate for the job and, second, its surface clearly displayed the effects of the tooling or machining used during its processing. The concept allowed for a wide variety of worked surfaces but did not accept materials that were applied after a form was completed. Paint, varnish, shellac, and other protective coats, as well as imitative surfaces, were shunned in favor of untreated surfaces. In woodworking, however, the oiled surface was usually considered the most honest, because oil brought out color variations in the structure of the wood and thus made it more interesting. Of course, this process was as much at variance with the concept of honesty as was that of polishing or "finishing" a surface; strict adherence to the concept would demand that the wood be left completely untreated, or raw.

The response to an oiled wood surface is almost completely sensuous. Where varnish and shellac exhibit a highly reflective surface and one that is usually considered cold, oiled woods project a warm, invitation-to-be-rubbed quality. Moreover, successive applications of the traditional varnishes and shellacs eventually darken wood to the point of completely hiding the natural surface qualities. Although modern plastic finishes do not have this effect, the association has been strong enough to work against their acceptance.

In earlier periods, wooden furniture surfaces were completely untreated. The well-oiled and rubbed tabletops that have survived probably received their patina only because of the eating habits of their users. Even as late as the early nineteenth century, it was not considered in terribly bad form to drip fats and oils onto the tabletop while eating, and tablecloths did not come into general use until relatively recently. Because wood is porous, a certain amount of the oil dripped on it was absorbed and worked into the surface. And the normal method of cleaning the tabletop—with water, soap, and sand (a practice that lasted until the development of varnished surfaces)—helped create the patina.

At this point, it should be noted that most contemporary surface applications, including paints and varnishes, are used for decorative purposes, in spite of the rationalization that they protect the wood. It has been learned from measurements that untreated wood is worn down by natural abrasion at the rate of about ¼ inch every 200 years; surface-treated woods tend to deteriorate somewhat faster than untreated woods, because moisture trapped under the surface covering causes the wood to rot. To counteract this, modern paints have been developed with the ability to "breathe," that is, they allow the treated material (wood) to absorb and eliminate moisture, the condition that is obtained more easily by leaving the surface untreated.

The honesty-of-materials-and-craftsmanship concept was used by twentieth-century designers and craftsmen as a rationale for the unornamented surfaces produced so easily and economically by mass production methods. These designers found that texture could provide a sensuous response, which they considered a more direct response than that elicited by ornament. The extent of the modern designers' involvement in this rationale was indicated by Laszlo Moholy-Nagy (1895–1946), Bauhaus instructor and founder and leader of the Chicago Institute of Design. "About fifteen years ago [c. 1925–1930], the problem of ornament was an important issue. Today it is not even the subject of argument. The creative power which went into the production of ornament is transferred now into materials, tool-formed textures, and surface treatments. . . . Texture is, at least for our time, the legitimate successor of ornament." [3]

[3] Laszlo Moholy-Nagy, *Vision in Motion*, Chicago: Paul Theobald & Co., 1947, p. 42–44.

INDUSTRIAL USES OF MATERIALS. The deep concern about the nature of surfaces was not transferred, however, to the bulk of manufacturing enterprises either in America or abroad, and the manufacturers' lack of concern about the nature of materials is indicative of the distance between industry and concepts of modern design. Other production problems are of paramount importance, because as yet the industrial community has had no guarantee that good design outsells bad. When a manufacturer does use a new material as a substitute for an established one, one of the qualities of the original he most often wants to retain is texture. If the texture can be successfully imitated, the chances are fairly good that the newer material will be accepted, provided its use is economically advantageous. This was demonstrated by the industrial acceptance of synthetic fibers, which can be made to feel and look like cotton, silk, linen, or wool. Of course, synthetics do not perform in exactly the same way as the original fibers. In some cases, they bring new and desirable qualities to fabrics; in others, they do not even retain the qualities that made the natural fiber originally desirable.

The invention of plastic is an excellent example to illustrate industry's quandary concerning the acceptance of new materials.

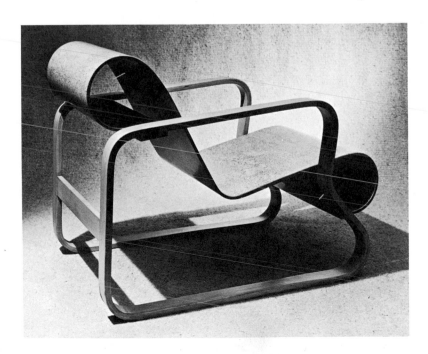

Alvar Aalto, lounge chair, c. 1934. Surface finish (texture) replaced ornamentation as a decorative element in modern industrial design. (Collection, The Museum of Modern Art, New York. Gift of Edgar Kaufmann, Jr.)

It is easy to make plastic that looks like, feels like, and often works like glazed ceramics, glass, wood, leather, metal, etc.; and products made of plastic may cost less to manufacture and be, to all intents and purposes, as good as those made with the original material. *But this is not true in all cases.* Often, the plastic objects are merely shoddy imitations of the originals and do not perform nearly so well. However, plastic is *the* material of the twentieth century. It has the unusual quality of allowing the surface texture to be built-in rather than applied. A number of designers look upon this quality as a great advantage; they see an opportunity to impose their concepts of surface on the material. Other designers, however, consider this quality a serious disadvantage, because there are no defining limits established by the material's innate qualities. This is one of the principal reasons that plastic has not been extensively used for "serious" sculpture, even though it can be made to imitate so many different surfaces. For those designers who have chosen to use plastic, however, this high degree of surface and form flexibility has been its primary appeal. The various points of view cluster about the artists' concepts of the relation of materials to form.

Process

A silver spoon that is hand-forged is permitted, by the canons of modern design, to have a surface that reflects the forging process. The final hammer marks, known as *planishing marks*, are proof of the process. However, if a spoon is cast, these marks are not supposed to appear; instead, the spoon should have the smooth surface of cast ware. A ceramic form that is thrown on the potter's wheel will often display the fingermarks of the thrower as concentric ridges. This is a surface quality that would not occur in cast ware unless the ridges were cut into the plaster mold so that the mass-produced ware, when finished, would exhibit marks characteristic of hand-thrown ware. An aluminum bowl or lampshade that is lathe-spun will have the characteristic surface marks that result from the spinning process, but a wooden trencher that is hand-carved exhibits a surface quite unlike that obtainable on a lathe.

Thus each material and process produces its own unique surface quality; however, it is the final stages of formation that

most affect texture. Traditionally, the skill of a craftsman was usually measured by the degree of finish he could obtain by a gradual development of the surface. One of the handmade silver pitchers designed by the Danish sculptor Henning Koppel was described as follows: "The silversmith has worked on it almost one month and thereby everything has been done to make it as perfect a piece of craftsmanship as possible. With its supple curves, its aristocratic appearance and lovely subdued sheen, it is not only a jug, but a piece of sculpture, not only a useful object, but a work of art." [4] (See the illustration, page 210.)

Most items we use in our everyday life were originally handmade, and the originals had textures that differed greatly from those of the forms we know, which are made by machine. The traditional goal of the craftsman was to produce wares that were as even and regular as possible. The nearer a surface approached the ideal of perfect regularity, the better quality the piece was considered to have. But as traditional handicraft processes became mechanized and technologically more sophisticated, it has become increasingly less difficult to achieve the regularity once so eagerly sought. The growing sophistication in the area of technology was matched by the development of a new concept of production, first described by Adam Smith (1723–1790); it was based on the division of labor and took production away from the skilled craftsmen and divided it among several workers, each highly trained to perform only one specific task. The result is a more mechanical form with a surface quality that is not developed slowly as the form is developed but that is achieved in the final processing.

Sometimes the materials and processes are so closely related that only a limited range of textural qualities is possible. For example, in reed or grass weaving, the surface texture is completely controlled by the nature of the material and the weaving process; thus, different styles of weaving or plaiting produce only minor texture variations. But at other times, when textures depend more on the material and form than on the process of production, there can be considerable latitude in surface quality. Such forms as those made of metal or plastic that depend on a number of different processes are excellent examples.

[4] Arne Karlsen, *Made in Denmark*, New York: Reinhold Publishing Corporation, 1960, p. 42.

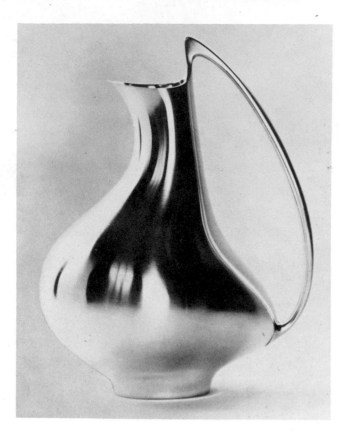

Function, which is more closely related to the applied arts than to the expressive arts, is a fairly complex consideration. The most obvious measure of function is generally considered to be the level of performance efficiency relative to the amount of energy and material expended. But as the need to conserve or expend energy and the availability of materials changes, so does the concept of efficiency. The concept also changes with shifts in the level of available technology, the number of items to be produced, and the methods of production and distribution. What might be a perfectly acceptable and functional way to produce a single piece might have to be drastically altered to be functional for mass production. Thus function is never based on a single factor but rather on a complex of related factors, such as the purpose for which the form is to exist, the materials available for its production, the level of technology available to its producers,

Left: Henning Koppel, pitcher. This contemporary hand-forged silver pitcher can be appreciated as much for its sculptural qualities as for its craftsmanship. (Courtesy, Georg Jensen, Inc., New York.)

Right: Plaited basket, Papago Indians, Pima, Arizona. In the hand production of forms in which the material and process of manufacture are responsible for surface texture, the skill of the craftsman is an essential factor in the quality of the form. (Courtesy, The American Museum of Natural History, New York.)

the economy and methods of distribution, and the factors of time and propriety.

Of the many factors that affect the concept of functionalism, the one most often overlooked is that of propriety. The history of the knife, fork, and spoon as eating implements is an excellent illustration of how propriety is involved in the development of a functional norm. At one time, eating with the fingers was not only recognized as efficient but also considered quite correct; it is still the principal and correct manner of eating for a large segment of the world's population. But in our society, we no longer use our fingers to convey most foods from our plates to our mouths. The first change was from hands and teeth to hands and a knife, at which point the knife served not only to cut food but also to bring it to the mouth. And from this developed the two-tined then the three-tined fork.

Originally, eating implements evolved by social classes, first in the households of royalty and in the court, from there into the homes of the wealthy, and finally filtering down to the lower social levels. In Mexico the spoon has not yet been adopted by the poorest segments of the social order; they still use the rolled tortilla as a scoop. In our society we not only consider it proper to use a spoon, we have special spoons for special functions: the teaspoon; the sugar spoon; the orange spoon; the grapefruit spoon; a host of serving and cooking spoons—slotted, punched,

Examples of spoons and the special functions they serve in American culture. Left to right: sherbert spoon, dessert or place spoon, serving spoon, round soup spoon, cream-soup spoon, bouillon spoon, iced teaspoon, standard teaspoon, four o'clock teaspoon, demitasse spoon, baby spoon, grapefruit spoon. (Collection of the author.)

and plain—each designed to perform its job most efficiently; and the soup spoon, which may differ according to the nature of the soup. Although for a large part of American society eating has become somewhat ritualistic in form, a spoon too small for our soup is still a point of annoyance; thus a bouillon spoon is not the same as a cream-soup spoon and differs from a standard soup spoon. However, even though we have gained a certain amount of speed and efficiency in soup eating (or drinking), we have not yet reached the sensible approach of the Chinese and Japanese—drinking soup from a small bowl.

When one examines the assorted bowls, cups, and glasses used in Western society, the number is staggering. We have different cups or glasses for coffee, tea, milk, hot chocolate, soup, fruit juice, ice cream sodas, and such special drinks as Cokes and Alka Seltzer. For wines and spirits, the glass used depends not on the general type of liquor, but on the specific type—beer, sherry, claret, burgundy, chablis, champagne, brandy, whisky, or liqueur. And there is a further distinction according to the type of mixed drink—a highball, a whisky sour, a martini, an old fashioned, an Alexander, etc. Dilettanti seem to agree that using the proper glass for a wine adds a special enjoyment to the drink; however, the California wine industry has been maintaining in its advertising [5] that the glass does not make much difference —people should just drink wine.

Thus when we speak of function, such as the function of a glass or spoon, of a complicated tool or machine, or even of a vast complex such as a city, we are speaking of a relative quality; and when we speak of the function of texture, we are speaking of a relative quality of an abstract aspect of form. All people recognize functional texture differences. But how these differences are achieved and developed depends on a number of interrelated factors including, in addition to materials and technology, such abstract considerations as value judgments and philosophies.

Concept

The surface quality of a man-made object depends, to some extent, on the concepts of texture that are prevalent at the time

[5] Consumer advertising sponsored by the California Wine Institute, 1964.

Plate 27. Édouard Manet, "The Spanish Singer," 1860. This early painting, along with others of the artist's Spanish series, was attacked by critics for what they considered a confusion of bright color. (Courtesy, The Metropolitan Museum of Art, New York. Gift of William Church Osborn, 1949.)

Plate 28. Claude Monet, "Old St. Lazare Station, Paris," 1877. With Impressionism, color became a means for creating light and atmosphere. Impressionism marked the beginning of what was to become an interest in color as a method of defining form. (Courtesy of The Art Institute of Chicago. Mr. and Mrs. Martin A. Ryerson Collection.)

27

28

29

30

Plate 29. Georges Seurat, "Une Baignade, Asnières," 1884. Developing what he believed to be a scientific method, Seurat created paintings that depended on carefully juxtaposed dots of color for their form. (Reproduced by courtesy of the Trustees, The National Gallery, London.)

Plate 30. Paul Cézanne, "Mont Sainte Victoire," 1904-1906. This painting exhibits the abstract quality that was the inevitable result of Cézanne's development of color and plane to determine form. (Courtesy, Philadelphia Museum of Art, George W. Elkins Collection.)

Plate 31. Vincent van Gogh, "The Ravine," 1889. It was van Gogh who, recognizing personal expression as the essential quality of painting, brought a new freedom to the use of color. (Courtesy, Museum of Fine Arts, Boston. Bequest of Keith McLeod.)

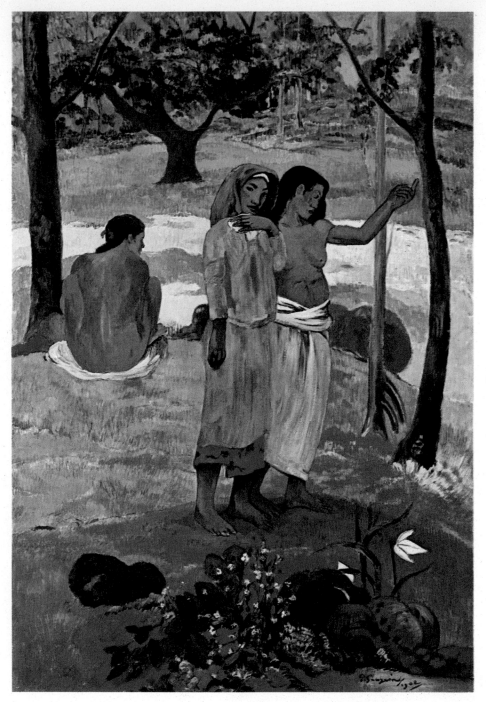

32

Plate 32. Paul Gauguin, "L'Appel," 1902. Advocating the use of pure and sometimes arbitrary color, Gauguin anticipated the time when color was to be a totally independent esthetic element. (Courtesy, The Cleveland Museum of Art. Gift of Hanna Fund and Leonard C. Hanna, Jr., 1943.)

Plate 33. Henri Matisse, "Lady in Blue," 1937. Although still attached to objective form, color is used here for its own sake and its expressive value. (Collection of Mrs. John Wintersteen. Photo courtesy, Philadelphia Museum of Art.)

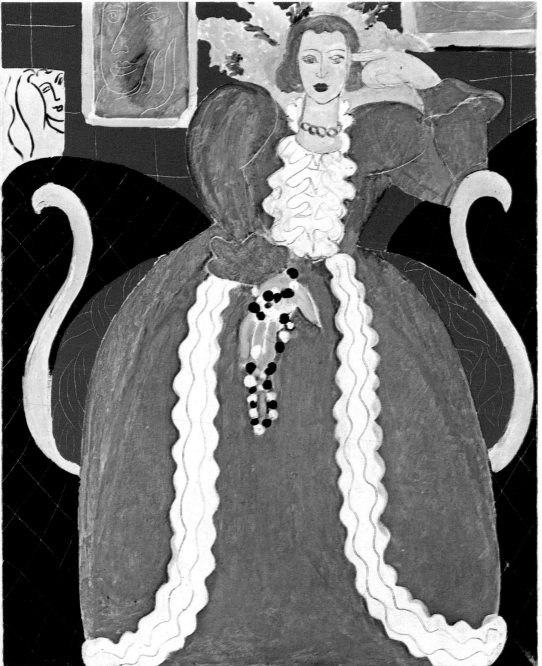

34

35

Plate 34. Wassily Kandinsky, "Improvisation, No. 29," 1912. With the advent of nonobjective painting, the function of color was completely dependent on the expressive desires of the artist. (Courtesy, Philadelphia Museum of Art. The Louise and Walter Arensberg Collection.)

Plate 35. Larry Bell, "Old Cotton Fields Back Home," 1962. Color (by itself) reached its ultimate use as a means of creating an esthetic object in paintings that consist of large, flat, nonobjective fields of color. (Courtesy, The Los Angeles County Museum of Art. The David E. Bright Foundation.)

36

Plate 36. Camille Pissaro, "River, Early Morning," 1888. With Impressionism, paintings began to take on surface qualities that were independent of the nature and form of the subject matter. (Courtesy, John G. Johnson Collection, Philadelphia. Photo, A. J. Wyatt.)

37

Plate 37. "Prince Rahotep and His Wife," c. 2610 B.C.E. Egyptian sculpture, Old Kingdom, Third Dynasty. The Egyptian practice of painting figurative sculpture was an attempt to make it as lifelike as possible. The idea that figurative sculpture — or any sculpture — should reveal the nature of the material of which it is made is a modern concept. (Photo, Hirmer Fotoarchiv, Munich.)

Plate 38. "The Virgin Adoring the Infant," fifteenth century. Polychromed bas-relief from Alsace, France. (Courtesy, Musée du Louvre. Photo, Giraudon, Paris.)

of the object's production. But by and large, appreciation for finishes is cyclic; it is more closely related to the fashion taste of a period than to any absolute quality of the material itself. There is no "right" texture for wood or any other material.

Appreciation for surface quality or texture has shifted periodically from the hand finish to the machine finish and back again, paralleling the development of machine production. As the predominant form of production moved from the handmade to the machine-made, the most desired forms moved from the machine-made to the handmade. Only a few decades ago the machine-made and -finished form was preferred; today the handmade and hand-finished form holds the status position among a large segment of design-conscious Western society. As regularity of finish and texture has become more easily and automatically obtained, esthetic concern has shifted to complex and unique surfaces. Smooth finishes have given way to rough, overlaid surfaces. In

Peter Voulkos, ceramic container. With the absolute regularity of form and surface guaranteed by modern production methods, handi craftsmen have become increasingly interested in forms and surface qualities that deny any relation to mechanical production. (Courtesy, American Craftsmen's Council, New York.)

the area of the crafts, the preference for fine, translucent cast porcelain has been replaced by that for crude, hand-formed stoneware in which the surface displays the emotion of the producer rather than the skill of the craftsman. Highly polished or hand-rubbed wooden finishes have been replaced by those that show the results of exposure to the natural elements. Woven textiles also reflect the new interest in unrefined surfaces; slub textures and textures that depend on irregularity have become most highly prized. Personally expressive surfaces are an integral feature of the work displayed in major middle-twentieth-century craft shows.

Texture in painting

At one time, textures in painting were rendered as they occurred naturally, depending, of course, on the light source. However, this practice has evolved, through a series of well-defined stages, so that today textures are created for their own intrinsic esthetic value, divorced from illustrative qualities.

Naturalism—Adherents and Dissenters

THE RENAISSANCE. During the Renaissance, painting, produced primarily to imitate nature, demanded as much textural fidelity as possible with the tools and media available to the painter. Leon Battista Alberti, in his *Della Pittura* (1436), declared, "So great is the force of anything drawn from nature. For this reason always take from nature that which you wish to paint, and always things will turn out more beautifully." [6] Almost three-quarters of a century later the same type of advice was given to painters by Leonardo da Vinci: "A painter ought to study universal Nature, and reason much within himself on all he sees, making use of the most excellent parts that compose the species of every object before him. His mind will by this method be like a mirror, reflecting truly every object placed before it, and becoming, as it were, a second Nature." [7]

[6] Leon Battista Alberti, *On Painting* (trans. by John R. Spencer), New Haven, Conn.: Yale University Press, 1956, p. 94.
[7] Leonardo da Vinci, *The Art of Painting*, New York: Philosophical Library, 1957, p. 213.

The concepts of naturalism stressed by Leonardo reached their high point in the Mannerist paintings of Michelangelo Merisi (1565–1609), known as Michelangelo da Caravaggio. Although light provided the dramatic effect in Caravaggio's paintings, absolute fidelity to the visual qualities of the surface was in no way diminished. Caravaggio brought a new and clear vision to painting, but his importance was not immediately recognized and his style was not sustained.

The sixteenth century, however, was a period of expansion, a new spirit filled the atmosphere. One result of this spirit was a

Michelangelo da Caravaggio, "Bacchus," c. 1590. Although exhibiting many Mannerist qualities, the work of Caravaggio projected a new sense of naturalism and a feeling for the dramatic. (Photo, Alinari-Art Reference Bureau.)

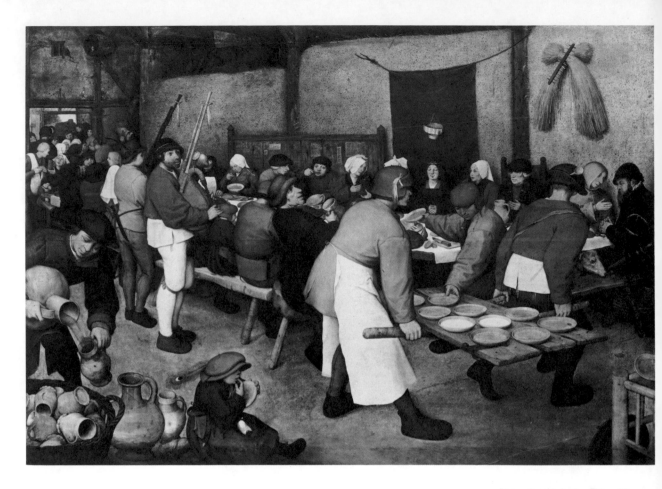

Pieter Brueghel, the Elder, "Peasant Wedding," c. 1565. The paintings of Brueghel, all based on persistent and accurate observations of peasants and village life, can be fully appreciated only if one understands the culture from which they came. (Courtesy, Kunsthistorisches Museum, Vienna.)

broadening in the vision and subject matter of the painter, as seen in the work of Pieter Brueghel (c. 1525–1569). Brueghel illustrated the peasant life of his time in masterful vistas of landscapes and people and provided more intimate close-ups of middle-class culture than had hitherto been available.

THE SEVENTEENTH CENTURY. But naturalism continued to play an important role in paintings in the seventeenth century in both Northern and Southern Europe; however, the paintings were then tinged with an opulent paint surface. The nature of painting had changed by this time, and the wealth of the court and rising middle classes was depicted in rich and sensuous surfaces. One of the most successful painters of the period was Peter Paul Rubens, who, at the peak of his career, was aided by about two hundred apprentices and assistants. Rubens, a cosmopolitan, was at home

in the courts of Flanders, Spain, and Italy, where his work was eagerly sought after. His large, complex paintings, with their intricate and rhythmic compositions, were painted with a fullness of form that shone with the new sensuality. While Rubens was busy in the courts, other painters were beginning to cater to the developing middle classes, by painting portraits of professional men—soldiers, doctors, and members of the various trade guilds.

Peter Paul Rubens, "Rape of the Daughters of Leucippus," c. 1625. Based on the legendary founding of Rome, Rubens's painting displays an opulent paint surface that complements his robust and sensuous forms. (Courtesy, Bayerische Staatsgemäldesammlungen, Munich.)

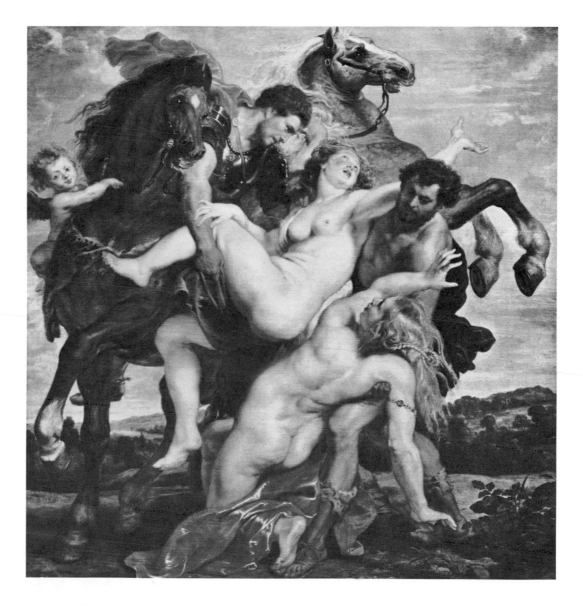

Frans Hals, "Banquet of Officers of the Civic Guard of St. George at Haarlem," 1616. Using a flexible medium, Hals was able to paint with a verve and spontaneity that gave his work an immediacy to which modern man easily relates. (Courtesy, Frans Halsmuseum, Haarlem.)

One of the important painters of this period who contributed a new texture to the painted surface was Frans Hals. By 1616, when Hals received his first major commission—for the group portrait of the company of Saint George—portraits had long been established as a major subject for painters. But one of the demands of portraiture, at least during the greater part of the history of painting, has been the reproduction of a recognizable likeness; and in Flanders during the seventeenth century, this was the accepted rule. In a group portrait, such as the one Hals painted, each person paid for his own likeness; therefore, the success of the painter depended on his ability to satisfy a multitude of patrons. Hals did this. He also organized his figures into complex

compositions in which each figure related to all the others. As Robb pointed out, "Nothing seems to have escaped his eye, from the pattern on the damask cloth, the glinting glass and metal of the beakers and plates, the material of ruffs and doublets to the hands and faces of the men in sharply characterized and individual gestures and expressions." [8]

Moreover, Hals composed his paintings with a spontaneity and assurance that allowed every brush stroke to add to the creation of a surface that was as much characteristic of the paint application as of the subject. Although the texture created by brush strokes had appeared in earlier work by such masters as El Greco (c. 1541–1614) and Rubens, it was not until the work of Hals, especially in the noncommissioned portraits of his drinking companions and their friends, that the texture of the pigment became an independent vehicle for appreciation. In these portraits (see page 103), in which Hals took full advantage of color and value, the vitality of form was established by a dancing surface of paint strokes that, although obviously applied with spontaneity and verve, fall into place to build a solid, recognizable, and powerful three-dimensional form. Hals's ability to create form and texture by this most direct and spontaneous use of pigment is one of the factors that determines our response to his work. His paintings are as meaningful and interesting for the method used in making their statements as for the statements themselves. Hals established a new involvement with his surface—one that, although not taken up by all those who came after him, was important enough to mark a turning point in the nature of painting.

The involvement with paint and surface quality that exists in Frans Hals' work is also seen in the work of Rembrandt van Rijn. The most important of all Dutch painters, Rembrandt was a prolific graphic artist whose work included themes from mythology and the Bible as well as portraits, landscapes, and genre, all of which he produced not only as oil paintings but also as ink and wash drawings and etchings. Although he was deeply concerned with problems of light, his work covered a broad

[8] David Metheny Robb, *The Harper History of Painting*, New York: Harper & Row, Publishers, Incorporated, 1951, p. 523.

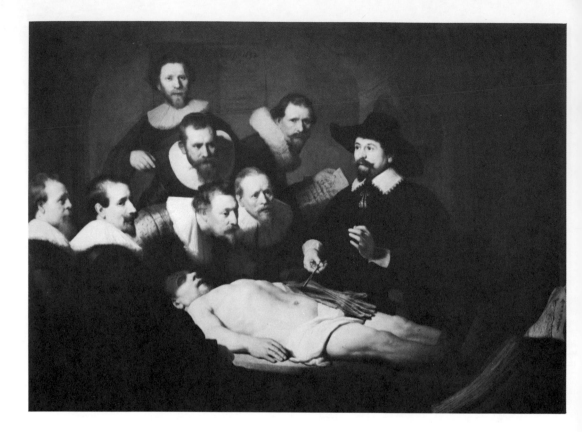

scope of surface and pigment treatments, ranging from the con-
servatively rendered, naturalistic textures that appear in his early
painting "The Anatomy Lesson of Dr. Tulp" to the more heavily
impasto and scummed surfaces that are evident in his later self-
portraits. In some of these self-portraits, the entire surface area
of the head is governed by the textural quality of the paint—
not the spontaneous quality executed by Hals, but one that is
suggestive of built-up stucco.

The use of pigment in this manner was not taken up by Rem-
brandt's contemporaries, because most of the painters of the
period still relied on a naturalistic rendition of texture in which
the application of the pigment was subordinated to the subject
it represented. Naturalism was to be the dominant textural quality
of official European painting for the next 150 years, culminating
in the smooth surface treatment of Jacques Louis David, First
Painter of France under Emperor Napoleon, and that of David's
pupil, Jean Auguste Dominique Ingres.

THE EIGHTEENTH CENTURY. In the eighteenth century, although the use of paint and brush stroke to develop textures other than those of natural representation was still not generally favored, the technique was used by some important painters of the period. One of these was the English painter William Hogarth, who, although involved with too broad a cross section of society to be considered "official," nevertheless was extremely important in the development of British painting. In France, Jean-Baptiste Siméon Chardin (1699–1779), in his genre painting, built up still-life forms with textured layers of paint, and Honoré Fragonard (1732–1806), who more typically recorded the rococo life of the French court or the rosiate bloom of the boudoir, used pigment textures in some of his portraits of lower-ranked personages.

In Spanish painting, the textural qualities imparted by media and brush strokes had appeared in the works of the two most important painters supported by the Spanish court, Diego Velázquez (1599–1660) and Francisco José de Goya y Lucientes.

Left: Rembrandt van Rijn, "Self-Portrait," 1659. This portrait exhibits Rembrandt's later interest in surface texture as a means of expressing form. (Courtesy, National Gallery of Art, Washington, D.C., Mellon Collection.)

Right: Jean Auguste Dominique Ingres, "Madame Rivière," 1806. This seemingly naturalistic portrait, with its sensuous textural qualities, was considered structurally unsound and bizarre when first exhibited in the Salon of 1806. (Courtesy, Musée du Louvre, Cliché des Musées Nationaux.)

William Hogarth, "The Shrimp Girl." In his portraits of members of the lower class, Hogarth revealed the emerging values of the middle-class culture of which he was a part. (Courtesy, National Gallery, London.)

Goya's reliance on paint and brush stroke to develop texture and define form is seen not only in much of his oil paintings but also in his magnificent frescoes in the cupola of the Church of San Antonio de La Florida.

Toward the end of the eighteenth century, there were two painters who developed the expressive textural qualities of the brush stroke and pigment; and their work, extending into the nineteenth century, constituted brilliant exceptions to the dominant style. These were the English painters Joseph Turner and John Constable. They worked with landscapes, and their paintings possess surface qualities that were not to be repeated until the middle of the twentieth century.

Top: Diego Velázquez, "The Maids of Honor," 1656. This painting reveals Velázquez's ability to define form with an almost Impressionistic understanding of light and shape. (Courtesy, Museo del Prado, Madrid.)

Bottom: John Constable, "Stoke-by-Nayland," 1836. Constable's interest in the sky and atmosphere brought a new surface quality to painting. (Courtesy, The Art Institute of Chicago, Mr. and Mrs. W. W. Kimball Collection.)

THE NINETEENTH CENTURY. Although the neoclassicism of David was the officially recognized style during the French Revolution and the turbulent years that immediately followed, texture became expressive of the paint as well as of the subject in the work of the more romantically oriented painters. This is evidenced in the work of Théodore Géricault; his masterpiece "The Raft of the Medusa" was painted with a hatching technique making use of small brush strokes and a quick-drying oil but when "shown in the 1819 Salon . . . was taken as the work of a hastily ambitious student and discussed mainly for its political implication." [9] Eugène Delacroix, who brought Romantic painting to full fruition, also gave texture a prominent place in his work. In his "Scenes of the Massacres at Chios," entire areas depend on texture to define and maintain form.

[9] Jack Lindsay, *Death of the Hero: French Painting from David to Delacroix*, New York: Studio Books, The Viking Press, Inc., 1960, p. 140.

Théodore Géricault, "The Raft of the Medusa," 1818–1819. Géricault's revolutionary masterpiece broke with the Academy in a flush of dramatic realism that brought color and texture to a new level of expression. (Courtesy, Musée du Louvre, Cliché des Musées Nationaux.)

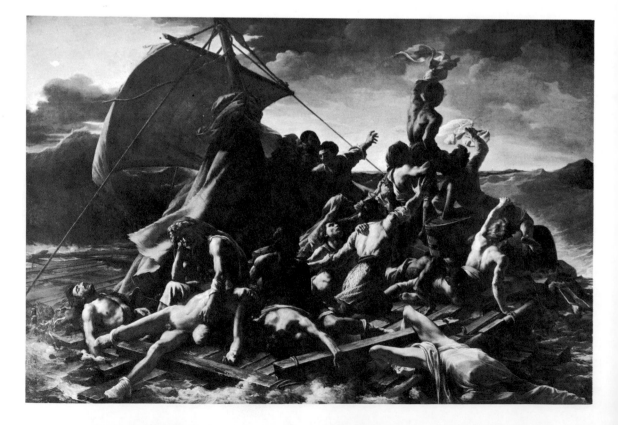

The technique of creating texture from paint was further advanced by the French landscape painter Camille Corot and the emerging realist Gustave Courbet (1819–1877). Establishing themselves as independents removed from the official tradition of the Academy and Salon, these men painted with a deep concern for surface quality and successfully replaced the Romantic with the Realistic. The most impressive examples, up to this time, of texture used as a plastic element are Corot's figure studies, paintings the artist apparently considered less important than his landscapes. Of the three thousand paintings Corot executed during his lifetime, three hundred were single figure studies, but, of these, only two were shown by him.

Jean Baptiste Camille Corot, "The Interrupted Reading," c. 1865. Although always subordinate to the reality and esthetics of the image, Corot's paintings induce a growing awareness of surface quality. (Courtesy, The Art Institute of Chicago, Potter Palmer Collection.)

With the work of Honoré Daumier (1808–1879), texture assumed a new stage of independence. Using texture as he used color, Daumier was able to define entire areas within his paintings with texture alone. However, he earned his living as a political cartoonist and caricaturist, so his work was not considered seriously. Daumier was far ahead of the mainstream of nineteenth-century painters, and he developed textural qualities that were not to appear again until almost three-quarters of a century later.

Impressionism

As the nature of painting and its subject matter and purpose for being changed, its plastic elements also began to undergo change. Thus the paint surface and brush strokes that appeared in the work of El Greco and Rubens became increasingly important as elicitors of a response in the work of major painters of the eighteenth and nineteenth centuries. For example, the paintings of Édouard Manet were not only brilliant in color and decisive in vision but also maintained the quality of the painted surface.

Édouard Manet, "A Bar at the Folies-Bergère," 1881–1882. In this, Manet's last major painting, the form of the shimmering image reflected in the mirror behind the barmaid has been created by brush stroke and texture. (Courtesy, The Courtauld Institute Galleries, London.)

Manet used colors so that their vitality was increased by the surface quality they exhibited.

Until this period in the history of painting, texture always played an accompanying role to the creation or delineation of form, a role the Impressionists intended to maintain. Searching for a new way to define form through color and light, they divided each color into its component elements; these they placed on canvases in a juxtaposed position in the hope that the elements would be reunited in the eye of the observer. In the paintings in which they succeeded, the Impressionists achieved far more brilliant, sunlit, scintillating colors than would otherwise have been obtainable. However, the technique introduced a new textural image into painting. Texture that lent itself to the creation of light and color created an insistent surface that could not be ignored. Thus the paintings began to elicit a response to their textural qualities that was no longer related to their subject-matter form (see Plate 36). In the paintings of Camille Pissaro, Claude Monet, and Alfred Sisley, Impressionism found its truest expression—an expression that was formalized into a more rigid textural pattern by the Pointillist Georges Seurat.

Supported by the newly developed textural imagery of the Impressionists, the Postimpressionists began to use texture as a means of personal expression. The implications of this new role for texture, although certainly recognized by earlier painters, were never displayed so fully as by the Dutch master Vincent van Gogh. In van Gogh's work, texture assumed an emotional role apart from all other considerations of form. An applied or patterned texture is present in most of his paintings and is a consistent factor in his drawings. Using texture to establish rhythms and movement, van Gogh gave his work a personal intensity and meaning that were to lay the groundwork for modern Expressionism.

The textural qualities in van Gogh's paintings, which had their origin in the brush strokes of Impressionism, were continued in the work of Pierre Bonnard (1867–1947), whose paintings are rich with texture and color. But texture continued to be only an accompaniment to subject matter and was carried into the twentieth century still related to recognizable forms. Henri Matisse moved it into decoration and pattern; Georges Rouault (1871–1958) developed heavy impasto paint surfaces; and men such as Oscar Kokoschka (b. 1086) and Chaim Soutine (1894–1943) used it to maintain their Expressionistic efforts.

Left: Vincent van Gogh, "Stairway at Auvers," 1890. The textures of van Gogh's paintings often create a dynamic rhythm - that dominates whatever he has painted. (Courtesy, City Art Museum of Saint Louis.)

Right: Chaim Soutine, "Portrait of Moise Kisling." The subject of this painting is still related to an objective image, but its texture is divorced from objectivity in a manner that was to become basic to Abstract Expressionism. (Collection of the Philadelphia Museum of Art; photo, A. J. Wyatt.)

Expressionism

The ultimate role of texture in painting was reached in the twentieth century, when texture began to elicit an esthetic response of its own; texture and image then became one element. Because of the nature of surface, however, this occurred somewhat obliquely. All surfaces carry the implication of both color and texture. But color, because it is more easily manipulated and more readily conceived theoretically and mystically, was first to gain the position of independent existence. However, what was seen to be true for color soon came to be accepted as true for texture also.

The consideration of color and texture as total art forms capable of eliciting meaningful esthetic responses had two sponsors—the theories of nonobjective art formulated by Wassily Kandinsky and the emerging concern about the state of man's psyche. Kandinsky declared that color and subjective form are the key factors in the art experience and linked them to his *principle of internal necessity*; this principle established, for the painter,

the rationale of nonobjective painting and Abstract Expressionism. And concern for the psyche, reinforced by the work of Sigmund Freud, provided the support needed for an art form based on or received from the subconscious.

Having eliminated subject matter from his work, Kandinsky produced the first nonobjective painting in 1910. Two years later, he published his rationale for nonobjective painting in a small book called *Concerning the Spiritual in Art*. Subsequently his concepts became so widely and enthusiastically accepted that by 1947 nonobjective painting was commonplace. Its proponents divided into two general camps: one group based its work on personal expression or action and projected a heavily textured surface in which each application of paint left its textural as well as its color mark; the other group used calculated geometric or semigeometric compositions in which primarily flat applications of color were used to create a unified, symbolic image. The English painter and critic Patrick Heron referred to these, respectively, as the "hard" and the "soft" abstractionists. Of the soft abstractionists, he said that their surface areas were as "painterly [and] as rich and diverse in colour, texture and handling as those of the impressionists and post impressionists." [10]

Of all the painters involved with the primacy of textural surfaces, Jackson Pollock and Mark Tobey (b. 1890), both Americans, have perhaps been the most significant. More than any other painter, Pollock, whose life was cut short by an automobile accident, was responsible for the public's image of nonobjective Abstract Expressionist action painting. Turning to the nonobjective method only after examining several other directions, he involved his total body in his work; he spread his large canvases on the floor and usually poured or dripped the paints from sticks. Pollock's canvases display a wide variety of rhythmic and textural patterns that range from a powerful, direct, slashing image to one of lyric delicacy. Although his paintings project spontaneity and kinesthetic force, they are highly ordered and indicate a control that fails to appear in the work of many of his imitators. Pollock's approach to the nonobjective form was primarily calligraphic in that it was the result of controlled line.

[10] Sheldon Cheney, *The Story of Modern Art*, New York: The Viking Press, Inc., 1958, pp. 633–634.

Top: Jackson Pollock, "Number 1," 1948. Having eliminated subject matter, nonobjective painting often demands a consideration of the textural rhythms that form an image. (Collection, The Museum of Modern Art, New York. Purchase.)

Bottom: Mark Tobey, "Written over the Plains," 1950. Based on Chinese calligraphy, Tobey's paintings exhibit a texture that dominates the individual qualities of his brush strokes. (Courtesy, San Francisco Museum of Art. Gift of Mr. and Mrs. Ferdinand Smith.)

This is also the approach taken by Mark Tobey. Of his own work, Tobey wrote, "According to one critic, my works looked like scraped billboards. I went to look at the billboards and decided that more billboards should be scraped. . . ." [11] Highly involved in mysticism, Tobey's paintings are an extension of his philosophic and religious beliefs; since 1935, they have consisted of calligraphically textured surfaces that William Seitz has described as follows: "His surfaces are worked with brush strokes that can be explosively bold, but are more often as delicate as the strands of a spider web or as ephemeral as smoke rising from a cigarette." [12]

Another type of nonobjective Abstract Expressionism that makes use of textural qualities consists of paintings whose images are primarily dependent on color and brush strokes. This style can be related back to the work of Chaim Soutine or Pierre Bonnard—but with the added stipulation that nonobjective forms be the subject matter. Philip Guston (b. 1912), one proponent of this technique, is an American painter who, in his early work, created realistic, romantic figures. However, he emerged into a period of symbolic realism heavily endowed with social commentary, and from this stage, in 1950, he shifted to a completely nonobjective style. One of his better-known nonobjective paintings, "Dial," was described by John Baur, associate director of the Whitney Museum of American Art, as seemingly "Withdrawn, complex, and infinitely subtle." In describing the work further, Baur said, "It is as if the artist's brush had endlessly probed the surface, searching its way through the delicate nuances of touch and color until it emerged with the bolder but still tentative areas of red in the center." [13]

Thus, in the development of painting, texture has emerged from its earlier function of imitating natural surfaces and from its position of subservience in the total esthetic response. Today, surface quality (texture) and color assume the primary role in determining esthetic appreciation when forms are devoid of any apparent subject matter or recognizable stimulus. One segment

[11] Allen S. Weller, *Art: U.S.A.: Now* (Lee Nordness, ed.), New York: Studio Books, The Viking Press, Inc., 1963, vol. I, p. 46.

[12] William C. Seitz, *Mark Tobey*, New York: The Museum of Modern Art, 1962, p. 34.

[13] Lloyd Goodrich and John Baur, *American Art of Our Century*, New York: Frederick A. Praeger, Inc., 1961, p. 222.

Philip Guston, "Dial," 1956. The esthetic value of this painting has been defined in terms of the artist's expressive search for texture and color. (Collection, Whitney Museum of American Art, New York.)

of the contemporary art world maintains that "real" art immediately and universally elicits an esthetic response and that the absence of subject matter and recognizable stimulus aids this process. However, it is a mistake to assume that because these elements are missing the esthetic response is either direct or immediate. Often an observer can achieve the deepest response only after a period of learning, consideration, and contemplation. Without subject matter as a convenient device from which to derive meaning, more formal or sensually direct responses must be established.

Collage

Before leaving the subject of painting in our consideration of texture, we must recognize the importance of *collage* as a pictorial form in which texture is a primary aspect. Cutting and pasting paper to make decorations has been a popular art ever

232

Kurt Schwitters, "Cherry Picture," 1921. A collage consists of fragments of real material; the next step, illustrated here, uses pictures originally produced for other purposes. (Collection, The Museum of Modern Art, New York; Mr. and Mrs. A. Atwater Kent, Jr., Fund.)

since printed papers became an inexpensive, middle-class commodity. The creation of "pretty" pasted pictures (*découpage*) was a nineteenth-century pastime; however, it was not recognized as a serious art form until the second decade of the twentieth century. When collage finally gained status, it served the purpose of providing a real surface—one that existed in its original form rather than as a representation of it. And, as such, collage also provided new support for the independence of the artists' images. No longer did graphic images have to be appreciated for the skill demonstrated in copying a surface, because the original surface and form were part of the final form. Paintings and constructions could be appreciated for their more formal elements—composition, arrangement, texture, color, etc.

Although visualization of natural forms has traditionally played a major role in painting, only a relatively small number of pieces were so executed as to deceive the viewer into thinking he was seeing real forms rather than pictures of them. It was not until the Renaissance, however, that this type of painting, usually referred to as *trompe-l'oeil*, became significant. In Italy at that time entire walls were painted in a manner and style to show non-existent space and architectural detail, and in Holland and Flanders a large number of pictures appeared depicting the bountifully laden sideboard or dining table. The tradition, which waned during the eighteenth century, was picked up by the nineteenth-century American painters Raphael Peale (1774–1825) and William Harnett (1848–1892).

Typical paintings of the genre are those in which various objects were depicted, pasted, tucked, or hung onto a flat, usually weathered, surface. One of Peale's most important works, painted in 1802 and called "Deception," shows a meticulously rendered paper surface, cracked and dog-eared, to which various tickets and announcements were fastened. Carefully arranged water-stained, creased, written-on, and printed papers that were cut, folded, and torn display the virtuosity of the painter's technique. Although a portion of the observer's response is certainly due to the formal elements of the painting, no small part is due to the incredible skill demonstrated in rendering a variety of surfaces. Harnett's paintings, which had much the same type of attraction as Peale's, were extremely popular and were reproduced lithographically for wide distribution.

The tradition of collage can certainly be related to this type of painting, as evidenced by the fact that rendered surfaces and letter forms appeared in the paintings that immediately preceded the first Cubist collages. Although it was but a short step from rendering surfaces and letters to including actual newspaper segments with printed lettering, it was a major stride in the history of painting. Wood-grain papers, newspapers—especially *Le Journal* —and fragments of wallpaper made up the majority of pasted forms in Cubist collages. The three painters most responsible for the establishment of collage as a modern art form were Pablo Picasso, Georges Braque (1881–1963), and Juan Gris (1887–1927). The technique was also used to a limited extent by the Italian Futurists and extensively by the Dadaists (primarily a

Right: William Harnett, "Old Models," 1892. This painting relies on the painter's ability to create the illusion of three-dimensional form, including the careful imitation of surface qualities; the style is very popular. (Courtesy, Museum of Fine Arts, Boston, Charles Henry Hayden Fund.)

Far right: Juan Gris, "Breakfast," 1914. In an effort to eliminate false illusion from their work, the Cubists substituted bits of real wallpaper or newspaper for rendered images of them. (Collection, The Museum of Modern Art, New York. Acquired through Lillie P. Bliss bequest.)

literary movement that started in Switzerland as a protest group during World War I) and the Surrealists, who saw in it a way of projecting psychoanalytical meanings by including objects brought together because of their disassociative or shock value.

Kurt Schwitters (1887–1948), an important German Surrealist who eventually produced entire rooms by the collage technique, created a type of construction now known as *assemblage,* the act or product of assembling parts. Emerging from the concepts of collage, this type of art consists of images or pictures put together of discarded materials—pieces of junk wood or metal, wastepaper, etc.—in both bas-relief paintings and full, three-dimensional

Kurt Schwitters, "Merzbau," c. 1920–1930. During the 1920s and 1930s, Schwitters built constructions that carried the concept and form of assemblage to the total environment. (Courtesy, Niedersächsische Landesgalerie, Hannover.)

constructions or sculpture. And because texture is capable of evoking responses apart from all other elements, the textural qualities of the assembled materials contribute to the observer's esthetic involvement. But in spite of this, it should be remembered that in *assemblage*, as in many other modern art forms, the prime concern is the ability of the total form to motivate psychologically oriented responses within the observer. Robert Rauschenberg (b. 1925), one of the more highly publicized contemporary producers of *assemblage*, has said, "I am trying to check my habits of seeing, to counter them for the sake of greater freshness. I am trying to be unfamiliar with what I am doing. . . . If you do not change your mind about something when you confront a picture you have

not seen before, you are either a stubborn fool or the painting is not very good." [14]

During the late 1950s and the 1960s, the *assemblage* concept was expanded to the production of total environments from which could be solicited a variety of responses—from social observations to psychedelic reactions to nonobjective color, pattern, light, and sound. Having moved from traditional painting and sculpture to *assemblage* and total environments, the next step was not difficult —the *happening*, essentially a form of psychodrama, with or without script, in which an improvised acting out of individual or group responses provides not only the form of the action but also its content. The significance of "happenings" perhaps lies more in their rejection of painting and sculpture as art forms than in their own esthetic worth.

Texture in sculpture

The development of texture in relation to sculpture followed a pattern similar to its development in relation to painting. As in painting, texture was first used in sculpture to portray realistically the surfaces of natural and man-made forms and progressed to its current use in the art of *assemblage*. Throughout its chronology, the surface quality of sculpture, again paralleling that of painting, continually changed to conform to the prevailing attitudes and concepts of art in the periods through which it passed. But in addition to the factors that influenced the textural aspects of both painting and sculpture, two factors related uniquely to sculpture: (1) the wider range of materials and processes available to the sculptor and (2) the fact that the observer is often concerned with a tactile texture rather than a visual one, in spite of the museum guards hired to keep people from touching the pieces.

Although the painter has several media—tempera, oils, plastics, water colors, etc.—and a variety of surfaces—plaster, wood, paper, canvas, silk, etc.—with which to work, neither these nor the methods of application can compare in scope to those available to the sculptor. (The exception, of course, is in the art of *assemblage*, where the painted and the sculptured forms merge.)

[14] William C. Seitz, *The Art of Assemblage*, Garden City, N.Y.: Doubleday & Company, Inc., 1961, p. 116.

quality and most often lacks sharp edges or angular planes. Pieces that are cast usually have more of the qualities of modeled work than those of carved, even though a metal such as bronze is much harder and denser than materials used for modeling. Assembled work usually reflects qualities of the machined or worked surface.

In examining the sculpture of the periods of Western civilization, we find once again that texture was most often geared to the nature of the material and the process used for working on it, each material providing its own range of technique possibilities. Of course, the single most important skill that all groups developed during their earliest periods was the ability to handle materials. The goal usually seemed to be to work the materials so they would be as highly wrought and finished as possible.

Primitive Sculpture

The earliest pieces of sculpture certainly were not valued because of any esthetic or sensual response to texture. As with other early art forms, sculpture was significant only because of the magical or symbolic powers it possessed. The form and its surface quality were determined by the materials available, the methods used in working them, and the nature of the subject. Neither the form nor its surface were considered apart from the totality of the object.

This attitude is still evident in the work of various ethnic or social groups that are usually referred to as primitive. But in relation to the arts, *primitive* is a rather ambiguous term and, at best, can be interpreted only to mean the work of people untrained in either a major Western or Eastern tradition. The term cannot refer to either the merit of the work, its degree of sophistication in relation to form, or its technique. Primitive has been used to describe such highly sophisticated forms as the twelfth-century cast bronze heads of Ife as well as the naive, incised shell pendants of the twentieth-century Australian aborigines. So-called primitive sculptures show the widest possible range of textural qualities because of the multitude of materials and techniques used to produce them. But although we of the twentieth-century West may consider the formal aspects of surface qualities when judging the sculptures, this consideration usually had no place in the original judgment of the sculptures' value or worth. Only in cases in which the surface

Ife heads, twelfth century. Cast in bronze by the lost-wax process, these heads demonstrate the high degree of sophistication attained by a so-called primitive culture. (Photo, courtesy of the American Museum of Natural History.)

quality demonstrated the carver's or image maker's skill do we find exceptions to this rule. The skill necessary to produce a highly polished or intricately carved texture differs from that needed to produce a relatively crude surface, and anthropological reports have indicated that in some African tribes the works of certain carvers are preferred because of the greater skill displayed in the finishes. However, the magical power the pieces contained was no greater than that in the work of lesser carvers.

Egyptian Sculpture

The sculpture of the Egyptians was primarily stiff and frontal in concept and execution, but the surfaces indicate a desire to project images as naturalistically as the materials and concept would allow. Wood, alabaster and terra cotta, and limestone figures were stuccoed and painted. And although symbolic conventions were maintained, the figures project a finish that relates them directly

to the original form. In addition to the materials mentioned, the Egyptians also used, primarily for durability, hard materials such as granite, quartzite, and diorite. The materials were finely carved and highly polished, a process that, considering the primitive techniques available, depended on a large work force, a great deal of time, consummate skill, and infinite patience. However, even the statues made of these hard materials were painted, and for highly polished surfaces, this probably required an undercoat of a stucco whitewash. The purpose of painting the work is clear: ". . . the painting of statuary did not arise from a desire in the ancient artist for aesthetic effect, but from the necessity to make his statue into as life-like as possible a replica of the man whom he was engaged in portraying. Without the colours of life (as conceived conventionally according to Egyptian standards) the statue was incomplete." [15] Thus the appreciation we feel for the unpainted, highly polished carvings and figures of the Egyptians is an esthetic awareness that was not part of the tradition followed by the Egyptian craftsmen (see Plate 37).

Greek and Roman Sculpture

The Greeks, whose sculptural forms began with the stiff, frontal qualities of the traditional Egyptian sculpture, also used a wide variety of materials—wood, limestone, marble, bronze, terra cotta, and some gold, silver, and ivory. Silver and gold generally were used only for small figures and reliefs. However, gold was combined with ivory to make the so-called chryselephantine statues, usually large and important figures, in which the ivory was used for all exposed skin surfaces and the gold was used for the rest of the figure. The 40-foot-tall "Athena Parthenos," with its face and arms of ivory and its draperies of hammered gold, was one of the two major chryselephantine figures sculptured by Phidias.

Bronze was the material most commonly used by the Greeks for sculpture, but the number of surviving examples is small. Apparently, during various periods of history, most of the statues were melted down in order to recast the bronze for other uses. From those that remain, however, we have learned that large

[15] William Stevenson Smith, A *History of Egyptian Painting in the Old Kingdom*, 2d ed., Fair Lawn, N.J.: Oxford University Press, 1949, pp. 107–108.

figures were worked in parts that were later assembled to form the complete statue. The work was both forged from sheets, which were often riveted together to a wooden form, and cast, by the lost-wax method. Even with cast ware, however, the statues were carefully worked after they had been removed from their molds. The modeling was sharpened, surfaces were smoothed, and body hair was often engraved. Color was obtained by the use of varnishes or paints that modified the raw quality of the newly cast metal; thus flushed or pale cheeks or sunburn could be indicated. In order to project a more naturalistic quality, in some cases the lips and nipples of the figures were inset in copper, ornaments were added in gold or silver, and eyes and eyelashes were either inset or painted.

Greek sculptors made an effort to achieve a naturalistic quality in both color and texture, regardless of the material they worked with. On the sculpture of wood (a medium used extensively in the early archaic period), as on that of limestone, marble, and terra cotta, the figures were carefully painted; and although the nature of the colors changed during the several distinct periods of Greek art, the ones used were usually fairly bright and basic—red, yellow, blue, violet, some black, white, and brown, and occasionally green. Coats of punic wax and oil were then applied to the painted statues to maintain and protect the brilliance of the color and the polish of the surface. Lawrence has noted that "in the fourth century the custom of polishing the surface was carried to such a degree that the muscles lay merely suggested beneath the gloss." [16] The mixture of wax and oil was applied with some degree of regularity (specialists were employed for the purpose) and gave the statues a warm, soft, glowing smoothness.

Color and finish were important elements in Greek sculpture, but not in the same esthetic sense that they are today. Color was based primarily on a system of conventionalized naturalism, with interest in it growing during the Hellenistic period. The painting of a statue was often as important as its carving. Paint was applied to all statuary including bronze and "at all periods gilt was applied to portions of marble statues, occasionally (especially in later times) to the whole figure; and sometimes

Right: "Charioteer," from the sanctuary of Apollo at Delphi, c. 470 B.C.E. Originally part of a larger sculpture including the horses, this figure is one of the few extant examples of full-size Hellenic bronze sculpture. (Photo, Hirmer Fotoarchiv, Munich.)

Far right: Torso of a man, bronze, found near Rome. The round depressions originally held inset nipples (most likely of copper) to achieve a more naturalistic quality. (Courtesy, The Metropolitan Museum of Art, New York, Rogers Fund, 1920.)

[16] Arnold Walter Lawrence, *Classical Sculpture*, London: Jonathan Cape, 1929, p. 32.

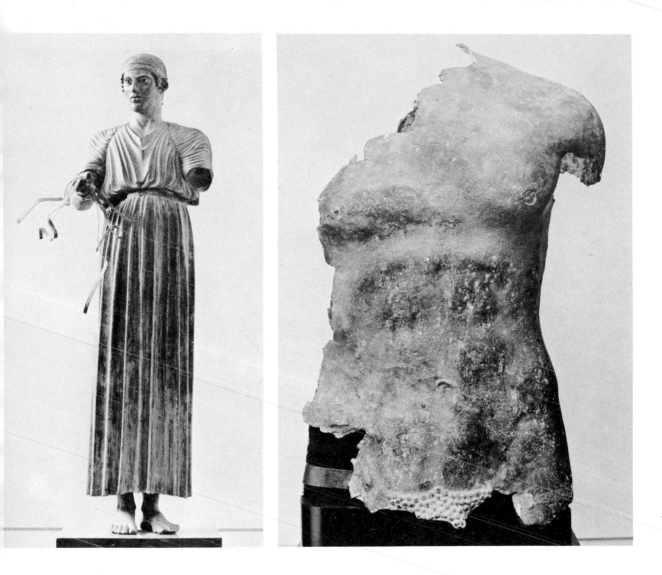

marble was painted to resemble bronze." [17] According to Pliny, Praxiteles considered those statues painted by the famous painter Nikias to be his most valued, and Richter cites an "inscription from Delos of the third century B.C., which records equal sums paid to the sculptor of a statue and to its painter." [18]

Roman sculptors closely followed the Greek patterns, with the exception that they were even more concerned with naturalism; to this end, the Romans raised the sculptured portrait to new

[17] *Ibid.*, p. 54.
[18] Gisela Richter, *The Sculpture and Sculptors of the Greeks*, New Haven, Conn.: Yale University Press, 1930, p. 156.

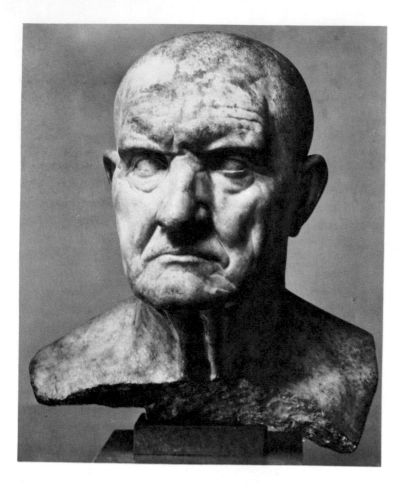

Portrait of a man, first century B.C.E. Roman sculpture exhibits a realism that was an extension of Hellenistic naturalism. (Courtesy, The Metropolitan Museum of Art, New York, Rogers Fund, 1912.)

heights of realism. In relation to texture, the increased realism was simply an extension of the attitudes developed during the Hellenistic period, but with more attention paid to lines and wrinkles of skin and fabric. Naturalism was well in keeping with the narrative style of the Roman art forms.

Christianity's Effect on Sculpture

With the advent of Christianity, sculpture was relegated to a subordinate role in the development of the arts, and the production of monumental sculpture was temporarily stopped. But, as evidenced in the limited amount of work that was produced, the attitudes concerning surface treatment continued in a direct line from the Hellenistic and Roman.

244

It was not until the Carolinginan dynasty, when, under the sponsorship of Charlemagne (reigned 768–814), the art of ivory carving was brought West by Byzantine exiles, that there were faint stirrings of a reviving interest in sculpture. However, although the Byzantine influence introduced small, carved ivory reliefs, these followed the tradition of Eastern miniature painting and presented surfaces completely covered with color and gilt. No attempt was made to establish either the surface quality of the material or its esthetic value.

This period was followed by that known as the Ottonian, which lasted from the middle of the tenth century to the beginning of the eleventh. It was during this period under the Saxon kings, especially Otto I, II, and III, that Germany became the most influential and powerful nation in Europe. Although the art forms were still affected by the Byzantine tradition, they took on a new vitality, which has been recognized as the rugged realism that even today occurs in Germanic art. In spite of this, however, sculpture was limited either to an extension of the Byzantine concept of the miniature or to wood carving, which was used for the few large pieces that were produced.

Romanesque and Gothic Sculpture

The reemergence of stone sculpture in Western Europe in the last half of the eleventh century can be attributed to the general growth of the religious fervor that resulted in the building of more and larger churches—churches that utilized sculpture and ornamentation. During this period, sculpture was conceived and executed as part of the architectural system on which it appeared, and usually the same craftsmen who were employed to build were also employed to carve. Because realistic representation was not a particular value of the era, the builder-sculptor did not hesitate to make the figures conform to the architectural form.

To our eyes, most of these early churches appear to be monochromatic structures, but we know not only that the interiors, including the sculpture, were highly colored but that color was also used on the exteriors. During the Romanesque period, the exterior figures tended to be flat and completely attached to the buildings. During the Gothic period, although the figures were still attached to the buildings, they were carved to stand out

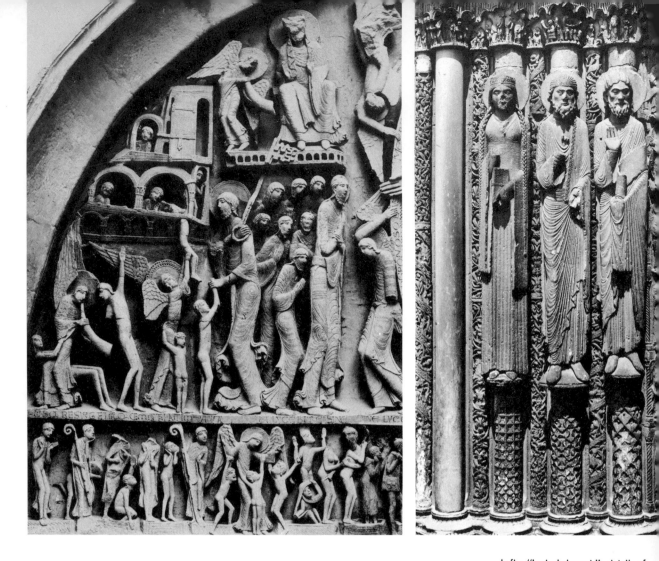

farther from them. In both eras, however, the figures were polychromed: on some, color was applied directly to the stone; on others, a coat of gesso was applied first. Figures inside the churches were made of either local stone or wood and received the same polychrome treatment. Gilt was also used, especially for crowns and halos and often for border designs on drapery. The colors were conventionalized "and were not chosen with the purpose of reproducing closely those observed in actuality, but rather with the idea of creating agreeable decorative effects." [19] Thus color was of primary importance to Romanesque and Gothic

[19] R. Post-Chandler, *A History of European and American Sculpture*, Cambridge, Mass.: Harvard University Press, 1921, p. 32.

sculpture, as it was in the Egyptian and Greek periods, but texture as we consider it today was not a factor in either the understanding or appreciation of the statues.

During the Gothic period, there was a shift to a more naturalistic use of color and, in some of the tomb effigies, a more realistic texture treatment of skin, hair, and fabrics. Devotional statues, often depicting the Virgin and Child or the Pietà (the seated figure of Mary with the dead Christ on her lap), produced during the fourteenth century, which is considered still part of the Gothic period, were carved of wood, usually covered heavily with gesso, and painted. And although the forms often expressed current mysticism, the textural involvement was primarily narrative. Color and texture were used only to increase the sense of realism (see Plate 38).

In England, tomb effigies were a popular sculptural form and were made of many materials, the most common being alabaster and wood. Alabaster lends itself to a wide variety of surface treatments: it can be polished to a soft, translucent glow or given a dull eggshell finish; it can be immersed in boiling water to make it appear opaque; and it can be stained, painted, or gilded. All these techniques were known and used by fourteenth-century carvers. Sometimes, tinted alabaster faces were set into stone figures to achieve greater naturalism. And on both the alabaster and the wooden figures, which were coated with gesso and painted, accessories were added. These were often of silver, gold, or semi-precious stones; in addition, metallic foils, carefully fitted under glass, were used to make decorative borders.

The Renaissance

The Renaissance began in the fifteenth century with a quiet shift away from the high Gothic of the fourteenth. And with this shift came the ideas that were to lead eventually to many of our modern concepts of art, including those that relate texture to sculpture. In earlier times, the sculptural image had expressed a sense of symbolic reality; form, color, and texture were used to create an immediate presence—crude and poorly executed sometimes and conventionalized at others, but always direct in appearance and position.

During the Renaissance, art took many directions, one of the most interesting and significant of which was an increase in

the attention paid to the more formal qualities of the art form. An offshoot of this new concern was interest in antiques. In 1550, Giorgio Vasari (1511–1574) wrote of the attention given to the sculpture of the Greco-Roman period by the important sculptors of the Renaissance and of the part this interest played in the contemporary sculptors' esthetic considerations.

Although statues are often destroyed by fires and by the ruin and fury of war, and buried or transported to divers places, nevertheless it is easy for the experienced to recognize the difference in the manner of all centuries; as, for example, the Egyptain is slender and lengthy in its figures, the Greek is scientific and shows much study in the nudes, while the heads have almost all the same expression, and the most ancient Tuscan is laboured in the hair and somewhat uncouth. That the Romans (I call Romans, for the most part, those who, after the subjugation of Greece, betook themselves to Rome, whither all that there was of the good and the beautiful in the world was carried)— that, I say, is so beautiful, by reason of the expressions, the attitudes, and. the movements both of the nude and of the draped figures, that it may be said that they wrested the beautiful from all the other provinces and moulded it into one single manner, to the end that it might be, as it is, the best—nay, the most divine of all.[20]

Renewed interest in the classical form was accompanied by a new concept of naturalism, one that recognized sculpture as a representational image to be naturalistically projected within the limits of skill and material. This new concept was to have a direct bearing on the relation of texture to the sculptured form. The realism that had been provided by color on the painted surfaces was replaced by the naturalism that sculptors could obtain in the surface finish by working in the most valuable materials available to them—marble, bronze, and the precious metals. Vasari, who was certainly aware of the esthetic tenor of his period, in describing the work of the Renaissance sculptors, gave high praise to their ability to make marble appear as flesh. Of the figures on the Sienese fountain carved by Jacopo della Quercia (1374/5–1438), a fountain so famous that the sculptor came to be known as Jacopo della Fonte (Jacob of the Fountain) after its completion, Vasari wrote, "Whereas Jacopo made them as soft as flesh, giving

[20] Giorgio Vasari, *Lives of the Painters, Sculptors, and Architects* (trans. by Gaston du C. DeVere), New York: Dutton Everyman Paperbacks, E. P. Dutton & Co., Inc., 1912–1915, vol. I, p. 124.

finish to his marble with patience and delicacy." [21] And of the "Pietà" of Michelangelo Buonarroti, whom Vasari considered the greatest of all the sculptors, he wrote,

Among the lovely things to be seen in the work, to say nothing of the divinely beautiful draperies, is the body of Christ; nor let anyone think to see greater beauty of members or more mastery of art in any body, or a nude with more detail in the muscles, veins, and nerves over the framework of the bones, not yet a corpse more similar than this to

[21] *Ibid*., vol. II, p. 95.

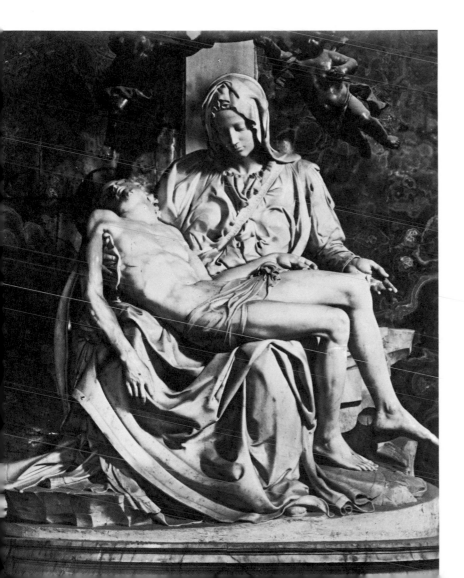

Michelangelo Buonarroti, "Pietà," 1499. Vasari, the sixteenth-century chronicler of the arts and artists, in writing of this sculpture, declared it "a miracle that a stone without any shape at the beginning should ever have been reduced to such perfection as nature is scarcely able to create in the flesh." (Photo, Italian Government Travel Office.)

a real corpse. Here is perfect sweetness in the expression of the head, harmony in the joints and attachments of the arms, legs, and trunk, and the pulses and veins so wrought, that in truth Wonder herself must marvel that the hand of a craftsman should have been able to execute so divinely and so perfectly, in so short a time, a work so admirable; and it is certainly a miracle that a stone without any shape at the beginning should ever have been reduced to such perfection as Nature is scarcely able to create in the flesh.[22]

Under this new emphasis on the most naturalistic finish possible, the sculptural surface became a criterion of esthetic judgment. And this criterion apparently has been maintained over the last four centuries, for in a recent (1960) biography of Michelangelo, Charles H. Morgan, in referring to the "Pietà," noted that "a spring-like quality of youth pervades the earlier masterpiece with its meticulous polish and quite dignified restraint." [23] Although much of the credit for the shift in the manner of handling surfaces has been laid to the cultural atmosphere that Heinrich Woelfflin (1864–1945) an eminent German art historian, described as "a growing desire for the refined, the graceful, [and] the elegant," a part of it must be laid to the new interest in *chiaroscuro*, in which form is defined by the play of light and dark, and to a new feeling for contained movement.

Although chiaroscuro replaced color as a surface treatment, and in so doing helped support the new esthetic attitudes, color was not suddenly eliminated from all sculptural form in favor of a more highly carved, highly polished surface. But the use of chiaroscuro signifies the beginning of sculpture as an esthetic form—even though the art was to remain attached to the Church and power groups for the next two centuries—and marks the origin of a chasmatic split in the ranks of the image makers. One segment, remaining well within the medieval tradition of the polychromed, devotional figure, maintained itself primarily, though not solely, as sculptors of religious figures; modern members of this group often work at the esthetic level of the polychromed plaster saint. The other segment moved away from tradition and presaged the direction of the non-Church-oriented sculpture of the eighteenth and nineteenth centuries, which was completely involved,

[22] *Ibid.*, vol. IX, p. 14.
[23] Charles H. Morgan, *The Life of Michelangelo*, London: Weidenfeld and Nicolson, 1960, p. 229.

for esthetic definition, with the play of light on the surface of the three-dimensional form.

Baroque Sculpture

The surface qualities of the Renaissance classical sculpture became an important part of the sculpture of the Baroque period, which followed the Renaissance. In the Baroque period, surface imitation was intensified, within the limitations dictated by the materials used and by the rejection of applied color.

Giovanni Lorenzo Bernini (1598–1680) was the major sculptor of the Italian Baroque. In his work can be seen, in addition to the classical rendering of flesh, hair, and draperies, the surfaces of heavy brocade, fur, feathers, wicker, lace, and clouds. Each texture is carved to produce the visual qualities of tactile experience, and the observer finds himself marveling at the skill of the sculptor in reproducing such surfaces. Miller has described Bernini and his followers as having forced ". . . their message on the world with the crusading ardour of the Jesuits, and they did this by exploiting new methods of representation, and with widely increased and enlarged technical skill." [24]

The Baroque concept of texture, as exemplified in the work of Bernini, was extended by the ultrarealism of the Spanish sculptors of the period; on figures of wood and gesso, they added "crystal eyes, real eyelashes and eyebrows, pearly tears, bloodstains, and wounds." [25] But the concept was not much followed in France. France had remained more closely allied to the classic style and, in order to maintain it, had founded, in 1648, the French Academy of Sculpture. But, as Janson has observed, although the French Baroque sculpture may look somewhat static when compared to that of the Italian school, it is far from its antique prototypes. When French art did shift, after the death of Louis XIV, it developed into the style known as Louis XV, or the Rococo— primarily miniature in concept, excessively curvilinear, and highly ornamental. Much of the sculpture produced was small and dealt with sensual subject matter, with textures chosen to support the sensual nature of the work.

[24] Alec Miller, *Traditions in Sculpture*, London, New York: Studio Publications, 1949, p. 113.
[25] *Ibid.*, p. 117.

The Emergence and Growth of Modern Sculpture

The Rococo was, in a sense, an extension of the Baroque, the more important shift being the Romantic return to Classicism. During the Romantic period, sculpture was tethered to portraiture and heroic commemoration, and the classical attitudes toward the surface texture of sculpture, as well as toward sculpture itself, were to remain until the nineteenth century. At that time, modern sculpture came into being, primarily as the result of two factors. The first contributing factor was an increased reliance on modeling as a sculptural technique, which had a great effect on the surface quality of sculpture and thus on the observer's appreciation of it. The second was the interest shown in the three-

Left: Giovanni Lorenzo Bernini, "The Ecstasy of St. Teresa," Cornard Chapel, Santa Maria Della Vittoria, Rome, 1644–1647. The Baroque form of Bernini's sculpture, set within an exquisitely Baroque, highly polished, and dramatic side chapel, is in keeping with the spirit of exaltation expected by the church at this time. (Photo, Alinari-Art Reference Bureau.)

Right: Charles Cressent, "Cartel Clock," c. 1745. Cast in bronze, this clock is an example of the ornate Rococo form that moved beyond the Baroque interest in space to a new concern for the decorative. (Courtesy, The Wallace Collection, London.)

dimensional form and the production of sculpture by artists who were primarily oriented toward the graphic.

As early as the 1830s, Honoré Daumier was producing quickly conceived caricatures of the French deputies, modeled directly in clay, which in later years helped establish the validity of what has been considered Impressionistic sculpture. Much of the appeal of the caricatures lies in the quickly modeled form, which, although dependent on dark and light patterns, reveals a spontaneously produced but highly recognizable human form. A part of the appeal is also found in the figures' implied energy and deep psychic insight—qualities that established the link between Impressionist and Expressionist sculpture. Daumier, incidentally, did not think highly of these pieces; for him, they were merely working figures, preparatory to his graphic work. But for many of those who came after him, these modeled caricatures represented the way to a new sculptural mode.

Auguste Rodin (1840–1917) was the sculptor who turned this new mode into a major contribution in the arts. Unabashedly a modeler, Rodin drew on the tradition of those sculptors who saw their material as a completely plastic mass to be manipulated at the artist's will. This tradition did not include the stone carvers who allowed—in some cases, demanded—the nature and shape of the stone to contribute directly to the finished form; nor did it include those who used material merely as a core to support a polychromed, naturalistic facade.

Rodin did believe in the supremacy of naturalistic form, but only in relation to the play of light on the surface. His sculpture, whether cast in bronze or carved in marble, has the soft look of modeling. "He manipulated sensitive, soft, willing clay which could and did catch the most fleeting touch of his clever figures." [26] In Rodin's work in bronze one is able to see the texture of the modeled surface, in addition to that of the material; the modeled surface exhibits the nervous energy of the sculptor in a way that a carved and polished surface never could. In his marble sculpture, the figures are soft as they emerge from the stone, which, in order to increase the fleshy softness of the bodies, was often rendered hard and rough. Rodin's figures, which were based

[26] Philip R. Adams, *Auguste Rodin* (ed. by Aimée Crane), London: The Hyperion Press, Ltd., 1945.

on natural forms, contrast with the rhythmically textured background surfaces he used to increase the sensual quality of the human form. When his first full figure—that of a nude male and now called "The Age of Bronze"—was exhibited in 1877, Rodin was accused of using molds taken directly from the live model.

Auguste Rodin, "St. John the Baptist Preaching," 1878. Like much of Rodin's work, this sculpture exhibits an interest in the natural and sensual as opposed to the more traditional interest in the ideal and heroic. (Collection, The Museum of Modern Art, New York. Mrs. Simon Guggenheim Fund.)

Although this was a false accusation, three years passed before the sculptor was vindicated. The statue, exhibited again in 1880 under a considerably different climate of critical opinion, was bought, along with Rodin's second full figure, "St. John the Baptist Preaching," also a nude male, by the French government for the Luxembourg Palace.

Rodin's importance to modern sculpture is that he carried the tradition that began with chiaroscuro into the mainstream of sculpture. And in the process, he liberated the sculptural surface so that eventually it became as important as the form. The result is that the sensual or tactile qualities of the sculptured mass can now be considered as independent factors. In 1946, W. R. Valentiner stated, "Good sculpture develops the sense of touch. And it is not always necessary to touch it; it is sufficient to know that one can do so. *A sculpture has no value if it does not awaken in us this longing.*" [27] [Italics mine.] Although this viewpoint does not consider the tactile quality to be esthetically independent, it does hold that this quality may or may not be attendant to a piece of sculpture and that no good piece of sculpture can be without it. Thus in contemporary considerations, the tactile and tactile perception (perceived texture) have a definitive importance—an importance that relates directly to the sensual aspects of form. Constantin Brancusi (1876–1957), Jean Arp (1888–1966), Gaston Lachaise (1882–1935), Henry Moore (b. 1898), and Isamu Noguchi (b. 1904), all of whose work can be referred to as organic abstraction, have used the sensually smooth surface to enhance an existent sensual form.

But not all contemporary sculpture moved in this direction. Just as there are sculptors whose work displays sensually inviting surfaces, so there are those—for example, Julio Gonzales (b. 1908), Alberto Giacometti (1901–1966), Theodore Roszak (b. 1907), and Ibram Lassaw (b. 1913)—whose work exhibits surfaces that are not inviting to the touch. And, of course, there is still a dominant segment of modern sculpture that is based primarily on an idea— an idea oriented either to the realistic and semirealistic human image and its many ramifications or the nonobjective image in which the surface texture is synergetic to the total sculptural

[27] W. R. Valentiner, *Origins of Modern Sculpture*, New York: Wittenborn and Company, 1946, p. 11.

Jean Arp, "Ptolemy," 1953. As an exponent of "biomorphic" form, Arp's sculpture depends on the illusion of organic growth and the smoothed surface as sources of its form. (Collection, The Museum of Modern Art, New York. Gift of Mr. and Mrs. William A. M. Burden.)

form. Nonobjective sculpture includes almost all that which idealizes form, abstracts it, rearranges it, or relates it to geometry, construction, the subconscious, or expression. The form conception of contemporary sculpture is so unlimited that an observer can examine a work at best in terms of the personal response it elicits or its historical derivatives.

One significant aspect of contemporary sculpture has been its attempt to create forms that are dependent on a fuller exploitation of textural qualities, a legitimate result of the sculptor's engagement with nonfigurative form. This shift resulted partially from the sculptor's turning away from the Church and state as artistic patrons and finding new patrons in the ranks of industry,

Theodore J. Roszak, "Spectre of Kitty Hawk," 1946–1947. Based on the idea of a single form expressing the qualities of the pterodactyl, a prehistoric predatory bird, and the flight of man-controlled airplanes, also capable of predatory behavior, the sculpture displays a form and surface that invites the observer to keep his distance. (Collection, The Museum of Modern Art, New York. Purchase.)

commerce, and culture. Because the needs of the new patrons were quite different from those of the old ones, the artist was released from his commitment to the naturalistic form demanded by most religious and commemorative work and has felt increasingly free to create nonobjective forms.

The esthetic perception of nonobjective form relies on either a sense of the mystic or a response to the formal elements, among which is the surface quality, texture. Esthetic quality may be experienced in the projection of a natural finish, such as that in the work of Brancusi and Arp; it may also be formed by a complex of linear or projective forms, such as that in the work of the American sculptors Claire Falkenstein and Harry Bertoia. In either case,

257

Claire Falkenstein, "U as a Set,"
1965. In this work the sculptor has
successfully transcended scale to
combine form and texture into a
single image. (Courtesy, California
State College at Long Beach.)

apart from any symbolic content, the forms depend completely
on their volumetric contours and surface qualities for esthetic ap-
preciation. One piece of sculpture created by Falkenstein projects
an image not unlike that of a painting by Jackson Pollock or Mark
Tobey. Made of wrought copper tubing of several diameters and
seemingly resting on top of the reflecting pool in which it is set,
the sculpture can be best described as an open nestlike construc-
tion; if it were not for its large scale, it could be considered wire-
like. The title of the work, "U as a Set," does not help an observer
relate it to any sculptural form he might have perceived previously;
its esthetic qualities are discovered only when it is considered as a
form made for the effect it projects in relation to its total environ-
ment.

Thus, it is clear that there are some unavoidable problems re-
lating to the appreciation of nonobjective sculptural forms. An
observer is faced with a highly abstract quality when, in order
to perceive an esthetic response, he attempts to relate a form to
his sensory experience of its surface quality. To attain the level
of perception necessary for an understanding or appreciation of
this type of sculpture, he must have had a great deal of experience
with nonobjective forms or have actively engaged in studying the
art form. But a large number of people currently trying to under-

stand the nonobjective form do not have these prerequisites and therefore do not perceive the sculpture on this level. Without understanding, they are likely to dismiss this work as merely decoration or esthetically insignificant, positions that, although often untrue, are not unfair in the light of the current frequent use of sculpture as less than significant, ornamental display pieces. When one is faced with form that cannot be perceived because it is outside the realm of traditional sculpture or is so lacking in significance as to be meaningless to the observer, little if any esthetic appreciation can be expected. When form becomes the vehicle for a private language, the language must be learned before any comprehension or communication can be developed.

Composition, the creation of order

Everything that is made up of an arrangement of parts is composed. Thus, composition or the act of composing is, by definition, a most important element of the arts. But not all artists use the same word to designate this activity: musicians, choreographers, poets, and painters compose, but architects and designers design, film makers produce, and authors and playwrights write. However, they all engage in the act of arranging various elements to produce a whole; therefore they all are involved in composition.

In this sense, the term *composition* has much the same meaning as *design* and, to a limited degree, *structure*; we frequently speak of the design or structure of a painting, a building, or even a layout when referring to the arrangement of parts. However, the three terms do have some individual distinctions. Composition most often refers to the surface arrangement of parts within a form or the arrangement of a group of forms. But design can refer to the problem-solving aspects of such factors as the choice of materials, the shape of a form in relation to its function, or the mode of a form's production. And structure goes farther than either composition or design and includes, in addition to the ordering of visual elements, all the forces that have been involved in creating the form and allowing it to be perceived. In terms of a painting, these forces include the physical aspects as well as those sociological and psychological factors that bring it into being and give it meaning; structure is the means by which a work of graphic art is formed and given visual organization. When the term is used in relation to architecture, it involves the physical phenomenon of statics, that is, the forces that maintain the stability of the form.

Good composition, which may be either simple or complex, cannot be equated to art, even though it can often be such an integral part of the art form that to change it is to destroy the form. Its importance is that it gives an image character, but it is only one of the many factors that enter into the creation of an art object and therefore must not be considered disproportionately. Other factors can cause a well-composed painting to fail as a work

of art. Composition is the ordering system that carries the art form, but it is never the art form itself.

In our time, artistic qualities are often intuitive and not part of the conscious effort of the artist. However, in order to better understand the organization of the total form, elements of composition—including not only the subject matter, but also non-objective elements such as shape, space, value, color, and texture—can be abstracted from a work of art and examined singly. The purpose of composition is the creation of a unified image in relation to a system of either visual logic or functional intent. Each element must be given a ranked order, because it is only through this ranking that the artist is capable of organizing all the elements into a unified whole. If any elements are ignored or inappropriately ranked, in terms of either logic or purpose, the composition will lack the unity that alone is capable of making its meaning evident. When the distribution of the subject-matter forms and the quality of the plastic elements are such that each is given its proper position, the work becomes a synergetically involved whole that is greater and more significant than the sum of its parts.

Composition should heighten our esthetic appreciation but in no way assert itself over the total form. Perhaps the best composition is that which supports the image so discreetly that it is never noticed. But composition can be discussed only after it has been perceived, so learning how forms are perceived is very important. If we understand how and why we perceive an image, we should be able to perceive more effectively.

Perception

A great deal of the initial investigation of perception, a highly complex phenomenon, was carried out by the early Gestalt psychologists, and one of their basic concerns was the identification of the factors that organize the elements in a visual field. They demonstrated that ". . . sensory organization constitutes a characteristic achievement of the nervous system,"[1] and, allowing

[1] Wolfgang Köhler, *Gestalt Psychology*, New York: Liveright Publishing Corporation, 1947, p. 160.

for individual differences, this organization occurs, either consciously or unconsciously, for all visual stimuli. First recognized by Max Wertheimer (1880–1940), the theory of sensory organization was subsequently presented as a series of basic principles—the psychological laws that govern how and what we see—by Kurt Koffka (1886–1941), Wolfgang Köhler (b. 1887), and others.

1. *The law of proximity:* All other factors being equal, those elements that are closest to each other will tend to be seen as a grouped unit.

2. *The law of similarity:* When more than one type of element is included in the field of reference, those that are most similar will tend to form groups.

3. *The law of closed forms:* All other factors being equal, lines that form closed surface areas tend to be seen as units.

4. *The law of "good" contour or "common destiny":* Those parts of a figure that maintain independent resolution tend to form units.

5. *The law of common movement:* Elements form a group when they move simultaneously or in a similar manner.

6. *The law of Prägnanz* (pregnance): Psychological organization will always be as "good" as prevailing conditions allow.[2]

These principles formed the greater part of the psychological basis for the theories of visual perception expounded by such champions of the modern design movement as Gyorgy Kepes, L. Moholy-Nagy, and Rudolf Arnheim.

A statement by Kurt Koffka shows how the first five laws relate to our consideration of composition: ". . . the equality of stimulus produces forces of cohesion [and] inequality of stimulation [produces] forces of segregation, provided that the inequality entails an abrupt change." [3] Thus, because we have the tendency to organize similar material into ever larger units, the factors that might interfere with this process are seen as violations of order and unity; they should be considered as such when one is consciously aware of the organizing process. The sixth law, although more general than the first five, can also be related directly to the problems of composition. "Good," in this law, refers to such qualities as regularity, unity, and symmetry; so the principle,

[2] Kurt Koffka, *Principles of Gestalt Psychology*, New York: Harcourt, Brace & World, Inc., 1967.

[3] *Ibid.*, p. 126.

stated another way, holds that forms will tend to look as much like the closest projectionable regular form as possible. This law provides the psychological rationale for the repeated use of relatively simple geometric figures as a unifying device of composition.

Mathematical order

Perhaps the most significant quest mankind has ever engaged in is his search for an understanding of his world and the universe of which he finds himself a part. Although this search has led many men into the area of religion, it has also led some of them to consider the existence of a mathematical system into which all aspects of their world could fit. Man's strong interest in the rational order of numerical systems, including his concern for proportion and symmetry, is reflected in this search for understanding. And this search is related to composition because proportion and symmetry are integral parts of composition.

Ever since man began to civilize himself, his concern for order has been apparent. And one of the most basic ways he was able to establish some order and, incidentally, gain some control over the forces of nature was by developing a number system. This must have occurred early in the evolution of mankind, for even in a hunting or gathering society, the concept of sharing cannot be conceived without some understanding of proportional division. Number systems and the four elementary operations of arithmetic—addition, subtraction, multiplication, and division—are a necessary part of any system of rational order. Later, the understanding of order was expanded, through observation of the figures inherent in or formed by physical objects, to include many of the concepts basic to geometry.

As man progressed and continued to observe his widening world, he conceived numerical and geometric systems by which he was able to explain great segments of the world's physical and phenomenological characteristics. Because these systems were the only constant factor in all that he observed, he concluded that they held the key to the order of his world. From this, it was but a short step to the further conclusion that there might be one system that could provide the key to the understanding of the entire universe. The search for this system is still going on.

Although modern man has been able to draw support for his belief in a universal order from the work of the ancient Egyptians and Babylonians, his strongest support has come from the ancient Greeks. The Greeks conceived of mathematics as a highly abstract consideration and used it in dealing with the most essential relationships; from this they felt that they might be able to discover the essential truths about the nature of the environment.

Early in their development, the Greeks began to look for rational interpretations of nature, and, by the sixth century B.C.E., the Pythagoreans had used mathematics to support rationalism and had developed mathematical concepts that were capable of explaining natural phenomena. Because they observed that physically diverse forms, if similar in shape, could exhibit identical mathematical properties, they assumed that the mathematical relationships that overcame the diversity of the forms must provide the essential truths of the forms' nature. In the fifth century B.C.E., Philolaus, a famous Pythagorean, wrote, "Were it not for number and its nature, nothing that exists would be clear to anybody either in itself or in its relation to other things. . . . You can observe the power of numbers exercising itself not only in the affairs of demons and Gods but in all the acts and thoughts of men, in all handicraft and music." [4] Thus was established the concept that through the projection of mathematical truths, expressed by proportional relationships, universal beauty and goodness can be demonstrated. Even Plato maintained that "Geometry will draw the soul towards truth, and create the spirit of philosophy." [5] This belief, although not so strongly or consistently held today as it once was, is still with us.

The concept of a proportional relationship that reveals both beauty and truth became a powerful factor in the development and critical evaluation of architecture and painting. Although we know of no Greek treatise on architectural proportion, the Roman architect Vitruvius, in his *Ten Books on Architecture*, wrote at length about Greek building methods and tradition and fully discussed his own concepts of proportion. The Vitruvian text, which became the basis for a great deal of the speculation and writing

[4] Morris Kline, *Mathematics in Western Culture*, Fair Lawn, N.J.: Oxford University Press, 1953, p. 76.
[5] *Ibid.*, p. 33.

on proportion that was produced during the Renaissance, was reproduced in both Latin and Italian early in the sixteenth century. It continued to be a dominant force in architectural thinking during the remainder of that century and was an important factor in the writings of Leon Battista Alberti (1404–1472) and Andrea Palladio (1508–1580).

With the reinforcement supplied by Renaissance writers, the Greek ideas of harmonic proportion and the absolute power of numbers were applied to architecture. This application occurred in spite of the fact that there seems to be no direct evidence that the Greeks either made use of or depended on harmonic proportion as a part of their building technique. However, one could easily conceive that they did follow the concept, especially after some of their buildings had been measured in such a way as to show that harmonic proportions did occur.

The idea that an absolute numerically ordered proportion is the key to architectural and compositional perfection or beauty was a strong element in the esthetics of the nineteenth century and still exists in our own time. Because the concept has been and, to some extent, still is so influential, it is important to have some understanding of the mathematical systems of proportion and symmetry.

Proportion

Regardless of the discipline with which an artist is engaged, he cannot escape the existence of ratio and proportion in his work; they are present wherever there is a measurable comparison between parts. However, proportion, as it relates to architecture and composition, has a more inclusive meaning than ratio.

Ratio is the quantitative relationship of two elements compared in terms of a common feature. Thus, without using specific measurements, we can describe the ratio between similar forms— for example, one segment of a line to another segment of the same line or to the entire line—or even dissimilar forms—if we compare them to the same unit of measure. For example, the ratio of apples to oranges can be determined as, say, 2 to 5 if both numbers refer to pounds, bags, or individual pieces. With a simple geometric form such as a rectangle (as used for a painting or the facade of a building), we can establish the ratio of the base to a side; it could be 1 to 2, 3 to 4, or 1 to 6 (Figure

Figure 7–1. (A) A rectangle whose sides exist in a ratio of 1 to 2. (B) A rectangle whose sides exist in a ratio of 3 to 4. (C) A rectangle whose sides exist in a ratio of 1 to 6.

7–1). Of course, these would all look quite different and present the artist or designer with differently shaped areas within which to work.

Proportion is used to describe a simple ratio but more often to describe a ratio of ratios, that is, a comparison of surfaces. If we compare two rectangles formed by common units, we can describe their proportional relationship as $AB/BC = A'B'/B'C'$ (see Figure 7–2). This means that side AB of rectangle 1 is to side BC of rectangle 1 as side $A'B'$ of rectangle 2 is to side $B'C'$ of rectangle 2. It indicates that the rectangles are similar and that, although they are not the same size, they are the same shape and related to each other positively. The surface of the area bounded by lines AB and CD has been compared to that bounded by $A'B'$ and $C'D'$. Thus proportion most correctly relates the sizes of similar shapes or measurements.

When proportions exist in a continuing numerical relationship, they are often referred to as a *series*. There are three types of

Rectangle 1 Rectangle 2

Figure 7–2

series that are of interest to artists and designers—the arithmetic, the geometric, and the harmonic. In an arithmetic series, each element (number) of the series is separated from the elements before and after it by the same amount. For example, in the series 2, 3, 4, each number is separated by one; in 6, 9, 12, each is separated by three. In a geometric series, each element is multiplied by the same amount to find the succeeding element—2, 4, 8 or 3, 9, 27. For our purposes, a harmonic series consists of three elements; the numerical distance of the first element from the median is the same fraction of the first element as the numerical distance of the third element from the median is of the third element. For example, in the series 12, 8, 6, the first element minus one-third of itself (12 − 4) equals the median 8, and the third element plus one-third of itself (6 + 2) also equals 8. Another harmonic series would be 8, 12, 24; the determining fraction in this series is one-half.

The theory of harmonic relationships was developed by the Pythagoreans in relation to their theory of musical structure; they believed harmony to be a reflection of the divine order that was evident in the universe. But the adaptation of musical harmonies to those devised for architecture did not occur until the Renaissance, when it was believed that the rules used to establish harmonic relationships in architecture should be the same as those used in music.

Symmetry

The consideration of symmetry as the identical disposition of form on either side of an axis or plane will be considered later; at this time it is important to point out that symmetry has another meaning that is more closely related to proportion. As we have seen, proportion is based on the size of parts compared to the whole; however, when the whole or parts of it are compared to the the smallest unit, or module, the comparison is referred to as *symmetry*. This use of the word, which lasted from the time of the Greeks until well into the Renaissance, was derived from the sense of Greek rationalism that produced the concept of *analogia*—that which achieves consonance among the parts and between the parts and the whole. Thus symmetry was achieved when a common standard of measure was followed throughout a work and its parts.

The harmonic mean can appear as either a proportion or a symmetrical arrangement of numbers or shapes. In order to understand an architecturally proportional arrangement, one can begin by considering the idealized form of a man—a form much used by the Greeks and one that was an important element in the proportional theories of the modern French architect Le Corbusier. The normal height of the ideal male form is most often considered to be 6 feet; however, because this figure does not give us a very wide range of whole numbers with which to work, it is usually transposed to 72 inches.

If we consider 72 inches to be our whole unit (the *module*), we can build a *proportional* scale, in which the parts are described as

Le Corbusier, "Modulor," 1947–1952. This figure appears in all of Le Corbusier's work as a symbol of his architectural concept of the module.

proportions of the whole, by *dividing* the whole unit (1) into progressively smaller units and ending with the smallest possible segment of the whole (1/72).

1	1/2	1/4	1/8
1/3	1/6	1/12	1/24
1/9	1/18	1/36	1/72

If, however, we were to start with a unit or module of 1 as the smallest measure, we could arrive at a similar grouping, but one that would be *symmetrical*—the size of the parts would all be compared to or composed of the smallest part. In this case, we would *multiply* the smallest unit (1) to get progressively larger units and end with the largest (72).

1	2	4	8
3	6	12	24
9	18	36	72

Proportion and symmetry become increasingly interesting as they become increasingly complex. Notice that the symmetrical consideration of a 6-foot man is a double geometric progression in which the common multipliers are 2, horizontally, and 3, vertically; and if these two common multipliers are multiplied, the answer (6) turns out to be the geometric multiplier of the left to right diagonals—1, 6, 36; 2, 12, 72; etc.

Proportion and Symmetry in Art

One of the requirements of two-dimensional design, whether a painting or an architectural facade, is that the smaller parts always add up to form the larger parts, which, in turn, compose the whole. In order for a design to fulfill this requirement and maintain a numerically systematized relationship, its linear dimensions must be capable of being formed into proportional surface dimensions and must have "a wide range of additive properties, by means of which smaller terms of the progressions can be added together to form larger terms." [6] Not all geometric progressions have these characteristics. As Scholfield, an important English

[6] P. H. Scholfield, *Theory of Proportion in Architecture*, Cambridge, Mass.: Harvard University Press, 1958, p. 9.

researcher in the field of architectural proportion, has pointed out, ". . . it is therefore no accident that in tracing the history of our subject [architectural proportion] we shall find comparatively few patterns of proportional relationships, generated automatically or used deliberately in the solution of architectural proportion." [7]

One of the concepts that recurs in nonscholarly discussions considering the esthetics of classical architecture is that of the golden mean. When originally introduced by the Roman poet Horace, the concept referred to the way of wisdom and safety between extremes; but in relation to proportion, where it is sometimes referred to as the golden section, it has taken on the implication of an absolute proportion, universally appealing because of its supposed relation to the divine laws of life and harmony. The divine perfection attributed to the golden mean stems from its incommensurability, considered a reflection of divine mystery.

The square provides us with the $\sqrt{2}$ (root 2) rectangle, which gives us a way of building a geometric series based on numbers with no common measure; such numbers are used as geometric figures only for convenience. The $\sqrt{2}$ rectangle is formed by using the length of the side of a square and the length of the diagonal of the square as the lengths of the two sides of the rectangle. Its name derives from the fact that if the shorter side is designated as 1, regardless of the actual measured length, the longer side always equals the square root of 2 ($\sqrt{2}$). This is true because of the Pythagorean Theorem, $c^2 = a^2 + b^2$, which concerns the length of the hypothenuse of a right triangle (see Figure 7–3). If we apply the formula to our square (Figure 7–4), we see that the diagonal *DB* radiated to *F* produces the rectangle *ABEF* in which *AB* is to *BE* as 1 is to $\sqrt{2}$.

[7] *Ibid.*

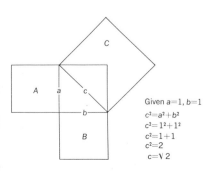

Given $a=1, b=1$

$c^2=a^2+b^2$

$c^2=1^2+1^2$

$c^2=1+1$

$c^2=2$

$c=\sqrt{2}$

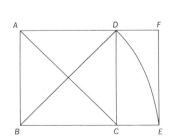

Figure 7–3. (Left)

Figure 7–4. (Right)

A double square provides us with the measurements of the √5 rectangle, which has often been called the "geometry of life" and is the basis of the golden mean. The measurements are determined by the side of the double square, expressed as 1, and the diagonal of the double square (Figure 7–5). The features that make

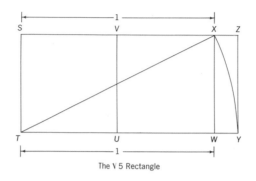

Figure 7–5

The √5 Rectangle

the √5 rectangle so important are that it presents an infinite projection of its own proportions and that it is characteristic of certain organic forms. D'Arcy Thompson, in his important work *On the Growth of Form*, pointed out that

(1) If a growing structure be built up of successive parts similar in form, magnified in geometrical progression, and similarly situated with respect to a centre of similitude, we can always trace through corresponding points a series of equiangular spirals; and (2) it is characteristic of the growth of horn, of the shell, and of all organic forms in which an equiangular spiral can be recognized, that *each successive increment of growth is similar, and similarly magnified, and similarly situated to its predecessors, and is in consequence a gnomen to the entire pre-existing structure.*[8]

This observation was extremely exciting to those searching for a mathematical basis of shape and proportion. Indeed, for some, the existence of a proportion or geometric figure that could be seen as a basic organic growth pattern was irrefutable proof that there was one absolute proportion that was the result of an order higher than man's. And, as such, this proportion would be the most universally perfect and perpetually beautiful one available.

[8] D'Arcy Wentworth Thompson, *On Growth and Form*, 2d ed., New York: Cambridge University Press, 1952, vol. II, pp. 763–764.

In spite of the concern during the Renaissance for the esthetics of form, no dominant theory of proportion was developed. Instead, several different theories were followed: those based on musical harmony, as derived from the Greek interest in a harmonic system; those based on the human form, among which must be included the concepts of Vitruvius and Albrecht Dürer; and those based solely on the magic of numbers, including, of course, the concepts of the geometric mean and the $\sqrt{2}$ series. Advocated by Vitruvius for specific uses and appearing in the works of John Shute (d. 1563), Andrea Palladio, and Leon Battista Alberti, the $\sqrt{2}$ rectangle lent itself to the development of patterns of expanding squares and spirals (see Figure 7–6).

Figure 7–6

Expanding square

Expanding spiral
based on the whirling square

The $\sqrt{5}$ rectangle did not occur significantly during the Renaissance; it found its greatest support in the twentieth century when Harvard professor Jay Hambidge claimed it to be the form basic to the principle of rebirth. According to Hambidge, this principle was known by the ancient Greeks and the $\sqrt{5}$ rectangle was the basis of the greatness of their work, but the principle was lost to the world until he restated it in his Principle of Dynamic Symmetry. Supporters of dynamic symmetry contended that forms based on the $\sqrt{5}$ rectangle could be created with infinite subdivisions, each of which was potentially the same as the total form. A demonstration of their theory is evidenced by plant and animal growth, where seeds produce forms that produce seeds that

produce forms, etc.—in effect, the life cycle. The strongest attacks on the system came from those who could not support a concept of beauty existing independently of man and the variations of his sensibilities. Although the $\sqrt{5}$ rectangle is no longer popular, it must be recognized as one of the major efforts in our time to develop a theory of absolute proportion, one that still finds support among latter-day classicists.

Bilateral Symmetry

In Hambidge's theory, symmetry referred to the proportional relationship in which all the parts are derived from or composed of smaller parts or modules—the meaning we have been discussing and that carries with it an implication of harmony or equal proportions. Today, symmetry has come to be related to balance and, as such, is often revealed in the work of the designer. In this sense, it is called *bilateral symmetry*, a symmetry of left and right that is most easily perceived as a mirror image located on a plane equidistant from a center line between it and the object mirrored. A geometrical phenomenon, bilateral symmetry can occur only when a spatial configuration is carried into itself, either by reflection on a straight line through a plane or by a complete rotation around a center axis. The latter is referred to as *rotational symmetry* (see Figure 7–7). When symmetry is expressed as a rhythmic repeat along a line, it forms a linear or border unit. This can also occur with rotational symmetry, especially if there are equidistant stopping points along the rotational path.

Bilateral symmetry depends on the consideration of space as an entity into which figures may be placed in order to form a com-

Rotation of Figure *A B C D*
180° to Figure *A′ B′ C′ D′*

Figure 7–7. Rotational symmetry. On the two-dimensional surface, the body of rotation moves 180°; with a three-dimensional form, the plane segment moves 360°.

plete image. With man as the model, the idea of a symmetrical image as a complete form seems to be a deep-seated concept. The symmetrical form, as the ideal of equilibrium and rest, has been the basic model away from which artists have moved throughout history, from symmetry to asymmetry. A mirror image is the only true bilaterally symmetrical form, but, because it so strongly signifies equilibrium and rest, painters have often resorted to less complete forms to attain greater interest in their work. However, as artists moved from symmetry to less rigid arrangements, they were forced to use other means to come to grips with the problems of balance in their work. This they often accomplished by relating a work to factors outside of or apart from the work itself. Although symmetry can be replaced by asymmetry, it is still necessary for the art form to retain a measure of equilibrium.

Purposes of composition

Composition aims at the harmonious or functional arrangement of all the elements within a given field. A harmonious arrangement is one in which all the parts establish a positive relationship, not only to each other and the format, but also to the broader image that results from the specific parts used. And a functional arrangement is one that performs its prescribed task in the most efficient and economic manner. Harmony and function are not new goals of composition; in the Renaissance they were seen as the original aims of the Greeks and Romans. Andrea Palladio, the Italian architect who was responsible, perhaps more than any other Renaissance architect, for the establishment of the classical canon, wrote, "Beauty will result from the form and correspondence of the whole with respect to the several parts, of the parts with regard to each other, and of these to the whole; that the structure may appear an entire and complete body, wherein each member agrees with the other, and all necessary to compose what you intend to form." [9] Sometimes these two compositional goals—harmony and efficiency—overlap in a single image, but at other times the intention of the work prevents their merger.

[9] Andrea Palladio, *The Four Books of Architecture* (I. Ware, ed.), New York: Dover Publications, Inc., 1965, book I, p. 1.

When we consider function as an integral part of composition, we are concerned primarily with the intent of the total form and how well the parts of the form relate to each other in relation to that intent. This is especially true in art forms in which ranked visual directions are necessary for literary or conceptual understanding and in forms that depend on continuity for their meaning. In architectural forms, function is also based essentially on intent, but with the added dimension that an architectural form must exhibit physical efficiency and economy rather than impart meaning or evoke esthetic reaction.

One of the most important ingredients in establishing harmony within a form, aside from the positive relationship among its parts, is a sense of psychophysical balance. It has been demonstrated experimentally that man can operate effectively only when he is able to maintain normal balance or when he has had compensatory learning. Our sense of balance is both physiological and psychological; thus, we live and move in an arena of physiopsychological space, the major axes of which are determined by gravity and our own body sense. Because our relation to the earth is geotropic, we have developed several reflex psychosensory responses, instigated by visual and kinesthetic clues from within and outside our bodies, that help maintain a balanced position in relation to the earth plane. This is expressed most commonly by the establishment of fixed vertical-horizontal planes of reference.

The experiences of Margaret Bourke-White, the famous American photographer who has long suffered from Parkinson's disease, provide a dramatic example of the importance of balance to man's sense of well-being. Whereas most of us quickly and successfully—and unconsciously—respond to forces that might throw us off balance, Miss Bourke-White, in her autobiography, makes clear how weak a force is capable of causing one to lose balance if his autopsychic control centers are no longer functioning.

Balance is a mysterious and highly personal thing. If my cat unexpectedly brushed the back of my legs with his feathery tail, it was enough to send me soaring off to the left side or to the right, whichever way my internal tower of Pisa was leaning that day. Due to the benefits of the therapy, I could usually recover my balance.[10]

[10] Margaret Bourke-White, *Portrait of Myself*, New York: Simon and Schuster, Inc., 1963, p. 336.

The horror and fear that must accompany loss of balance, coupled with the realization that only a major effort allows one to maintain it even temporarily, was clearly pictured:

> I could not shout down the fact that Parkinsonism is a progressive disease. In spite of everything Mr. Hofkish taught me, and everything I tried to do for myself, time moved on and Parkinsonism took its toll. When the relentless unearthly pull which might erase all control of balance—"forward compulsion"—started in earnest, this was something that could not be dismissed by a wave of the hand. This was the face of the enemy.[11]

This innate quality of balance—a sense of being upright and in psychic control of one's body motion—is a powerful conditioner. Whereas it may be exciting to allow ourselves the momentary sense of balance loss that accompanies a ride on a roller coaster, the sensation can be experienced as pleasurable because it is neither psychically involuntary nor permanent.

Because we respond to balance in this way, we tend to respond negatively to images that either project a sense of an imbalanced environment or cause us to feel a potential loss of our own balance. And it is this orientation that is the basis for man's efforts at composition in the plastic arts. Balance is generally created in a painting by placing the shapes in an axial relationship either parallel or perpendicular to the horizontal base line (usually the bottom edge of the picture). The elements within the painting then assume a positive relation to the vertical and horizontal axes —our preferred planes of visual space.

Sometimes, of course, values other than order and stability are dominant in the art form. When art is used to express a philosophic or psychological point of view based on either no order or the destruction of order; when it is used to get attention, to shock, or to express other-worldliness; when it is used to express a condition or state beyond itself—in all these instances art often fulfills its intention best by projecting a calculated sense of imbalance, and the resultant forms and their esthetic qualities cannot be judged against a traditional order system. This lack of traditional balance, which is more closely related to asymmetry than symmetry and often requires a period of personal adjustment before one can feel

[11] *Ibid.*, p. 367.

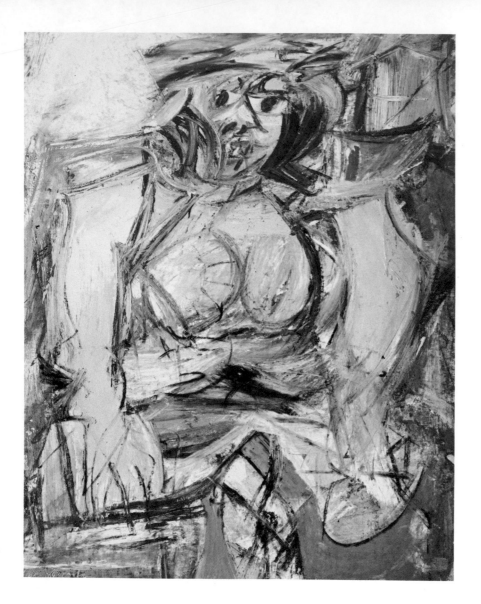

Willem de Kooning, "Woman IV," 1952–1953. This painting shows how balance based on parallel-perpendicular axial relationships can stabilize an image that otherwise depends on slashing distortion for its esthetic quality. (Collection, William Rockhill Nelson Gallery of Art, Atkins Museum of Fine Arts, Kansas City. Gift of Mr. William Inge.)

comfortable with it, has become the rallying point of a sizable segment of twentieth century art.

Weight is another important factor in balance. When weight is added to one side of a simple beam scale, the heavier side lowers, pulling the scale out of balance and resulting in a slide. The imbalance is noted visually. When this type of diagonal motion is observed in a composition and there is no compensating support or limitation, one has a tendency either to reject the image or to correct it.

Factors other than those that normally attend weight must be considered when weight is related to the visual elements. With a physical mass, a simple 1 to 1 ratio of mass to gravity results in horizontal equilibrium. However, to equalize the weight of visual elements, the size, amount, and density of each element must be considered, as well as its relationships, direct and indirect, to the context in which it appears. Visually, it is possible to balance a small, light unit with a large, heavy unit; a small, embellished area with a large, plain area; and a small, intricately contoured shape with a group of larger, less intricately contoured shapes. A single line of black lettering or type can balance a full-color illustration; and an implied movement, especially one involving a shift in eye direction, can often balance all other elements in a composition—as can a human figure placed as a foil for a full landscape. When dealing with visual balance, a factor of inversion operates: the greater the visual difference between an image and what it seeks to balance, the smaller the balancing unit can be; but if the forms to be balanced are qualitatively similar, almost equal amounts of each are required to reach a balance point.

Space in composition

Because we always perceive forms in relation to their spatial environment, the problems of spatial representation must be considered an integral part of composition. In our discussion, the term *spatial representation* will have a wider scope than is usually meant by *perspective*, because what we know as perspective is only one of the means by which space can be represented. Spatial representations of all types demand a relatively high level of sophistication not only on the part of the artist but also on that of the observer, and although we must not read perspective into works in which none exists, we must recognize that there is more than one valid type of spatial representation. Far too often paintings that are not based on the concepts of optical or mathematical perspective are considered inferior. As late as 1911, the *Encyclopaedia Britannica* maintained, "No competent artist, or even teacher of drawing, who examines what is left of ancient painting, can fail to see that the problems of representing correctly the third dimension of space, though it may have been attacked, had cer-

tainly not been solved." [12] This attitude, although no longer supported by art scholars, is nevertheless still part of art mythology.

But before we discuss spatial representation, we must consider the problem of eye movement and the tensions that occur between points or objects on the picture plane—the tensions that result from the observer's desire to see or look at two or more related forms at the same time. Because we can focus on only a relatively small area at any one moment, our eye moves from the image we are looking at to related images or those that are powerful enough to draw our attention. Thus the term *tension*, as used here, describes the pull involved in visually shifting one's attention from point to point.

We know, of course, that the greater the distance between the viewer and an object, the greater the field of vision will be. Figures or units in the visual field develop spatial qualities in relation to the total field and other objects in it. One of the most important qualities they can develop is a sense of direction, for this can control, to some extent, the movement of the observer's attention. The direction in which we shift our attention is determined by the relative strength of the attraction of the forms and the space surrounding them. In this sense, the significant field of vision is determined by the spatial boundaries created by the points of tension.

All defined areas have a spatial quality, which is determined by the size of the area, the nature of its boundaries, what exists within it, its purpose, and those who utilize it. The quality of the space is induced as we try to perceive the organization of the visual field and the elements within it. However, we rarely maintain fixed vision, and thus space is seen as a partial and continually fluctuating field. The main reason pictures are framed is to create a limited field that can be comprehended within the scope of our attention.

The elements in a picture that can be manipulated are the visual elements of surface and structure. Although every element has a set of indigenous characteristics, these can be altered by, among other things, their position in relation to the picture plane and other units within the picture plane. Because we recognize

[12] *Encyclopaedia Britannica*, 11th ed., New York: Cambridge University Press, 1910–1911, vol. XX, p. 469.

that a bilateral symmetrical form is at rest and consider it a visual norm or starting point, we create movement as we shift the elements from a condition of symmetry to one of asymmetry. But when the size and number of the elements is restricted, the field of reference remains flat and movement occurs only on its surface. Movement can take place only between the elements or between the elements and the edges of the picture plane (see Figure 7–8A). As the sizes of the elements begin to vary in a perspective proportion, however, the flat plane is destroyed and the illusion of depth begins to appear. And with an increase in the number of elements and their spatial involvement, the surface changes from a flat passivity to an active dimensionality (see Figure 7–8B).

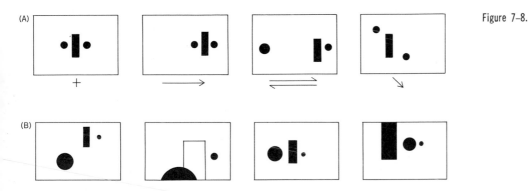

Figure 7–8.

The problems of limited spatial tension have been the basis for a certain amount of modern painting and have played an important role in modern graphic design. However, the esthetic value of examining art in this way is relatively limited, because, as the visual units become more dependent on the complex of elements, the tendency to see the whole image develops and it becomes increasingly difficult to establish the qualities of isolated units.

As a picture's surface is changed from one that is flat to one that creates the illusion of depth, the problems of spatial representation become important. Not only have these problems been broadly studied, but, more important, a number of well-defined methods have been presented for solving them. Basically there are three types of spatial representation that must be considered—the conceptual, the optical, and the geometric.

Conceptual Systems

In the conceptual type of space representation, which is the most unlike what we call true perspective, the position of forms is determined by some nonoptical code and space is represented by overlapping or figure placement. Conceptual systems were used by the Egyptians, the Persians, the Chinese, and the early Christians, as well as by some of the less-developed cultures and certain modern schools of painting. These people chose to create visual images according to constructs other than those determined by what they saw.

In the tomb paintings of ancient Egypt, an individual's size and spatial position was determined more by his rank or position in the political or religious hierarchy than by where he was actually located in space. Thus a pharaoh would appear larger than his wife and children, who would be larger than those bringing offerings, who, in turn, would be larger than captives. The size of a figure indicated his position in life rather than his spatial position in relation to the picture plane; spatial relationships were indicated by overlapping the figures, and, in many cases, a spatial or even a time relationship was created by the *registers* (bands) into which Egyptian tomb painters often divided their work. The figures most often appeared in what is referred to as *perspective tordue* (twisted perspective); certain parts were shown in profile and other parts were shown frontally. The logic of this type of presentation has often been defended as being ". . . in principle, far more direct and immediate than optical perspective, since it portrayed the essential aspects of the entire object (whether animal or human being) by depicting each, frontally or in profile, so as to display its most characteristic features." [13]

The Persians made use of a conceptual rather than an optical system of perspective in their manuscript painting. Although they paid some attention to rank, their most important device was tilting the ground plane at a right angle, thus bringing the plane into a vertical position with the lower front edge maintained. This resulted in a conceptualized bird's-eye view of the landscape with

[13] Sigfried Giedion, *The Eternal Present*, vol. I, *The Beginnings of Art*, Princeton, N.J.: Princeton University Press, 1962, p. 19.

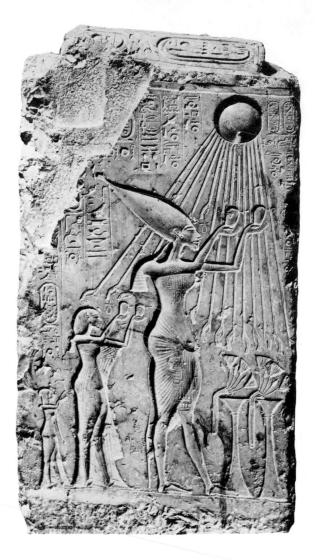

King Akh-en-Aton and Queen Nefert-iti making offerings to the sun god, Aton. In this limestone bas-relief the sizes of the individuals were determined by their importance and rank, not by their spatial proximity to the sculptor. (Photo, courtesy of The Metropolitan Museum of Art, New York.)

the objects that are normally considered part of the ground plane or parallel to it—floors, rugs, couch surfaces, walks, and, occasionally, fountains—depicted flat and from above. However, organic forms—men, animals, and plants—were maintained in their geotropic orientation and pictured in a normal vertical position. The painting had a static and more conventionalized quality than that usually seen in Western art. At various times, architectural details in optical perspective were included, but, because of the highly conventionalized and patterned surface, they most often appeared as part of the background plane.

Chinese artists were another group that did not use perspective (as we know it) to solve the problems of spatial representation.

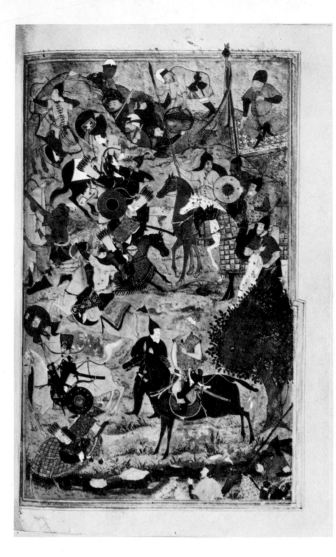

Bihzad (or his atelier), a manuscript painting from the book, Zafarnamah, c. 1500. Distance from the observer is indicated by page position—the men and horses at the bottom of the picture plane are in the foreground and those at the top of the page are the farthest away. (Courtesy of the Walters Art Gallery, Baltimore.)

The differences between the solutions found by Chinese and Western artists were due to the groups' divergent cultural points of view regarding the desired relationship between man and his environment. Whereas Western man sought to come to grips with his natural environment by scientifically studying it and organizing it to meet his own ends, the Chinese sought to maintain the "eternal mystery which can only be suggested." The respective outlooks led Western artists to develop a spatially closed area in which to create their figures and Chinese artists to an unrestricted spatial area not bound by the picture plane, which ". . . suggested the unlimited space of nature as though they had stepped

through that open door and had known the sudden breathtaking experience of space extending in every direction and infinitely into space." [14]

In Chinese painting one senses an opening of the landscape with the point of reference being the observer, in contrast to the sensation, felt in Western one-point perspective, of a landscape that closes down to a distant vanishing point. Traditional Western perspective has localized the focus, but the Chinese have maintained a shifting focus; even when architectural details are included in a painting, they are usually used to increase lateral movement. Part of this tradition is certainly related to the practice of painting on scrolls; the technique allows not only for lateral movement but also for the development of a time sequence, which is not possible in the single, constricted picture plane. The image in Chinese landscape painting has often been inaccurately labeled *reverse perspective*—inaccurately because the effect is due not to a conscious attempt to render form and spatial relationships according to an optical or mathematical system, which perspective would demand, but rather to a keen awareness of the concept of the moving focus and a desire to present the subjective quality of nature significantly.

Most traditional Chinese landscape painters used a three-depth system—foreground, middle distance, and far distance. However, these were not necessarily firmly connected or even seen from the same position. The artists felt free to change their observation point whenever they felt the change would help them achieve a more characteristic view of the landscape. Often, the result was an image composed from more than one vantage point, with the breaks usually occurring at one of the depth changes—foreground to middle ground or middle ground to background—in such a manner that the gap could easily be bridged by the observer. Mist and clouds were often introduced to help the transition.

Conceptual perspective was also very much a part of the drawing and manuscript illumination of the Middle Ages and can be seen in the Byzantine mosaics that preceded the development of Western painting. Art during these periods was generally concerned with the mysteries, rituals, and symbols of the Church.

[14] George Rowley, *Principles of Chinese Painting*, 2d ed., Princeton, N.J.: Princeton University Press, 1959, p. 32.

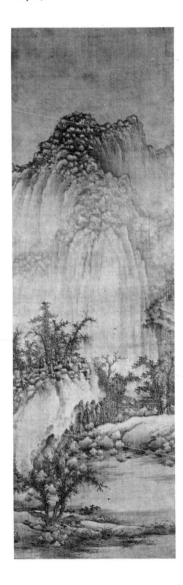

Chu Jan (?), "Buddhist Monastery in Stream and Mountain Landscape," Northern Sung Dynasty. By maintaining a shifting focus, the Chinese present more expansive landscapes than do Western artists. (Courtesy, The Cleveland Museum of Art. Gift of Katherine Holden Thayer.)

Giovanni Cimabue, "The Crucifixion." This wall painting illustrates Cimabue's solution to the problems of perspective. The observer can sense the third dimension. (Photo, Alinari-Art Reference Bureau.)

Optical Perspective

As the Renaissance approached, man's interest in the natural world grew. This meant that the painter, instead of ignoring natural form and favoring symbolic form, now felt obliged to examine the environment carefully in order to be able to render it more accurately; that is, he was now to become involved with a system of perspective based on optical perception. A painting was supposed to look as much like the natural scene as possible. This interest in nature and, consequently, in science was characteristic of the Renaissance; in painting, it resulted in the development of the illusion of three-dimensional space on the two-dimensional surface. Thus the visual effects of space and distance, as well as volume and mass, were introduced into painting.

Perhaps the first painter in Western tradition to propose a new graphic solution to the problems of viewing objects in space was Cimabue (c. 1240–1302). Cimabue's wall paintings in the

286

Space in composition

Upper Church of San Francesco at Assisi marked the beginning of the optical organization of a total spatial commitment. Although his work and that of his assistants did not present "a scientific interpretation of the facts of vision, or of conformity with them," [15] it did show a consistent compositional approach to the problems of space representation. There was an increased impression of depth and solidity and the appearance of a closed interior space, and solid rectangular forms began to be seen obliquely.

The space-oriented type of composition first developed by Cimabue was carried into a system of more complete optical perspective by Giotto di Bondone and Duccio di Buoninsegna.

[15] John White, *The Birth and Rebirth of Pictorial Space*, Boston, Mass.: Boston Book & Art Shop, Inc., 1957, p. 30.

Giotto di Bondone, "St. Francis Renouncing His Inheritance," 1296–1300. By combining foreshortening with a new awareness of optical spatial relationships, Giotto was able to create a greater illusion of spatial reality than painters before him. (Photo, Alinari-Art Reference Bureau.)

Giotto di Bondone was able to turn the structural qualities of the new compositional form into a cohesive spatial statement by combining a foreshortened frontal type of picture construction with the more realistic oblique forms to create "a steadily increasing harmony between the flat wall and an ever more ambitious spatial realism." [16] It was his consistent use of the oblique construction that makes Giotto a leading figure in the development of perspective, for, although frontal construction had existed earlier, oblique construction had not.

Duccio, the early Sienese master, also used oblique construction but added to it what can best be described as area and axial perspective. In his method, diagonal parallel lines receded to a well-defined area or a single vertical line. Duccio also developed a new sense of spatial realism by depicting greater movement than had ever been shown before. Movement occurs in his work, not only in depth, which had been well-defined by Giotto, but also forward, upward, on the diagonal, and around forms, as seen in his "Christ Entering Jerusalem."

Although a more realistic depiction of space now occurred with some degree of regularity, it was still based only on an optically perceived and empirically developed form of perspective, it had been developed on the strength of the creative vision of individual masters only, without a theoretical foundation. The next advance in the development of optical perspective was the discovery of diminishing proportion and the establishment of vanishing points, those points in space to which all parallel surfaces that are set obliquely to the observer recede.

It is true that the initial problems of perspective dealt with the form of objects rather than with problems of spatial reality. But as an attempt was made to develop a single point of view toward exterior and interior space and the depiction of objects within space, the use of diminishing proportion and rationally located vanishing points became imperative. Although the method did not reach full fruition until the fifteenth century, the essential qualities were developed by Maso di Banco (active between 1341–1347), to whom is attributed the painting of a well-established interior space in the fresco "St. Sylvester and the Bull." These innovations—diminishing proportion and vanishing points—appeared

[16] *Ibid.*, p. 65.

Duccio di Buoninsegna, "Christ Entering Jerusalem," 1308–1311. The illusion of spatial reality is created more because of spatial confrontation than the rendering of space. (Photo, Anderson-Art Reference Bureau.)

in the work of Ambrogio Lorenzetti (d. 1348), who, without using a system of geometric construction, was able to depict scenes that displayed the normal visual sense of both man-made and natural environments. His double fresco "Good Government in the City and Country," painted in 1338–1339, is an especially fine example of spatial realism. It displays a diminution of both figures and architecture, and the observer is led spatially through the city

streets and into the distant landscape. In "The Presentation of Jesus at the Temple," Lorenzetti's sense of optical perspective is clearly demonstrated by an architectural complex that leads into a deeply recessed choir, convincingly set behind four boys. Although the artist still relied primarily on axial perspective, he also developed a single vanishing point for the inset marble floor.

Perspective and Geometry

The role of the artist during this period of the Renaissance was far from insular. Not only was there a great deal of social and business intercourse between painters, architects, and mathematicians, but geometry was known to all of them and the abilities necessary to succeed in all three fields were often found in one man. Geometry was a key to knowledge and a tool of the artist, whose aim now was to find a more accurate way to analyze and present his new vision of the natural world.

Above: Ambrogio Lorenzetti, "Good Government in the City," 1338–1340. Although Lorenzetti did not use a complete system of perspective, he created a sense of spatial reality. In this fresco the observer can transcend perspective logic because of the perspective imagery created by the artist. (Photo, Anderson-Art Reference Bureau.)

Right: Ambrogio Lorenzetti, "The Presentation of Jesus at the Temple." Lorenzetti's clear understanding of optical perspective is demonstrated by his handling of the architectural detail of this painting. (Photo, Alinari-Art Reference Bureau.)

290

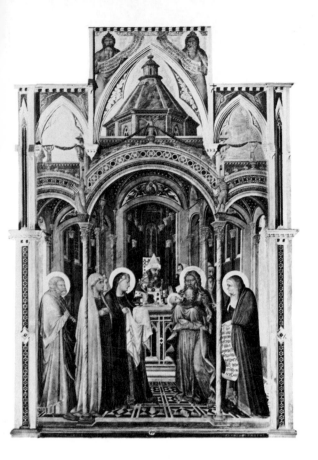

The development of actual geometric perspective is credited to the Florentine architect Filippo Brunelleschi (1377–1446) by his biographer, Antonio Manetti.

Thus in those days he himself proposed and practiced what painters today call perspective; for it is part of that science, which is in effect to put down well and with reason the diminutions and enlargements which appear to the eyes of men from things far away or close at hand: buildings, plains and mountains and countrysides of every kind and in every part, the figures and the other objects, in that measurement which corresponds to that distance away which they show themselves to be: and from him is born the rule, which is the basis of all that has been done of that kind from that day to this.[17]

Brunelleschi presented his perspective in the form of two painted panels; although the panels have been lost, we can reconstruct them from Manetti's description and what we know of the sites

[17] *Ibid.*, p. 113.

they depicted. The most important concept incorporated in the panels was that the picture plane is a flat interjection in the normal angle of vision at a specific distance from a fixed observation point. This was explained by Manetti, who observed, "In the painting . . . the painter needs to presuppose a single place, whence his picture is to be seen, fixed in height and depth and in relation to the sides, as well as in distance, so that it is impossible to get distortions in looking at it, such as appear in the eye at any place which differs from that particular one." [18] From this clarification, and further description that includes the statement ". . . it seemed as if the real thing was seen," it can be assumed that Brunelleschi had developed a vanishing-point system based on a geometrically controlled rate of diminution.

One of the artists who were directly influenced by the work of Brunelleschi was a contemporary of his, the painter Masaccio (c. 1401–1428). Putting Brunelleschi's system to work, Masaccio became noted for a more well-developed sense of naturalism than had ever been displayed before. He combined the new concepts of spatial structure, based on the newly developed mathematical perspective, with a sense of directed light. An outstanding example of the technique can be seen in his well-known fresco "The Tribute Money," which is in the Brancacci Chapel, Santa Maria del Carmine, in Florence. In this painting, which was composed as an asymmetrical triptych, Masaccio depicted a sequence of three events. The center section shows Christ and his disciples entering Capernaum; the tax collectors are requesting money and Christ is telling Peter to find the money in the mouth of a fish. The left section displays Peter's taking the money from the fish's mouth; and the right, Peter's giving it to the tax collector (Matthew 17:24–27). Masaccio used architectural details to define and limit the foreground and, to indicate deep space, mountains and diminishing trees to the right and behind the main figures. Thus he established a sense of scale that opened the space behind the figures and allowed him to place the figure of Peter, drawing the coin from the fish's mouth, in a transitional middle ground.

When geometric perspective had indeed become the tool of the painter, the next major step was to establish an independent system of geometric construction that could exist apart from painting. Leon Battista Alberti, in his *Della Pittura*, successfully

[18] *Ibid.*, p. 116.

separated the theory of perspective from its practice. Alberti credited Brunelleschi as the first practitioner of a geometric system and Donatello (1386–1466), Lorenzo Ghiberti, Luca della Robbia (c. 1400–1482), and Masaccio as men who had all made use of the new system after Brunelleschi. *Della Pittura* is divided into three books, as described in the prologue: ". . . the first, all mathematics, concerning the roots in nature which are the source of this delightful and most noble art. The second book puts the art in the hand of the artist, distinguishing its parts and demonstrating all. The third introduces the artist to the means and the end, the ability and the desire of acquiring perfect skill and knowledge in painting." [19]

Alberti codified four major principles in his work:

(a) There is no distortion in straight lines; (b) There is no distortion or foreshortening of objects or distances parallel to the picture plane . . . ; (c) Orthogonals converge to a single vanishing point dependent on the fixed position of the observer's eye; (d) The size of objects diminishes in exact proportion to their distance from this observer, so that all quantities are measurable.[20]

[19] Leon Battista Alberti, *On Painting* (trans. by John R. Spencer), New Haven, Conn.: Yale University Press, 1956, p. 48.
[20] White, *op. cit.*, p. 123.

Masaccio, "The Tribute Money," c. 1427. Masaccio created a fresco that depicts the passage of time and demonstrated optical perspective. (Photo, Alinari-Art Reference Bureau.)

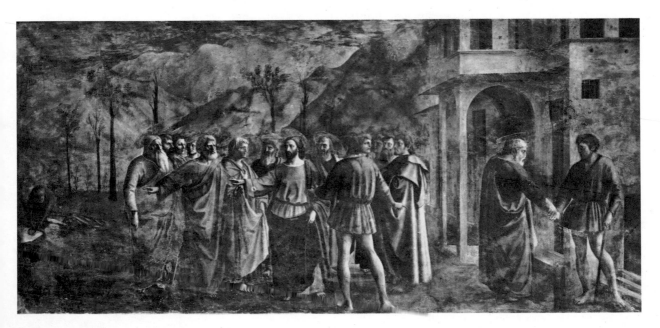

The first two of these principles had been established as part of the efforts that had culminated earlier in area and axial systems of perspective; the last two principles had been empirically discovered by such men as Brunelleschi and Masaccio.

The codified system of geometric perspective, once it had been established and accepted as the scientific basis for art, served to help the artist change his status. No longer was he willing to be related to the crafts; henceforth he demanded a position among the humanists of the period. After all, he argued, was his work not founded on science and was it not useful in the understanding of the natural environment and its laws? This position was strengthened and supported during the remainder of the fifteenth century by other important works on perspective, including Lorenzo Ghiberti's unfinished *Third Commentary*, a work dealing with optics in relation to perspective; Piero della Francesca's *De Prospettiva Pingendi*, which examined perspective painting; and Leonardo da Vinci's *Treatise on Painting*, which, although only one last extension of an already well-developed system, was nevertheless important.

The system of perspective that had been empirically developed by Brunelleschi and codified by Alberti, being based on a fixed point and direction of vision, had the tendency to freeze the vision of the observer. The problems thus created were examined by Paolo Uccello; he introduced the concept of multiple vanishing points, thus recognizing, as had Giotto before him, that we normally see things from a shifting viewpoint. Bernard Berenson, the American art historian, criticized Uccello for the strength of his interest in a solution to the problems of perspective: "Uccello had a sense of tactile values and a feeling for colour, but insofar as he used these gifts at all, it was to illustrate scientific problems. His real passion was perspective, and painting was to him a mere occasion for solving some problems in that science and displaying his mastery over its difficulties."[21] Harsh criticism, indeed, for the man who painted "The Battle of San Romano" (see page 17).

Leonardo also dealt with the problems of static vision posed by the perspective of Brunelleschi and Alberti. He suggested a system that conceived of space, not as a flat surface, but as a spherical surface in which diminution and distortion take place

[21] John Pope-Hennessy (ed.), *Paolo Uccello*, London: Phaidon Press, Ltd., 1950, p. 30.

in all directions from the point of observation; Brunelleschi had used only a flat interjection of the visual cone, not conceiving of its spherical bisection. Later, by projecting his spherical surface onto a flat plane, Leonardo arrived at his final system of perspective. Through his composite system, the viewer was no longer faced with an image that had to be perceived as geometrically flat, because everything in the picture, as though existing on a plane parallel at all points to the receiving surface, would diminish and distort in relation to the convex pupil of the eye.

The Effects of Perspective on the Development of Art

The theories of perspective that were formulated in Italy during the fifteenth century were to be an influential and significant part of composition for all Europe until well into the nineteenth century. In earlier periods, composition was considered a two-dimensional problem, but the introduction of geometric perspective and its extensions added a new dimension to it. The flat surface of the wall or panel had to be conceived of as a three-dimen-

Leonardo da Vinci, study for "Adoration of the Magi," 1481–1482. Although Leonardo developed a number of systems of perspective, it was his linear perspective, demonstrated in this study, that was concerned with the function of sight lines and the visual diminution of forms in space. (Courtesy Uffizi Gallery, Florence.)

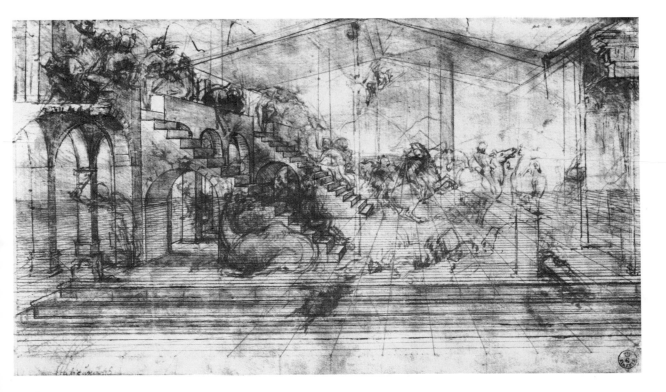

sional space in which the forms of the painting would exist. Tensions and direction no longer moved only parallel to the picture plane—they could move in any direction and were limited only by the edges of the picture plane itself, which had now assumed the qualities of an opening into space. Compositions that were once static, held rigidly by restrictive lateral and vertical movement, now gained a new freedom, and the directions available within the newly conceived space were limited only by the purpose and skills of the painter.

Compositionally, space was a new element that the painter could use in organizing his picture. From the studies of the Gestalt psychologists, we know that we perceive things in relation to a field of reference. When this field is visual, the addition of the third dimension creates a greater potential for unity than is possible in the composition that depends on only two dimensions. Space had once been only the unfilled area of a picture plane after the picture was finished, but with perspective, it gained a positive quality of its own; therefore, it added to the organization of whatever images were placed in it.

But of course there were also added problems. Because we perceive the world with a given spatial quality, anything that is presented as a realistic copy of it must conform fairly accurately to the established visual and spatial patterns. When these are disturbed and not replaced by an understood and accepted conceptual system, the magic of both art and illusion is lost. Thus if the artist chooses to work in terms of the illusion of real space or if the observer chooses to perceive the artist's work in those terms, a picture displaying anything less would be considered unsuccessful. Once the illusion of space is accepted as a realistic view, the figures and objects placed within it are subject, not only to all the laws of perception and proportion that attend the two-dimensional composition, but also to the added complexities created by the fact that it is an illusion.

But the image created by the painter can never really be more than a two-dimensional illusion. Therefore a very special relationship must exist between the picture plane and the illusion of the third dimension. The flat picture plane must allow for the natural visual distortions of the images that appear within it but cannot become distorted itself. It is this problem that has led modern painters to continually reexamine space and the picture plane.

Development of modern composition

Concepts of composition and space depend not only on how the artist sees his natural environment but also on how he sees his role in society. In cultures where the two-dimensional image is used to serve the symbolic needs of religion or ritual, only a concept of composition bound by two-dimensional symbolic restrictions can develop. When the image is allowed to expand and become a mirror of the environment, serving to enlighten the observer with new precision and clarity, another concept of composition can emerge. And when the image is allowed to express the artist alone, a third is seen. However, all three concepts uphold a position in relation to the picture plane and the illusion of space.

As we examine composition as it occurs in much of contemporary painting, the canons of proportion, the concepts of perspective, and the systems of organization we have dealt with do not explain the images that appear. In order to gain an understanding of composition in contemporary painting, one must turn to factors that exist apart from and outside of the picture plane, either in a sense of extended time or space or in the new attitudes of the artist or the function of the image. The "moving focus," often observed in Chinese paintings, is one concept that can help explain the dependence on time and space that exists outside of the picture plane. The new attitudes of the artist or the function of the image can be examined best in relation to the shift that occurred in Western art when the artist, turning away from his interest in the constructed illusion of measurable observation, began to search for an extended reality that exists apart from the man who perceives it. In the twentieth century this search has been made immeasurably more complex because the artist is also deeply involved with problems of personal expression.

The Chinese, in developing a conceptual system of space rather than one based on scientific observation or geometric construction, allowed for an extended expression of nature based on considerations of both space and time. The hand scroll, the common painting form in both China and Japan, is usually examined segmentally as it is unrolled from right to left; a lateral time sequence naturally occurs. The observer is forced to shift his focus from

sequence to sequence and involve elements of time and space that are not normally available on a single-panel painting. On a scroll, landscape and figures move horizontally, and often a single scroll will take on the qualities of an animated film. Scroll composition is additive; the total content is built from a series of spatially developed pictures, and perception of the whole depends on image, space, and interval, as well as the continuing participation of the observer. (This same sense of expanding the picture plane by time and space also became a part of the hanging scroll.)

The Chinese treatment of architectural settings will illustrate the most elementary contrasts between the eastern use of a moving focus and the Renaissance passion for perspective. Instead of a centralized focus, the Chinese preferred architectural elements paralled to the picture plane, or with one side parallel and the other giving a strong movement of oblique lines in one direction (a kind of rhomboidal treatment), or, if the inscenation was placed diagonal to the picture plane, the diverging lines were emphasized to lead the eye out of the picture. In all three instances the artist increased the lateral movement in time; this movement was then regulated by various devices such as screens and garden walls.[22]

When one combines this treatment of space with the traditional Oriental convictions that groupings must be small and simple enough to be comprehended as a total unit and that it is more important to present a sensed but unknowable spirit than an accurate, descriptive illusion, one can begin to understand the compositional differences that existed between East and West before Western artists shifted away from realism.

Hsia Kuei, "Twelve Views from a Thatched Cottage" (section), c. 1200. Horizontal scrolls often depicted journeys that transported the observer through a landscape; the scrolls were meant to be examined segmentally as they were unrolled. (Courtesy, Nelson-Atkins Gallery, Kansas City, Missouri. Nelson Fund.)

22 Rowley, *op. cit.*, p. 62.

Baroque Art

However, before we can fully understand the composition of modern art, we must examine the compositional changes in art that transformed Renaissance art to Baroque art, changes that were based mainly on an expansion of ideas. As the Renaissance skills in defining space became widespread, the major artists began to expand their own interests beyond them. And this was a period during which the social and physical support of the art form was also changing; painting and architecture were no longer dominated by the Church. Thus fresco and panel painting gave way to oversized canvases, and the panorama of religious subject matter gave way to allegory, mythology, and extravagant portraiture. When the religious subjects did appear, they were depicted, as often as not, merely as an excuse to examine the formal and sensual qualities of the human figure. Decoration and ornament became increasingly important, and the Baroque style, born in Rome, moved to Flanders, Holland, Spain, France, England, and Germany.

Compositionally, the frame and the picture plane no longer served as strict boundaries for the space they defined. Compositions became more and more complex, with an ever greater number of figures brought into the picture and the whole taking on a writhing, twisting, sensual quality that was not part of the Renaissance image. Painting became more exuberant, richer, and more intricate as a new interest in controlled dark and light brought more dramatic form to the emotional subject matter. The close-up appeared as a new compositional device, and the viewer was

299

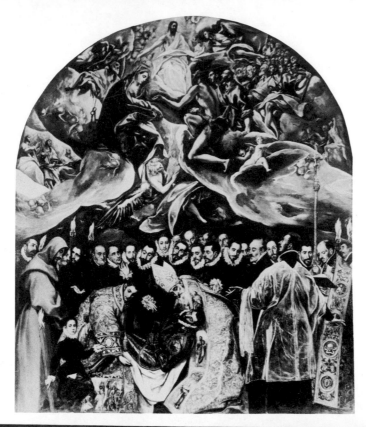

Left: El Greco, "The Burial of Count Orgaz," 1586. In this painting, honoring Count Orgaz, the artist included a large group of figures—Saints Stephen and Augustine (seen lowering the Count into his grave), the clergy and gentry of Toledo, the artist's son (as an acolyte), and a host of heavenly characters. (Courtesy, S. Tomé, Toledo.)

Below: Peter Paul Rubens, "Lion Hunt," 1616–1621. By the seventeenth century, painting had expanded beyond the demands and restrictions of the church and the court. Painting included the generally decorative and the romantically dramatic. (Courtesy, Pinakothek, Munich.)

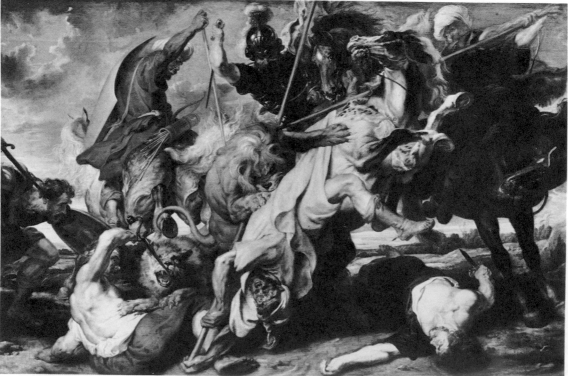

invited to extend his thoughts to actions or images that extended beyond what was framed.

The compositional concepts that helped form the picture images of the period also affected architecture. Earlier facades had been based, for the most part, on calculated proportion related to a flat surface, but the Baroque facade began, as did the picture plane, to warp and bulge sensuously into the space in front of it. The effect was one of plastically redefining the space into which it penetrated, and the eventual result was a form that was as sculptural as it was architectural. Heinrich Woelfflin, an early authority on the definition of style, has characterized Baroque composition as evidencing a shift from the linear to the painterly, from the plane to the three-dimensional, from the closed to the open, and from a multiplicity of related visual elements to unity; he maintained that the Baroque style gave composition, light, and color a structural life of their own.

Bottom left: Sir Christopher Wren, Cathedral of St. Paul (west facade), 1675–1710. Although construction took thirty-five years and Wren had to contend with insufficient funds, a conservative clergy, and a difficult site, the result was a cathedral that is an excellent example of the Baroque form in England and a tribute to the architect's genius. (Photo, British Information Services.)

Bottom right: Dominikus Zimmermann, Pilgrimage Church, Die Wies, 1745–1754. The interior of this church is a fine example of the extent to which the Bavarian Rococo rejected the concept that decoration should reveal or support structure. (Photo, Hirmer Fotoarchiv, Munich.)

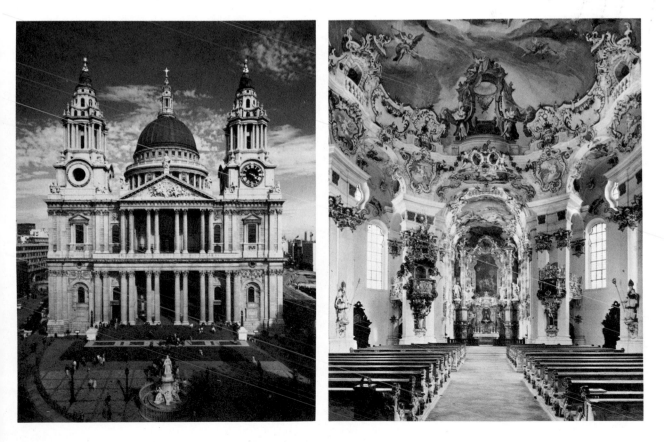

Aside from composition, space and surface also became independent elements to be used and manipulated for their own sakes as well as for the sake of painting or the architectural facade they defined. Just as, a century earlier, the discovery of space had introduced a new compositional image, so did the newly developed freedom with which it was handled. Composition was now either a two-dimensional or three-dimensional consideration. But once the third dimension is specifically introduced, it becomes an element that preempts all other spatial elements and relationships. If the illusion of space, regardless of its shallowness, is part of a composition, it will occupy a position of prime consideration.

The Nineteenth Century

Considering the frame and flat-surface distortion of the seventeenth century and the dependence on the engaged surface of the Rococo during the eighteenth century, the negation of both frame and surface evident in the nineteenth century was merely one more step in a logical development. The lateral movement off the picture plane—anticipated by the Chinese conceptual system and encouraged by the Baroque considerations of space as a manipulatable, plastic element—became an integral part of nineteenth-century composition. Beginning with the Impressionists, painting appeared to display an ever-enlarging view of a smaller and smaller random segment—even a random moment—of the painter's environment or the scene presented. The atmospheric quality of an instant became the engrossing engagement of Claude Monet. The interrupted figure—the figure whose action is caught as though by a camera—became a standard subject for Edgar Degas (1834–1917) and others. The scroll form was transferred to the wall by Pierre Puvis de Chavannes (1824–1898) for his decorations in the amphitheater of the Sorbonne, and Henri de Toulouse-Lautrec (1864–1901) recorded initimate scenes of cabaret life in nineteenth-century Paris.

The Twentieth Century

Although composition in painting clearly relates to man's concepts about the nature of his environment, it has also always related to the flat, two-dimensional or illusionary, three-dimensional

Top right: Claude Monet, "Rouen Cathedral: Tour d'Albane, Early Morning," 1894. One of a series of paintings of the cathedral at Rouen in which Monet set out to record the nature of light and atmospheric change. He was unconcerned with form and the traditional concept of composition. (Courtesy, Museum of Fine Arts, Boston. Arthur Gordon Tompkins Residuary Fund.)

Far right: Edgar Degas, "Ballerina and Lady with Fan," 1885. Degas's interest in the momentary attitude of figures in motion added a new element to composition—the fragmentary vision in which only a part of a figure need appear in order to create the illusion of reality. (Courtesy, John G. Johnson Collection, Philadelphia.)

Bottom right: Henri de Toulouse-Lautrec, "At the Moulin-Rouge 1892," 1892. Toulouse-Lautrec extended Degas's concept of the moving figure to a concept of candid observation, which intimately revealed the nature of what was seen. (Courtesy, The Art Institute of Chicago, Helen Birch Bartlett Memorial Collection.)

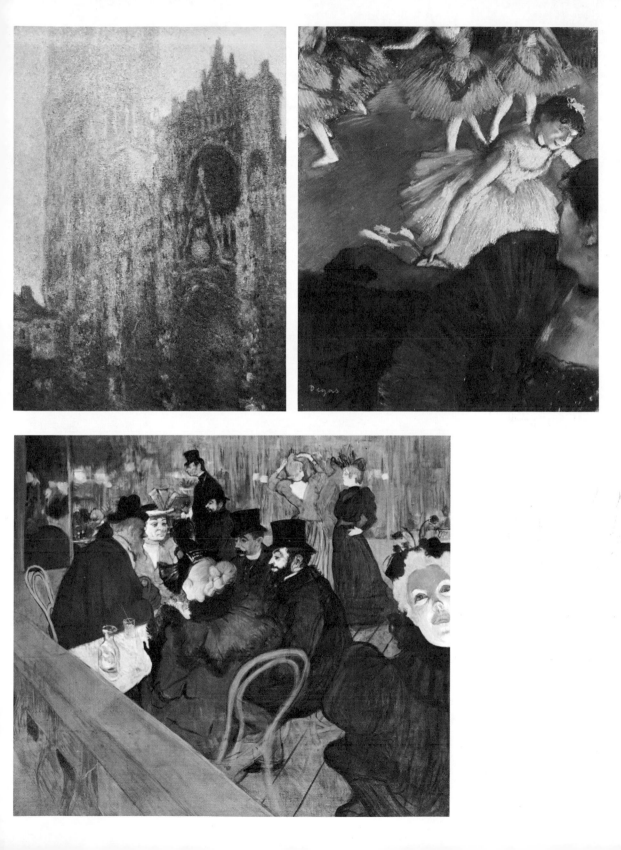

surface. And it was the problem of dealing with an illusionary third dimension on a two-dimensional surface that became the first major compositional consideration of the twentieth century. Early in the century, painters began to consider the two-dimensional quality of the surface objectively. No longer was a painting to be merely an illusion of spatial reality—it was to exist as a two-dimensional, surface image, independent of all considerations of form. This meant that shape (or volume), color, texture, and arrangement (or composition) were to be considered only in relation to themselves and the total art form. Once related to subject matter, the elements now took on an independent value according to their ability to contribute to the development of an esthetic response.

CUBISM. Beginning with Cubism, an analytical formalism was introduced into painting that reached its apex in the monolithic compositions of Kasimir Malevich (1878–1935) and Piet Mon-

Kasimir Malevich, "Suprematist Composition: White on White," 1918. Malevich conceived the Suprematist concept of art as the representation of forms liberated from the natural world. The concept, based solely on man's feelings of the rhythm of the time was expressed through simple non-objective forms—the square, the triangle, and the cross. (Collection, The Museum of Modern Art, New York.)

drian (1872–1944); it has currently been revived as a school of Hard-edged Abstractionism. The Cubists, holding that the illusion of the third dimension is a false image, developed a new geometry of space, one that was not based on visual phenomena but rather on a projection of abstract geometric forms. Because no amount of illusion can create a three-dimensional form on a two-dimensional surface, the Cubists chose to incorporate elements from all points of visual or geometric reference to create a new form that

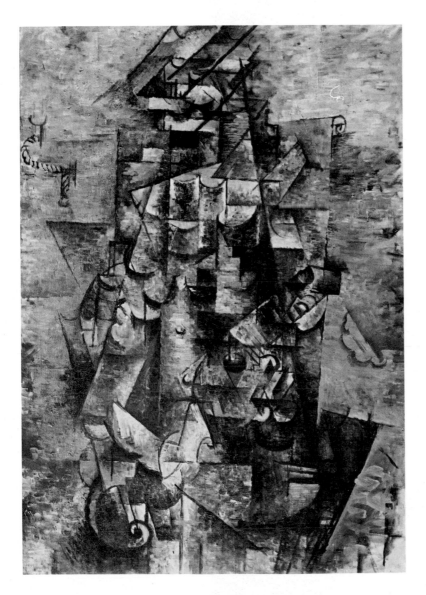

Georges Braque, "Man with a Guitar," 1911. In this painting, which represents the analytical stage of Cubism, Braque has redefined the realistic forms into geometric shapes. The subject is considered with a sense of spontaneity that is supposed to give the observer more insight into the nature of the forms than could be obtained from a naturalistic representation. (Collection, The Museum of Modern Art, New York. Acquired through the Lillie P. Bliss Bequest.)

could stand as a display of their personal creativity, presented in terms of analytical rationalism. It is interesting to note that in the literature supporting Cubism there is continual reference to the significance of proportion and geometry and an implication that beauty is related to mathematics and science. But although the Cubists tried to approach their images analytically and logically to solve problems of spatial relationships, they rejected measurable analysis and accurate proportion

. . . in favor of dimensions of the mind . . . based on the greater or lesser significance assigned to certain objects and figures. This systematic disproportion is basic to cubist art, in which "true" proportions of familiar objects are deliberately sacrificed to an abstract architectural concept and a compositional scheme in which the normal "balance" of the various elements is disregarded.[23]

Eventually, as Cubism progressed, it completely eliminated subject matter. And when this occurred, the only elements to which the observer could turn for comprehension were composition and

[23] Maurice Raynal, *Modern Painting*, New York: Skira, Inc., Publishers, 1956, p. 94.

Piet Mondrian, "Composition 2," 1922. Mondrian believed that the essence of all painting was line and color. Therefore, these elements had to be released from their task of representing nature and made to exist for themselves. (Courtesy, The Solomon R. Guggenheim Museum.)

expression. It was Mondrian who carried the idea of composition to its ultimate abstraction. His paintings, usually referred to as "pure compositions," relied on relationships for their own sakes. Although considered highly architectural and allied to the science of perception, the images were actually intuitive and based on mysticism. Mondrian's paintings, which are asymmetrically balanced, exhibit highly calculated, two-dimensional spatial and color balance, which for some indicate a search for basic relationships. The deepest significance of this type of imagery, however, is to be found in the individual, personal, and often mystic contemplation it is able to evoke.

EXPRESSIONISM. The neoplastic painting of Mondrian's de Stijl movement gave abstract composition the position of ultimate value and, in so doing, became one of the foundation stones of modern graphic design. But in pre-World-War-I Germany, Expressionism, the artistic counterpart of Neoplasticism, became established as a major art force and placed composition at the bottom of the value scale. The roots of this style can be seen in the work of Vincent van Gogh, Paul Gauguin, James Ensor (1860–1942), and Edvard Munch (1863–1944). Relying on a new and complete spatial freedom that began with illusionary space, matured as a result of the spatial manipulations of the Baroque, and declined in the experiments of the nineteenth and twentieth centuries, the Expressionists placed primary significance on *what* they said rather than *how* they said it. The aim of Expressionism "was (and is) to make paintings, as it were, a *speculum hominis*, a mirror held up to the artist's ego and a vehicle for the unfettered expression of his soul." [24] Clearly related to the impact of the psychoanalytical thories of Freudian psychology and the political and social unrest of the late nineteenth and early twentieth centuries, Expressionism disavowed the traditional canons of Western composition in favor of a psychosocial portrayal of the lack of order and the horror of twentieth-century man's condition. Proponents of the style often depended on strange and unique arrangements of form calculated to jar man's sense of balance and order. The close-up and the interrupted figure combined with a strong rhythmic pattern were typical of their compositions.

[24] *Ibid.*, p. 204.

Edvard Munch, "The Death Chamber" (lithograph), 1896. With the advent of Expressionism and the revelation that the artist's psychosocial responses were the core of paintings, composition was considered to be the result of the artistic activity itself; it was not planned in advance. (Collection, The Museum of Modern Art, New York.)

Eventually, Expressionism—in the form of its mid-twentieth-century successor, Abstract Expressionism—arrived at the point of "anti-composition," where the merest hint of a planned or contrived arrangement was suspect. Once again, the rationale behind this concept was man's search for a reality that extended beyond the visible. This time, however, instead of looking outward for an absolute or deistic order, the artist turned inward and looked for one that was born of the inner nature of the individual, one free from the crystallized imprint of the external human condition. The result was a nonobjective, expressionistic form that depended for order on the painter's psychochemical rhythm and intuition. To this end, Franz Kline (1910–1962), a major American painter, was able to declare, "Procedure is the key word. The difference is that we don't begin with a definite sense of procedure.

It's free association from the start to the finished state." [25] In many cases, painting became a recorded moment of the artist's biography, a record of the artist's encounter with materials and a surface. The leading segment of mid-twentieth-century painters that moved in this direction made up the school known as Action Painting. Here composition was reduced to a symmetrical or asymmetrical balance of color and texture.

[25] Eric Protter, *Painters on Painting*, New York: The Universal Library, Grosset & Dunlap, Inc., 1963, p. 248.

Franz Kline, "Black, White and Gray," 1959. Kline reduced images and composition to directional gestures; these gestures form the structure and content of his paintings. (Courtesy, The Metropolitan Museum of Art, New York. Purchase, 1959, George A. Hearn Fund.)

MONTAGE. The concept involved in montage is the extension of composition beyond the limits of the spatial and temporal aspects of the single image. It was expressed dynamically by Sergei Eisenstein (1898–1948), the Russian film maker, and relates directly to the theory of composition that underlies much contemporary art. In speaking of painting, Eisenstein said, "What comprises the dynamic effect of a painting? The eye follows the direction of an element in the painting. It retains a visual impression, which then collides with the impression derived from following the direction of a second element. The conflict of these directions forms the dynamic effect in apprehending the whole." [26]

In its most common graphic form, montage functions as a single image repeated for the purpose of indicating movement, such as occurred in the work of the Italian Futurists, who flourished on the speed and dynamism they projected. One of their intentions was to establish the fourth dimension, time; they attempted to do this visibly, not by the spatially induced time of the Chinese scroll painting or the Baroque surface, but by the staccato repetition of the image as it would appear in movement. The viewer becomes aware of—if not actual movement—a deliberately directed, rapidly repeating form whose visual intention can become complete only when the multiple images fuse into movement. This type of montage did not remain within the confines of Futurism, but became a tool also of the Surrealists, Neosurrealists, and other image makers.

Although this primitive montage did play a part in the development of modern painting, it was Eisenstein's theory—montage developed by the juxtaposition of conflicting images—that was to make the most significant contribution to modern composition. Eisenstein stated that ". . . montage is an idea that arises from the collision of independent shots—shots even opposite to one another: the 'diamatic' principle." [27] He explained that the dynamic quality that results is due to "The incongruence in contour of the first picture—already impressed on the mind—with the subsequently perceived second picture which engenders, in conflict, the feeling of motion. Degree of incongruence determines

[26] Sergei Eisenstein, *The Film Form* and *The Film Sense* (ed. and trans. by Jay Leyda), New York: Meridian Books, Inc., 1963, p. 50.
[27] *Ibid.*, p. 49.

that tension which becomes the real element of authentic rhythm." [28]

Although Eisenstein developed his concept of montage in relation to the film form, he realized, as did others, that its implications extended well beyond his original intention. Referring originally to a series of separate film images juxtaposed in a timed sequence and building on one another, the concept has been adapted to painting and, to a lesser degree, contemporary sculpture. In painting, the separate images, instead of being resolved

[28] *Ibid.*, p. 50.

Luigi Russolo, "Dynamism of an Automobile." The Futurists' interest in the dynamics of speed and motion often led them to compositions that tried to carry the observer beyond the limits of the painting. (Courtesy, Musée National d'Art Moderne, Cliché des Musées Nationaux.)

into a final, remembered, total image, remain to remind the observer that the conflict of motion is always attendant on the image. The result is often a spatially dissolute painting, the degree of dissolution depending on the degree of conflict involved.

In the plastic arts, conflict can occur on two levels—first, by well-defined differences between related or juxtaposed visual elements and, second, by juxtaposed ideas. Double conflict (conflict on both levels) reinforces the total conflict and results in a more dynamic montage than could be established with a single conflict. The montage is visually successful when the meaning of the image develops from the psychological meeting of what is witnessed and the physiopsychological experience of the observer.

Pablo Picasso's "Guernica" illustrates how this concept can be used to develop a graphic image of major importance. Although the painting is filled with highly charged psychopolitical symbolism, it is not necessary to understand it to sense the drama and passion portrayed. Emotion has been intensified by the presence of conflicting forms, juxtaposed into a montage of visual elements and ideas in which the grotesque imagery and spatial disorientation present the horrors of war and destruction more forcefully and dramatically than could the illusionistic painting of earlier genera-

Pablo Picasso, "Guernica," 1937. Highly dramatic distortions, surrealistically juxtaposed, turn Picasso's static symmetrical structure into a dynamic image that moves beyond composition to a powerful and total statement by the artist. (On extended loan to the Museum of Modern Art, New York, from the artist, M. Picasso.)

tions. Triptych in form, the painting crowds its elements into a tight and overlapping composition that manages to keep itself within both the boundaries of its frame and the surface on which it appears. The composition, which is organized symmetrically, is built on a major triangle whose base, running parallel to the lower edge of the painting, extends the full width of the canvas. The triangle is flanked on both sides by vertical rectangles, so the original symmetry is broken into by the head and arm that move into the picture plane just right of the center. The forms, although distorted, maintain a sense of balance by constantly being related to the geotropic lines of axial direction in the painting.

Although composition touches on all the other aspects of art, it is clear that it depends mainly on the concepts of two- and three-dimensional space—how the artist or designer conceives of space and how he arranges all his elements within it. Composition may consist of formal or informal arrangements, contrived or random proportions, symmetrical or asymmetrical order, the perception of illusionary space or the negation of it. It may be based on strict and formal canons or on a calculated disregard of considered principles. It may refer only to what appears in the image or engage experiences of the observer that exist separately and apart from what is being observed. It may depend on a closed sense of unity and "nowness" or take flight into a spatial or temporal world that cannot be contained within the immediate picture plane. But whatever form composition takes, it is completely dependent on the frame of reference determined by the art form it is given and the human qualities of the artist.

SUGGESTED READINGS

Language and Perception

Arnheim, Rudolf, *Art and Visual Perception*, Berkeley, Calif.: University of California Press, 1954.

Gibson, James Jerome, *The Perception of the Visual World*, Boston: Houghton Mifflin Company, 1950.

Gombrich, Ernst H., *Art and Illusion*, 2d ed., Princeton, N.J.: Princeton University Press, 1961.

Gregory, R. L., *Eye and Brain*, New York: McGraw-Hill Book Company, 1966.

Hall, Edward Twitchell, *The Hidden Dimension*, Garden City, N.Y.: Doubleday & Company, Inc., 1966.

———, *The Silent Language*, Garden City, N.Y.: Doubleday & Company, Inc., 1959.

Kepes, Gyorgy, *Language of Vision*, Chicago: Paul Theobald & Company, 1945.

Segall, Marshall H., Donald T. Campbell, and Melville J. Herskovits, *The Influence of Culture on Visual Perception*, Indianapolis: The Bobbs-Merrill Company, Inc., 1966.

Urban, Wilbur M., *Language and Reality*, 2d ed., New York: The Macmillan Company, 1951.

Wheelwright, Philip, *The Burning Fountain: A Study in the Language of Symbolism*, Bloomington, Ind.: Indiana University Press, 1954.

Esthetics: Theory and Concept

Biederman, Charles, *Art as the Evolution of Visual Knowledge*, Red Wing, Minn.: Art History Publishers, 1948.

Boas, George, *The Heaven of Invention*, Baltimore: The Johns Hopkins Press, 1963.

Carpenter, Rhys, *The Esthetic Basis of Greek Art*, Bloomington, Ind.: Indiana University Press, 1959.

Chambers, Frank P., *The History of Taste: An Account of the Revolutions of Art Criticism and Theory in Europe*, New York: Columbia University Press, 1932.

Collingwood, R. G., *The Principles of Art*, Fair Lawn, N.J.: Oxford University Press, 1938.

Dewey, John, *Art as Experience*, New York: G. P. Putnam's Sons, 1959.

Dorner, Alexander, *The Way beyond Art*, rev. ed., New York: New York University Press, 1958.

Fischer, Ernst, *The Necessity of Art*, Baltimore: Penguin Books, Inc., 1964.

Fishman, Solomon, *The Interpretation of Art: Essays on the Art Criticism of John Ruskin, Walter Pater, Clive Bell, Roger Fry, and Herbert Read*, Berkeley: University of California Press, 1962.

Foçillon, Henri, *The Life of Forms in Art*, 2d Eng. ed., New York: George Wittenborn, Inc., 1966.

Gilbert, Katherine, and Helmut Kuhn, *A History of Esthetics*, 2d ed., Bloomington, Ind.: Indiana University Press, 1953.

Gilson, Etienne, *Painting and Reality*, New York: Meridian Books, Inc., 1959.

Huyghe, René, *Art and the Spirit of Man*, trans. by Norbert Guterman, New York: Harry N. Abrams, Inc., 1962.

Ivins, William Mills, *Prints and Visual Communication*, 2d ed., New York: Plenum Publishing Corporation, 1968.

Kahler, Erich, *The Disintegration of Form in the Arts*, New York: George Braziller, Inc., 1968.

Kallen, Horace, *Art and Freedom*, vols. 1 and 2, New York: Duell, Sloan & Pearce, Inc., 1942.

Osborn, Harold, *Aesthetics and Criticism*, London: Routledge & Kegan Paul, Ltd., 1955.

Panofsky, Erwin, *Meaning in the Visual Arts*, Garden City, N.Y.: Anchor Books, Doubleday & Company, Inc., 1955.

Peckham, Morse, *Man's Rage for Chaos: Biology,*

Behavior, and the Arts, New York: Schocken Books, Inc., 1967.

Pepper, Stephen, *Principles of Art Appreciation,* New York: Harcourt, Brace & World, Inc., 1949.

Rader, Melvin, *A Modern Book of Esthetics,* 3d ed., New York: Holt, Rinehart and Winston, Inc., 1960.

Rosenberg, Harold, *The Tradition of the New,* New York: McGraw-Hill Book Company, 1965.

Rowley, George, *Principles of Chinese Painting,* 2d ed., Princeton, N.J.: Princeton University Press, 1959.

Saarinen, Eliel, *Search for Form: A Fundamental Approach to Art,* New York: Reinhold Publishing Corporation, 1948.

Scranton, Robert, *Aesthetic Aspects of Ancient Art,* Chicago: The University of Chicago Press, 1964.

Taylor, Harold, *Art and the Intellect, and Moral Values and the Experience of Art,* Garden City, N.Y.: Doubleday & Company, Inc., 1960.

Art and Psychology

Freud, Sigmund, *Civilization and Its Discontents,* New York: W. W. Norton & Company, Inc., 1962.

Jung, Carl G., *Modern Man in Search of a Soul,* trans. by W. S. Dell and C. F. Baynes, New York: Harcourt, Brace & World, Inc., 1956.

Kohler, Ivo, *The Formation and Transformation of the Perceptual World,* New York: International Universities Press, Inc., 1964.

Kris, Ernst, *Psychoanalytic Explorations in Art,* New York: International Universities Press, Inc., 1962.

Kubie, Laurence S., *Neurotic Distortion of the Creative Process,* New York: Noonday Books, Farrar, Straus & Cudahy, Inc., 1961.

Malraux, André, *The Psychology of Art,* vol. 1, *Museum without Walls,* trans. by Stuart Gilbert, New York: Pantheon Books, a Division of Random House, Inc., 1949.

Philipson, Morris, *Outline of Jungian Aesthetics,* Evanston, Ill.: Northwestern University Press, 1963.

Mathematics and Composition

Borissaulievitch, M., *The Golden Number and the Scientific Aesthetics of Architecture,* pref. by Louis Hautecocur, New York: Philosophical Library, Inc., 1958.

Bouleau, Charles, *The Painter's Secret Geometry,* trans. by Jonathan Griffin, New York: Harcourt, Brace & World, Inc., 1963.

Freebury, H. A., *A History of Mathematics,* New York: The Macmillan Company, 1961.

Ghyka, Matila, *The Geometry of Art and Life,* New York: Sheed & Ward, Inc., 1957.

Hambidge, Jay, *Dynamic Symmetry: The Greek Vase,* New Haven, Conn.: Yale University Press, 1920.

Kline, Morris, *Mathematics in Western Culture,* Fair Lawn, N.J.: Oxford University Press, 1953.

Weyl, Hermann, *Symmetry,* Princeton, N.J.: Princeton University Press, 1952.

History and Exposition

Canaday, John, *Mainstreams of Modern Art,* New York: Holt, Rinehart and Winston, Inc., 1959.

Carpenter, Rhys, *Greek Art: A Study of the Formal Evolution of Style,* Philadelphia: University of Pennslyvania Press, 1962.

Childe, Gordon V., *The Dawn of European Civilization,* 6th ed., New York: Alfred A. Knopf, Inc., 1958.

Coulton, George Gordon, *Art and the Reformation,* Oxford: Basil Blackwell & Mott, Ltd., 1928.

Fleming, William, *Art and Ideas,* rev. ed., New York: Holt, Rinehart and Winston, Inc., 1963.

Frankfort, Henri, *The Birth of Civilization in the Near East,* Garden City, N.Y.: Anchor Books, Doubleday & Company, Inc., 1959.

Giedion-Welcker, Carola, *Contemporary Sculpture, an Evolution in Volume and Space,* 3d rev. ed., New York: George Wittenborn, Inc., 1961.

Haftmann, Werner, *Painting in the Twentieth Century,* 2 vols., New York: Frederick A. Praeger, Inc., 1965.

Hauser, Arnold, *The Social History of Art,* 4 vols., New York: Vintage Books, Random House, Inc., 1957.

Hind, Arthur Mayger, *A History of Engraving and Etching,* 3d ed., New York: Dover Publications, Inc., 1923.

————, *An Introduction to a History of Woodcut,* New York: Dover Publications, Inc., 1935.

Janson, H. W., *History of Art,* Englewood Cliffs, N.J.: Prentice-Hall, Inc., 1962.

Kirby, Michael (ed.), *Happenings,* New York: E. P. Dutton & Co., Inc., 1965.

Kostelanetz, Richard, *The New American Arts*, New York: The Macmillan Company, 1967.

Ladd, Henry, *The Victorian Morality of Art*, New York: Octagon Books, Inc., 1967.

Lee, Sherman, *A History of Far Eastern Art*, Englewood Cliffs, N.J.: Prentice-Hall, Inc., 1964.

Lindsey, Jack, *Death of the Hero: French Painting from David to Delacroix*, New York: Studio Books, The Viking Press, Inc., 1960.

Mendelowitz, Daniel M., *Drawing, a Survey*, New York: Holt, Rinehart and Winston, Inc., 1966.

Moskowitz, Ira (ed.), *Great Drawings of All Time*, New York: Shorewood Publishers, Inc., 1962.

Rheims, Maurice, *The Strange Life of Objects*, trans. by David Pryce-Jones, New York: Atheneum Publishers, 1961.

Ritchie, Andrew C., *Sculpture of the Twentieth Century*, New York: The Museum of Modern Art, 1953.

Richter, Gisela, *A Handbook of Greek Art*, 5th ed., London: Phaidon Press, Ltd., 1967.

———, *The Sculpture and Sculptors of the Greeks*, rev. ed., New Haven, Conn.: Yale University Press, 1950.

Robb, David M., and J. J. Garrison, *Art in the Western World*, 4th ed., New York: Harper & Row, Publishers, Incorporated, 1963.

Rosenberg, Jakob, *Great Draughtsmen from Pisanello to Picasso*, Cambridge, Mass.: Harvard University Press, 1959.

Sachs, Paul Joseph, *Modern Prints and Drawings*, New York: Alfred A. Knopf, Inc., 1954.

Trier, Edward, *Form and Sculpture*, New York: Frederick A. Praeger, Inc., 1962.

Valentiner, W. R., *Origins of Modern Sculpture*, New York: George Wittenborn, Inc., 1958.

Weltfish, Gene, *The Origins of Art*, Indianapolis: The Bobbs-Merrill Company, Inc., 1953.

Woelfflin, Heinrich, trans. by Peter and Linda Murray, *Classic Art: An Introduction to the Italian Renaissance*, 2d ed., New York: Phaidon Publishers, Inc., 1953.

Woolley, Leonard, *The Beginning of Civilization*, vol. I, part II, *History of Mankind*, New York: New American Library of World Literature, Inc., 1965.

Color

Albers, Josef, *Interaction of Color*, New Haven, Conn.: Yale University Press, 1963.

Birren, Faber, *Color: A Survey in Words and Pictures, from Ancient Mysticism to Modern Science*, New Hyde Park, N.Y.: University Books, Inc., 1963.

Church, Arthur Herbert, *Colour*, London: Cassell, Petter and Galpin, 1872.

Evans, Ralph M., *An Introduction to Color*, New York: John Wiley & Sons, Inc., 1948.

Itten, Johannes, *The Art of Color*, New York: Reinhold Publishing Corporation, 1961.

Munsell, Albert Henry, *A Color Notation*, 11th ed., Baltimore: Munsell Color Company, Inc., 1961.

Newton, Sir Isaac, *Opticks*, New York: Dover Publications, Inc., 1952.

Optical System of America Committee on Colorimetry, *The Science of Color*, New York: Thomas Y. Crowell Company, 1953.

Ostwald, Wilhelm, *Color Science*, vols. 1 and 2, London: Winsor & Newton, Ltd., 1931–1933.

Taylor, F. A., *Colour Technology for Artists, Craftsmen, and Industrial Designers*, Fair Lawn, N.J.: Oxford University Press, 1962.

Teevan, Richard C., and Robert C. Birney (eds.), *Color Vision*, Princeton, N.J.: D. Van Nostrand Company, Inc., 1961.

Design

Alexander, Christopher, *Notes on the Synthesis of Form*, Cambridge, Mass.: Harvard University Press, 1964.

Banham, Reyner, *Theory and Design in the First Machine Age*, 2d ed., New York: Frederick A. Praeger, Inc., 1967.

DeZurko, Edward, *Origins of Functionalist Theory*, New York: Columbia University Press, 1957.

Drexler, Arthur, and Greta Daniel, *Introduction to Twentieth Century Design from the Collection of The Museum of Modern Art, New York*, New York: The Museum of Modern Art, 1959.

Giedion, Sigfried, *Mechanization Takes Command, A Contribution to Anonymous History*, Fair Lawn, N.J.: Oxford University Press, 1948.

———, *Space, Time and Architecture: The Growth of a New Tradition*, 5th ed., Cambridge, Mass.: Harvard University Press, 1967.

Greenough, Horatio, *Form and Function: Remarks on Art, Design, and Architecture*, Berkeley, Calif.: University of California Press, 1958.

Grillo, Paul-Jacques, *What Is Design?* Chicago: Paul Theobald & Company, 1960.

Suggested readings

Johnson, Philip, *Machine Art*, New York: The Museum of Modern Art, 1934.

Nelson, George, *Problems of Design*, New York: Hill and Wang, Inc., 1957.

Pevsner, Nikolaus, *Pioneers of Modern Design*, Baltimore: Penguin Books, Inc., 1964.

Pye, David, *The Nature of Design*, New York: Reinhold Publishing Corporation, 1964.

Materials and Techniques

Doerner, Max, *The Materials of the Artist*, rev. ed., New York: Harcourt, Brace & World, Inc., 1949.

Janis, Harriet, and Rudi Blesh, *Collage: Personalities, Concepts, Techniques*, rev. ed., Philadelphia: Chilton Company—Book Division, 1967.

Mayer, Ralph, *The Artist's Handbook of Materials and Techniques*, rev. ed., New York: The Viking Press, Inc., 1966.

Rich, Jack C., *The Materials and Methods of Sculpture*, Fair Lawn, N.J.: Oxford University Press, 1947.

Seitz, William Chapin, *The Art of Assemblage*, Garden City, N.Y.: Doubleday & Company, Inc., 1961.

Artists on Art

Alberti, Leon Battista, *On Painting*, rev. ed., trans. by John R. Spencer, New Haven, Conn.: Yale University Press, 1966.

———, *Ten Books on Architecture*, Levittown, N.Y.: Transatlantic Arts, Inc., 1955.

Goldwater, Robert John, and Marco Treves (eds.), *Artists on Art*, New York: Pantheon Books, a Division of Random House, Inc., 1945.

Herbert, Robert L., *Modern Artists on Art*, Englewood Cliffs, N.J.: Prentice-Hall, Inc., 1964.

Holt, Elizabeth G. (ed.), *A Documentary History of Art*, Garden City, N.Y.: Anchor Books, Doubleday & Company, Inc., vol. 1, 1957, vol. 2, 1958, vol. 3, 1966.

Kandinsky, Wassily, *Concerning the Spiritual in Art and Painting in Particular*, New York: George Wittenborn, Inc., 1964.

McDarrah, Fred W., *The Artist's World*, New York: E. P. Dutton & Co., Inc., 1961.

Mondrian, Piet, *Plastic Art and Pure Plastic Art, 1937, and Other Essays, 1941–43*, New York: George Wittenborn, Inc., 1945.

Protter, Eric (ed.), *Painters on Painting*, New York: Grosset & Dunlap, Inc., 1963.

Sirén, Osvald, *The Chinese on the Art of Painting*, New York: Schocken Books, Inc., 1963.

INDEX

A

Aalto, Alvar, lounge chair *207*
"Abraham and Melchizedek," *54*
Abstract Expressionism, 62, 229–231, 308–309
Abstractionism, Hard-edged, 62, 305
Achromatic gray scale, *Plate 13A*
Action Painting, 62, 309
"Adam" (Rodin), *238*
Adams, Philip R., *quoted,* 253
"Adoration of the Magi," study for (Leonardo), *295*
"Adoration of the Magi, The" (Fabriano), *Plate 4*
"After the Hunt" (Homer), *Plate 5*
Akh-en-Aton, King (limestone bas-relief), *283*
Albers, Josef, 165
Alberti, Leon Battista, 266, 273, 292–293
 quoted, 214, 293
Aluminum, as material for sculptor, 86–87
American Regionalists, 162
"Anatomy Lesson of Dr. Tulp, The" (Rembrandt), *220*
"Annunciation, The" (Byzantine silk fabric), *51*
Antiart Artists, 62
Aquinas, St. Thomas, 15
Architecture, Baroque, 301
 Renaissance, 266
 role in evolution of art, 30
Aristotle, 161–162
Arnheim, Rudolf, 263
Arp, Jean, 255
 "Ptolemy," *256*
Art, definitions of, 25–26
 effects of changing values on, 116–117
 evolution of, 26–39
 forms of, 66–69
 nature of, 3–4
Art Nouveau, 62
Art objects, original significance of, 9–12
 ways of classifying, 65
Assemblage, 235–237

B

"At the Moulin Rouge 1892" (Toulouse-Lautrec), *303*
Aton (sun god), in limestone bas-relief, *283*
"Augustus of Primaporta" (Roman sculpture), *49*

"Bacchus" (Caravaggio), *215*
"Baignade, Asnières, Une" (Seurat), *Plate 29*
Balance, in composition, 276–279
"Ballerina and Lady with Fan" (Degas), *303*
Bank of Pennsylvania, facade of (Latrobe), *61*
"Banquet of Officers of the Civic Guard of St. George at Haarlem" (Hals), *218*
"Bar at the Folies-Bergère, A" (Manet), *226*
Baroque style, 58, 251, 299–302
Basic (primary) colors, 156–157
Basilica, Roman, 50
Basket, plaited (Papago Indian), *210*
Baskin, Leonard, "Head of a Poet," *146*
"Bathers" (Lipchitz), *13*
"Battle of San Romano, The" (Uccello), *17*
Baur, John, *quoted,* 231
Beam scale, *16*
Beauty, concept of, 15–22
Bell, Larry, "Old Cotton Fields Back Home," *Plate 34*
Bellini, Jacopo, 142
Bello, Francis, *quoted,* 167
Bellows, George, "Stag at Sharkey's," *114*
Berenson, Bernard, *quoted,* 294
Bernini, Giovanni Lorenzo, 251
 "The Ecstasy of St. Theresa," *252*
Bernstein, Martha, *quoted,* 187
Bertoia, Harry, 257
Bihzad, manuscript painting, *284*
Birren, Faber, 183
Bishop's chair, *11*
Bistre, 147

"Black, White and Gray" (Kline), *309*
"Blue in the Middle" (Vasa), *Plate 2*
Bonnard, Pierre, 227
Bookcase, in Neogothic style, *61*
Borromini, Francesco, facade of S. Carlo alle Quattro Fontane, *59*
Boucher, François, 139
Bourke-White, Margaret, *quoted,* 276, 277
Brancusi, Constantin, 255
Braque, Georges, 234
 "Man with a Guitar," *305*
 "Young Girl with Guitar," *5*
Brass, as material for sculptor, 86
Bread sculpture, Ecuadorian, *73*
"Breakfast" (Gris), *234*
Brewster, Sir David, 180–181
Broderson, Morris, "Sound of Flowers," *37*
Bronze, as material for sculptor, 86
Bronzino, Agnolo, "Portrait of a Young Man," *58*
Brueghel, Pieter (the Elder), "Peasant Wedding," *216*
"Buddhist Monastery in Stream and Mountain Landscape" (Chu Jan), *285*
Buddhist priests, *Plate 18*
Buon fresco, 95
"Burial of Count Orgaz, The" (El Greco), *300*
Butter sculpture, Tibetan, *72*
"Butterfly Ballet, The" (Dufy), *100*
Byzantine period, stylistic classification of, 50–52

C

Calder, Alexander, "Lobster Trap and Fish Tail," 17, *19*
Canaday, John, *quoted,* 195
"Canyon" (Rauschenberg), *74*
Caravaggio, Michelangelo Amerighi da, "Bacchus," *215*
"Cartel Clock" (Cressent), *252*
Carving, as sculptural technique, 88–89, *89*

Casein paint, 99–100
Casting, as sculptural technique, 90–92
Cathedral of St. Paul (Wren), *301*
"Cattle Fording a River" (painted limestone relief), *45*
Cellini, Benvenuto, "Salt Cellar of Francis I," *31*
Cennini, Cennino, 143
Ceramics, container (Voulkos), *213*
 forms (McIntosh), *125*
 platter (Picasso), *79*
Ceremonial objects, as art forms, 9–12
Cézanne, Paul, 193
 "Mont Sainte Victoire," *Plate 30*
Chair, bishop's, *11*
 in eighteenth-century Chinese style, *60*
 lounge (Aalto), *207*
 in nineteenth-century Egyptian style, *60*
 in nineteenth-century rustic style, *60*
Chalk, as drawing medium, 137–139
Charcoal, as drawing medium, 140
Chardin, Jean-Baptiste Siméon, 221
"Charioteer," *242*
Chartres Cathedral, jamb statues from, *246*
Cheney, Sheldon, *quoted,* 47
"Cherry Picture" (Schwitters), *233*
Chevreul, Michel Eugène, 179–180, 186
 quoted, 180, 186
Chiaroscuro, 190–191, 250–251
Childe, Gordon, 75–76
Chinese art, composition in, 297–298
 conceptual perspective in, 283–285
Chinese ink, 145–147
"Christ Entering Jerusalem" (Duccio), *289*
"Christ in Glory" (Romanesque sculpture), *54*
Chroma and value scale, *Plate 13B*
Chu Jan, "Buddhist Monastery in Stream and Mountain Landscape," *285*
Church, Arthur Henry, *quoted,* 158
Cimabue, Giovanni, 286–287
 "Crucifix," *68*
 "The Crucifixion," *286*
Cire perdue (lost-wax) process, 91–92
Clay, as material for sculptor, 82–83
Click, Robert, "Still Life #1," *115*
Collage, 232–237
Color, 148–197
 changing nature of, in painting, 190–197
 complementary, 155–156, 158–159

importance in art, 149–151
primary properties, 151–156
 hue, 152–154
 lightness, 154–155
 saturation, 155–156
primary, secondary, and tertiary, 156–158
recession and advancement, 160
relationships among, 185–190
in sculpture, 241–243, 246–247
systems, 176–185
temperature, 159
theories of, 160–176
 Aristotle, 161–162
 color consistency, 171
 color preferences, 171–172
 color symbolism, 172–176
 Goethe, 165
 Hering, 167
 Land, 168–169
 Maxwell, 167
 Newton, 162–164
 nonoptical color, 170–171
 Young-Helmholtz, 165–167
Color circle(s), *Plate 15*
 of Munsell, *163*
Color solid, of Munsell, *Plate 20*
Color triangle, of Ostwald, *Plate 19*
Composition, 260–313
 development of modern, 297–313
 Baroque, 299–302
 nineteenth century, 302
 twentieth century, 302–313
 mathematical order, 264–275
 proportion, 266–268, 270–274
 symmetry, 268–275
 perception, 262–264
 purposes of, 275–279
 space in, 279–296
 concepts of, 282–285
 perspective, 286–296
"Composition 2" (Mondrian), *306*
Constable, John, 191, 222
 "Stoke-by-Nayland," *223*
Constructivists, 62
Conte, N. J., 143
Coors porcelainware, *205*
Copper, as material for sculptor, 86
Corot, Jean Baptiste Camille, 143, 225
 "Henry Leroy as a Child," *145*
 "The Interrupted Reading," *225*
Courbet, Gustave, 225
Crafts, development of, 30–33
 modern position of, 77
Crespelle, Jean Paul, *quoted,* 194
Cressent, Charles, "Cartel Clock," *252*
"Cross of Garnerius," *68*
"Crucifix" (Cimabue), *68*
"Crucifixion, The" (Cimabue), *286*
Cubists, 62, 234–235, 304–307
Cup, Attic, *11*

D

Da Vinci, Leonardo, (*see* Leonardo da Vinci)
Dadaists, 62, 234–235
Daumier, Honoré, 226, 253
David, Jacques Louis, 9, 191, 220
 "The Death of Socrates," *Plate 26*
"Day After, The" (Munch), *10*
De Kooning, William, "Woman IV," *278*
De Stijl, 62, 307
"Death Chamber, The" (Munch), *308*
"Death of Socrates, The" (David), *Plate 26*
Decoration, 39–40, 125
Découpage, 233
Degas, Edgar, 302
 "Ballerina and Lady with Fan," *303*
 portrait of Manet, study for, *129*
 "The Tub," *Plate 11*
Delacroix, Eugène, 191, 224
Della Robbia, Luca, 293
 "St. Michael, the Archangel," *82*
Denning, Kay, *quoted,* 32
Design, 33–39, 261
 texture in, 200–214
 concept, 212–214
 function, 210–212
 materials, 201–208
 process, 208–209
"Dial" (Guston), *232*
Donatello, 293
"Donkey Nursing Two Lion Cubs" (Roman mosaic), *105*
Drawing, history of, 130–136
 media for, 137–147
 chalk, 137–139
 charcoal, 140
 ink, 143–147
 metals, 140–143
 pastels, 139
 pencil, 143
Dry points, 113
Duccio di Buoninsegna, 55–56, 287–288
 "Christ Entering Jerusalem," *55*
 "Madonna Enthroned," *289*
"Ducks and Reeds" (Tanyu), *129*
Dufy, Raoul, "Butterfly Ballet," *100*
Dürer, Albrecht, 142, 273
"Dynamism of an Automobile" (Russolo), *311*

E

Early Christian period, as stylistic classification, 49–50
Earthenware, 82
Eclecticism, 59

"Ecstasy of St. Theresa, The" (Bernini), *252*
Egyptian art, conceptual perspective in, 282–283
 painting, 93–94, *94*
 "Feeding the Oryxes," *46*
 "Triumphant Hunter," *134*
 "Tut ankh-Amun Hunting Desert Animals," *46*
 sculpture, 240–241
 "Cattle Fording a River," *45*
 King Akh-en-Aton, *283*
 "Prince Rahotep and His Wife," *Plate 37*
 as stylistic classification, 44
 tombs, evolution of, 12
 use of line in, 133–134
Eisenstein, Sergei, 310–312
 quoted, 310, 310–311
El Greco, 219
 "The Burial of Count Orgaz," *300*
Encaustic painting, 95–98
Engravings, 113
Ensor, James, 307
Esthetic judgment, development of, 14–23
 concept of beauty, 15–22
 concept of good, 14
 concept of interest, 22–23
Esthetic reaction, 4–12
 perception, 4–6
 response, 6
 sense of awe, 7-12
 taste, 12
Etchings, 113
Expressionism, 62, 195–197, 228–232, 307–309

F

Fabriano, Gentile da, "The Adoration of the Magi," *Plate 4*
Fabrication, as sculptural technique, 92–93
Falkenstein, Claire, 257–258
 "U as a Set," *258*
Fauves, Les, 62, 195
"Feast in the House of Levi" (Veronese), *34*
"Feeding the Oryxes" (Egyptian tomb painting), *46*
Fibula, *53*
Figurative Painters, 62
"Figures and Decorative Elements" (medieval drawing), *135*
Fine arts, 28–30
Fischer, Mildred, "Improvisation," *126*
"Fishermen" (Wu Chen), *123, 146*
Flaxman, John, 77
 "Sacrifice to Hymen," *78*
Florentine school, 55–57
Flourishing, a (Lehman), *128*
Focus, moving (shifting), 285, 297–298

Form, 16–17, 41
Fragonard, Honoré, 221
Frasconi, Antonio, "Self-Portrait," *109*
Fresco secco, 95
Function, 16–17, 210–212, 275–276
Furniture finishes, 205–206
Futurism, 62, 234–235, 310

G

Gauguin, Paul, 194, 307
 "L'Appel," *Plate 32*
Geometry, and perspective, 290–295
"George Washington" (Greenough), *238*
Géricault, Théodore, 191, 224
 "The Raft of the Medusa," *224*
Ghiberti, Lorenzo, 136, 293–294
Ghirlandaio, Domenico, "St. Christopher and the Infant Christ," *96*
Giacometti, Alberto, 255
Giedion, Sigfried, *quoted*, 131, 282
Gilding, 203
Giotto di Bondone, 55–57, 287–288
 "The Lamentation," *57*
 "Madonna Enthroned," *55*
 "St. Francis Renouncing His Inheritance," *287*
Goethe, Johann Wolfgang von, 165, 179
Gold, as material for sculptor, 86
Gonzales, Julio, 255
"Good Government in the City" (Lorenzetti), *290*
Gothic style, 54–57, 245–247
Gouache, 99
Goya y Lucientes, Francisco José de, 66, 221–222
 "The Third of May, 1808," *67*
Graining, 202
"Great Dome, The" (Klee), *128*
Greek art, drawings, styles of, 134–135
 "Herakles, Nessos, and Deianeira" (red-figure style), *Plate 8*
 "Shoemaker's Shop" (black-figure style), *Plate 7*
 "Woman Playing Lyre" (white-ground style), *Plate 9*
 sculpture, 241–243
 "Charioteer," *242*
 Kore, *Plate 17*
 "Zeus" (or "Poseidon"), *48*
 stylistic classification of, 44–45
Greenough, Horatio, 16
 "George Washington," *238*
Gris, Juan, "Breakfast," *234*
Grosz, George, 143
 "Portrait of Anna Peter," *145*
"Guernica" (Picasso), *312*
Guston, Philip, 231
 "Dial," *232*

H

Hagia Sophia (Byzantine church), *52*
Hals, Frans, 101, 218–219
 "Banquet of Officers of the Civic Guard of St. George at Haarlem," *218*
 "Malle Babbe," *103*
Hambidge, Jay, 273–274
"Hamburger with Pickle and Tomato Attached" (Oldenburg), *Plate 1*
Hamerton, Philip Gilbert, *quoted*, 136
Happenings, 237
Hare, David, "Juggler," *92*
Harnett, William, "Old Models," *234*
Harris, Moses, 179
Harris, Robert, (sculpture), *91*
"Haystacks, Setting Sun" (Monet), *Plate 22*
"Head of a Poet" (Baskin), *146*
"Head of a Woman" (Prud'hon), *141*
"Head of Buddha" (sandstone sculpture), *83*
Helmholtz, Hermann von, 166–167
"Henry Leroy as a Child" (Corot), *145*
"Herakles, Nessos, and Deianeira," *Plate 8*
Hering, Ewald, 167
Heron, Patrick, *quoted*, 229
Hicks, Sheila, "Prayer Rug," *32*
"History of Charlemagne" (stained-glass window), *108, Plate 6*
Hogarth, William, 221
 "In Bedlam," *111*
 "The Shrimp Girl," *222*
Homer, Winslow, "After the Hunt," *Plate 5*
Hoover Dam, *8*
"Horse and Rider" (Marini), *86*
Hsia Kuei, "Twelve Views from a Thatched Cottage," *298*

I

Ice sculpture, *72*
Icon, Russian, "Our Lady of Vladimir," *5*
 traveler's, *68*
Ife heads, 240
Igneous stones, 83
Impressionism, 62, 191–192, 226–227, 253, 302
"Improvisation" (Fischer), *126*
"Improvisation" (Kandinsky), *Plate 35*
"In Bedlam" (Hogarth), *111*
India ink, 145–147

Ingres, Jean Auguste Dominique, 101, 143, 220
 "Madame Rivière," *221*
 "Portrait of Madame Armande Destouches," *145*
 "Portrait of the Comtesse d'Haussonville," *102*
Ink, as drawing medium, 143–147
Intaglio prints, 113
"Interrupted Reading, The" (Corot), *225*
Iron, as material for sculptor, 86
Ishtar Gates, *Plate 16*
Islamic art, boundaries of, 43
 decoration in, 39
Itten, Johannes, 165

J

Jacopo della Quercia, 248
James, William, *quoted*, 22
Janson, H. W., *quoted*, 47
Johnson, Philip, *quoted*, 204
"Juggler" (Hare), *92*

K

Kandinsky, Wassily, 122–124, 195–196, 228–229
 "Improvisation," *Plate 35*
 quoted, 123–124, 195–196
"Kannon" (Japanese woodcut), *110*
Karlsen, Arne, *quoted*, 209
Kepes, Gyorgy, 263
Klee, Paul, "The Great Dome," *128*
Kline, Franz, *quoted*, 308–309
 "Black, White and Gray," *309*
Knife, predynastic flint, *44*
Koffka, Kurt, *quoted*, 263
Köhler, Wolfgang, 263
Kokoschka, Oscar, 227
"Kongorikishi" (Japanese wood carving), *85*
Koppel, Henning, hand-forged silver pitcher, *210*
"Kore," *Plate 17*
"Krishna with the Gopis," *Plate 23*

L

Lachaise, Gaston, 255
"Lady in Blue" (Matisse), *Plate 33*
Lambert, Johann Heinrich, 178–179
"Lamentation, The" (Giotto), *57*
Land, Edwin, 168–169
"L'Appel" (Gauguin), *Plate 32*
"L'Arlesienne" (van Gogh), *103*
Lassaw, Ibram, 255
"Last Judgment" (detail of tympanum, St. Lazare), *246*
Latrobe, Benjamin Henry, facade of Bank of Pennsylvania, *61*
Lawrence, Arnold Walter, *quoted*, 242–243

Le Blon, Jacques Christoph, 177–178
Le Corbusier, "Modulor," *269*
Lead, as material for sculptor, 86
Lehman, H. B., flourishing (pen and ink drawing), *128*
Leonardo da Vinci, 28, 95, 191, 294
 drawing of human body, *29*
 quoted, 214
 study for "Adoration of the Magi," *295*
 "The Virgin of the Rocks," *Plate 24*
Limbourg brothers, "Octobre," *136*
Lindsey, Jack, *quoted*, 224
Line, 118–147
 concept of, 119–122
 function of, 124–126
 history of, 130–136
 ancient world, 133–135
 middle ages, 135–136
 prehistoric, 130–132
 media for (*see* Drawing)
 and nonobjective painting, 122–124
 quality of, 127
"Lion Hunt" (Rubens), *300*
Lipchitz, Jacques, 12
 "Bathers," *13*
Lithographs, 113–114
"Lobster Trap and Fish Tail" (Calder), 17, *19*
Lorenzetti, Ambrogio, 289–290
 "Good Government in the City," *290*
 "The Presentation of Jesus at the Temple," *291*
Lost-wax (cire perdue) process, 91–92

M

Macaroni lines, *130*
McIntosh, Harrison, ceramic forms, *125*
McKinley, Donald, *quoted*, 32
"Madame Rivière" (Ingres), *221*
"Madonna Enthroned" (Duccio), *55*
"Madonna Enthroned" (Giotto), 55
Magic objects, as art forms, 9–12
Magic Realists, 62
"Maids of Honor, The" (Velázquez), *223*
Malevich, Kasimir, "Suprematist Composition: White on White," *304*
"Malle Babbe" (Hals), *103*
"Man with a Guitar" (Braque), *305*
Manet, Édouard, 191, 226–227
 "A Bar at the Folies-Bergère," *226*
 "The Spanish Singer," *Plate 27*
Manetti, Antonio, *quoted*, 291, 292
Mannerist style, 58

Mantegna, Andrea, 139
Marble, 84
Marbling, 203–204
Marini, Marino, "Horse and Rider," *86*
Martini, Simone, 56–57
 "The Road to Calvary," *56*
Masaccio, 292
 "The Tribute Money," *293*
Mask, Eskimo, *11*
Maso di Banco, 288
Materials (*see* Media)
Matisse, Henri, 77, 227
 "Lady in Blue," *Plate 33*
 quoted, 195
 stained-glass window, *78*
Maxwell, James Clerk, 167, 181
 quoted, 167
Mayer, Johann Tobias, 178
Mayer, Ralph, *quoted*, 99
Media, characteristics of, 77–80
 history of, 74–77
 mixed, 73
 (*See also* Drawing; Painting; Sculpture)
"Merzbau" (Schwitters), *236*
Metals, as drawing media, 140–143
 as materials for sculptor, 85–86
Metamorphic stones (marbles), 84
Michelangelo Buonarroti, 28, 95, 139, 191, 249–250
 "Pietà," *249*
Miller, Alec, *quoted*, 251
Millet, Jean François, 9
 "Planting Potatoes," *10*
Minor arts, 30–33
"Minotauromachy" (Picasso), *113*
"Miraculous Draught of Fishes" (Raphael), *79*
Mixed media, 73
Modeling, as sculptural technique, 89
Modigliani, Amedeo, 143
 "Portrait of Madame Zborowska," *144*
"Modulor" (Le Corbusier), *269*
Moholy-Nagy, Laszlo, 263
 quoted, 206
Molds (for casting), types of, 89–91
Mondrian, Piet, 303–304, 306–307
 "Composition 2," *306*
Monet, Claude, 192, 227, 302
 "Haystacks, Setting Sun," *Plate 22*
 "Old St. Lazare Station, Paris," *Plate 28*
 quoted, 189
 "Rouen Cathedral: Tour d'Albane, Early Morning," *303*
 "Two Haystacks," *Plate 21*
"Mont Sainte Victoire" (Cézanne), *Plate 30*
Montage, 310–313
Moore, Henry, 12, 255
 "Reclining Nude," *13*
Morgan, Charles H., *quoted*, 250

Mosaics, 104–107
Müller, Johannes, 170
Mumford, Lewis, *quoted,* 16
Munch, Edvard, 307
 "The Day After," *10*
 "The Death Chamber," *308*
Munsell, Albert, 154–155, 184–185
 color solid of, *Plate 20*
 quoted, 184, 188

N

Nabi, the, 194
Naturalism, 214–226, 248–250
Nefertiti, Queen (limestone bas-relief), *283*
Neoclassic style, 59–61
Neogothic style, 59–61
 Bookcase in, *61*
Neoimpressionism, 192–193
Neolithic period, media and techniques in, 75–76
Newton, Isaac, 162–164, 177
 quoted, 162
Nizzolo, Marcello, typewriter, *35*
Noguchi, Isamu, 255
 sculpture, Marine Building, *40*
Nonobjective painting, 122–124, 195–197, 228–229
Nonobjective sculpture, 256–259
"Number 1" (Pollock), *230*
"Number 32" (Pollock), *67*

O

Objets trouvés (found objects), 93
Obscene Artists, 62
"Octobre" (Limbourg brothers), *136*
Oil paints, 100–104
"Old Cotton Fields Back Home" (Bell), *Plate 34*
"Old Models" (Harnett), *234*
"Old St. Lazare Station, Paris" (Monet), *Plate 28*
Oldenburg, Claes, "Hamburger with Pickle and Tomato Attached," *Plate 1*
Op Artists, 62
Order, in relation to art, 20–21, 264–275
Ostwald, Wilhelm, 182–183
 color triangle of, *Plate 19*
 quoted, 178, 179, 187
"Otani Oniji III as Edohei" (Sharaku), *112*
"Our Lady of Vladimir" (Russian icon), *5*

P

Painting, media and techniques of, 93–104
 buon fresco, 95
 distemper, 93–94

encaustic, 95–98
 fresco secco, 95
 oil, 100–104
 plastics, 104
 synthetic resins, 104
 tempera, 98–100
 texture in, 214–237
 collage, 232–237
 Expressionism, 228–232
 Impressionism, 226–227
 naturalism, 214–226
Paleolithic art, carvings, "Venus Magdalinienne," *75*
 "The Venus of Willendorf," *12*
 cave drawings, 130–132
 bison, *132*
 cows, *Plate 3*
 media and techniques in, 74–75
Palladio, Andrea, 266, 273
 quoted, 275
Pastels, as drawing medium, 139
Peale, Raphael, 234
"Peasant Wedding" (Brueghel), *216*
Pencil, as drawing medium, 143
Pepper, Stephen, *quoted,* 186
Perception, 4–6, 262–264
Persian painting, conceptual perspective in, 282–283
Perspective (*see* Composition)
Phidias, 241
Philolaus, *quoted,* 265
Picasso, Pablo, 77, 234
 ceramic platter, *79*
 "Guernica," *312*
 "Minotauromachy," *113*
 study for "The Pipes of Pan," *121*
Piero della Francesca, 294
"Pietà" (Michelangelo), *249*
Pilgrimage Church, Die Wies (Zimmermann), *301*
"Pipes of Pan, The," study for (Picasso), *121*
Pisanello, 142
Pissarro, Camille, 192, 227
 "River, Early Morning," *Plate 36*
Planographic printing, 113–114
"Planting Potatoes" (Millet), *10*
Plaster, as material for sculptor, 80–81
Plastic paints, 104
Plasticine, 82–83
Plastics, 207–208
Plato, *quoted,* 265
Pliny, 97–98
Pointillists, 62, 227
Pollock, Jackson, 66, 229
 "Number 1," *230*
 "Number 32," *67*
Pop Artists, 62
Porcelain, 82
"Portrait of a Young Man" (Bronzino), *58*
"Portrait of Anna Peter" (Grosz), *145*

"Portrait of the Comtesse d'Haussonville" (Ingres), *102*
"Portrait of Madame Armande Destouches" (Ingres), *145*
"Portrait of Madame Zborowska" (Modigliani), *144*
"Portrait of Moise Kisling" (Soutine), *228*
Post-Chandler, R., *quoted,* 246
Postimpressionism, 193–195, 227
"Prayer Rug" (Hicks), *32*
Prehistoric art, as stylistic classification, *44*
 (*See also* Paleolithic art)
"Presentation of Jesus at the Temple, The" (Lorenzetti), *291*
Primaticcio, Francesco, stucco decoration, *81*
"Prince Rahotep and His Wife," *Plate 37*
Prints, 109–116
Proportion, diminishing, 288–290
 mathematical, 266–268
 and symmetry in art, 270–274
Prud'hon, Pierre Paul, "Head of a Woman," *141*
"Ptolemy" (Arp), *256*
Puvis de Chavannes, Pierre, 302
"Pyramid of the Sun," *9*
Pythagorean Theorem, 271
Pythagoreans, 265

R

"Raft of the Medusa, The" (Géricault), *224*
"Rape of the Daughters of Leucippus" (Rubens), *217*
Raphael, 77, 139, 142
 "Miraculous Draught of Fishes," *79*
 "The Three Graces," *Plate 10*
Ratio, 266–267
Rauschenberg, Robert, "Canyon," *74*
 quoted, 236–237
"Ravine, The" (van Gogh), *Plate 31*
Raynal, Maurice, *quoted,* 306, 307
"Reclining Nude" (Moore), *13*
Relief prints, 112
Rembrandt van Rijn, 191, 219–220
 "The Anatomy Lesson of Dr. Tulp," *220*
 "Self-Portrait," *221*
Renaissance period, concept of art during, 28
 painting in, 214–216, 286–295
 sculpture in, 247–251
 as stylistic classification, 57–58
 theory of proportion during, 273
Resins, synthetic, 104
Rewald, John, *quoted,* 192, 194

Reynolds, Sir Joshua, 29
Richter, Gisela, *quoted,* 243
Richter, Manfred, 185
"River, Early Morning" (Pissarro),
 Plate 36
"Road to Calvary, The" (Martini),
 56
Robb, David Metheny, *quoted,* 219
Rococo style, 58, 251
Rodin, Auguste, 253–255
 "Adam," *238*
 "St. John the Baptist Preaching,"
 254, 255
Roman art, mosaic, "Donkey Nurs-
 ing Two Lion Cubs," *105*
 sculpture, 243–244
 portrait of a man, *244*
 torso of a man (bronze), *243*
 as stylistic classification, 45–49
 types of, 27–28
Romanesque style, 54, 245–246
Rood, Ogden N., 192
Roszak, Theodore, 255
 "Spectre of Kitty Hawk," *257*
Rouault, Georges, 227
"Rouen Cathedral: Tour d'Albane,
 Early Morning" (Monet),
 303
Rowland, Benjamin, Jr., *quoted,* 47–
 48
Rowley, George, *quoted,* 284–285,
 298
Rubens, Peter Paul, 77, 139, 191,
 216–217
 "Lion Hunt," *300*
 "Rape of the Daughters of Leu-
 cippus," *217*
Rugg, Harold Ordway, *quoted,* 20,
 21
Runge, Phillip O., 179
Russolo, Luigi, "Dynamism of an
 Automobile," *311*

S

"Sacrifice to Hymen" (Flaxman),
 78
St. Basil's Cathedral, 17, *18*
"St. Christopher and the Infant
 Christ" (Ghirlandaio), *96*
"St. Dorothy" (woodcut), *110*
"St. Francis Renouncing His In-
 heritance" (Giotto), *287*
"St. Mary Magdalene" (Van der
 Weyden), *142*
"St. Michael, the Archangel" (della
 Robbia), *82*
"Salt Cellar of Francis I" (Cellini),
 31
S. Carlo alle Quattro Fontane, fa-
 cade of (Borromini), *59*
San Vitale (church), *53*
Sand-molding, 91
Santayana, George, 15

"Sariguzel Sarcophagus, The," *50*
"Satyrs and Nymphs" (Signorelli),
 138
Scholfield, P. H., *quoted,* 270, 271
Schopenhauer, Arthur, 179
Schwitters, Kurt, 235–236
 "Cherry Picture," *233*
 "Merzbau," *236*
Sculpture, materials of, 80–87
 clay, 82–83
 metals, 85–86
 plaster, 80–81
 stone, 83–84
 wood, 84–85
 techniques of, 87–93
 carving, 88–89
 casting, 89–92
 fabrication, 92–93
 modeling, 89
 texture in, 237–259
 Baroque, 251
 Christianity's effect on, 244–245
 Egyptian, 240–241
 Gothic, 245–247
 Greek and Roman, 241–244
 modern, 252–259
 primitive, 239–240
 Renaissance, 247–251
 Romanesque, 245–247
Secretary, veneer and marquetry,
 204
Sedimentary stones, 83
Seitz, William C., *quoted,* 231
"Self-Portrait" (Frasconi), *109*
"Self-Portrait" (Rembrandt), *221*
Sepia, 147
Series, mathematical, 267–268
Serigraphs, 114–115
Sérusier, Paul, 194
Seurat, Georges, 192–193, 227
 "Une Baignade, Asnières," *Plate
 29*
Sharaku, Toshusai, "Otani Oniji III
 as Edohei," *112*
"Shoemaker's Shop," *Plate 7*
"Shrimp Girl, The" (Hogarth), *222*
Shute, John, 273
Sienese school, 55–57
Signac, Paul, 192–193
Signorelli, Luca, "Satyrs and
 Nymphs," *138*
Silk-screen prints, 114–115
Silver, as material for sculpture, 86
Silver-point drawings, 140–143
Sisley, Alfred, 192, 227
Six-color circle, *Plate 15A*
"Slave Ship, The" (Turner), *Plate
 25*
Smith, Adam, 209
Smith, William Stevenson, *quoted,*
 241
Social Realists, 62
"Sound of Flowers" (Broderson), *37*
Soutine, Chaim, 227
 "Portrait of Moise Kisling," *228*

Space, in composition, 279–296
"Spanish Singer, The" (Manet),
 Plate 27
"Spectre of Kitty Hawk" (Roszak),
 257
Spectrum, *Plate 14*
Spirit drawing, Australian aborigi-
 nal, *8*
Spoons, *211*
 functionalism in, 211–212
"Stag at Sharkey's" (Bellows), *114*
Stained glass, 107–109
"Stairway at Auvers" (van Gogh),
 228
Standard, bronze (pre-Hittite), *86*
Stencil prints, 114–115
"Still Life #1" (Click), *115*
"Stoke-by-Nayland" (Constable),
 223
Stone, as material for sculptor, 83–
 84
Stonehenge, *8*
Stoneware, 82
Stucco, 80–81
Style, elements of, 41–42
 methods of classification of, 42–
 63
Sullivan, Louis, drawing for archi-
 tectural ornament, *136*
"Suprematist Composition: White
 on White" (Malevich), *304*
Surrealists, 62, 234–235
Sutter, David, 192
Symmetry, 268–275

T

Tanyu, Kano, "Ducks and Reeds,"
 139
Taste (esthetic), 12, 174–175
Tattooing, as art form, 70, *71*
Teapoy, papier mâché, *204*
Techniques, 77–80
 classification of art objects by,
 65–73
 history of, 74–77
 of sculptor, 87–93
Tempera, 98–100
Terra cotta, 82
Texture, 200–259
 (*See also* Design; Painting; Sculp-
 ture)
"Third of May, 1808" (Goya), *67*
Thompson, D'Arcy, *quoted,* 272
"Three Graces, The" (Raphael),
 Plate 10
Tiedemann, Anker, *quoted,* 209
Tiepolo, Giovanni Battista, "Two
 Magicians and a Youth,"
 Plate 12
Tintoretto, Jacopo Robusti, 191
Tobey, Mark, *quoted,* 231
 "Written over the Plains," *230*
Toulouse-Lautrec, Henri de, 302
 "At the Moulin Rouge 1892," *303*

"Tribute Money, The" (Masaccio), *292*

"Triumphant Hunter" (Egyptian tomb painting), *134*

Trompe-l'oeil painting, 234

"Tub, The" (Degas), *Plate 11*

Turner, Joseph Mallord William, 191, 222

"The Slave Ship," *Plate 25*

"Tut ankh-Amun Hunting Desert Animals," *46*

Twelve-color circle, *Plate 15B*

"Twelve Views from a Thatched Cottage" (Hsia Kuei), *298*

"Two Haystacks" (Monet), *Plate 21*

"Two Magicians and a Youth" (Tiepolo), *Plate 12*

Typewriter (Nizzolo), *35*

U

"U as a Set" (Falkenstein), *258*

Uccello, Paolo, 294

"The Battle of San Romano," *17*

Utilitarian forms, as art objects, 9–12

Utitz, Emil, *quoted,* 187

V

Valentiner, W. R., *quoted,* 255

Value systems, in judgment of art forms, 66, 116–117

Van der Weyden, Rogier, "St. Mary Magdalene," *142*

Van Eyck, Jan, 100

Van Gogh, Vincent, 93–94, 101, 227, 307

"L'Arlesienne," *103*
quoted, 193–194

"The Ravine," *Plate 31*

"Stairway at Auvers," *228*

Vanishing point, 288–290

Vasa, "Blue in the Middle," *Plate 2*

Vasari, Giorgio, *quoted,* 248, 249, 250

Velázquez, Diego, 221

"The Maids of Honor," *223*

Veneers, 202

"Venus Magdalinienne" (Paleolithic carving), *75*

"Venus of Willendorf, The" (Paleolithic carving), *12*

Veronese, Paolo, "Feast in the House of Levi," *34*

"Virgin Adoring the Infant, The," *Plate 38*

"Virgin of the Rocks, The" (Leonardo), *Plate 24*

Vitruvius, 265–266, 273

Voulkos, Peter, ceramic container, *213*

W

Water color, 99

Watteau; Jean Antoine, 139

Weber-Fechner Law, 182–183

Wedgwood, Josiah, medallion designed for, *78*

Wertheimer, Max, 263

White, John, *quoted,* 287, 288

"Wies, Die," Pilgrimage Church (Zimmermann), *301*

Woelfflin, Heinrich, 301

quoted, 250

"Woman IV" (De Kooning), *278*

"Woman Playing Lyre," *Plate 9*

Wood, as material for sculptor, 84–85

Woodcuts (*see* Prints)

Wren, Christopher, "Cathedral of St. Paul," *301*

"Written over the Plains" (Tobey), *230*

Wu Chen, "Fishermen," *123, 146*

Y

Young, Thomas, *quoted,* 165, 166

"Young Girl with Guitar" (Braque), *5*

Young-Helmholtz theory of color vision, 165–167

Z

"Zeus" (or "Poseidon"), *48*

Zimmermann, Dominikus, Pilgrimage Church, "Die Wies," *301*